AUTHENTIC HANDCRAFTED

MAGIC WANDS
and BROOMS

MADE FROM ONLY THE FINEST HARDWOODS

ALIVAN'S

MASTER WANDMAKERS

www.alivans.com

ULTIMATE UNOFFICIAL GUIDE

to the

MYSTERIES

of

HARRY POTTER

(Analysis of Book 5)

ULTIMATE UNOFFICIAL GUIDE

to the

MYSTERIES

of

HARRY POTTER

(Analysis of Book 5)

Galadriel Waters
assisted by
E. L. Fossa
& Prof. Astre Mithrandir

Illustrations by
Michelle Heran and Galadriel Waters

Wizarding World Press

Published in the United States by Wizarding World Press
8926 N. Greenwood Ave., Vault 133
Niles, IL 60714

Library of Congress Cataloging-in-Publication Data available at the Library of Congress

ISBN 0-9723936-4-1

Printed in the United States of America by TPS (Total Printing Systems), Newton, IL, and
Litho Communications, Paramount, CA
Distributed by SCB Distributors, Gardena, CA

Illustrations by Michelle Heran and Galadriel Waters copyright © 2002-5 Wizarding World Press
Book Cover Design and Layout by Dan Nolte, Graphic Design - www.dannolte.com
Original Book Layout Design by Beth Adams
Genealogy by Anne Fisher - frelighgenealogy@yahoo.com
Publication Consultant: S.P. Sipal
Administration: Bob Russo and Glenys Reyes

Proof Edition, June 22, 2005
First Edition, Fall Term -- September 1, 2005

To HP Sleuths who waited patiently while we worked on this guide;
and to the family of Jo Rowling for sharing their mum with fans

Special Thanks to:
S.P. Sipal

FOREWORD

Just yesterday I was conversing with young Sir Gawain about his new lady-wife, the now fair Dame Ragnell, when he reminded me of the words of wisdom which gave him his lady-love: What she desired most was to choose her own destiny.

As I remarked to the besotted Gawain, I know one young woman who has done just that. Not only has Lady Rowling chosen her own destiny, but she has created it for a whole world of characters who enliven the novels she has lovingly created. For indeed, choosing our own destiny is what most of us, male or female, would see in our mirrors of desire, I do believe.

It was thus with great pleasure that I answered the owl from Wizarding World Press with the request to pen another Foreword to this their newest release: *Ultimate Unofficial Guide to the Mysteries of Harry Potter (Analysis of Book 5)*. For who else among us (yes I include myself as one of you fanatic Harry Potter fans) has enjoyed more than Wizarding World Press searching out those sly clues the Lady Rowling does love to bury within her stories, and providing a trail to follow for others along the way.

Many of you, picking up this hefty bit of parchment at--what do you call your bazaars--ah, yes, your bookstores, may be wondering if this book is for you. Perhaps you think there are no new clues to unearth in that wonderfully full tome called *Harry Potter and the Order of the Phoenix*. Perhaps you believe yourself to be thoroughly ready to seek out all the new clues contained within Harry Potter and the Half-Blood Prince. But I believe you will find within these pages that there is always more to discover.

For instance, the revelation of that precious Philological Stone (mentioned within these pages) alone is enough to send me back to all five books, quill and parchment in hand, ready to decipher out more of Lady Rowling's wily clues. Just when I think I've gotten the hang of this hunt, Wizarding World Press gives me another tool to unearth more.

Regarding the Half-Blood Prince in the upcoming story--I had a friend once he reminds me of. Can't place the young man's name now, but it will come to me...

Now where did I leave my stone...?

Merlin

P.S.—Have you viewed the most excellent moving photography from the brothers Warner covering Lady Rowling's third tome? I did wonder a wee bit how they so knowledgeably portrayed time travel. Perchance, some of my Druid friends versed them?

Message to J. K. Rowling:

*It's been a busy couple of years. You are right—self-publishing **is** a lot of hard work, and it doesn't seem to get any easier. Time is always a cross we bear—we wish we could summon a time-turner, for then we wouldn't be running as intensely as the Red Queen or having to start over every time we got to the end.*

There are many different kinds of roadblocks for people, and many ways to realize dreams. We are so happy that you are opening doors for the world, and hope you have enough time to enjoy what you created. We see you haven't been lying around dreamily either! Your website is awesome, your family is growing, and, as we write this, Book 6 is about to rise over the horizon...are you sure you didn't go to Hogwarts? ☺

*We have tried to do the best we can, but sleuthing Book 5 was like opening Moody's seven trunk spaces—every time we opened a loch, we spotted another level – we kept spinning in circles. We were contemplating chucking it into the bin when we finally think we got tuned in to the clues you planted and our notes were flowing. The possibilities just kept growing, and the time just kept shrinking. *sigh* So many choices—all we can ever do is try to make the right one.*

Our intent is reverential fun (with a lot of work mixed in). We hope you can also see it from our side...upside down and in reverse.

Thank you!

INTRODUCTION

Welcome back, HP Sleuths, *welcome back!* Thank you for your support. It is because of you that we are able to continue publishing.

J.K. Rowling has done it again! *Harry Potter and the Order of the Phoenix* is not only big and mean, it's a literary tour de force. And it's *pecked...that is...packed* with clues on every page! Harry Potter fans have been given a difficult task if they wish to find and decipher all those clues. In a personal appearance at Royal Albert Hall, Jo put up the challenge when she said: *"I had to put in some things because of what's coming in books 6 and 7 . . . I want you to be able to guess if you've got your wits about you."* Now, what self-respecting HP Sleuth could resist that challenge?

Not us.

So here we are again with the full version of UUG5.

Our ending to the original *Ultimate Unofficial Guide to the Mysteries of Harry Potter* probably summarizes our Introduction to this new Guide the best. If you recall, this is how we left you last...

Reality Check

Due to Jo's precise writing style, plus her well-developed world and character profiles, we are able to spot clues and predict events, as she has challenged us to do. She has carefully designed her magical world and adheres to strict "rules" (just as she explains in interviews). Her mysteries are so well implemented that we can solve riddles in a world which defies our own physics.

However, we have only followed the trail she has left for us, as we have no special insight into what will actually happen. We are having a great time trying to find the clues and hypothesize what she might do. Nonetheless, Jo's works are so complex and intricate that nothing is ever certain until it is published (and even then, watch out for twists and red herrings!).

If Jo finds out that HP Sleuths are on her trail, she might raise the stakes and change the rules again – as she is not only brilliant, but also in control of this game...

The dedicated fans who deconstruct the Harry Potter books demand precision at its highest level, just as anyone who interprets a piece of literature must. You can't be precise if you don't know the exact context of the clue being discussed. The purpose of our guide is to show fans the procedure for breaking down and analyzing the embedded clues and literary techniques utilized by J.K. Rowling, so using a chapter-by-chapter examination was chosen as the most effective methodology.

In our first Guide, we only summarized those passages that we felt contained hints or mysteries. There are many scenes that we didn't cover, and we left out a lot of the shipping

references (which you made sure we knew). The trouble is, there are subtle hints dropped all along, so the credibility of our hypotheses is best supported if the references are presented where they are found and within context. Additionally, we do not give out spoilers in advance, so by using that technique, the reader was able to watch how the story and clues were evolving as the knowledge was exposed. We included all key passages as we analyzed them, as a means of building our case. We even braved the wrath of the publishers in order to make sure you had a thorough analysis. Nonetheless, while many fans love our original format, there are those who did not understand how much work went into picking just the right passages so we could build our arguments. But rather than upset anyone, we have decided to back off from a lot of the passages that would build our case.

An example of this is with Petunia's unnaturally-clean kitchen. Only one mention of her kitchen would just be a probable hint about her personality having a need for things to be clean – we already know she has a distaste for natural or "dirty" things such as birds, mud, or real (sooty) fireplaces. However, if we were to highlight each instance where it is referenced in Chapter 2 of Book 5, it quickly becomes apparent that it is probably much more than a personality profile. By our recounting each mention, you would get to see it for yourself so you can make a better value judgment as to whether it should be considered a hint or not.

That was our methodology for a specific book. Of course, for those items that had constant references throughout the whole septology, like socks and the number 12, we described each of the early references and then having seen the pattern, allowed you to continue investigating them on your own. We then only described future references that we thought had special significance. It is a valuable sleuthing tool, but we also are sensitive to the perception that we may have been retelling the story by including so much detail, so we have changed the way we present our evidence. It will be a bit more difficult for you to note all instances, but since you love the Harry Potter books so much, we are sure you won't mind reading through them some more so you can pick up all the nuances. Since the whole point of this Guide is not to give you answers, but to spark ideas and discussions, you should enjoy discovering all the extra occurrences of the running bits and reinforced hints.

If you have read *New Clues* and are looking for the answers, they should all be in here, but not all of them will be answered in the same order that they were presented in *New Clues*. *New Clues* was written as a spoiler, and did not maintain the order of the chapters for the discussion of the material. Similar to our first *Ultimate Guide*, here we don't discuss what the information might mean before getting to the chapter where it becomes evident. You should see some hints in the same place where they appeared in *New Clues*, but you may need to wait until a later chapter in order to see how it all fits together. If you have participated in the online New Clues Brain Room, be prepared for a long wait...

So, grab your Hintoscope and your new *Philological Stone*, because we've got a lot of work ahead.

WE'RE GOING SNARK HUNTING!

Spoiler Warning

Even though we have very carefully avoided exposing the plot in advance, this is a mystery plot analysis. Therefore, whenever something is revealed, we discuss it (disclosing patterns), and when we get to the ending, we openly talk about it!

Just like with any storybook, do not turn to the ending if you are not ready to read it!

In the Restricted Area: Future plot probabilities and speculations about the ending to the whole series are discussed – based on known information and existing clues.

TABLE OF CONTENTS

WWP HELP DESK

FAQs (Frequently Asked Questions)

ᘒ When Should I Read This Guide?

ᘒ Rowlinguistics in Book 5 ...or What Is the *"Philological Stone"*?

ᘒ Are There Too Many Words in Book 5?

ᘒ Are There Differences Between the UK and U.S. Versions of Book 5?

ᘒ What Is Significant About the Date That Book 5 Was Released?

ᘒ *(Review)* How Reliable Is the Information in This Guide?

ᘒ *(Review)* What Is an Ultimate Unofficial Mystery Guide? ...*and What Is an "HP Sleuth"™?*

ᘒ Review) What Is a Septology?

When Should I Read This Guide?

Ultimate Unofficial Guide to the Mysteries of Harry Potter (Analysis of Book 5) is for HP Sleuths only! If you have read *Harry Potter and the Order of the Phoenix,* and are ready to ferret for clues and solve the mysteries of Book 5 and Beyond, then this Guide is for you. We are making the assumption that you are familiar with the skills involved in sleuthing a Harry Potter book. We also *highly recommend* that you have read the easily-available school books *Fantastic Beasts* and *Where to Find Them and Quidditch Through the Ages* (see the HP Sleuth Recommended Reading). So, if you haven't, we can't be responsible for glassy looks as you sit staring straight at the clues.

Rowlinguistics in Book 5 ...or What Is the *"Philological Stone"*?

Not only have the reading level and plot line become more advanced in Book 5, but the clues have become far more sophisticated. By Book 7, we may need some NEWT-level spells to decipher all of them! One of the reasons for this new degree of difficulty is Jo's use of wordplay. In previous books, the Rowlinguistics (Jo's coined words) generally consisted of words and phrases from mythology, other languages and Olde English that Jo used verbatim ("vol de mort," "dumbledore"), or puns. Sometimes she put a little twist on the spelling, homophone-style, just to give us a bit of a challenge in tracing the words ("Knockturn Alley" = *nocturnally*).

However, just as Harry's personality has become more complex in Book 5 (you may call it multiplexed), the literary tricks Jo has hiding up her sleeve have also become far more intricate. The wordplay that she draws from most often now includes metonyms, homonyms/homophones, malapropisms, portmanteau words, and even baby talk! Depending on how they are implemented, the portmanteau words can be the most difficult.

The way a portmanteau word works is to combine 2 or more words into one so that it sort of looks a little like each word, but not like anything at all. That technique was made

FAQs ... WWP Help Desk

ULTIMATE UNOFFICIAL GUIDE TO THE MYSTERIES OF HARRY POTTER

famous by Lewis Carroll in his *Alice in Wonderland* stories. As Lewis Carroll explained it:

> "... take the two words 'fuming' and 'furious.' Make up your mind that you will say both words, but leave it unsettled which you will say first. Now open your mouth and speak. If your thoughts incline ever so little towards 'fuming,' you will say 'fuming-furious;' if they turn, by even a hair's breadth, towards 'furious,' you will say 'furious-fuming;' but if you have the rarest of gifts, a perfectly balanced mind, you will say 'frumious.'"

However, since Carroll had the nasty habit of placing letters out of order when he created a portmanteau (neither fuming or furious begin with an "fr"), scholars are still tracking his Snarks. In our opinion, that makes it much less fun when the cleverness is lost on all of us.

We prefer Jo's style – where we at least stand a chance of getting it. One of the few early examples of a portmanteau in the Harry Potter series is the name "Gringotts," a combination of gringou (French for *miser*) and ingot (*a nugget of precious metal*). Hers are still not that easy to trace because portmanteau words are often difficult to research. You may not know where one word ends and the next begins – especially since letters are dropped, doubled, or slightly altered. In the case of Gringotts, it can look as if it is a combination of grin+got, but as goblins aren't very funny, we didn't think that was what Jo intended.

Book 5 has the most elaborate use of wordplay. As always, every name has a meaning – and there are a gazillion new names in Book 5. We picked only those that are key clues. We attempted to include every name that we could find, which might give *new* insight into the septological mysteries.

In the UK edition of OoP, Neville does a little malapropism that is a very big key to deciphering Book 5. In Chapter 16 ("The Hog's Head"), he inadvertently calls the Philosopher's Stone (that's the "Sorcerer's Stone" for U.S. readers) a **Philological Stone**. However HP Sleuths might call it the Book 5 Rosetta Stone, since we now know that is the key to the secrets of Book 5. If you don't know the meaning of "philological," you may want to look it up. That's what you are going to be doing – if you're doing Book 5 detective work!

— *Are There Too Many Words in Book 5?* —

Book 5 is a literary wonder! Don't let the critics send you off the trail. They are just not well informed. *There are **not** too many words in Harry Potter and the Order of the Phoenix!*... That is...unless you don't care about what is going to happen in Books 6 and 7...

The people who are under the misguided impression that there are too many words in Book 5 haven't quite yet grasped the concept that this is a cerebral mystery, and that the clues (unlike in a blood-and-guts thriller) are buried in the words! If HP Sleuths personally encounter any of those poor underprivileged members of society who haven't discovered the secret, you can help by opening their eyes to the other half of the brilliant writing that has gone into these great works of literature.

Now, you will have to be sensitive to the realization that some people will turn up their noses because they won't want to admit that they were fooled; and then there are others who will *never* get it (or even if they do, they still may not like puzzles). That is fine. One

WWP Help Desk ... *FAQs*

Ultimate Unofficial Guide to the Mysteries of Harry Potter

doesn't have to become a champion or even *like* chess in order to understand that it is highly complex and that it takes much more time for a Grand Master to play it than a novice.

The important issue is that at least those who are informed will have an appreciation for why the Harry Potter books are so long. Hopefully they will also appreciate the headaches we get trying to decipher it all!

Are There Differences Between the UK and U.S. Versions of Book 5?

Once again, we have considerable differences between the two editions. However, this time it is *not* just because they were edited for an "American" audience. It appears that the editing was done completely independently by the two publishers. Some corrections to actual errors appeared in the U.S. version but not in the UK version, and vice-versa. It seems that both publishers received the raw manuscript and edited independently. That means whole sentences are often quite different. We used one of each copy, but generally gave precedence to the UK version (including favoring the UK method of capitalization, i.e. "Dementor"). Serious HP Sleuths may want to have both editions. Jim Dale's U.S. Listening Library audio version does use the Scholastic edition.

What Is Significant About the Date That Book 5 Was Released?

Harry Potter and the Order of the Phoenix was released on June 21, 2003. This date just happened to correspond to the northern summer solstice that year. The summer solstice is the date in which the sun is the highest in the sky and is the longest day of the year. The tie to a celestial date rather than a Gregorian Calendar date is significant. As with everything else in Book 5, even the release date holds clues.

(Review) How Reliable Is the Information in This Guide?

Even though this is an unauthorized Guide, all observations are based solely on what J.K. Rowling has written in her books (#1-5 and *Comic Relief* schoolbooks), what is contained on the *Bloomsbury* web site (www.bloomsbury.com), the *Scholastic* web site (www.scholastic.com), the *Warner Bros.* web site (www.harrypotter.com), and/or what has been personally stated by Jo in public interviews, or on her website at www.JKRowling.com.

Accuracy and supported evidence are highly valued by Wizarding World Press.

Please remember: We are not revealing any proprietary information as all our insights are strictly from careful literary detective work on her published works.

(Review) What Is a Septology?

There are many well-known three-volume series called "trilogies." According to J.K. Rowling, the Harry Potter stories will span a seven-volume series. As it is clearly an aggregate

work (not just sequels), we are calling it a septology {"septem" = *seven* in Latin + "ology" = "logia" = *discourse* in Latin and Greek – used in words like zoology}. Before deciding on "sep-tology," we did a search on the Internet in order to discern the best term for a seven-part series. We considered the use of "heptalogy" {"hepta = *seven* in Greek}, but there is very little precedence for its use (and it doesn't appear in the dictionary). Additionally, it is often mis-spelled — confusing it with a very nasty medical ailment. Heptalogy just doesn't work. The word "septology," however, was already in use — and commonly applied to works of science-fiction and fantasy, in particular. There are several series which have historically been described with that term. Those utilizing "septology" have included very reputable reviewers from highly respected sources such as *The Washington Post,* ScienceFiction.com, and universi-ty professors. We thought Jo's works also deserved that recognition.

(Review) What Is an Ultimate Unofficial Mystery Guide? ...and What Is an "HP Sleuth"™?

THIS IS NOT A CHEAT BOOK to give away or help skip over any parts of the original sto-ries – in fact, you will probably find yourself going back to reread in disbelief what you missed the first time! The primary objective of this Guide is to show readers how to look for the hidden clues, and then have fun speculating about what will really happen.

This is an *unofficial* "mystery guide" to the Harry Potter stories, by Wizarding World Press. It is not authorized by J. K. Rowling, Warner Bros., Bloomsbury Publishing, or Scholastic Inc. Nonetheless, since we like what they have done for us fans, we hope that this Guide will create new excitement for Harry Potter (plus new book and merchandise sales), when everyone discovers the truly sophisticated mystery hiding in the Harry Potter stories.

The Harry Potter septology is an *epic mystery* and is considerably more intricate than it appears. This Guide specifically highlights these *mystery* aspects, including all the puzzles and brain-teasers that J. K. Rowling has painstakingly hidden within her story line. She has divulged that she purposely concealed clues along the way, and challenges us readers (we call ourselves "HP Sleuths"™) to discover them.

The goal of this Guide is to show HP Sleuths what to look for, since there are so many clever references that can slip by us (even on a third or fourth reading!). This Guide does not presume to have answers for anything that has not yet been published. Its purpose is to present reliable evidence in order to generate entertaining discussions. We encourage HP Sleuths to use this as a starting point for new theories and debates.

From the moment you uncover your first hidden clue, you will see how much fun it is being an HP Sleuth. *This meeting of the HP Sleuth Club™ is now in session!*

How to Read This Guide (Very Carefully) ☺

(WWP HELP DESK)

Navigating This Guide

Unlike our previous *Ultimate Unofficial Guide*, you will not find it as easy to review all of the mystery plot elements. We have skipped over many of them in this new format—leaving it up to the reader to locate multiple references.

For this Guide we've joined a shorter review directly to the mystery analysis for a quicker review and a more combined analysis bringing together related material under one reference.

Just sit back and enjoy every word of this not-so-brief (but definitely cool) *Wizarding World Press' Ultimate Unofficial Guide to the Mysteries of Harry Potter (Analysis of Book 5)*.

Spoiler Warning

Even though we have very carefully avoided exposing the plot in advance, this is a mystery plot analysis. Therefore, whenever something is revealed, we discuss it (disclosing patterns), and when we get to the ending, we openly talk about it!

Just like with any storybook, do not turn to the ending if you are not ready to read it!

In the Restricted Area: Future plot probabilities and speculations about the ending to the whole series are discussed – based on known information and existing clues.

A Clue About Clues

There are two kinds of clues that can be found in the Harry Potter books:

A story-line clue – which is specific to the book in which it is found. An example of this is that Harry's scar hurts at certain times throughout Book 1.

A septology clue – which is not resolved by the end of one book. This kind of clue relates to the whole seven-volume mystery, and will not be revealed by Jo until after Book 5 (the current HP book as of the time of this writing). An example of this is Dumbledore's reluctance in Book 1 to reveal the secret behind why Voldemort wanted to kill Harry until Book 5.

Abbreviations

Book Numbers

Throughout this guide, to make the analysis easier (and to keep our typist sane), we will be referring to the Harry Potter books by number. Therefore, just in case, here is a cross-reference list of the books by title.

Book 1: *Harry Potter and the Philosopher's (Sorcerer's) Stone*

Book 2: *Harry Potter and the Chamber of Secrets*

Book 3: *Harry Potter and the Prisoner of Azkaban*

Book 4: *Harry Potter and the Goblet of Fire*

Book 5: *Harry Potter and the Order of the Phoenix*

Jo

On her website J. K. Rowling has asked all fans to call her Jo, so this is the format we'll be using throughout this guide (www.JKRowling.com).

WWP

This is us. This is an abbreviation for *Wizarding World Press* – the virtual pressroom where we spend real hours bringing you all these goodies.

HP SLEUTH HOME PAGE

The WWP Magical Toolkit

(HP Sleuth Home Page)

Toolkit Contents

HP Sleuths have some useful tools to help them as they read. In the spirit of Jo's own humor, we have had a little fun with satire for these. Here is your box of magical mechanisms:

- **The HP Hintoscope** – This is a very delicate device that detects Jo's hints and clues about the story-line plot. When it gets near an important hint, the HP Hintoscope makes a noise to alert HP Sleuths that a hint is being detected. The more annoying it gets, the bigger the clue.

- **The WWP Sleuthoscope** – This is a super-sensitive sensor that can sniff out cleverly disguised septology clues. It alerts using flashing and various motions. The brighter it gets and the faster it moves, the greater the septology implications.

- **The WWP Rememberit** – This is a really remarkable recording quill. It automatically transcribes all key clues and brain ticklers (Rememberits), and annoys us with rude reminders until we solve them.

- **The *Philological Stone*** – This is the Rosetta Stone to deciphering all the complex linguistics that Jo has buried in Book 5. In order to help you understand and decipher all her clever linguistics, Jo was kind enough to have planted a hint about how to translate Book 5. We have spent the last 3 months in a sleepless quest, searching grimy ancient archives, and have finally succeeded in laying our hands on this rare treasure. It is included it in your HP Sleuth Toolkit.

Note: Sharp HP Sleuths know that these magical devices never make random motions or sounds. By paying close attention to their reactions, you will get very precise readings that can help you pinpoint and solve the clues.

— HP Sleuth Suggested Supplies & Recommended Reading —

5TH YEAR LIST

INCLUDED

- WWP Magical Toolkit

PREREQUISITES

* ✴ The Harry Potter series – including an on-hand copy of Book 5!
 * Book 1 - *Harry Potter and the Philosopher's (Sorcerer's) Stone*
 * Book 2 - *Harry Potter and the Chamber of Secrets*
 * Book 3 - *Harry Potter and the Prisoner of Azkaban*
 * Book 4 - *Harry Potter and the Goblet of Fire*
 * Book 5 - *Harry Potter and the Order of the Phoenix*

HIGHLY RECOMMENDED

* ✴ Textbook: *Fantastic Beasts and Where to Find Them*, by Newt Scamander

* ✴ Background Reading: *Quidditch Through the Ages*, by Kennilworthy Whisp

* ✴ HP Sleuth detective quill and parchment - 12 rolls (or an official Harry Potter notebook)

SUGGESTED READING AND OTHER MEDIA

Reference

* ✴ *Dictionary of Phrase and Fable* (Brewer's or Oxford versions)

* ✴ *Bartleby's Reference* (printed or online)

* ✴ Dictionary – Hermione's favorite tools - the biggest (and heaviest) English-language dictionary (preferably International) that you can find, and a local reference library.

Literature & Art

* ☾ Aeschylus - *Prometheus Bound*

* ☾ L. Frank Baum – *The Land of Oz*

* ☾ Lewis Carroll, – *Alice in Wonderland*, (we use an annotated edition by Donald J. Gray – Norton) (Mad Hatter Tea Party), *Through the Looking Glass*, "Hunting of the Snark," Discussion of "Raven-to-Writing Desk" (www.straightdope.com/classics/a5_266.html)

* ☾ Emily Dickinson – "I'm Nobody"

* ☾ E.R. Eddison – *The Worm Ouroboros*

* ☾ T.S. Eliot – *Murder in the Cathedral*, "Burnt Norton"

* ☾ Homer – *The Odyssey*

* ☾ Washington Irving – "Legend of Sleepy Hollow," "Rip Van Winkle"

* ☾ W.W. Jacobs – "The Monkey's Paw"

- James Joyce – (in moderation!), *Finnegan's Wake, Portrait of the Artist as a Young Man*
- Franz Kafka – *Penal Colony, Metamorphosis, The Trial*
- Rudyard Kipling – *Rikki-Tikki-Tavi*
- Leonardo da Vinci – sketch "Vitruvian Man"
- Michelangelo – painting "Crucifixion of Peter" (hint – upside-down)
- John Milton – *Paradise Lost*
- A.A. Milne – *House at Pooh Corner*
- George Orwell – *1984, Animal Farm*
- Charles Perrault – *Contes du Temps*
- Edgar Allan Poe – "The Raven"
- Philip Pullman – *His Dark Materials* (theologically controversial)
- Saki – "The Open Window"
- Jean Paul Sartre – *Huis Clos (No Exit)*
- William Shakespeare – "King Henry V," (Act III, Scene 6), "Romeo and Juliet," "Macbeth"
- Robert Louis Stevenson – *Treasure Island*
- Frank R. Stockton – "The Lady or the Tiger"
- Alfred Lord Tennyson – "Sir Galahad"
- J.R.R. Tolkien – all works
- Mark Twain (Samuel Clemens) – *Puddin' head Wilson*
- H.G. Wells – "The Red Room," "Under the Knife"

Classical Mythology/Mysticism Resources

- Greek, Roman, Norse, Egyptian Mythology
- Druid Legends & Monuments
- Ouroboros Eastern Mysticism resource

Kids Korner Nursery Rhymes

- *The House that Jack Built*
- *Humpty Dumpty*
- *Jack and Jill*
- *Little Jack Horner*
- *Peter Piper*
- *Sing a Song of Sixpence*
- *Three Blind Mice*

Movies/TV

- ☾ *Forbidden Planet*, Metro-Goldwyn-Mayer
- ☾ *The Highlander,* Fox/EMI Films
- ☾ Monty Python - *Life of Brian,* Warner Bros./Orion Pictures
- ☾ *Rosencrantz and Guildenstern are Dead,* Cinecom International
- ☾ *Time of Their Lives* -Abbott and Costello, Universal Studios
- ☾ *Young Frankenstein* - Mel Brooks, Fox
- ☾ *Dr. Who* TV series
- ☾ *Star Trek* TV series
- ☾ *Deathtrap* (Michael Caine, Christopher Reeve – can be controversial!), Warner Bros.

Music Lyrics

- ☾ Moody Blues – "The Dream" from *Threshold of a Dream*
- ☾ Gilbert & Sullivan – *The Mikado*
- ☾ Caravan – *In the Land of Grey and Pink* - Album

TCG

- ☾ The Harry Potter TCG (Trading Card Game) by Wizards of the Coast (www.wizards.com).

Special Request to HP Sleuths

The key word is "respect." Some people prefer to be surprised. If you are captivated by mysteries and puzzles, you may not understand those who are not interested in the mystery aspects of Harry Potter, but at least respect them. Please do NOT discuss or post these or your own clever theories about what might happen in the future with those people who don't wish to try guessing in advance. There are plenty of us HP Sleuths out here who like to dig for clues, so only reveal insights to those who want to know. We certainly are willing to discuss them with you. www.wizardingworldpress.com

Secrets of the HP Super Sleuth

NEW COROLLARY ADDED

The clues in Book 5 are brilliant!

Just as Jo intended, OoP had us "running in circles." With a proper-sized thesaurus and some dictionaries, it is not impossible (with a few sleepless weeks) to cross-reference the wordplay in order to identify keywords and running bits. However, what took almost all of our time was sorting them out so we could see the patterns and understand the clues.

In Books 1-4, a running bit in the form of a "flute" or "sing-song voice," could point us to a "music" hint. That would usually have been the keyword clue.

However, in Book 5, Jo has purposely used *ambiguous* keywords as running bits!

A seemingly simple phrase like "Elephant and Castle" may be pointing us to "sharp" hints or "trunk" hints. But then... would that be a "trunk" like a *nose*, or like a *chest* of clothes? ...Or could that be a trunk of a *tree*? There are *noses, chests* (on the body), and *trees* – all proliferating throughout Book 5, it is impossible to know which one she meant without a year of research (or some legilimens skills).

Our new corollary to Rule #1, *Juxtaposition [jux-ta-position]*, can help. By scouting the area in which the words are used, it is possible to spot additional hints that give the true intent of the clue. Then again, in the "trunk" example, even if we found out it related to noses, we would have yet another problem because both *smells* and *injured noses* are running bit clues as well. (groan) You get the idea.

We will give you one hint that would have helped us had we known from the beginning: as mind boggling as it may seem – when in doubt, assume all are clues.

Book 5 is one huge cerebral cortex charmer! (That's "brain-teaser" for those who have misplaced their *Philological Stone*.) Every time we cracked the code and stripped away a layer, we found another one laying in wait. It is unbelievable that Jo could have done this at all – let alone in less than three years. ...And you thought Book 5 was about stealing an orb?

If you have a Ph.D. in language and literature, you would say Book 5 is a literary dream, but for the philologically challenged, it can be a nightmare. Jo gives us clues by playing with words in a manner similar to that utilized by Lewis Carroll *(Alice in Wonderland)* – but in a much more subtle way – so you don't always realize she is doing it (see Rowlinguistics FAQ).

We have made your task tons easier by pointing you directly to the running bits and segments containing the clues. Now all you have to do is spot the exact clue, based on the hints we are giving, fit the pieces together, and solve the mysteries. Well...it's easier said than done because it's going to take some brainwork. However, we know that's what HP Sleuths crave, so we are sure you will have a jolly good time picking out these gems.

WWP's Rules of Constant Vigilance

Here's the "secret" to being an HP Super Sleuth. There are 4 rules to keep in mind about the way J.K. Rowling writes:

Rule #1

If she reinforces it, she means it – HP Sleuths need to focus on these kind of clues. Like everyone else, Jo is not flawless, and she has made a few minor errors in her books. Unfortunately, a few people may try to put special meaning on those or use those to debunk her intentional, masterful clues. The general rule here is to ignore conflicting information or a one-time questionable reference. However, if she repeats a reference/clue (no matter how subtle), she means for us to take it seriously. We do.

Corollary
1a) **Juxtaposition [Jux-ta-position] of repeated information (especially running bits) points to clues.**

Rule #2

If she suddenly interrupts something (and never finishes), she's hiding a key clue! – What was that? If Harry misses a lesson, if a character gets cut off while saying something, or even if someone forgets to ask a question, it's probably because we are being tormented by Jo. HP Sleuths should take note that if we know that we missed out on something, it is almost as good as knowing the information itself – especially if you like mysteries.

Rule #3

There's no such thing as a coincidence – When a character conveniently shows up at the right time (or wrong time), or when the same topic keeps mysteriously popping up over and over, it is a clue begging for attention. In her magical world, Jo has put a high emphasis on fate, plus there is often a good reason why things that look like coincidences happen. Yet, she also has a mischievous sense of humor, so HP Sleuths have to work hard to also avoid the red herrings. Often, her red herrings are just incomplete clues, so that if we pick up on all the "real" clues, we find that she has actually given us enough information to sort it out accurately.

Rule #4

Don't take a character's word for it – Characters often interpret events for us in her books. That is what characters are supposed to do. However, their analysis will be colored by their own personality and their particular perspective of the events. Just because the character has an explanation does not mean it is correct. Jo constantly uses this technique to throw us off the trail, and a good HP Sleuth must be wary of that trick.

Corollaries
4a) **Hermione is usually right (except when she gets emotional).**
4b) **Ron is usually wrong (except when he makes a joke about it).**

CONSTANT VIGILANCE! ☺

The Pocket Version

WWP's Rules of Constant Vigilance!

Never let your guard down with Jo. These are the Rules to remember (unless your memory is as bad as Gilderoy's). Rules for HP Sleuths:

1) **If she reinforces it, she means it (and wants us to remember it).**

 1a) **Juxtaposition counts!**

2) **If she suddenly interrupts something (never finishes), she's hiding a key clue!**

3) **There's no such thing as a coincidence.**

4) **Don't take a character's word for it.**

 4a) **Hermione is usually right (except when she gets emotional).**

 4b) **Ron is usually wrong (except when he makes a joke about it).**

(see WWP Help Desk FAQs for full explanation)

 # BOOK 5 MYSTERIES

About Book 5

(Harry Potter and the Order of the Phoenix)

Book 1 Title — *Harry Potter and the Order of the Phoenix* — by J. K. Rowling

Facts & Statistics:
- First British printing, Bloomsbury Publishing, June 21, 2003
- Simultaneous first U.S. printing, Scholastic, Inc., June 21, 2003 (June 21, 2003 was the summer solstice for the northern hemisphere), Raincoast Books, Canada
- Initial U.K. print run of 4.5 million
- Initial U.S. print run of 6.8 million copies (a second print-run of 1.7 before publication brought the total up to 8.5)
- 1,777,541 copies sold of the Bloomsbury edition in first 24 hours (compared to 372,775 for Goblet of Fire), making it the fastest selling book to that date
- 5 million copies estimated sold by Scholastic in first 24 hours with Barnes and Noble selling nearly 80 copies a second
- In the first 24 hours, one book was sold for every 60 residents of the US and UK.
- Many bookstores worldwide were open at midnight to sell to the waiting crowds.

Illustrations:
- Mary GrandPré, for Scholastic
- Jason Cockcroft, for Bloomsbury, children's cover
- Michael Wildsmith (photographer) and William Webb, Design Director, for Bloomsbury adult cover

Audio Versions:
- Listening Library (Random House), Jim Dale, voice, US
- Stephen Fry, voice, UK

Length:
- Over 255,000 words
- 870 pages, Scholastic
- 766 pages, Bloomsbury

Awards & Records:
- WH Smith People's Choice Book Awards, Fiction Category, 2003

Movie Stats:
- Movie Release date: 2007
- Director: David Yates
- Screenplay: Michael Goldenberg

Sources: www.factmonster.com/spot/harrypotter10.html
www.nationmaster.com/encyclopedia/Harry-Potter-and-the-Order-of-the-Phoenix
www.bloomsbury.com/harrypotter

Key Mystery Characters

STUDENTS
Hannah Abbott (Hufflepuff)
Susan Bones (Hufflepuff
Lavender Brown (Gryffindor)
Cho Chang (Ravenclaw)
Michael Corner (Ravenclaw)
Colin Creevey (Gryffindor)
Dennis Creevey (Gryffindor)
Vincent Crabbe (Slytherin)
Seamus Finnegan (Gryffindor)
Anthony Goldstein (Ravenclaw)
Gregory Goyle (Slytherin)
Hermione Granger (Gryffindor)
Lee Jordan (Gryffindor)
Neville Longbottom (Gryffindor)
Luna Lovegood (Ravenclaw)
Draco Malfoy (Slytherin)
Theodore Nott (Slytherin)
Parvati Patil (Gryffindor)
Padma Patil (Ravenclaw)
Harry Potter (Gryffindor)
Dean Thomas (Gryffindor)
Fred Weasley (Gryffindor)
George Weasley (Gryffindor)
Ginny Weasley (Gryffindor)
Ron Weasley (Gryffindor)

RELATIVES
Great Uncle Algie
Regulus Black
Amelia Susan Bones
Mr. Crabbe
Aberforth Dumbledore
Cousin Dudley Dursley
Aunt Petunia Dursley
Uncle Vernon Dursley
Mr. Goyle
Bellatrix Black Lestrange
Alice Longbottom
Frank Longbottom
Mrs. Longbottom
Lucius Malfoy
Narcissa Black Malfoy
Mr. Nott
James Potter
Lily Potter
Nymphadora Tonks
Mr. Arthur Weasley
Bill Weasley
Mrs. Molly Weasley
Percy Weasley

TEACHERS & STAFF
Prof. Binns (History of Magic)
Prof. Albus Dumbledore (Headmaster)
Argus Filch (Caretaker)
Firenze (Divination) (cross-referenced
 with Creatures and Entities)
Prof. Flitwick (Charms)
Rubeus Hagrid (Groundskeeper/Keeper of
 the Keys/Care of Magical Creatures)
Prof. Minerva McGonagall (Deputy
 Headmistress/Transfiguration)
Madam Irma Pince (Librarian)
Madam Pomfrey (Nurse)
Prof. Sinistra (Astronomy)
Prof. Severus Snape (Potions Master)
Prof. Sprout (Herbology)
Prof. Sibyll Trelawney (Divination)
Delores Jane Umbridge (Defense Against
 the Dark Arts)
Prof. Vector (Arithmancy)

Key Mystery Characters (continued)

OTHER HUMANS

Sirius Black
Dawlish
Fleur Delacour
Antonin Dolohov
Arabella Doreen Figg
Mundungus Fletcher
Cornelius Oswald Fudge
Viktor Krum
Walden Macnair
Griselda Marchbanks
Mad-Eye Moody
Warlock Perkins
Peter Pettigrew
Augustus Rookwood
Kingsley Shacklebolt
Rita Skeeter
Lord Voldemort ("You-Know-Who")

CREATURES & ENTITIES

Bloody Baron (Slytherin Ghost)
Buckbeak (Beaky) the hippogriff
Centaurs
Crookshanks the feline
Dementors
Dobby the house-elf
Fang the boarhound
Fat Lady Portrait
Fawkes the phoenix
Firenze the centaur (cross-referenced with
 Teachers)
Giants
Grawp the giant
Hedwig the owl
Hogwarts Lake Giant Squid
Kreature the house-elf
Magorian the centaur
Sir Nicolas de Mimsy-Porpington
Moaning Myrtle the ghost
Nearly-Headless Nick/Sir Nicolas de
 Mimsy-Porpington (Gryffindor Ghost)
Phineas Nigellus the portrait
Mrs. Norris the cat
Peeves the poltergeist
Pigwidgeon (Pig) the owl
Ragnok the goblin
Tenebrus the thestral
Winky the house-elf

Updates to Books 1-4 Analyses

It doesn't take magic to become enchanted by the Harry Potter books. You can read them several times and still have fun without even thinking about the underlying mysteries. Once you start picking up on the clues, however, you can't help but be spellbound by the magic in the words. And for some reason, you never stop finding clues....

We at WWP keep thinking that Jo cannot possibly have crammed anything more into those books — that we have already picked them to the bone. Ha! Yes, we are *still* discovering new treasures hidden in the first four books, and also finding out that we missed a few theories and potential clues that might come in handy for solving the mysteries in Book 5.

Here are the most important ones for sleuthing Book 5, which didn't make it into our previous Guide.

Neville's Gran and Uncle Algie

C Have you noticed that the more important the character, the less we know about their background? (sigh) We now have confirmation from Book 5 that Neville is a key character (even if Voldemort doesn't think so). Yet, what do we know about his Gran and the rest of his family? Other than Gran being the vulture lady and Uncle Algie being the guy who dropped Neville out of a window (friendly types) — nothing much. Are we convinced that Gran and Uncle Algie are "good guys"? Could Uncle Algie be making sure Neville doesn't recover? What happens during Neville's visits to St Mungo's? Could someone be administering any "booster" charms? You gotta wonder...

Neville's Toad Trevor

C What's going on with Trevor? Could he be around to watch out for Neville, or maybe to spy on him? If so, then why is Trevor always running off — does that make sense? Is that because Neville's own mind is so unfocused, or is something/someone prodding Trevor to take off? As we had mentioned on our site, we had not really thought about some Trevor clues until too late — our first Guide had already been printed. If you recall, Trevor has been awfully eager to escape from Neville's grip every chance he gets, and was found lurking in the bathroom at the end of Book 1. We are sure that it was a general hint about a certain bathroom in Book 2, but we also agree with the opinion that Hagrid's hen house is a bit too close to Trevor for comfort (if you're not sure what we're getting at, look in the "Bs" in your copy of *Fantastic Beasts and Where to Find Them*). He does seem to be a toad on a mission.

————————————— *Bits and Rememberits* —————————————

————————————— ***Rememberits*** —————————————

Running Bits

It's not a matter of finding the running bits — it's more like — can we keep from falling over them! There are so many that we could write a whole guide just on the running bits in Book 5. Hope you have your thesaurus "adroitly accessible." (hehe) This is not a simple repetition of words like in the previous books (eg. lots of "eye" and "nose" references). Jo has gotten extremely sneaky. She has *disguised* the running bits this time, using synonyms, puns, literary references, and even code-like messages. When you begin to realize what she has done, you start to really appreciate Jo's wizardry.

But then reality sinks in. While those are a lot of fun, they make the job of an HP Sleuth almost impossible (couldn't be what she had in mind, could it?). The red herrings are no longer simple plot decoys, but either a big clue or a big fish... or even both! There are often several hints for every running bit in Book 5, so it is difficult to know which meaning (if any) Jo intended. Her extensive use of homonyms in Book 5 doesn't make it any easier either.

Here's an example:

One of the most prominent running bits is **"bark"** or **"barking."** That can be interpreted as the *bark of a dog*. Bark of a dog — could that running bit be pointing to Padfoot? However, "bark" can also mean the bark of a tree. Since the word "trunk" is also a running bit, should we associate "bark" with *tree* as well? Just to complicate things, "barking" can also be used the way Uncle Vernon likes to use it — to mean *barking mad*. We know that "mad" is not only another running bit, but is also a big emotion throughout Book 5, and defines the way a certain character's sanity is viewed, even by herself. So, what meaning do we attribute to this hairy running bit? (sigh) That's where jux-ta-position will help you.

You are starting to get the picture. And take our word for it — this was one of the *easy* ones!

What we will do to help, is to tell you what the running bits are. Not only will you have fun spotting them, but there are so many (we have found *over ten* in one sentence), that they are generally easy to find.

Because there are so many of them in each chapter, we will handle it the way we did in our original Guide — which is to give some examples and then let you HP Sleuths spot the rest on your own. The examples that we give may not necessarily be the most important instances in which they are used. In Book 5, Jo's running bits are quite a bit trickier — we try to show some of the clever (we're being kind — the word should be "devious") ways Jo has disguised the running bits so we don't notice them right away; or to show how she has packed multiple running bits into one phrase. By observing those, you will be able to acquire the technique as well as an appreciation for the "subtle science and exact art" of hunting running bits (thank you, Professor Snape).

One thing that HP Sleuths should practice is "mixing and matching" of running bits. As we explained in the Help Desk section at the front of this Guide, the running bits and clues are all puns with multiple meanings. "A trunk" can be a nose, a chest, or a tree. So, you need to look at the running bits and attempt mixing and matching them up to see all the possible combinations. For example, start with the running bit "spindly." Think about other forms of the word — the obvious is spindle. A spindle can mean a spike — and there are "sharp" and "poking" running bits, so you know that is an important meaning for it. A spindle can also be a spinning wheel/weaving tool. "Wheels" and "spidery" are both running bits as well. Now try matching legs and spindly with chairs from your Running Bits list. There are oodles of chairs and tables with spindly legs in Book 5. And those are only a few combinations for that example. By seeing the different combinations Jo has used, you can start recognizing the clues in order to solve the mysteries.

Please keep in mind that we have only pointed out some of the more subtle running bits in each chapter. The pages are pecked with them.

Running Bits That May Be Clues

Actions
- ☾ Automatic (actions)
- ☾ Dreaming
- ☾ Ducking
- ☾ Swelling
- ☾ Jumping, Falling Back
- ☾ Levitating, Mid-Air, Soar
- ☾ Poking, Sharp, Edge
- ☾ Sliding, Sinking
- ☾ Vanishing

Body Parts
- ☾ Brains, Minds
- ☾ Ears (hurt)
- ☾ Eyes (bulging, black, hurt)
- ☾ Hands, Claws, Fingers (hurt)
- ☾ Heads (severed, missing)
- ☾ Hearts
- ☾ Knees
- ☾ Legs, Feet (many)
- ☾ Mouths (open)
- ☾ Noses (hurt)
- ☾ Teeth

Creatures and Animal Related
- ☾ Babies, Calves, Babytalk
- ☾ Eggs
- ☾ Frogs, Toads
- ☾ Grims
- ☾ Horns
- ☾ Mouse, Mice
- ☾ Spindly, Spidery
- ☾ Tails, Queues

Directional, Geometric, Opposites
- ☾ Across, Crossing
- ☾ Circles, Round, Wheels
- ☾ Crosses
- ☾ Turns (left, right)
- ☾ Twisted, Coiling
- ☾ Upside-down
- ☾ Balance, Measure
- ☾ Hot/Cold, Flame/Freezing

Garbage, Toiletry Related
- ☾ Regurgitating
- ☾ Rubbish
- ☾ Stinking, Smells
- ☾ Toilets, Dung

Running Bits, Continued...

Numbers
- (2s, 4s, 5s, 10s, 12s, 9 of 10, 14s
- (Pairs, Doubles, Mate

Seasonal, Celestial
- (March
- (Moon, Planets (Luna, Phases, Umbra)
- (Water, Rain, Mist

Sounds
- (Barking
- (Bells, Rings, Tones
- (Cracking
- (Muttering, Mumbling
- (Noises, Screeching
- (Pounding, Hammer
- (Silence, Muffle

Structure Parts
- (Bolts, Padlocks, Chains
- (Ceiling
- (Chairs
- (Corners
- (Doors, Corridors
- (Pipes
- (Tableware
- (Towers
- (Glass
- (Stone

Trees, Growing
- (Bark
- (Growing
- (Stubby, Stump
- (Trunks, Chests, Trees

Wonderland
- (Kings, Rooks, Crowns
- (Mad, Nuts
- (Watches, Clocks

Woolies and Clothing
- (Hats and socks (wool)
- (Hems and skirts
- (Rags

Miscellaneous (but still important)
- (Bubbles, Balloons
- (Color (pink, blue, orange, silver)
- (Pies
- (Spots, Dots, Ink

Interesting Tidbits

Missing Persons List

<u>Totally Missing</u>
 Aragog
 Ludovic Bagman
 Bloody Baron
 Crouches Jr/Sr (the bodies)
 Goyle Sr
 Karkaroff
 Myrtle
 Wormtail / Peter Pettigrew

<u>Suspiciously Absent</u>
 Fleur
 Krum
 Nagini (?)
 Winky

Chapter 1 Analysis

(Dudley Demented)

What Are the Mysteries in Chapter 1?

Déjà vu — The Beginning

Book 5 begins with Harry "lying flat on his back" in the heat-parched garden. Think Jo Rowling. Think classical literature as her influence. This scene is strangely reminiscent of Milton's *Paradise Lost*, which begins with Satan lying on his back in a burning lake, *"talking to his nearest mate,"* and includes references to Adam, who becomes aware of himself and his place in the world after waking in a bed of flowers. What are the themes of *Paradise Lost*? Subversion, rebellion, the building of Pandemonium, and a little satanic possession. (shudder) Something to keep in mind as you read Book 5.

So, if Book 5 begins like *Paradise Lost*, how does it end? You will have to be patient until we cover James Joyce in the final chapter analysis — which means you need to stay "awake" or you may end up having to start all over again. ☺

Thoughts of Dying

The drought is a major theme in this first chapter. Descriptions of the drought include references to "hose pipes," "water," and dying things such as "dying begonias." Jo announced that a major character would die in Book 5, so those may be foreshadowing the death. Since they are Petunia's dying begonias, is it possible she could die soon? HP Sleuths might also want to look at the jux-ta-position of other key words that could be related to a certain person who has already died. In addition to the hose pipes and water, there are references to "sinking," "cracks," "spots," and "moaning" — which are running bits and cause Moaning Myrtle and her bathroom to float into our minds.

News At Seven

In an unsuccessful attempt to blend in with Petunia's hydrangea bush, Harry doesn't hear anything notable on the local Muggle news. He also hadn't seen anything important in the *Daily Prophet*. Dumbledore tried to teach us in Book 4 how information that is important to wizards, and even the world, may be imbedded in the news. In Chapter 30 {"The Pensieve"}, he told Harry that the not-so-notable Muggle news story about the disappearance of Frank Bryce helped him piece together the evidence that Voldemort was regaining power.

With that in mind, was it significant that Harry heard a report about a helicopter almost crashing, or was it just a news item? In Chapter 9 {"The Midnight Duel"} of Book 1, Draco talked about numerous near-misses with helicopters in the past, so why not again? And if Draco could, why not a Dementor or two? We know that Dementors cause lights to go out, and we also know that excessive magic can cause electricity to fail. Was it truly an unrelated incident that Harry heard on the news? Seen any Dementors lately?

Mind Matters

While Harry lies in the garden pondering his aunt and uncle, Vernon suddenly speaks — as if Harry's thoughts had been broadcast to him. The WWP Sleuthoscope and the HP Hintoscope are taking turns sputtering and oscillating wildly. The Hintoscope seems to be suggesting

that it's a nudge to help us think about *the process of thinking* and how it affects magic—a definite storyline clue. The WWP Sleuthoscope, however, is bopping us on the head trying to get us to consider if there could be something magical about Harry's mind. HP Sleuths should stay alert for more thought-provoking evidence.

DOBBY'S POWERS

Harry makes the assumption that Dobby can't become invisible. Throughout the septology, Harry makes a range of assumptions based on his observations. Sometimes they are right, but mostly we end up referring to Rule #4. Therefore, we should dispute his statement, plus in this case, we have seen Dobby several times resort to extra measures to not be seen: hiding in the bushes as he watches Harry in Chapter 1 {"The Worst Birthday"} of Book 2, or disappearing from the hospital ward when he hears people approaching in Chapter 10 {"The Rogue Bludger"}. Why would he have to do all that if he could just become invisible? Then again...maybe we do need to watch for unexplained activity.

MAGICAL SOUNDS

A loud crack precedes various events occurring in rapid succession — the first of which is a "shriek," followed by a cat running out from under a car. The HP Hintoscope is purring like a happy motor. Did you happen to notice the cat that streaked out from under the car? Was that cat just for effect? Have you checked Rule #3?

Contemplate this...if we can be reasonably sure that the "shriek" came from within the Dursley residence, and that men (and especially Uncle Vernon) don't usually shriek, we assume it was Petunia. Why would a crack out in the street make her shriek? Even the Muggles didn't shriek. Could it be that she recognized the sound of Apparating? Where would she have heard Apparating?

RADIATING POWER

After Harry smashes his head on the open window, Uncle Vernon places a stranglehold around his neck — but before Vernon can do much damage, an "electric shock" surges through Harry as he feels a "throb" of pain, causing Vernon to release him. The HP Hintoscope is yelping as if in pain. This is the first of many references to heads and damaged heads — better keep your head if you want to solve the clues in Book 5.

In our *New Clues* guide, we explained a possible parallel between wandless magic in Jo's world and extrasensory perception (ESP) in the Muggle world (see FAQs). ESP reportedly shows up most during times of high emotion, and that is exactly when we have witnessed both unintentional and wandless magic by wizards. The problem with this particular incident is that there is more than one possible explanation. In addition to wandless magic, the circumstances could apply to Lily's protective charm, or have something to do with that throb in Harry's head.

Book 5 is definitely "charged with emotion," and there are many more references yet to ponder about the effect of emotion on Harry. Something we are seeing is that when Dumbledore is at his most powerful, he is usually furious, but not raging (unlike Snape). Dumbledore focuses that "terrible" anger into magical power that "radiates" intensely from his being, as it did when he burst through the door to face Crouch Jr in Chapter 35 {"Veritaserum"} of Book 4. Could that be a key to magical power, and will Harry be able to learn to do the same?

MAGICAL FEELINGS

Harry is "sure" that a magical person had been close by. The sounds that accompany magical Apparation are being reinforced. We now know for sure that the crack that accompanies people Apparating and Disapparating is an artifact of the magic. However, was it only the cracking sound that convinced Harry? He wasn't dwelling on the sound, but more on his *sense* that someone had been "near." We already know that the Ministry has ways to detect underage magic, and presumably magic performed in the presence of Muggles, plus Draco Malfoy has hinted that wizards have ways of identifying half-bloods. In the movie/TV series "The Highlander," one immortal can "magically" sense another's presence. It would seem that there could be something similar in Jo's wizarding world.

NIGHTMARE ON PRIVET DRIVE

Harry wanders off as he tries to sort things out, and worries about the dreams he is having about dead ends or locked doors at the end of long corridors. The HP Sleuthoscope is sputtering in frustration over by the wall. Harry assumes that his being trapped at the Dursleys' is triggering the nightmares. However, Harry assumes a lot of things. We'll just review Rule #4.

KID STUFF

Harry turns a corner and crosses onto Magnolia Crescent, where he stops to sit on a swing in the playground, until some "soft ticking noises" from turning bicycle wheels catches his attention. Some very interesting themes in this scene. There are constant references to children, infants, and baby talk in Book 5. It may be that babies were top-of-mind for Jo, but it could also be a clue. HP Sleuths might want to check for eggs, nurseries, or other birthing hints.

"Turning," "corners," and "crossing" come up frequently in Book 5 also. It may be that the "turning" has to do with the book being a "turning point" in Harry's life, or it could be a storyline clue. "Corners" are also everywhere, and there is usually something a bit weird or even nasty in all of them. The most memorable corner we know of was what we discussed in the "Updates" section — that Trevor's toad was found lurking in one. The "crossing" theme is most peculiar, and is usually jux-ta-posed with (near) circles and discs, and other round things. We will discuss it further as we encounter more instances of it.

What catches our ear most is the ticking noise. There is no mistaking the sound of clocks and time. There are many intriguing time devices in the septology, and this puts us on close watch.

MARKED OFF THE LIST

There is a 10-year-old boy by the name of Mark Evans mentioned a couple of times in this chapter. As HP Sleuths probably remember, Jo had already tantalized us in an interview with the fact that Lily's maiden name was "Evans," so we speculated that, according to Rule #3, this was probably significant.

Not.

Jo told us on her official website {www.jkrowling.com} that it was just a (cough!) coincidence. Now, if it happened in the real world, we could buy that. However, Jo is writing the story and she has spells and people using that name throughout this book, so is it just a coincidence? Maybe Jo is trying to ensure that she cannot be predictable by baiting us with a red herring. We detect a bit of puckishness here, which means that HP Sleuths do

indeed need to be on their toes and ready for some slight-of-hand, Jo Rowling-style (otherwise known as — we may need to expect more exceptions like this to the WWP Rules).

HARRY'S TAUNTING

Harry taunts Dudley, effectively bullying him — Harry describes it as "siphoning off" his emotions "into his cousin." Curious. We have observed both memory Riddle and Voldemort taunting Harry...apparently enjoying it. Did Harry enjoy taunting Diddykins? We also saw Riddle pouring his own emotions into Ginny so she could open the Chamber in Book 2, as well as growing stronger off of Ginny's emotions. Is there a danger that via the failed curse, Voldemort put enough of himself into Harry to influence Harry's personality; or is Harry more like Voldemort than he realizes? We are given some imagery that starkly reinforces a Voldemort influence on Harry's brain. Harry's actions are described as "coiled," "writhed," and "hissed." Was Harry truly infusing Dudley with his own frustrations? Is he capable of doing that? Is there a correlation between the way Riddle fed on Ginny and Harry's effect on Dudley, or the way that the Dementors feed off human emotions?

MAGICAL PARAMETERS

In the vicinity where Harry first saw Sirius, two Dementors appear and attack both Harry and Dudley. Talk about foreboding...we start right off with a Grim reminder. Why were the Dementors attacking both Harry and Dudley in a Muggle neighborhood — how would Fudge or anyone explain that to the Muggles? This implies a Ministry "inside job," or the magical reversal squad would certainly have been on the scene. Also, is there anything significant about either that area of Little Whinging or the distance from Privet Drive? How did the Dementors home in on Harry? They can't see, and Harry wasn't at his house, so how did they locate him? Does each wizard have a "signature" aura, or was someone in the area helping the Dementors?

BIRTHDAY BADDIES

Ron and Hermione had sent Harry chocolate for his birthday, but he is so upset with them for being secretive about what has been going on all summer, that he throws it away. Let's see... for the first time, Harry doesn't receive a cake for his birthday, but instead is sent two boxes of *chocolate*...and just two days later, is attacked by Dementors, but is now chocolate-less. Is anyone thinking Rule #3?

MIND OVER MAGIC

Dudley knocks Harry's wand out of his hand, and as his hands search "flying over the ground like spiders," in desperation, Harry manages to cast a Lumos spell with his wand even though it is lying a few inches away. Here we go again...does that come under the category of wandless magic, emotion-driven magic, or highly-focused magic? Did you catch the spidery imagery of Harry's hands? Is it a hint that his hands are becoming powerful like Voldemort's, or does it imply a sinister link between Harry and Voldemort?

DARK POWERS

When the two Dementors approach Harry and Dudley in the street, not only do the lights go out, but even the stars are blotted out. The HP Hintoscope and WWP Sleuthoscope are both

off shivering in the corner. Harry describes his dark encounter as a "weightless veil" against his eyes. Besides being extraordinary imagery, it is a storyline clue. The deathlike veil, as weightless as it is, weighs heavily on us as we progress through this very dark book.

Having watched Lupin rekindle the classroom lights after Harry practiced with the boggart in Book 3, we know that lights actually snuff out in the presence of a Dementor. However, it is unlikely the *stars* physically go "out" because that would certainly have made headline news — so some effects of the Dementors are real, while some are perceived. Harry defines that phenomenon as a "sphere of influence." Astronomers describe a similar effect for black holes — it is called an "event horizon" — the dense core of a black hole where the gravity is so strong that time is distorted and even light can't escape. How strong have the Dementors become? Can they distort time? Here's a scary thought: Do they grow stronger as Voldemort grows stronger?

As HP Sleuths know, when Dementors approached Harry, he always heard his parents' last moments. In our first Guide, we had questioned what Harry might see the next time he came into contact with one since he seems to have fairly well mastered his fear of Dementors. We now know that his emotions concerning Voldemort seem to be overriding even the trauma of his parents' deaths as it is Voldemort's voice he hears this time.

CLOAKED CLUES

Harry casts his Stag Patronus, which snags one Dementor "where the heart should have been" and drives the other off Dudley as it is apparently about to administer the Kiss. We hope that HP Sleuths have been doing their recommended reading because there appears to be a clue here, based on what we learned in *Fantastic Beasts and Where to Find Them*. If you look up Lethifolds, you will find they are missing certain parts of the anatomy and that the Patronus spell is the defense against them too. What is most uncanny is the description of the Lethifold attack in *Fantastic Beasts*, where the sound of the cloak rustling is described. If you compare it to the description of the sound they heard in the Forbidden Forest in Chapter 15 of Book 1, it makes you wonder if it really was Quirrell's cloak they heard, or if a Lethifold had been wandering around that night. You would think Hagrid could recognize the sound of a wizard's cloak, but he was spooked by it too.

Rowlinguistics

✴ In her 2004 World Book Day chat, Jo said her least favorite character is **Vernon Dursley**. There may be some hints about him in his first name, which comes from a French surname meaning *alder tree*. Alder wood resists water, and when you cut them they "bleed" — changing color from white to red. It was once illegal to cut down an alder because it could anger the tree's spirit, which would then burn down houses. Some people thought of the alder as a tree of death and resurrection. In the Celtic zodiac it is associated with Mars, the god of war, and the month of January (named for the two-faced god Janus). {www.novareinna.com/constellation/alder.html}

Curiosities

✴ We now have confirmation that magical powers are hereditary and that they are passed along just like any other genes. On her website {www.jkrowling.com}, Jo has explained that the wizarding genes are "dominant and resilient," which explains why they often pop up unexpectedly in Muggle families. Therefore, when thinking about Squibs or wizard family trees, think in terms of normal genealogical traits.

✴ Harry felt out of place among Muggles, but Squibs have it worst of anyone since they don't belong in either world. Unfortunately for Squibs, they are a social "fish out of water," having lost it big in the gene pool lottery. According to Jo, we can pity Filch. But does that make him any less mean or less responsible for his horrid actions?

✴ "Hydrangeas" are a plant with multiple flowers to a head—a possible correlation to the Greek mythological "Hydra" snake with all its heads. Funny thing about Wisteria Walk (yes, Walk, not Lane)—the twisty climber the street is named after has got a snake connection too. One of its cultivars is called "Black Dragon." Both flowers come in a wide variety of colors, but the Hydrangea, in particular, is known for its ability to change its color according to what type of soil it's planted in. As to the begonias..."begonias" mean *beware* in the language of flowers. . . {www.ohioline.osu.edu/hyg-fact/1000/1246.html}

✴ The term "Budgie" comes from the Australian name, *budgerigar,* a type of bird. Budgies have something called a "blood feather," which is just what it sounds like, a feather filled with blood (sounds painful). A group of five feathers, like — the name of the inn where Bungy lives, is called a "plume" in heraldry, and means "willing obedience and serenity of mind." {www.exoticpets.about.com} {www.somewhereintyme.com}

Chapter 2 Analysis

What Are the Mysteries in Chapter 2?

FURRY FRIENDS

Mrs Figg, who informs Harry that she is a Squib, had positioned Mr Tibbles under a car for surveillance duty on Mundundgus. You did notice Mr Tibbles in Chapter 1 when the fur went flying as Dung Disapparated? Mrs Norris is a Kneazle, which all HP Sleuths should be familiar with from having read about them in *Fantastic Beasts*, but why didn't Harry notice anything different about Mr Tibbles or Figgy's other felines? According to Fantastic Beasts, Kneazles can be interbred with Muggle cats, which is also what Crookshanks is (according to Jo on her website) — *part* Kneazle — and he looks just like a normal cat. Also on her website, Jo explained how Figgy is even breeding cat-Kneazle half-breeds.

Filch's cat, Mrs Norris, has a title as part of her name. Mr Tibbles has one too. We also know that Figgy has a cat named Mr Paws. This could indicate a naming convention of giving titles to Kneazle cats, but then what about Crookshanks? Could it be that the cats with titles were bred by Mrs Figg? You might want to go back to Figgy's house and get reacquainted with her pets (just stay away from her stale cake).

FISH BAIT

Mundungus is described as having "short, bandy legs," and "ginger hair." This looks to us like a Hagrid-sized herring. What makes us suspicious that this was an intentional red herring is that Jo is very aware of the rumors and theories being discussed online. She most likely would have seen that there were copious speculations about Crookshanks being an Animagus, and she seems to have purposely worded Dung's description to match that of Crookshanks. Well...it worked — people were fooled (see FAQs). What we learned from this is that Jo is going to play with us.

Jo has teased us with yet another tidbit. She has released a description of a new character in Book 6 with "tawny hair" who has the appearance of a lion and walks "with a slight limp." This may be the reason these same themes are prowling through the pages of her novels.

IT WAS ONLY...

As Harry lugs Big D back to Privet Drive, Mrs Figg detects something or someone else at the end of the street — it turns out to be only Mr Prentice . In *New Clues*, we speculated that Mr Prentice could have been someone important — another part-Kneazle cat, another Squib...his name derivation, *apprentice*, teased us as an interesting character, considering the concept of a wizard's apprentice. However, Jo assured us on her website that he is a "nobody."

DUDLEY'S DEMONS

Harry wonders what the pampered Dudley experienced that affected him so badly when the Dementors drew near. Even pampered kids have personal fears, but we know from Chapter

10 {"The Marauder's Map"} in Book 3, that people don't react as badly to Dementors if they haven't had many horrible experiences in their lives. Is Smeltings that terrible, or is something else bothering Dudley? Would Dudley be receptive to Harry's nightmares? Maybe Big D got rejected by a female and is experiencing adolescent heartache?

COMPULSIVELY-CLEAN KITCHEN

Vernon calls Harry into the Dursleys' "surgically clean" kitchen which had an "oddly unreal glitter" to sort out what happened. Some people clean things out of pride or because it needs to be done, some clean to alleviate frustrations, but there are the obsessive people who clean out of a need to wash away something in their lives. Aunt Petunia's kitchen is so "scrupulously clean" that the characters can't help noticing it — did it hit you too? Is she just trying to wipe out parts of her life, or is there something else going on? Would she be getting it that unnaturally clean with only elbow grease, or if there is a chance some deeply-buried magical talents are oozing out of her?

TWOS CLUES

*Chapter 2 chronicles letters spaced exactly "22" minutes apart, "seconds" of time, and "the old one-two," as Harry tries to sort out his encounter with a **pair** of Dementors, which we find out later has taken place on August 2nd.* Twos top the list of Running Bits — we get the feeling that there is something large about the number two. If you want to do more research on this, you can visit Jo's personal library at www.jkrowling.com, where you can spot doubles all over her shelves on subjects, authors, and even doubles of the same book! Twos seem to go with the word "mate," which also comes up a lot in Book 5 (see FAQs). She is leaving clues everywhere.

Jo has specifically tied Book 2 to Book 6, but then qualified it with a mysterious explanation. On her website, she says that the link between the two books is not the Half-Blood Prince, himself, but a piece of information that relates to something Harry *"finds out in 'Prince'."*

SILENT TREATMENT

Harry receives several owls and instructions, yet no explanations, and nothing from Dumbledore. Is it reasonable for Harry to *expect* an owl from Dumbledore? Well...Harry did just barely survive Voldemort, returning to warn Dumbledore — where he just barely survived Crouch Jr, so he probably does rate at least an explanation. Dumbledore is usually good about that, so why not now? Why the big silent treatment?

PECK OF CLUES

When Vernon gets upset from Sirius' owl, he is so furious that he messes up his words...transposing the word "peck" for "pack." The WWP Sleuthoscope is pecking away at the desk. We haven't seen Vernon do that in the past, so it caught our ear, but what made us really look carefully at it was that the title of the chapter is derived from that mistake: "A Peck of Owls." Maybe Jo thought it made a great, amusing title, but her chapter titles are usually meaningful and not just silly. If we are to consider it meaningful, we still have one

issue...which is the intended word?

"Peck" is a unit of measure, which seems to have some significance in Book 5, but because Vernon got his words all twisted up, it makes us think of tongue twisters. The most obvious and famous is the one about Peter Piper. This would reinforce the references to pipes and water, which were flowing through the first chapter. The name, Peter, is also top-of-mind, since we are wondering what Pettigrew is up to this year — considering he usually is doing Voldemort's work. Add to that, tongue twisters are another kid thing.

"Pack" is a trunk word, and it makes us think of Mad-Eye Moody's trunk from Book 4 and Fake Moody's nasty imposter trick. It still seems a bit suspicious the way trunks keep making appearances. And did you happen to notice that there has been an imposter of some type in every book so far? Think Quirrell, Gilderoy, Scabbers, and Moody. So, what about Book 5? Something to peck...er...pack away in your brain as you sleuth Book 5... CONSTANT VIGILANCE!

THE PETUNIA PARADOX

Petunia reveals that she knows about Dementors and Azkaban (which is met with "two seconds of ringing silence"), and she seems to know exactly what is going on when she receives a howler — all of which contributes to making Harry feel as if there was a "breach in the great, invisible wall that divided...Privet Drive and the world beyond." Petunia is just full of little surprises. How did she know about Dementors if they were only put in charge of the prison after Lily died (see Oddities)? How did she know who was talking to her if Harry didn't even recognize the voice? Who in the wizarding community knows her on a *first-name* basis? And why was it a "ringing" silence? That hit us loud and clear as "rings" are a running bit — (we need to keep our ears pealed for more hints).

How are the magical and Muggle worlds interconnected? Is there a wall that separates them, is it different physics, or is it a perceptual divide only? How many "worlds" are there besides Muggle and magical? What lies beyond those? Some of the spirit characters may be able to tell us more about that.

Hmmm. Based on all this information, we had assumed in *New Clues* that there had to have been other correspondence between Petunia and the wizarding world. No matter what, people from Hogwarts have been in touch with the Dursleys concerning quite a few issues — such as whether Harry was staying at the school over the holidays. There was the minor incident over a flying car, in which case Dumbledore had stated in Chapter 5 {"The Whomping Willow"} of Book 2, *"I will be writing to both your families..."* Jo has now clarified for us on her website {www.jkrowling.com} that school letters are addressed to the Dursleys "as a couple," and thus Petunia would not think of it as a letter to her. So, why did it say the "last" letter? Well...Jo also teased us with the information that *"there were letters before that..."* to her. There were? (Another "ringing silence" — this time throughout the fan community).

GREEN GAZE

Harry notices Petunia's eyes, which are nothing like his mother's bright green ones. Not too many wizards have the bright-green eyes that Harry or his mother share. You can see this is intended to remind us of Lily's green eyes — as we have been told they are important.

Rowlinguistics

✳ **Mafalda**'s the Italian and Portugese version of the name Matilda, which means *strength in battle*—but on whose side?

✳ **Mr. Tibbles** is the name of a reporter who crusaded for Native American rights, and whose wife, an Omaha chief's daughter, acted as translator for a Ponca chieftain in an important case in 1879, which established that Native Americans were in fact persons within the meaning of the 14th amendment and allowed to pursue writs of habeas corpus.
{www.nebraskastudies.org/0600/stories/0601_0107.html}

Curiosities

✳ If you look carefully at the way Vernon reacts to anything wizard-like vs. the way Petunia reacts, you will see that there is a subtle but definite difference. Vernon sees wizards as freaks and unnatural invaders in his world. He wants to stamp out magic as if it is a virus. When he hears or sees anything to do with magic, he freaks out the same way most people do if they see a cockroach. In his opinion, magic is something nasty that needs to be exterminated. Petunia, on the other hand, reacts as if she is afraid of the magic getting out into the open. She doesn't want to swat it — she wants to bury it. She doesn't want the word mentioned, but if it is, she doesn't yell — she acts as if the words need to be muffled for fear they will get out — similar to saying the name of "You-Know-Who." If Petunia grew up with magic in her household, why

would it bother her so much? In Chapter 1 {"The Worst Birthday"} of Book 2, she is familiar enough with it to recognize whether Harry is faking it: *"Aunt Petunia knew he hadn't really done magic."* Compare these reactions when Harry just uses the word "magic":

Petunia: *"gave a small scream and clapped her hands to her mouth."* She is described as "pale" (fearful).
Vernon: *"roared...pounding the table with his fist."* He is described as "purple-faced" (angry).

Maybe Petunia is afraid that if anyone notices, they will look more carefully and maybe notice her as well, or that the magic will *find her*?

⋆ In a Barnes&Noble chat in March of 1999, Jo was asked if anyone ever discovers their magical powers after becoming an adult. Jo replied that although "rare," it does happen to one of her characters. The events in this chapter put Petunia back on top of our list of candidates for that one.

⋆ Peter Piper is a tongue twister, which is word trick humor, intended to make speakers mess up their words — especially the faster they say them. This tongue twister begins: *Peter Piper picked a peck of pickled peppers.* What would Peter Pettigrew be poking his pointed little nose into presently?

Oddities

⋆ When explaining how she knew about the Dementors at Azkaban, Petunia says in a "jerky" manner that she heard "that awful boy — telling her about them — years ago." However, according to Dumbledore in Chapter 36 {"Parting of the Ways"} of Book 4, Fudge is responsible for putting them there, and we know that Fudge was elected to office only five years ago. In the Pensieve in Book 4, Harry saw some Azkaban Dementors while Crouch Sr was still in office, but that was also some time after Voldemort's fall. Fudge could have placed them at Azkaban somewhat before he was elected — when he was Junior Minister in the Department of Magical Catastrophes, however, all that that was still after Lily and James had died. What "boy" would Lily mean? That leaves us with some curious options. Could Petunia be lying about how she heard about Azkaban, or could "that awful boy" be someone other than James?

Chapter 3 Analysis

What Are the Mysteries in Chapter 3?

NIGHT NOISES

The Dursleys lock Harry in his room while they leave the house, and left alone, Harry listens to the creaking of the house and gurgling of the pipes. Everyone experiences creaking houses, but gurgling pipes are less common. What are the images floating in your brain when you hear about pipes that "gurgled"? We can't help it — our murky brains see an image of a pimply girl in a bathroom. Where is Moaning Myrtle in Book 5? We know she likes Harry, we have seen her travel throughout the Hogwarts Castle grounds via the pipes, and she told Harry that she used to haunt outside her bathroom — she is only restricted by decree. Could she have heard about the attack and be trying to get to Harry? Are we supposed to be thinking of her, her bathroom, or maybe Book 2 in general, or is this a story-line clue to Book 5 now? Who or what else can travel via the pipes?

THE DOOR'S AJAR

Hearing a crash and voices in the supposedly empty house, Harry stands in front of the door listening attentively, when it suddenly unlocks and opens on its own. (Insert Twilight Zone music theme here.) How did that door open? Harry didn't hear any spell, and there was no one right by the door. Also, this door was opened in two stages: first it unlocked, then it opened, which doesn't sound much like a spell, not to mention that everyone was way down at the bottom of the stairs.

Could it have been unintentional wandless magic? Whenever Harry performs wandless magic, he at least is aware that he was sort of wishfully-thinking it to happen. But in this case, he almost seemed as if he was afraid of what was out there and preferred the door to stay closed (which would make sense — since it would have been a very bad idea for him to perform more magic).

So, if it wasn't a member of the Guard, and it wasn't Harry, who was it? Harry didn't think Dobby was capable of becoming invisible, but what if the house-elf or someone else was in there with him and opened the door? Could the crash have been a signal to someone? Maybe we are to assume the Advance Guard opened it, but doors are highly suspicious in Book 5.

HEAD GAMES

Harry is introduced to the Advance Guard — one of whom is Sturgis Podmore. Would he be related to Sir Patrick — the one with the big, loose head, who won't let Nearly-Headless into the Headless Hunt? Another headless hint to stuff into your head.

OUT OF THE BOTTLE

The name "Kingsley Shacklebolt" conjures up images of being bound as some kind of prisoner or slave. The slavery image would fit with Jo's strong message on human rights,

although, the house-elves are fulfilling that role too. Additionally, he has a regal name, as well as a regal demeanor, so he is more likely to be a Prince than a slave.

Kingsley's description of being a very large, dark, bald, magical person with an incredibly deep voice and an earring (tiny shackle) in one ear makes us think of a genie. When Jo uses the traditional magical people and creatures from folklore, she typically draws from the most common version of the legend — but then gives them her own personal slant. For instance, it wouldn't be a proper wizard without a pointed hat, wand, and robes. Or, if it is a flying wizard, they would, of course, use a broom or flying carpet. And, what's a magical world without a magical genie? Therefore, when we see a description that matches a popular version of a genie, we have to consider that Shacklebolt really could be a genie — or like many people in Jo's world — descended from genies. There are several legends in which genies have been set free or somehow obtained freedom.

EYE-POPPING

After taking a drink from his hip flask, Mad-Eye Moody pops out his magical eye and dunks it into a glass of water from the sink, with the explanation that it needs cleaning because it keeps sticking after Fake Moody wore it. Are you finding yourself still suspicious of this Mad-Eye? It's hard not to be, as we watch him sip from that hip flask...or hear that the eye doesn't fit right. However, not only does it seem unlikely that someone would be able to fool Dumbledore like that again, but Jo had already told us in a chat that we were going to be seeing the real Moody (see Curiosities). Therefore, this is most likely the real thing. One possibility is this could be Dumbledore himself, as Moody did have the Put-Outer. On the other hand, we doubt Dumbledore would have been there in person (disguised or not) since he wasn't even *writing* to Harry (although we haven't ruled it out).

The word "sink" is a running bit in Book 5. It would seem to go with all the other pipe and water references.

TRUNKS AND TONKS AND TRICKY IMAGES

Tonks, the violet-haired Auror, goes to help Harry pack his trunk — there, she looks into Harry's wardrobe mirror, and automatically changes her hair color to pink. The WWP Sleuthoscope is turning purple as it tries to keep from bouncing off surfaces. This scene is packed with trunk references, and the pink hair is frizzing it out. Pink-haired Tonks is a master of concealment, and we have seen various examples throughout the septology of pink being a color of concealment: Hagrid's pink umbrella conceals his snapped wand; the Fat Lady in the pink dress conceals the entrance to Gryffindor; Lockhart, whose favorite color and most of his wardrobe were shades of pink, was an imposter; and the Weasley ears go pink when they are trying to conceal their feelings or a lie. Therefore, be very alert for pink things and pink people in Book 5.

The combination of the pink hair and the trunk does tend to make us suspicious of Tonks. Are we supposed to think that she might be an imposter like Mad-Eye Moody or Lockhart, or is it just related to her Metamorphmagus talents?

Then there's that interesting action in front of the mirror. Was Tonks just caught up in her own appearance, or could there have been something special about that mirror? That's the same mirror Harry used to look at his scar in Book 4, and we mentioned then

that it made us suspicious. HP Sleuths might want to reflect on the information we know about mirrors we have seen and to keep an eye out for more mirrors in Book 5.

HARRY'S HAIR

Tonks explains that having been born a Metamorphmagus, she can alter her appearance by just concentrating on it, but that "most wizards" cannot do it — at least not without a wand or potions. But...but...then how did Harry grow his hair back overnight as was mentioned in Chapter 2 {"The Vanishing Glass"} of Book 1? Does it mean unintentional magic is that incredibly powerful, or could it mean that Harry is a bit of a Metamorphmagus too but not know it? As an extremely powerful wizard, Dumbledore can do most anything he wants, so maybe Harry is potentially that powerful as well.

You should notice that the morphing did not appear to be a casual procedure. Tonks' had *"screwed up her eyes in a strained expression"* to make the change, so it may take a reasonable amount of concentration. Then again, that "screwing up" her face seems a little screwy too — as Book 5 is full of construction-related words.

Rowlinguistics

✴ One of the members of the Advance Guard was **Dedalus** Diggle. Daedalus in Greek mythology is the name of the man who constructed the famous Cretan labyrinth to hold the ferocious half-bull, half-man Minotaur. But Daedalus told Ariadne the secret about using thread to find one's way out and was imprisoned with his son, Icarus. By constructing wings for his son and himself he escaped, but Icarus disobeyed Daedalus' instructions, flew too close to the sun, and fell when the wax that held his wings together melted.

✴ Using the *Philological Stone*, **Nymphadora** Tonk's name sounds a lot like *adore a nymph,* giving the young Auror a classical mythology image—but "Tonks," is also the nickname of a particular breed of cat, the Tonkinese. It is a hybrid (!) of Siamese and Burmese, comes in many eye and coat colors, and is known as a particularly bright,

friendly, inquisitive, and loyal breed—almost has the sound of a kneazle about it. {www.cfainc.org/breeds/profiles/tonkinese.html}

* **Emmeline** is a pet name for *Emma*—also the title of a very famous book by Jane Austen you may have spotted sitting on the bookshelves on Jo's website (Jo has often mentioned that is one of her favorite authors).

* Moody's first name, **Alastor**, is very similar to *Alastair*, a Scottish name, that means "defender of man" — would seem like an appropriate name.

* **Kingsley** is a last name meaning *king's field*. A **shacklebolt** is also known as a *fetter-lock*, and is another name for a manacle (we have seen Sirius conjure those in the Shrieking Shack). In heraldry it means someone who's done well in battle. {www.somewhereintyme.com}

* Could Sturgis **Podmore** and Sir Delaney-Podmore be another old wizard family? In British history, a Frank Podmore let his house be used as the headquarters of The Fabian Society, a group dedicated to social justice, in the 1880's. {www.spartacus.schoolnet.co.uk/TUpodmore.htm}

* In Greek mythology **Hestia** was the goddess of the hearth—should we be thinking Floo Network?

Curiosities

* Tonks's favorite greeting, "wotcher," is very old slang, and is believed to be a shortening of the question, *what cheer?* Good question to be asking Harry these days...

* Mad-Eye's mad eye looks familiar to anyone who's visited Turkey. Take a trip to this ancient land and you'll find blue, glass eyes looking out at you from every nook and cranny. It's the Turkish *boncuk* and has long been used to protect the wearer, or the household it protects, from the evil eye. If cracked, it is believed to have warded off an evil spirit, and a new boncuk is needed. The color and design are strikingly similar to the Eye of Horus, an even more ancient Egyptian amulet, which was also believed to have healing and protective powers.

Chapter 4 Analysis

(Number Twelve, Grimmauld Place)

What Are the Mysteries in Chapter 4?

Ashes...Ashes

In order to even be able to see the building when they arrive, Harry is briefly shown the address to Number Twelve Grimmauld Place on a parchment — that Moody immediately ignites and lets fall burning to the ground. That's a powerful spell, and it's good that Moody immediately destroyed the evidence, isn't it? He did, didn't he? Do we know it is permanently destroyed? As you peruse the rest of this chapter, you might notice that Mrs Weasley didn't seem to think so, as she has no trouble recovering burnt parchment.

If you have been following Running Bits, you will notice that the number 12 continues to haunt us. Is it related to time, to Chapter 12, to dragon's blood, to Voldemort's return to power, to astrology, to calendars, or to any other known association? Maybe it will turn out to be related to something we don't yet know about, but whatever it is, there is no mistaking that particular number has a strong presence in the septology.

Deadly Domicile

Grimmauld Place gives Harry the creeps — like the decaying mansion of a dying person with all its crooked, "age-blackened" portraits, cobwebs, and plaques of beheaded house-elves. The HP Hintoscope is performing a funeral march. Was that just a figure of speech — is this a place of death? The address, alone, is very creepy — note the grimness of it (see Rowlinguistics). *Shudder* We have seen the Grim! We were told that someone was going to die in Book 5, and this grim house assuredly is foreshadowing that. But it's not just the house. HP Sleuths should notice all the "grim" words and doglike references used throughout Book 5.

Beheaded house-elves sure don't liven the place up very much. Could there be something more to those severed heads? They are gruesome. What do the House Elves think about this?

Also, aren't all portraits in the wizarding world of dead people? Do all portraits move, and if so, do we care about the ones in the hallway where Harry entered the house? Who is watching the comings and goings at Grimmauld Place?

Little Feets

Upon entering Grimmauld Place, there is a kind of rotting smell, and Harry hears the pattering of little feet behind the skirting board. Attentive HP Sleuths would recognize the characteristics of a moldy Bundimun, described in your copy of *Fantastic Beasts*. Take your *Philological Stone* and try it this way: Grim mold Place. How bad can an infestation of mold be? For one thing, it can topple a building. There is much more lurking at Number Twelve, so it would be advisable to do some refresher work in your Newt Scamander Schoolbook.

BEHIND THE CURTAIN

After being led through several doors, Harry has to tiptoe past some curtains that he assumes conceal one more door; and when it opens, his first thought is that it is a window until he realizes it is a life-sized portrait of a witch. Right from the very beginning, we are seeing that doors play a huge role in Book 5. Doors can represent choices, a beginning or ending (entrance/exit), they can be gateways to other places, they can hide secrets or hold answers, be locked and tempting or frustrating, or in a magical world, even be something else pretending to be a door. But what would be the meaning of a veiled doorway? Was this a window or doorway after all? We know that portraits are used to cover secret entrances like the Fat Lady, and the ticklish pears, so why not this portrait?

COOKING UP SOME PUMPKIN PIE

Mrs Weasley leads Harry to a room, and as he enters, Hermione pounces on him and calls to Ron who appears as he closes the door behind Harry. What were Ron and Hermione up to that was so distracting they didn't even notice Harry arrive? It was probably innocent, but how innocent? They are holding hands in POA movie — is there something between Ron and Hermione, or are we being teased some more? (We know Jo has had the Director remove inaccurate scenes — was this just another one that got to stay in?)

MATES

Ron refers to Hermione as "going spare" when he explains to his "mate," Harry, why they didn't communicate with him. What did he call Hermione? It was pointed out to us by a fan, Joyce, that back in Chapter 33 {"Flesh, Blood, and Bone"} of Book 4, when Voldemort gave the order to Wormtail to "Kill the spare," that it may have been used to imply more about Harry. "Spare" was a term used in royal families to describe a younger son to the prince — indicating that in case something happened to the heir to the throne, there was a spare. In the case of Book 4, Joyce thought it may have had more meaning than Harry being the main course — it could have been Jo's subtle way of telling us that if Cedric was the "spare," Harry is an heir (to Gryffindor). In this Book 5 reference, it may have more to do with the death aspect. There are death references everywhere (shiver), so it's hard to figure out who has the target painted on them.

Mates, pairs, and other doubles seem to be multiplying in Book 5. We already know that there are things breeding in the walls, so should we be watching for other pairings?

SNIGGERING ON THE WALL

Harry notices a blank parchment on the wall, which gives a faint snigger. Why and how would a blank canvas "snigger." We know in Jo's world that the people in portraits can not only communicate with the living, but move around and even leave to visit other portraits. But why would a portrait lurk and snigger at Harry? Does this portrait person have something to hide?

POINTING FINGERS

Ron shows Harry how Hedwig had pecked a deep gouge into his index finger because he wouldn't answer Harry's questions. How did Hedwig know that Ron wasn't answering Harry? We are still wondering what special abilities owls have that make them such great messengers. We were also intrigued by the slashed "index finger," which makes us suspicious about the whereabouts of a certain rat that has a finger missing.

PESTS AT #12

Hermione explains that due to neglect, the mansion is in dire need of cleaning because "stuff's been breeding in here." The WWP Sleuthoscope is buzzing around our heads. Are pests the only things that have been breeding in there? HP Sleuths should scout out all references to creatures and breeding as you march through Book 5. There may be more than one Kreacher roaming around the place.

COEURS AND FLEURS (HEARTS AND FLOWERS)

Fred and George inform Harry that Bill has transferred to a desk job in order to be closer to the Order — which also puts him closer to Fleur, who has a new job at Gringotts (and is being tutored in English by Bill). Ooo la-la! Shippers get ready to do battle... Is this just the twins' opinion, or did Fleur really take a liking to Bill in Chapter 31 {"The Third Task"} of Book 4? We still don't have any direct evidence as to whether Bill sees more in Fleur than Veela or student. So, is Fleur doing anything besides learning English? Is she helping out Madame Maxime or the Order? Is she on our side? In our first Guide, we had mentioned the French Resistance in Muggle wars, so it would be logical to speculate that there is more going on with them than flirting.

FUDGE'S FLUNKY — PROBING PERCY'S LOYALTY

The Weasley kids describe how Percy was promoted to Fudge's Junior Assistant, how he fought about the assignment with their parents, and then went to live in London to be closer to the Ministry. Percy can Apparate and he knows how to use Floo Powder. So, why does he "need" to be so close? Was it because he loves the Ministry so much? We weren't convinced. It's been obvious that Percy has always loved power, but we were suspicious it was being used as a ruse to blind us to direct manipulation by Voldemort's supporters. Why else would Fudge *willing* keep Percy right there in the office — beside him at all times? Surely there had to have been better choices.

Numerous references in the beginning chapters to dung, horns, glasses, and cauldrons contributed to our belief that there was something going on with Percy, and we continued to see what we thought were related hints to his being Polyjuiced and/or Imperiused by Wormtail. One of the major quotes by Fred appeared to support this when he told his mum, *"Percy's nothing more than a humungous pile of rat droppings."* It also seemed to explain all the Mad-Eye Moody-type (imposter) references. However, in her World Book Day chat in 2004, Jo assured us that he was not being controlled {see Curiosities}. So he is just a stupid prat, and we think he deserves to have Fred and George beat the "rat pellets" out of him!

Nevertheless, there could be some other shadiness going on from which we are still being diverted.... One explanation is that Percy is working undercover (no one knows but Dumbledore) for OOP. Even if Percy is acting of his own free will, is he good or evil? What do HP Sleuths think? Funny how more information still leaves us with several options.

STUNNING PORTRAITS

When Sirius' mother starts screeching, accompanied by the other portraits, Mrs Weasley has to stun them all into silence. She does?...That is...you mean she can? Mrs Weasley was able to use a stunning spell on a portrait? Does that mean all spells that affect wizards will work on a portrait, or is the stunning spell unique? For magical art connoisseurs, this is really enlightening information.

VAMPIRE OR NOT

After their meeting, the members of the Order prepare to stay for dinner, except for Dumbledore and Snape, who Ron says "never eats here." One small reference and the fan sites were out for blood. Those who are new to HP Sleuthing may not be aware that one of the biggest controversies surrounding *Professor* Snape was whether he may be a vampire or not. Since Vampires drink blood and usually can't eat normal food, Ron's comment was equivalent to saying that Snape may not be *capable* of eating their food.

However, after all these years of speculation, it looks as if Jo has actually answered the question (see Oddities). Unless there is additional clarification, we will assume that whatever he is, Snape isn't a Vamp. So, why does he not dine at Grimmauld Place? Is it the place or the company? He may have been on the wrong side initially, but since Dumbledore testified for him in court, they should know that Snape put his life on the line for them during the previous war.

Even if there is no other reason, we understand Snape may not feel totally comfortable with the other members, but why would Dumbledore not stay for dinner? Was he that busy, or does Harry have a legitimate reason for feeling that he is being snubbed?

BILL'S OPINION

Ginny states that Bill does not like Snape (count her in as well). Up until Book 4, we were all convinced that Snape was a hard-core Dark Wizard who could not be trusted. Granted, Dumbledore trusted him as a teacher, but even then, apparently denied him the Defense Against the Dark Arts position. At the end of Book 4, Snape was doing something very dangerous to help out Dumbledore, which implied great loyalty. And now we see that he is a member of the Order yet still carries that Dark Mark on his arm. Can we be sure he is truly a *reformed* Death Eater? HP Sleuths need to keep alert for all clues in Book 5.

GINNY'S NOISE

Ginny expresses her opinion with a noise that sounds like "an angry cat." Of course, this could be just an expression, but based on experience, we should probably examine it more closely. In the Harry Potter novels, characters' personalities often are expressed in terms

of animal characteristics. However, unlike other stories, these are more than just metaphors — they hide secrets about the characters and even special magical abilities that relate to the animal. In Chapter 9 {"The Writing on the Wall"} of Book 2, Ron told Harry that Ginny is "a great cat lover." We have never even seen anything feline around the Weasley residence (unless you count Mrs Saber-Tooth-Tiger Weasley when she is on the warpath). So, when or how does Ginny interact with cats? There are several other times in Book 5 when she also has been given catlike qualities,

GRIM WORDS

Sirius introduces his mother "grimly." Yes, we have been warned there will be a major death in Book 5, but it seems as if the whole house and everything in it is dead or dying. You can already tell this is going to be a very dark, disheartening book.

Rowlinguistics

✳ **Grimmauld** sounds like *Grim + old* and it certainly suits Sirius' (cough) beloved child-hood home. The Robert Burns poem you've probably mangled in song a time or two at New Year's, "Auld Lang Syne," literally means *old long since* in Scottish (it's been

around in various forms since the mid-1500's). Which makes Grimmauld Place a perfect name for the Black family home — not only is it Grim and Auld, it's been that way a long time since... { www.phrases.org.uk/}

✳ **Kreacher** sounds like *Creature*, and it's true enough this house-elf doesn't look like any of the others whose acquaintance we've made. He resembles an Igor-ish character from old horror movies. Should we be thinking of him as the creature, or maybe what he may doing with other creatures?

-- *Curiosities* --

✳ Since we know that Jo has modeled Voldemort and his Death Eaters on Adolf Hitler and the Third Reich, it might hint at the role of Beauxbatons. As we speculated in our first Guide, the French Resistance against Hitler was very famous, so we see a parallel there. The key with that kind of resistance is the use of double-agents, so it might be very difficult to know who to trust...

✳ If we are talking of heads, the Jivaro Indians of the Andes are a group of warrior tribes who are known for their production of shrunken heads. They call them "tsantsa," and believe that they have magical powers. In their beliefs, taking the head of an enemy, besides being the ultimate insult, fulfills an obligation to the taker's dead ancestors. It will produce luck and good crops, and increases the power of the taker because he then has control of the enemy's soul, which can no longer revenge itself upon the taker and his allies. Maybe the Blacks aren't lucky any more because they've all but run out of house-elves to behead...
{www.head-hunter.com/index.html}

✳ "Half-breed" was an offensive name for *a person of mixed racial descent, especially a person of Native American and white parentage.* Tags of this sort are pretty common—the Nazis called people who weren't actually full-blooded Jew "mischlings"—which means just what it sounds like, mixed-bloods.

✳ We had speculated that Percy was being controlled by Voldemort's people, and that he was under the Fidelius Charm when they needed him to interact directly, or Polyjuiced when he would not be in direct contact with others. The wording of the question during the 2004 World Book Day chat was, *"Was Percy acting entirely of his own accord in Order of the Phoenix?"* Jo's reply was, *"I'm afraid so."* Chris Rankin, who plays the character of Percy in the Warner Bros. movies is convinced Percy will redeem himself. What do HP Sleuths think?

Oddities

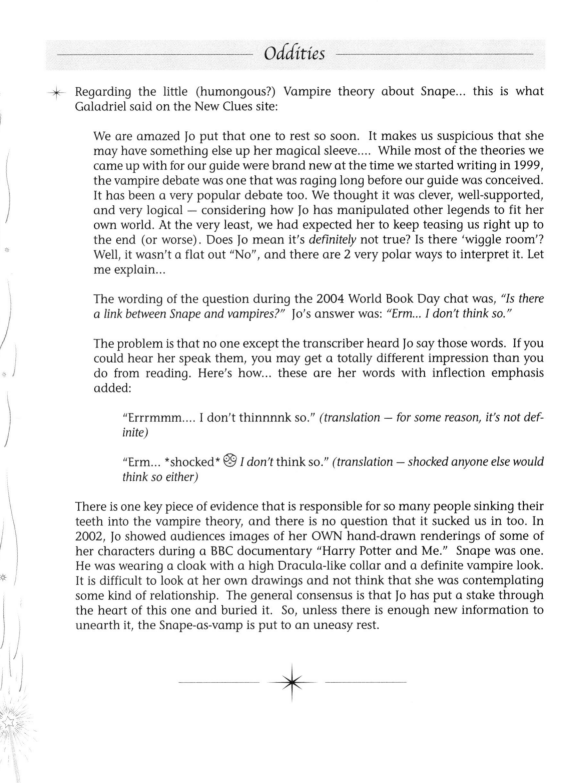

Regarding the little (humongous?) Vampire theory about Snape... this is what Galadriel said on the New Clues site:

> We are amazed Jo put that one to rest so soon. It makes us suspicious that she may have something else up her magical sleeve.... While most of the theories we came up with for our guide were brand new at the time we started writing in 1999, the vampire debate was one that was raging long before our guide was conceived. It has been a very popular debate too. We thought it was clever, well-supported, and very logical — considering how Jo has manipulated other legends to fit her own world. At the very least, we had expected her to keep teasing us right up to the end (or worse). Does Jo mean it's *definitely* not true? Is there 'wiggle room'? Well, it wasn't a flat out "No", and there are 2 very polar ways to interpret it. Let me explain...

> The wording of the question during the 2004 World Book Day chat was, *"Is there a link between Snape and vampires?"* Jo's answer was: *"Erm... I don't think so."*

> The problem is that no one except the transcriber heard Jo say those words. If you could hear her speak them, you may get a totally different impression than you do from reading. Here's how... these are her words with inflection emphasis added:

>> "Errrmmm.... I don't thinnnnk so." *(translation — for some reason, it's not definite)*

>> "Erm... *shocked* 😳 *I don't* think so." *(translation — shocked anyone else would think so either)*

There is one key piece of evidence that is responsible for so many people sinking their teeth into the vampire theory, and there is no question that it sucked us in too. In 2002, Jo showed audiences images of her OWN hand-drawn renderings of some of her characters during a BBC documentary "Harry Potter and Me." Snape was one. He was wearing a cloak with a high Dracula-like collar and a definite vampire look. It is difficult to look at her own drawings and not think that she was contemplating some kind of relationship. The general consensus is that Jo has put a stake through the heart of this one and buried it. So, unless there is enough new information to unearth it, the Snape-as-vamp is put to an uneasy rest.

Chapter 5 Analysis

What Are the Mysteries in Chapter 5?

HEAR HERE

The twins have invented Extendable Ears in order to eavesdrop on the Order's meetings. The HP Hintoscope is sending out a supersonic alert. Extendable Ears are just the beginning of ongoing references to *overhearing*. It makes our ears perk up to some potential clues. When we think of ear references throughout the septology, once again, Wormtail comes to mind with his "tattered left ear," but there are other people and creatures with big ears hanging around that might need some careful watching. Also, the snaking action of the Ears seems to fit in with this Slytherin mansion, but it could also relate to other activities going on in the house. CONSTANT VIGILANCE!

TROLL TRAP

Tonks keeps tripping over an umbrella stand in the hallway that is made out of a troll's leg, and then knocks a candle over onto a top secret plan that Bill is rolling up. This is even too grue-some for the Addams' Family. We won't speculate as to how a severed trolls' leg ended up being used as an umbrella stand — we just assume it represents the same mindset that would display the shrunken heads of the family house-elves on the wall.

Once again, it would seem that we are being led by Jo to concentrate on an overt action while the true nature of the information may be eluding us. There are a number of poten-tial clues buried in here. We become more suspicious of Tonks as time goes on. She keeps getting clumsy in the most "convenient" places. She crashes a plate just as they are ready to retrieve Harry, and just before his locked door opens by itself. She trips over the troll leg just as Harry walks in front of the portrait of Sirius' mum. She even manages to set fire to a classified document that Bill is clearing off the table after a meeting of the Order. Is she really that clumsy *and* that unlucky?

There are several running bits in Book 5 that seem to all relate to one theme — bath-rooms. And you can't help thinking about bathrooms without thinking of a Troll with something stuck up its nose. The umbrella stand is a troll's leg with an umbrella stuck into it (and Tonks' nose is quite popular). Maybe it's circumstantial...then again, maybe it's Rule #3.

BARELY A GLIMPSE

On the table, a pile of rags turns out to be Mundungus Fletcher, and as Mrs Weasley repairs the burned scroll with a wave of her wand, it illuminates a "plan of a building." The WP Sleuthoscope is playing a ragtime tune. Rags are significant in Book 5. It is important to notice who or what deals with rags. These references will be running HP Sleuths ragged.

Does this map mean something is being built, or is it the plans of an existing building? Could be a map, and if so, a map of what? Since most of the members of the Order are famil-iar with Diagon Alley, the Ministry, and Hogsmeade, what would the map be showing, and why would the Order need it? We did have some hints about maps that might be relevant.

We know there is at least one very detailed map of Hogwarts. It is also possible that the members would be using one for planning how to protect the school — unless Dumbledore is handling that all on his own. Hermione mentioned in Chapter 9 {"Grim Defeat"} of Book 3 that there are already tons of enchantments on Hogwarts. The existing protections on the castle must be centuries old, and Dumbledore might use multiple spells by multiple people the same way he protected the Philosopher's Stone.

In Chapter 5 {"The Dementor"} of Book 3, Hermione had read about the Inn at Hogsmeade that was used in 1612 as the headquarters for the goblin rebellion. In our first Guide, we had thought it was owned by the goblins, but we're now thinking that since it is a human town that it was most likely the human headquarters. We know goblins are powerful, so if it worked well against them back then, it would be a good choice this time against Voldemort. In addition to needing a map to plan how to reinforce it as a stronghold, we would expect the inn to have at least a wine cellar (if not extensive underground passages) that would require a map.

If you recall, in Chapter 1 {"The Boy Who Lived"} of Book 1, Dumbledore mentions a certain scar on his knee that he considered very useful. He said it was of the London Underground, but fans of the TV series *Beauty and the Beast* know that the Underground of a major city can contain much more than train tracks.

Just as intriguing as that mysterious map was the revelation that even burned items can be repaired. Hmmm...then we have to ask why would the overly-cautious Moody ignite the parchment on which the Grimmauld Place address was printed, and then let it fall to the ground? For being so paranoid, Moody seems to be awfully careless. Is that old age, or more evidence that there is something not-quite-right with Mad-Eye?

HAIRY STUFF

Ginny's red hair is described as being in a "long mane." Since "hair" is used as a personality trait, it is constantly referenced by most authors when talking about characters. Therefore, it is difficult to determine if it should have running bit status or not. Some of our favorite (and most powerful) wizards, Dumbledore and Bill, have very long hair. Ginny has a "long mane" of hair (very lion-like). Moody is also described as having a "mane" of hair. Even Hermione's "bushy" hair is thick and moderately long. We have been watching the growing references to hair. However, Shacklebolt is totally bald and Harry's hair is shorter and unmanageable. While the long hair appears to have significance, the primary factor is that, like many things in the magical world, what most influences hair is the personality and genetic background of the wizard.

AND THE POINT IS...?

While preparing dinner, the twins get overzealous with their spells and had Sirius not moved his right hand in time, a falling knife would have pierced it. That knife-hand relationship just begs for the image of Peter Pettigrew at the graveyard in Book 4. How do the two relate? Does it have to do with sacrifice, allegiance, hands, or are we supposed to think specifically of Wormtail? No word yet on him.

DUNG'S DEALINGS

Molly isn't too fond of Dung, prohibiting him from smoking his pipe that reeked of "burning socks," and curtailing his stories to the kids about his criminal activities — including one about an "associate," Will, who got stuck buying back the frogs he had previously stolen. There are curious running bits here. The socks are interesting, but the only thing to go on in this description is the "burning." There are frogs and pipes again too. Are these significant? They are major running bits, but their juxtaposition is suspect, as we know that Trevor and Basilisks hang out in bathrooms where the pipes are. Just something more to slosh around in our brains.

Dung's "business associate," Will, sounds like a fishy character. As frogs and toilets seem to go together, we might want to consider if he has been hanging around any toilets himself.

FW&W

Bill jokes about Dumbledore not caring about being demoted — as long as they don't take him off the Chocolate Frog cards. It could have simply been a joke. Then again...as we speculated in our first Guide, it could mean that there is something magical about the cards or about Dumbledore's card in particular. In general, a mass-produced or mechanical magical picture, such as a photograph, is usually black-and-white and does not hold much magical ability compared to a hand-painted portrait. However, photographs do still move, and still hold some essence of the personality of the person being captured. In an FAQ on her website about using Chocolate Frog cards as a means to communicate between Order members, even though it wasn't true, Jo thought it was a great idea. That means those cards *could* be used as more than just pictures...

FINE HEIRLOOMS

Dung is quite enamored with the Black Family fine silver goblets, which are crafted by goblins. Not that it surprises us (given his line of business), Dung certainly has an eye for valuables. We have confirmation now that in addition to their lust for treasure, goblins do a lot more with precious metals than just collect them. The implication is that they are highly-skilled craftsmen.

RAGS TO RICHES

Before his words are cut off, Harry hears Bill reporting that the goblin, Ragnok, is not very inclined to side with the wizards since they are still denied freedoms — and especially now, since a Ministry official (Ludo Bagman) never repaid them and there has been no public word about the incident. Uh, oh ...Bagman never did manage to pay back the goblins. (He's toast.) As we surmised in our first Guide, the goblin issue is a sticky one, and it's pretty scary that we still don't know if the goblins will remain neutral. Remember...they control the bank and the wizard money, so if they choose the wrong side, not only could that provide an advantage to Voldemort, but it could undermine the whole wizarding economy. In Chapter 7{"Bagman and Crouch"} of Book 4, Mr Weasley pointed out Cuthbert Mockridge, who he said is Head of the Goblin Liaison Office. We are betting Cuthbert is busy right about now — unless he also is pretending nothing is happening.

35

Apart from the financial issues, considering how deadly goblins are without any help from Voldy, their allegiance to either side could be crucial in the war. Then there's that new information about their social status — what "freedoms" are they being denied? Bill might have had more to tell, but thanks to Rule #2, this is all we've got.

There are two clues that seem to be embedded in the goblin's name. One of them is woven into the fabric of the Book 5 storyline. The "rag" part of Ragnok is somewhat of a running bit. It doesn't come up very often, but every time it is used, it is usually a disgusting cloth, and either a focal part of the scene or used in the vernacular, which draws attention to it.

The other clue could be implying something very deadly for the septology. So far, the goblins have not chosen sides, however, based on the goblin name "Ragnok," this war could be apocalyptic. In fact, there are numerous parallels to Norse mythology, all reinforced by Jo having used this name. Ragnok derives from the Norse legend of Ragnarok (see Rowlinguistics). The two primary foes in the Ragnarok conflict would be a wolf and a serpent. Well, it's not difficult to miss that we have a serpent and a werewolf who are deadly enemies. Is Remus Lupin going to play a major role in the final battle with Voldemort?

DINING AT #12

Dinner at Grimmauld Place ends with a difference of opinion over what Harry should be told — bringing Sirius almost to his feet, ready to battle Molly — which prompts Arthur and Lupin to suggest Harry be informed (Bill, Tonks, and Mundungus abstain from offering opinions), while the other five kids all want to hear too, but Ginny, who is playing on the floor, is dragged to bed by Mrs Weasley. We are hearing spooky sounds emanating from the HP Hintoscope. As you may know, we are of the opinion that although Professor Trelawney appears to be only a fake and a drama queen, she may be getting visions of true signs. However, due to her obsession with doom-and-gloom predictions, she keeps misinterpreting those signs. She also seems to be absurdly superstitious. In Chapter 11 {"The Firebolt"} of Book 3, she was afraid to join the dinner table because of the belief that if thirteen people dine at a table, "the first to rise will be the first to die."

During dinner at Grimmauld Place, there were 13 people seated at the table. The trouble is, who really was the "first to rise," and do we care? Sirius started to get up, but Lupin told him to sit back down — was he totally standing? However, if you notice, Ginny had already left her chair and was playing with the cat on the floor — but does the act of sliding down onto the floor count as "rising"? If we look at who truly rose first, it would technically be Mrs Weasley, who first got up to get dessert and then would have risen to her feet and left the table to escort Ginny to bed. So, even if we were to believe it, who was first? Do HP Sleuths think Trelawney is just silly about that superstition, or should we be wary?

Did you notice Ginny on the floor playing like a little kitten? It was not an obvious image, so we thought it would help to point it out.

FUDGE'S FEARS

Fudge and his Ministry are refusing to believe Voldemort has returned, and are even accusing

Dumbledore of plotting against Fudge — in spite of Dumbledore's refusing the position when it was offered to him when Millicent Bagnold retired. This sounds really stupid...it also sounds really frightening. If Fudge can be this delusional about Dumbledore, what could Fudge be convinced to believe by those working for Voldemort — especially if the convincing comes from a well-respected pure-blood with very deep pockets?

Rowlinguistics

✳ The goblin liaison who Bill talks about is called **Ragnok**. In Nordic legends, *Ragnarok* is the final battle between good and evil in which even gods would die. That apocalyptic war was foretold to the one-eyed Odin, and was supposed to follow a never-ending winter. Ragnarok could be equated to the darkness that devoured Middle Earth in Tolkien's *The Lord of the Rings*, so we are on the lookout for possible analogies as the weather worsens in the Harry Potter septology. This is the legend of Ragnarok:

> The war was destined to occur, and no one could prevent it from happening. Heidall, the Horn Blower, would sound his trumpet as the war began. Two primary foes in the Ragnarok conflict would be a wolf and a serpent. After the war, two humans hidden in the Tree of Life, would repopulate the world.

We already have seen Fawkes the phoenix sound a note in battle, and there are some famous war horns in the literature that Jo has already acknowledged — such as the *Chronicles of Narnia,* King Arthur, *Lord of the Rings*, and, of course, the Bible. The tree, Yggdrasill, is highly associated with the cycles of nature, and rebirth, which are playing prominent roles in the Harry Potter septology. The centaurs in Jo's story (who are knowledgeable) talk about destiny. How much does predestination factor in the septology? Does Jo believe in fate? She has answered that question on her website {www.jkrowling.com}. She doesn't specifically believe in fate as much as "hard work and luck," but she feels that "the first often leads to the second." This makes sense since the overriding theme in her Harry Potter novels is that of "the choices you make" being what determines who you are and what happens to you.

Curiosities

* Mr Weasley mentions a goblin family near Nottingham that was killed by Voldemort. Why would a goblin family live near Nottingham? Probably because Jo is being tricky again and intertwining legends into her works to give them substance and credibility. One thing Nottingham is famous for is the residence of Lord Byron, which used to be an Abbey. The trouble was, it was cursed, and legend has it that the ghost of a "Goblin Friar" would appear, followed by misfortune. So, if there is a "Goblin Friar" hanging around, there are probably other goblins, and it would explain why a goblin family would be living in the area. There have also been sightings of the ghost of Byron's big, black dog (where have we seen that before?). Of course, fantasy fans are very much aware that Nottingham's Sherwood Forest was the hideout for Robin Hood.

* It would seem that the 15th century was a good time for goblin-wrought silver in the wizarding world. In the Muggle world, it was the beginning of the Renaissance — the time of people like Galileo, and Leonardo da Vinci, Michelangelo, and Shakespeare, generating art and ideas. And yet... there were huge class discrepancies including poverty and enslavement. Since the only goblin wars we know about at this time occurred in the 17th and 18th centuries, it is possible that goblins and humans had a different relationship at that time.

* "Horn-rimmed glasses" are also called tortoise-shell. Check out the hauntingly familiar imagery of D.H. Lawrence's poem "Tortoise Shell." Lawrence is best known for his controversial novel *Lady Chatterley's Lover* — but did you know he also wrote the books *The Plumed Serpent*, and *The Man Who Died*? In the latter, a resurrected Jesus Christ chooses life with a priestess of Isis over a return to heaven. {www.poemhunter.com/p/m/poem.asp?poem=169282&poet=8085&num=16&total=19}

Oddities

* Wow, "evanesco's" a real word! It's Latin for *to disappear*. When clearing the valuable scrolls off the table, Bill uses the spell, *"Evanesco!"* The scrolls vanish, but do they literally disappear into thin air? Where do they go? If they are that valuable, it would not make sense that he dispensed of them completely, so did they go to some kind of temporary location, did he know where he was sending them, or did they become part of the room...waiting to be recalled? Would it be the equivalent of a "deleted" folder on your computer — which you have to empty it from time-to-time?

Chapter 6 Analysis

What Are the Mysteries in Chapter 6?

GHOULISH

While working on cleaning up the mansion, the kids come across a "murderous" ghoul in a toilet. Are we supposed to take that literally? Ghouls don't sound very friendly, but according to our favorite reference, *Fantastic Beasts*, ghouls are not supposed to be dangerous. Like the one in the Weasley attic, they are famous for being repugnant or irritating — but not killers. So, was that deadly word just describing his attitude, or is this ghoul unusually nasty?

BABY SISTER

When the kids are discussing what Voldemort's new weapon might be and that it doesn't need to be big in order to be powerful, George uses Ginny to make his point — you wouldn't know from Ginny's size how powerful she is. Wow! Respect from the twins — li'l sis must be quite impressive. We did see many signs that Ginny admired skillful wizards and wanted to be like them. Upon first meeting Ginny, we learn that she idolized Bill. We then saw she was smart enough not to be fooled by Percy's phony façade, and as a first year, she performed some very creative magic when she made the get-well card for Harry. Her "crush" on Harry certainly wasn't because the skinny boy with taped glasses was a magazine model or a beach hunk (muscle-bound beauties for the slang-challenged).

CREATURE WEAPONS

Harry has a dream in which Hagrid is showing their class multi-legged creatures that are first "cantering" but then "wheeling" around to become "weapons" with "cannons for heads" that are aimed right at Harry. The WWP Hintoscope is firing off smoke signals. Are the wheels in your head now grinding from all those running bits? Harry is in grave danger. What kind of creature could be gunning for him? What new surprise is Hagrid going to have for his class (Care of Magical Weapons) this year?

WIZARDS — BLACK AND WHITE

Sirius discusses the interrelationship of wizard pureblood families, how he is now the last of the Blacks since his mother died about ten years ago, and describes the background on each member that is on his family tree — as well as some that are not. We are seeing a lot of the pureblood wizarding families dying out. Of course, as Ron explained it in Chapter 7 {"Mudbloods and Murmurs"} of Book 2, there are hardly any totally pure families anyway, or wizards would have all died out — they had to inter-marry with Muggles just so their race could survive. That notwithstanding, it is still interesting that we now know of several families, such as the Crouches and the Blacks, who no longer will survive. We do not know if the Diggorys have any other offspring besides Cedric. Suzanne and Craig Foster have a very informative discussion about this tragedy in *The Plot Thickens* fanbook.

Much of this is Voldemort's fault, but we are curious about a piece of information that Jo put on her website. She has told us that Ginny is the first Weasley female in "several gener-

ations." Is that isolated to the Weasley lineage, or is it a symptom of a greater threat that affects all pureblood families? Could it be that due to some weird genetics in pureblood wizards that they do not easily produce females? As we have been told, the practice of intermarriage within pureblood families is common, so it probably causes its own set of problems.

Maybe Uncle Alphie was the (cough) black sheep of the Black family, until Sirius came along. You notice, Sirius says he's dead, not how he got that way.

Sirius comments about his mother's death 10 years ago, which is the second time we are told that. Rule #1. Sirius doesn't mention much about his father. Rule #2 or not important? What was happening 10 years ago? Let's see... Harry was around 5 years-old; it was about 4 years after Voldemort was vanquished; it was maybe around the time of the Longbottoms' torture by the Lestranges; and it was probably when Barty Crouch was at the peak of his power. There was a lot going on, and we don't know how old Sirius' mother was, but Sirius isn't that old himself, and we know that wizards live a lot long than other humans. Is there a tie to something important? What was the cause of he "Black widows"?

PRECIOUSS HEIRLOOMS

Kreacher, an old, bald, nearly-naked, wrinkled house-elf with big "bat-like" ears, is muttering audibly to himself and freaks out as they attempt to haul away Black family heirlooms — especially one golden ring bearing the Black family crest. Look at those big ears! More ears, and more suspicions. Reinforced by the twins, big ears are better at hearing things, and therefore very useful if you want to overhear things you aren't supposed to. Does Kreacher have better-than-normal hearing?

There were a few Black family artifacts (aka ancient cursed objects) that we considered important, and this gold ring is one of them. What would an old, bald, wrinkled creature with big ears who lived alone and talked to himself want with a ring? Does this scene remind you of a literary classic? If you are a fan of *Lord of the Rings* you might very well be suspicious of treachery. In JRR Tolkien's famous trilogy, Gollum has a similar characterization to that of Kreacher, and is obsessed with a magic ring. Of course, part of that obsession is caused by the magic of the ring, nevertheless, he is not to be trusted, and we have to question why he was so insane over that ring. Like most items in the Black house, this ring probably has magical powers.

Kreacher has many similarities to Gollum who at one point served two masters, just like Kreacher is having to do with Sirius and his mother. The question is...is he still taking orders from her?

Note — for some reason, when we wrote the *New Clues* Guide, we were under the mistaken impression that we had proof the ring had been salvaged. Maybe it was wishful thinking...maybe it was the way Jo talked about it...maybe it was the power of the ring? ☺ However, we were wrong — there is nothing we could find later to verify or hint that the ring was saved — except for the knowledge that Kreacher somehow managed to salvage those things he considered most valuable, and he made it known that ring was clearly at the top of the list!

TAPESTRY SECRETS

Sirius shows Harry an ancient tapestry into which is woven the Black family tree — with Phineas

Nigellus at the top. A certain rude willow tree turned out to be concealing huge secrets in Book 2. It is possible that Jo has gotten tricky and this virtual tree of the Black family is hiding deep secrets as well. It must contain at least seven centuries of information about wizard history. Could it be that something is literally "buried" under or behind this tapestree? Let's look at this from another perspective (aka upside-down). As is typically done for tracing ancestry, this is an *inverted* tree with Phineas and his generation near the top — assumed to be the "roots" of the family tree. That would mean what is "under" the tree roots may actually be up in the ceiling. Has anyone checked the attic lately? (Oh, yah — Kreacher has.)

GRIM PLACE

Kreacher is constantly up in the attic. The WWP Sleuthoscope is creeping around.... What is going on in the attic? There are some famous Gothic tales concerning locked rooms in attics — not to mention all the Gothic mansions that go with those tales. Sometimes past horrors haunt the house...sometimes there are horrors hidden in the house...and sometimes the house, itself, is alive through horror. Should we be concerned about what might be in the house, or about the house, itself? What relationship does Kreacher have with this house? Sirius doesn't like the house — we're not sure if we do either.

WHAT'S IN A NAME

On the Black family tree, Harry sees those relatives who were considered worthy of their Slytherin heritage — often named after astronomical objects (especially the reptilian ones, of course). Before Book 5, we had begun seeing a pattern cropping up. We saw an abundance of people who were named after flowers or celestial objects. Book 5 continued to seed that scheme as we saw more similar names popping up. It hinted at patterns of constellations with potential links between characters.

One of the names that we couldn't help but focus on was Regulus. Since we were given no proof that he is dead or that he truly was working for Voldemort, we had considered him to be a good candidate for one of Jo's "gotchas." What fueled this theory and made us feel that he may even have been defying his mother behind her back is that his name comes from the star, Regulus, the brightest star in the constellation Leo. In fact, the star is called the "Lion's Heart." However, when asked about Regulus in her 2004 World Book Day chat, Jo answered, *"Well, he's dead, so he's pretty quiet these days."* We get the feeling she isn't going to resurrect him. That doesn't stop us from wondering about his feline name.

We also now know from Jo's World Book Day chat that the practice of naming wizard children after stars, flowers, etc., was *not* intended as a clue to a specific relationship (such as between Narcissa and the Evanses). Jo explained that it is strictly a family tradition, and that Narcissa's name was just an exception. But if you think about it, for anyone who didn't break tradition, it *would* seem to imply a link to a specific family. In fact, Sirius did state here that, *"The pure-blood families are all interrelated."* Unfortunately, it will be difficult to assume links, knowing that there will be key exceptions.

That doesn't stop us from wondering about those families with beaucoup tradition. For instance, in order to be a Squib, you need to be born to two wizard parents. What if a certain noir family with a tradition of bestowing constellation names on their kids — as well as "ella" derivatives — had been responsible for the name "Arabella" (as in Figg)? Just like Sirius, she would certainly be an outcast from the family. Has Arabella been secretive about her ancestry only because of her undercover work for Dumbledore? Are her family ties important?

SLEUTH FORENSICS

The kids help Mrs Weasley decontaminate some Doxys from the drawing room (Fred and George confiscate a few for their experiments), where she also discovers "a nest of dead Puffskeins under the sofa." This is a bit disconcerting. There are no natural enemies listed in *Fantastic Beasts* for Puffskeins, and whatever it is that got them obviously wasn't looking for food or they would *not* have been dead — they would have been *devoured*. Were these a whole family in the nest, or were these only the babies who didn't live because something happened to their mum? How did these Puffskeins die? Would a Doxy do this, or is some creature(s) lurking in the house? If you have consulted your copy of *Fantastic Beasts*, you should know that Puffskeins like to eat wizard bogies. Damon, of MuggleNet.com, postulated whether it could be that the bogies of someone staying in the house are lethal to the little guys?

Was it significant that the dead Puffskeins were *under the sofa* in the drawing room? Given that Lucius and Narcissa Malfoy are members of the Black family, we can't help but think about what is going on under the floor of their drawing room.

What did the twins discover about Doxy venom? According to *Fantastic Beasts,* there doesn't seem to be anything notable about their venom — except that it is hazardous enough to require an antidote.

LULLABY

While removing hazardous creatures and hazardous artifacts from the drawing room, the kids come across a music box which lulls everyone to sleep except for Ginny, who recognizes and then masters the effect of the box enough to close the lid. The WWP Sleuthoscope is keeling over as it nods off... Did you recognize the effect of that box? HP Sleuths who are up on their Greek Mythology will, of course, recognize that it relates to the same legend that sedated Fluffy in Book 1 (see Rowlinguistics). Where did that box go? We never saw anyone trash it, and if the twins were pocketing whimpy things, then something this powerful must have been a temptation. Then again, it's not like you could mix the box into a potion, so it may not have been as enticing to them as to...perhaps...Ginny? You did notice that inthis instance, she fought the enchantment better than anyone else — including Harry?

KREACHER KLUES

Kreacher, a seemingly demented house-elf wearing only a grubby rag, shuffles "doggedly," hunchbacked, across the room as he converses aloud with himself and speaks of others as objects rather than people. The WWP Sleuthoscope is playing lightly with the Van de Graaff. Jo is a Monty Python fan, and the imagery just begs for (groan) black humor. Think Mel Brooks. Think *Young Frankenstein* and the hunchback, Igor. Don't you feel like you could be watching "Kreacher features" with that description of Kreacher shuffling across the floor? Even if you have never seen the movie, you probably have seen the stereotype of a mad scientist's hunchbacked assistant. Mrs Weasley asks, "...what that house-elf's been doing for the last ten years?" Boy, is that a leading question! He certainly hasn't been cleaning the house, so what has he been doing? Would he still be taking orders from Sirius' mother? What would those two mad minds be up to?

Kreacher clearly has no scruples and would be happy to find an excuse not to serve Sirius. The doglike reference is also nipping at us. Just toss that in with all the other "grim" running bits you find.

We hope HP Sleuths noticed that loin cloth of a "uniform" on Kreacher. It may not be a running bit, but it is certainly Rule #1.

Upon careful observation of Kreacher's actions, there is a grave likelihood that he is not as "distracted" as he wants us to believe. Remember how Quirrell stuttered and was considered cowardly? Whereas Harry's perception was that Kreacher didn't realize they could hear him, it is apparently Rule #4. Kreacher's words and actions imply comprehension. He is described as "acting," being "unconvincing" in his supposedly sudden awareness of people, and purposely answering "evasively." Additionally, he hears and understands when Hermione speaks only "tentatively," and acknowledges Sirius's sarcastic play-on-words. Even Fred is sure that Kreacher is playing — and who would know better than a professional trickster? How dangerous can a house-elf be?

BLOOD DETECTOR

Kreacher is casting insults at everyone in the drawing room — either due to their "impure" heritage, or for being a pure-blood traitor. Since it is doubtful that Kreacher would have somehow been briefed on everyone's "pedigree," he must be able to somehow know automatically whether they are purebloods or not. In chapter 10 {"The Dark Mark"} of Book 4, Draco had implied it was possible. Here we see a house-elf who seems to be capable of it, and wonder if human wizards have the same ability. If so, can all wizards recognize them, or only other purebloods? Given that there is a "Half-Blood Prince," we are thinking it could be very important.

TONKS TOPICS

Nymphadora Tonks is also related to Sirius, but her mother (Andromeda) was removed from the family tree because her husband, Ted, was Muggle-born. That would mean Tonk's dad would have the name "Ted Tonks"— a double-T — which we feel is a potential clue in Book 5. We have only seen one Ted in the septology (back in Chapter 1 of Book1). He was the news anchor on the telly discussing all the owls. The newsman is most likely just a Muggle, since he has a Mugglejob. Although, Tonk's dad was Muggle-born, so he may have wanted a Muggle career or he may be one of the media people who is working for the Ministry in the Muggle world. Nothing concrete to go on at this time.

There is also the anagram for Tonks — which comes out "knots," as was pointed out by "Silver Ink Pot" in *The Plot Thickens* fanbook. We don't even know what house Tonks was in, which may be unimportant or it may be Jo being sneaky. ☺

DUMBLEDORE'S SPELL

Sirius explains that the location of the Order was protected from prying eyes by "every security measure known to wizardkind" — augmented by Dumbledore's current spell, using himself as the Secret Keeper. Sirius never actually uses the name of Dumbledore's spell, but we learned in Chapter 10 {"The Marauder's Map"} of Book 3, that the spell which uses a Secret Keeper is called the "Fidelius Charm" (see FAQs). It is the same charm that was used to protect Harry's parents. Obviously, there are loopholes that a clever or devious person can circumvent — so even Grimmauld Place isn't impenetrable. Therefore, the members can't be careless or let their guard down at any time.

SEALING IMAGES

Harry is really stressed out over the upcoming hearing — the hardest times are when he is vegging in his room, "watching blurred shadows move across the ceiling." Ahem... Who or what is making those shadows? Shadows don't appear or move across the ceiling on their own...and you did notice that was *plural*? We thought Fred and George were in the room above, but certainly Harry isn't seeing through ceilings, is he? What's up with those shadows?

Rowlinguistics

* **Lestrange** is from French and English roots—it was a nickname for *a foreigner*. The LeStrange family in England dates back to William the Conqueror, originating from France (hence the LeStrange, meaning foreigner), and had a few baronies — many carried the title Lord Strange. There is a notable one atBlackmere —"Black" + "mere" (mother, in French)—*Black mother?* Hmmm...{www.ls.u-net.com}

* **Regulus** means *little king* and is a star located in the constellation Leo, in the front part of Leo (sometimes referred to as "the sickle "). From what we know about him, that is an odd association. If he were not dead, we would be questioning whether he might be hiding some brave acts.

* There's a **Phineas** in Greek mythology (spelled Phineus) who was an uncle to an Andromeda—of course, they were also engaged. (Not much different than the Black family). Perseus, who had just come from cutting off the head of the Medusa, finds Andromeda had been tied to a rock as a sea serpent snack. He rescues Andromeda and then turns Uncle Phineus into stone using the Medusa's snaky head.

✳ The Botanical Names in the Harry Potter Books

NAME	MEANING	CHARACTER	REF
Basil	Means King	Basil	B4, Ch-7
Daisy	A flower, Old English "day eye"	Daisy Pennifold	QA
Elladora	Stella D'oro — day lily (daffodil-like)	Elladora (Black?)	B4, Ch-6
Figg	fig leaf, concealment, not literal	Arabella Figg	B1, Ch-2
Firenze	Italian name of their city of Florence, "prosperous, flourishing"	Firenze	B1, Ch-15
Fleur	Means flower in French	Fleur Delacour	B4, Ch-16
Florean	Flowery	Florean Fortescue	B3, Ch-4
Florence	Latin for "prosperous, flourishing"	Florence	B4, Ch-30
Hogwart	Rumored to be a form of lily	Hogwarts School	B1, Ch-4
Lavender	A flower or color	Lavender Brown	B1, Ch-7
Lily	A lily flower	Lily Potter	B1, Ch-1
Myrtle	A shrub	"Moaning" Myrtle	B2, Ch-8
Narcissa	Sleep, numbness	Narcissa Black Malfoy	B4, Ch-8
Olive	A type of tree	Olive Hornby	B2, Ch-16
Padma	"Lotus" in Sanskrit. In Hindu myth Padma was an alternate name of god Rama and goddess Lakshmi	Padma Patil	B4, Ch-22
Pansy	Old French for "thought"	Pansy Parkinson	B1, Ch-9
Petunia	anger, resentment	Petunia Dursley	B1, Ch-1
Pomona	A fruit tree; name of Roman goddess of fruit trees	Pomona Sprout	B1, Ch-8
Poppy	A flower	"Poppy" Pomfrey	B2, Ch-5
Rose	A flower, perhaps from Germanic hros, "horse"	Rose Zeller	B5, Ch-11
Violet	English for flower, derived from Latin "viola"	Violet (portrait)	B4, Ch-13

✳ The Astronomical Names in the Harry Potter Books

NAME	MEANING	CHARACTER	REF
Alphard	(also Alfard, Alpherd, Alphart,) Arabic word Al Fard al Shuja — Solitary one in the Serpent. It is the name of the star alpha Hydrus (brightest star in the constellation Hydra, the Serpent)	Alphard	B5, Ch-6
Andromeda	Constellation of "The Woman Chained" bound by the Nereids to the rocks waiting for the sea monster. Daughter of Cepheus and Cassiopeia	Andromeda Black Tonks	B5, Ch-6
Bellatrix	Arabic word Al Najid (the Conqueror) Female Warrior. It is the name of the star gamma Orionis (3rd brightest star in Orion, the Hunter)	Bellatrix Black Lestrange	B5, Ch-6

Draco	The Dragon constellation Draco (Draconis)	Draco Malfoy	B1, Ch-6
Rabastan	Arabic word Rastaban — Head of the Serpent It is the star gamma Draco (3rd brightest star in Draco)	Rabastan Black	B5, Ch-6
Regulus	The Heart of the Lion. It is the star alpha Leonis (brightest star in Leo, the Lion)	Regulus Black	B5, Ch-6
Sirius	The Dog Star It is the star alpha Canus Majoris (brightest star in Canus Major, the Greater Dog of Orion)	Sirius Black	B1, Ch-1

Curiosities

★ We know that music can be powerful, and the idea of music being so powerful that it can calm a three-headed beast is from the Greek myth about Orpheus. According to the legend, Orpheus played his lyre so beautifully that everyone was mesmerized by it. He got married to his love, Eurydice, but shortly after their marriage, she was bitten on the foot by a snake and died. As all people did in Greek legends, her spirit descended to the Underworld — the domain of Hades (Pluto for those of you who prefer Roman names). Orpheus was so grief-stricken that he went to find her. His music had become so enchanting that the ferryman (who only allowed passage of the dead to the Underworld) brought him across the river Styx, and then Orpheus' music charmed Cerberus, the three-headed dog who guarded the gates to Hades. You might say that Orpheus was able to just waltz in (cough). He even struck a nerve with Pluto, himself. When Pluto heard him play, he was so moved that he promised to return Eurydice upon the condition that Orpheus not look at her until they had left the Underworld. Hades must have been a great judge of character — because Orpheus couldn't do it — he had to take a look, and as he turned to her, she faded away....

Oddities

★ Throughout Book 5 are numerous references to "ceiling," "sealing," "kings," "shoes," and flying pigs. If it were not for the huge number of homophone mentions, they would not stand out, but knowing Jo's penchant for doing analogies to *Alice in Wonderland*, those remind us of a quote from Lewis Carroll that makes us think of *Through the Looking Glass*: *"The time has come," the Walrus said, "to talk of many things...Of shoes and ships and sealing wax — of cabbages and kings... And why the sea is boiling hot — and whether pigs have wings."*

Chapter 7 Analysis

What Are the Mysteries in Chapter 7?

AN EARFUL

At five-thirty in the morning on the day of his hearing, Harry is suddenly wide awake "as if somebody had yelled in his ear." Ahem! Is this a figure of speech? After seeing the door to Harry's room in the Dursley house unlock itself, we are not taking these kind of things lightly. Maybe it's just an analogy. Maybe it's not. Most likely, it's another one of those pesky little "ear" running bits to remind us to keep listening for ear-like clues.

DEM BONESES

According to Tonks, Amelia Bones would give Harry a fair hearing, but now it's impossible to know. We are ready to believe Tonks — because in Book 1, Hagrid tells Harry in Chapter 4 {"Keeper of the Keys"}, that the Boneses were victims of the last tyranny of Voldemort. Besides the intimidation advantage, this may be a key reason that the hearing was changed to the full tribunal — so Fudge could better control the outcome by influencing members who are not so fair.

DIAL THE MAGIC NUMBER

To enter the Ministry of Magic from the street, Mr Weasley brings Harry into a phone box and dials 6-2-4-4-2. More *Doctor Who* imagery — but this time, the phone booth seems to occupy normal 3-D space. The number definitely has meaning. It could possibly relate to the late Nicholas Flamel, but phone phreaks would have recognized the significance. In case you didn't, you can find yourself a Muggle telephone and look at the letters associated with those numbers on the keypad. They spell out a very charming word. In case you haven't tried it yet, you may want to remember that number when you visit Jo's website.

WELCOME TO THE MoM

The main hall in the Ministry of Magic has constantly-changing gold symbols moving around a peacock-blue ceiling. The peacock-blue color of the ceiling may be for the purpose of having us notice that blue (not to mention yet another ceiling). It worked.

The symbols on the Ministry ceiling caught our eye as well. They are most likely supposed to be similar to a stock ticker, displaying financial information. Then again, they could be information about wizards, Muggles, or events. Maybe not important, but it was sort of a Rule #2 in that we were teased with the description, but not given any explanation.

READING THE SIGNS

Harry sees Knuts and Sickles at the bottom of a magnificent fountain in the Ministry of Magic, which has a "small smudged sign" indicating that coins thrown into the fountain would be donated to St Mungo's Hospital. Why did Jo bother with the description of the sign being

"smudged"? The first image it conveys is one of neglect — as if the donations are not a high priority. It does sound a lot like "Fudged," whose love of power is reinforced by his infatuation with Malfoy's "donations." Most people don't throw large coins into a fountain, but would Jo be making a statement by the fact that there aren't *any* gold coins in there? Very interesting how the hospital seems to be the Ministry's favorite charity.

SOUNDS OF MAGIC

The golden grills on the lift close with a "crash." If the image of the golden-gated lifts reminded you of the heavenly gates, you are not alone. (lol!) Has it hit you yet that Book 5 is a very *noisy* book? Book 3 was quite nerve-racking with all the "banging," but in Book 5 gongs, clanging, ringing, ticking, rattling and other things are propagating. All those noises sound like alarms going off. The ringing sounds have that word association with "rings," which seem to also be important. Whatever they are, they don't sound friendly — they are the kinds of sounds that put our nerves on edge.

CHICKEN!

When getting onto the lift, they see the wizard, Bob, carrying a box that contains a fire-breathing chicken — an illegal cross-breed according to the Ban on Experimental Breeding. This isn't the first time we have seen fire coming out of a creature that should have been non-flammable. In Book 4, Hagrid had somehow acquired fire-spewing Skrewts, which were a cross between a Fire Crab and a manticore. According to Rita Skeeter's news article that appeared in Chapter 24 {"Rita Skeeter's Scoop"} about Hagrid and his class, Blast-Ended Skrewts were possibly an illegal experimental breed. HP Sleuths who have done their homework would be aware that in 1965, Newt Scamander (known to HP Sleuths) helped to pass a ban on experimental breeding, and Skrewts are not listed in *Fantastic Beasts*. Did Hagrid get them from someone else, or was he doing the breeding himself? It wouldn't make sense for him to take chances since he wants to stay out of Azkaban so badly, therefore, he might have special allowances as part of an educational institution.

Also, some experimental breeding might still be allowed. In Rita's article, it says experimental breeding is "usually closely observed by the Department for the Regulation and Control of Magical Creatures." Was she being sarcastic, or did she actually mean that? If Dumbledore or someone in that department wanted to "observe" the breeding, it is possible they may be able to do so. Do we know anyone in that department? HP Sleuths who have been "observing" closely will know that Amos Diggory works in there. Hopefully, he is alert and still is willing to support Dumbledore (maybe more alert and more supportive if he isn't being influenced by the anti-Dumbledore hype). We do wonder how closely the Department for the Regulation and Control of Magical Creatures works with the Department for the Disposal of Magical Creatures, since we know that Lucius already controls that department.

One thing we found odd was that Scamander seemed to be overly confident that there would be yet another species discovered this year. Does he have a lead on something that no one knows about?

Note — we found it very interesting that the ban was finally passed in 1965. Was that to make sure our society was protected from dodgy creatures like the one that was "bred" in Chipping Sodbury that year? (joke)

LUDO FORGOT TO PACK HIS BAGS

Harry caught a glimpse of Ludo Bagman's Department of Magical Games and Sports, which was a mess — with "lopsided" posters, and in a state of disorganization. From all indications, Ludo Bagman is a "missing person," and the goblins probably aren't the only ones who would like to find him. His own department at the Ministry is in total disarray — presumably because he is not there to run it. Why haven't they appointed another manager? Are the goblins right about the cover-up? In Chapter 8 {"The Quidditch World Cup"} of Book 4, Percy is adamant about Bagman's lack of management skills, and questions how he got the job of Department Head. Maybe we should be questioning that too.

SEEING RED

Harry gets a look at Auror Headquarters — an office area designated by a lopsided sign, where he sees a lot of wizards hanging around in cubicles, including a wizard in scarlet with a ponytail. Until Book 5, our only image of an Auror was the unkempt, one-eyed, scar-faced Moody with the lopsided gait. He had a reputation for being a bit "different," so we expected the other Aurors to be more impressive and professional. Curiously, Auror Headquarters looked better-suited to Moody than to an idyllic Auror champion. Even the sign was "lopsided" — a major theme running through Book 5 that is often symbolized by people's glasses being askew and/or by one eye appearing bigger than the other.

The wizard in scarlet would most likely be a Gryffindor, and could therefore be sympathetic to the Order. Like Bill, this wizard has long hair.

POKING AROUND

Tonks had tipped off Lupin that Scrimgeour has been poking around, asking questions of her and Shacklebolt, and Harry sees here that Shacklebolt is being very careful regarding what his overdue reports say about Sirius and what he talks about in front of the other Aurors. HP Sleuths who are up on their Quidditch trivia will know that Brutus Scrimgeour was mentioned in one of Harry's favorite books, *Quidditch Through the Ages*, listed in your Recommended Reading.

Many jobs that are perceived as being "glamorous" have a mundane side steeped in paperwork. Clearly, the job of an Auror is no different — although you would think if Muggles can work their way toward a paperless office, that wizards should have been able to do so by now. It is probably in Sirius's favor that they are so inundated in the department. The problem we can see is if they are this inefficient when not much is going on with Voldemort, what will happen if there is an emergency? *sigh*

SOGGY CLUES

Mr Weasley reads a memo concerning regurgitating toilets by what appears to be "anti-Muggle pranksters." The WWP Sleuthoscope is splashing around getting our book soggy. We are drowning in references to pipes, water, sinks, dung, and toilets. Just like the water and pipes, all those regurgitating toilets again remind us of Myrtle and her bathroom. Are we supposed to be thinking about the Chamber of Secrets? Are there any other waterways this might refer to? In Book Chapter 5 {"Diagon Alley"} of Book 1, there were underground

waterways, there is the Hogwarts Lake (which we know goes under the castle where the first-years disembark), and then there's all the slimy passageways, which Harry thinks snake around under the lake. In the fanbook, *The Plot Thickens*, there is a discussion by Alisha Hajosy of the lake and waterways of the magical world, which we think may be relevant.

PERKINS IN PERSON

Perkins, a "stooped, timid-looking old wizard with fluffy white hair," rushes in, "panting," and without a glance at Harry, informs Mr Weasley that the time of the hearing is changed — so they are now 5 minutes late already. Perkins is somewhat of an enigma. We still don't know much about him — only that he is a "warlock." The trouble is, we have never been given a definition of a warlock or how it varies (if at all) from a wizard, so we don't know anything about him or why he is stuck working in this department with Arthur. Did you notice that Perkins never does look at Harry? Wasn't he curious? Had they met before? A lot of people in this book are not looking at Harry, and based on what we learned from Fake Moody and the fate of Crouch Sr, we know that eye contact is an essential element in magic. Is there a reason he would not look at Harry? Is that "panting" supposed to imply anything (or anyone)? Arthur thinks Perkins is okay, but do we trust him?

UNSPEAKABLY GRIM

In the elevator, Arthur greets Bode, a sallow-skinned wizard, who doesn't blink and speaks in a "sepulchral voice." Muwahahaha! Do we detect a coffin-like personality (hint: sepulchral)? How about those zombie-ish eyes? You can't have missed that "sallow skin." Would we know a vampire when we see one? Probably not, and definitely not now. 😵 HP Super Sleuths will remember Bode from Chapter 7 {"Bagman and Crouch"} in Book 4, when Mr Weasley pointed him out as a (shhh!) "Unspeakable."

Rowlinguistics

* **Scrimgeour** is a Scottish surname taken from "skirmisher," meaning *hardy fighter* or perhaps from the French "escrimeur," meaning *swordsman*. The family has a long history of fighting for Scotland. Lupin and Tonks' breakfast discussion about how Scrimgoeur has been asking funny questions of her and Kingsley, could indicate Scrimgeour works with them — which would imply he is an Auror. {www.scrimgeour-edin.freeserve.co.uk}

Curiosities

* "Bethnal Green," along with the better-known Whitechapel, is one of the places Jack the Ripper prowled. After one particular attack, Jack left a message on the wall about Jews, which was immediately washed off by the police so as not to incite racial violence. Bethnal Green's seen a lot of violence, all the same — Bethnal Green Tube Station saw the worst civilian loss of life in Britain when it was hit during an air raid alert in March 1943, killing 173 people. {www.towerhamletscemetery.org} {www.answers.com/topic/bethnal-green}

* There's a district in South London called "Elephant and Castle," but we think it worth noting that there's an elephant and castle on the seal of the ancient city of Coventry. (If the name sounds familiar, think Lady Godiva.) The elephant was thought to be the enemy of the dragon, as well as a symbol of strength and redemption. Interesting note — in 1959 a phoenix was added to the seal to symbolize the city's renewal after disastrous wartime bombing. {www.thecoventrypages.net}

Chapter 8 Analysis

What Are the Mysteries in Chapter 8?

HEARING AND SEEING

Harry goes to Courtroom 10 for his hearing, where Fudge is waiting, minus his usual green bowler hat, with Madam Bones seated beside him, a monocle in her eye. The WWP Sleuthoscope keeps tip-toeing around. This chapter is called "The Hearing" because that's what is going on. It's a simple and straight-forward title — it doesn't have anything overtly suspicious about it... If only it weren't for the male with an earring, Extendable Ears, the fact that Jo chooses her chapter titles verrry carefully, and that gnawing feeling that these are clues shouting at us. This isn't the last of them — ears are in your running bits — keep listening for more mentions.

Fudge originally came across as a bit of a Hufflepuff, but he may have been showing his true colors all along. Based on his lust for money, power, and purity of blood, that green bowler could indicate an allegiance with Slytherin.

Hmmm... Amelia Bones uses a monocle. Is that a fashion statement or is there something magical about it?

A CHAIR BY ANY OTHER NAME

Harry is told to sit in the very same chair with self-locking chains that he had seen in the Pensieve, while Fudge announces the hearing in a "ringing voice" as Dumbledore strides in (having arrived 3 hours early due to a "lucky mistake"), and literally draws himself up a "chintz "chair. The WWP Sleuthoscope is fidgeting in its seat. Chairs are not only a running bit in Book 5, but are potentially a septology clue. The first thing that comes to mind is (as always) Jo's Greek symbolism. There is a famous chair in Greek legend that was constructed by Hephaestus, which is either just like this chair, or maybe even this very chair (see Curiosities). A couple of other nasty chairs were hanging around Hades (the Underworld) which, when sat in, caused the sitter to forget everything.

However, your *Philological Stone* can help if you know how to tune it for metonyms. There is another famous "seat" in Egyptian mythology. It is the goddess, Isis, the most beloved goddess of ancient Egypt whose cult even survived into Greek and Roman cultures. Her hieroglyphic symbol and name means "throne" or "seat of authority." It was by her right that the pharaohs ruled Egypt. She was the living embodiment of the throne, with numerous images of her sitting with Horus, the resurrected Osiris, at her breast, her body his throne. Other relevant symbols associated with Isis—the veil, a vulture headdress, and the Knot of Isis.

Isis was the wife of Osiris. Osiris' brother, Set, was jealous and devised a plan to kill his brother and take Isis as his own wife. He tricked Osiris into lying in a sarcophagus, and immediately closed it and sealed it. He threw the sarcophagus into the Nile and tried to drown Osiris, but Isis and Nephthys (Osiris's sister) found the sarcophagus and let him out.

Set finally succeeded in murdering Osiris and, just to make sure, chopped his body into 13 pieces and sent them to far parts of the world. Isis and Nephthys found all but one of the pieces, reassembled Osiris, and brought him back to life long enough for Isis to impregnate herself upon his body. However, even the magic of Isis could not keep Osiris alive, and he was forced to go back to the land of the dead. Hence, Isis became the first to mummify anyone, and became associated with death. She continued to protect her child, Horus, from his uncle, Set, who wished to murder him.

BLUE CLUES

Dumbledore enters the courtroom in his "midnight-blue" robes. Book 5 certainly has the blues. Besides being a downer of a story, the blues are also magical. Key items and places are described in hues of blue. We see Moody's "electric-blue" eye. There is also the "peacock blue" robes and ceiling in the Ministry, and then there are Dumbledore's own blue robes. They are specifically "midnight" blue. Things associated with the number 12 (like midnight) have been prevalent throughout the septology, and initially it looked as if they were forebodings of Voldemort's rebirth. Now that we are at Book 5, we see that twelves continue to tease us, and they are closely-related to time and calendars. Could it be related to Tom Riddle and his diary, time travel, or is it something to do with astrology or ancient magic? We need to keep watch.

DUMBLEDORE WHO?

For the court record, Dumbledore gives his full name, which is: Albus Percival Wulfric Brian Dumbledore. Wow! That has the HP Hintoscope humming Christmas carols. So, it's not Percy Weasley who has the King Arthur/Holy Grail link — it's Dumbledore. But what has struck a chord with the HP Hintoscope is the name "Brian," which does stand out from all the other medieval names. Why Brian? Might be Jo's just being playful. We know she likes to play and she likes satire. In fact, in an October 2000 interview with Scholastic, Jo revealed that she loves *Monty Python* satire. Could she be hinting at a famous Brian in the *Monty Python* movie *The Life of Brian*? The premise for the plot of the movie is that Brian is born at the same time as Jesus, and is mistaken for being the child of the prophecy. Could that relate to Dumbledore and to Book 5? This could be one of many symbolic biblical references.

DUMBLEDORE'S LUCK

Dumbledore explains that "due to a lucky mistake," he managed to get there three hours early. If you are an experienced HP Sleuth, you know that Dumbledore's "lucky mistakes" (such as showing up early) have something to do with Rule #3. Why did he happen to show up early? It was exactly 3 hrs, which brings us back to that three-hour time-shift of the Time-Turner — but there is no specific evidence that he was messing with time. If not, maybe he was filling in for someone else's shift — didn't Tonks say that she was too exhausted to do her shift? When Dumbledore jokes, he is usually slipping the truth right by us. For instance, our first encounter with Dumbledore in person was at the Sorting in Book 1. There, he told us straight out that what was in the third-floor corridor could kill someone. It was phrased as a joke, but it was accurate. He has followed that ever since.

WHINGING WIZARDS

Madam Bones says that according to Ministry records, there are no other witches or wizards living near Privet Drive, but because she's a Squib, Mrs. Figg doesn't think she would have been "registered." That statement raises some big red flags. First of all, it implies that the Ministry might have a census of every wizard's whereabouts, or that they might be tracking all magical activity and people around Harry. Either way, it could be significant. Would it be possible to do that? In an interview with Scholastic in February 2003, Jo told us that a magic quill at Hogwarts senses and records the birth of all magical kids. If the quill is capable of that, then we can imagine something recording the location of magical people (similar to a huge Marauder's Map).

With the war coming, and with Voldemort's spies in the Ministry, a registry of all magical people might be of concern. It is feasible that someone could use that knowledge to get to Harry or to hurt innocent wizarding families. Used for peaceful purposes, it would be a vital document to help wizards sandwiched in-between Muggle settlements. But it could also be a dangerous document for those with evil intentions.

SUMMONING STATEMENT

At Harry's hearing, Dumbledore offers to "summon" Dobby "in an instant" as a witness. Exactly how would Dumbledore "summon" a house-elf? Did he mean summon — as in to send Dobby notification that Dumbledore needed him, or the kind of summoning that would deliver Dobby physically to the spot? Either way, it is very interesting that Dumbledore would have been able to get Dobby there so fast. Obviously, sending an owl was not what he had in mind.

How would Dumbledore have made contact with Dobby that quickly? Does the Ministry have special resources he could have used? We did see that he contacted Hagrid with a signal in Chapter 28 {"The Madness of Mr Crouch"} of Book 4, when Krum was stunned. Does he use that signal for anyone else? Jo has told us that the Order has a special way of communicating {see Curiosities} which sounds suspiciously like his signal to Hagrid — but that is between Order members. Could Dobby be in the Order? What did Dumbledore have in mind?

SPECTACULAR

Dolores Umbridge, a toad-like witch with her face in shadow, sits next to Fudge (who is getting so upset that he knocks over an inkbottle), while Dumbledore stays perfectly calm, peering at Fudge through his half-moon glasses. This is a Jo play-on-words. Did you see how the shaded face relates to the name of this shady person? (See Rowlinguistics.)

Hmmm...Those half-moon glasses of Dumbledore's are being used very strangely for reading glasses. Aren't you supposed to look down at close things through reading glasses, and then look up over them for things that are far away? He would have to crane his neck really badly to look up through some half-glasses that reside down on his nose. Why is he doing that? Doesn't Fudge look more blurry that way?

Ink is a running bit and this spilled ink is running all over us. The most notable ink we have encountered is from Riddle's diary. HP Sleuths should start taking notes, but make sure your quills are writing with normal ink on normal paper!

THE VOTE

The people who vote against Harry are Fudge (of course), the toady witch, a "heavily mous-tached" wizard, and a "frizzy-haired witch." We don't know when, but we are likely to see these people again. Remember them, and don't trust them....

Rowlinguistics

* The courtroom scene reveals that **Cornelius Fudge** goes by **C. Oswald Fudge** on official documents. Oooh, so Fudge is an Oswald. Are we surprised? Although that name is highly associated with a U.S. assassination, it is most likely that Jo had a certain Nazi in mind. Generally, Harry Potter is not highly allegorical, but Jo was firm about her analogies to Hitler and Nazism. A very famous British Nazi was Oswald Mosley, who formed a highly-influential fascist organization in England, (but later claimed he was just trying to prevent war). He married someone who was also connected to Hitler, Diana Mitford. HP Super Sleuths should recognize that name, because Jo's daughter, Jessica, was named after Jessica Mitford, the sibling who had the courage to stand up against her family. It is interesting that Jo mentions on her site that she has visited the U.S. Holocaust Museum in Washington, DC. Another Cornelius is Heinrich Cornelius Agrippa, who is famous for his work in geomancy and astrology, and has his picture on the Famous Witches & Wizards cards. The only alchemy Fudge probably knows is how to bake pies. (snigger)

* Percy's name is not Percival — it is plain old **Percy**. So, what would be the intended derivation of his name? It might be Percy Bysshe Shelley, who wrote the poems "Prometheus Un-Bound" and "Ozymandias" (an Egyptian Pharoah, Ramses II), and is known for his philosophy that love and the desire to banish evil wield great power — but can't happen on its own. It could also be the Greek hero, Perseus, who slew the snake-headed Gorgon, and rescued his future bride, Andromeda. (Percy Weasley and Andromeda Black Tonks are distantly-related.) Is it a heroic name or a tragic name? We have been leaning toward the choice of the Sorting Hat — that Percy *belonged* in Gryffindor — but people do change....

✴ Why are we given Percy's middle name, **Ignatius**? (Obviously, the Weasleys had no fear of Percy being teased at school!) Ignatius Loyola, also called Iñigo, founded the Jesuits, whose initial purpose was to strengthen the Catholic Church during the Protestant Reformation. (Could Inigo Imago be another reference?) Sir Arthur Conan Doyle, creator of Sherlock Holmes, also had a middle name of Ignatius. We've heard in a recent interview that Jo likes crime fiction, so maybe she's paying homage to one of its founders. {www.newadvent.org}{www.birminghamuk.com}

✴ **Dolores** comes from the root word *dolor* in Latin meaning *sorrow* or *pain*. **Umbridge** is a homophone for *umbrage*, which has a few meanings. One is shade or shadow — in an eclipse of the moon, the shaded area of the earth is called the umbra. Another is a hint or suspicion (and we certainly have a hint of suspicion about this character!). It also means displeasure or resentment, like "taking umbrage" at a remark means to being very displeased. All of those meanings do seem to fit the Shady Lady.

Curiosities

✴ In our *New Clues* Guide, we had questioned why Mrs Figg had not seen the Dementors. She told Fudge that Squibs could see them, and yet it was quite obvious that she hadn't. Was she too far away, or was there some other reason? Jo now has explained on her website that Mrs Figg had definitely felt the Dementors in the area, however, Squibs can't actually see them. We still don't know how close she was to the action, but it is interesting that she recognized the effect of the Dementors. How exactly would Figgy have learned what a Dementor feels like? Who is her tutor? And if the Dementors are attacking Muggles, how safe is Mrs Figg?

✴ The chair in the courtroom sounds identical to a chair from Greek mythology that was constructed by Hephaestus (Vulcan in Latin). Hephaestus, the son of Hera and the god of fire, was lame. According to one legend, Hephaestus was born this way, and in shame his mother threw him from Mount Olympus, the home of the gods. However, he survived the day-long fall because he landed in the Ocean and was rescued. To get revenge, Hephaestus constructed a gold throne, but with hidden chains, to immediately bind whoever sat in the chair. He sent the throne to his mother, who, as would be expected, sat in it and was trapped. Since only Hephaestus knew how to unlock the chains, the gods were forced to call him back to Mount Olympus to unlock his mother. {www.egyptianmyths.net}

Chapter 9 Analysis

(THE WOES OF MRS WEASLEY)

What Are the Mysteries in Chapter 9?

BLING BLING

As Harry and Mr Weasley walk back up to Level Nine, they are surprised to see that Fudge is conversing with Lucius Malfoy, whose pocket jingles as if filled with Galleons. What is Lucius doing down there? Did he have a personal interest in the outcome of Harry's trial, or was there something else on his mind? The last time that Lucius "lowered himself" to be seen in the vicinity of Mr Weasley, Ginny ended up with a cursed Diary. Did Fudge invite him down there? Was the jingling pocket meant for Fudge? Not that we're surprised (we had already figured that Fudge had certain weaknesses), but Harry does not notice any visitor's badge on Malfoy — he had to ask Lucius why he was there (Harry's visitor's badge states why he is there). Does Malfoy rate special privileges — such as free to enter and leave the Ministry without a badge?

MAGICAL BRETHREN

The Fountain of Magical Brethren has statues of a house-elf, goblin, and centaur looking "adoringly" at a human witch and wizard. Is this truly the image that wizards have of their fellow creatures? It isn't a very positive image. While we can visualize a house-elf with an adoring expression, there is no way we could see a goblin looking adoringly (barf!) on a human. As to the centaur, according to *Fantastic Beasts*, it is unlikely they would even agree to be in the same building with a human, so we think it is very lucky they probably haven't seen this statue. If they ever did see it, their expressions would not look anything like those statues. No, no, no.

The seeming innocence of that fountain may be hiding more than a festering conflict between differing ideologies and human arrogance — once again, we see pipes and water. That fountain is spewing suspicion.

CHICKEN JOKE

Everyone is thrilled that Harry was cleared of the charges, as Molly puts out a roasted chicken for everyone. Maybe it was a (cough!) coincidence, but didn't Harry run into a fire-breathing chicken at the ministry earlier that day? Molly did serve a lot of chicken. What do they do with dangerous illegal cross-breeds? Maybe Gred and Forge should be working on self-roasting chickens...

FOWL PLACE

Upon receiving letters that both Hermione and Ron were awarded Prefect status, they are treated to a celebration (chicken) dinner, where Fred and George negotiate for some illegal shriveled Venomous Tentacula seeds from Dung, and Moody sniffs suspiciously at a chicken leg.

HP Sleuths who have been studying their Herbology will recognize the Venomous Tentacular as the (ahem) teething plant from Chapter 6 {"Gilderoy Lockhart"} of Book 2, that Professor Sprout had to swat to keep from snaking around her. The conversation, centering around illegal stuff, makes us wary of that chicken, too. Obviously, Crouch Jr did a superb job of imitating Moody's habits, but we also wonder if this Mad-Eye detected anything unusual about that chicken. After Book 2, chickens should be on all HP Sleuths' watch-list, so when they are mentioned, it is a good idea to look around and see if there is a toad anywhere. Of course, in Grimmauld Place, there are plenty of corners to hide in where it would be difficult to be discovered.

STICKY SUBJECTS

Ron had something stubborn attach itself to his finger. If you remember what you learned about the scuttling going on when Harry first entered Grimmauld Place (think Newt), you then would know what got to Ron's finger. Otherwise, you can do an extra scroll on Bundimuns and on the benefits of studying *Fantastic Beasts*. This may just be more reinforcement that there are a lot of weird things lurking in that house.

HOGWARTS ALUMNI

Tonks describes her own rule-breaking days at Hogwarts, which prevented her from ever becoming Prefect for her House, while Sirius asserts that of James, Lupin, and himself, only Lupin qualified for Prefect. So, Auror Tonks had a little problem with rules. Seems that you don't have to be a model student to qualify for a career as an Auror. Guess that's good news for Harry — he can stop worrying that Hogwarts Groundskeeper is the only job they will let him do.☺ Tonks still left out one vital piece of information... the name of her House. We know she has a Slytherin heritage, but if she isn't worthy of the Black family, could she qualify for Slytherin? It's what's in her heart that counts, so she may just as easily be a Hufflepuff as a Slytherin.

We also get a huge hint from Sirius about his and Lupin's House when he implies that the choice for Prefect would have been from among the three of them. In fact, we do now have confirmation from Jo's 2004 World Book Day chat that all three of them were in Gryffindor. The problem is, the person who asked the question inquired about four names, but instead of asking about Peter, gave Lupin's name twice. Jo answered that they were all in Gryffindor — maybe assuming the four Marauders — or did she not specify Wormtail on purpose? So, where does that leave Peter? It would seem odd for a Slytherin to be tagging along with a group of Gryffindors without attracting a lot of suspicion. However, we also know from that same chat that, although the Sorting Hat seems to always choose right, Jo said it was "sincere," which isn't the same as "correct."

The most staggering information, however, was that James was not Prefect. Alert HP Sleuths will remember from Chapter 4 {"Keeper of the Keys"} of Book 1 that James was Head Boy. Although it is not totally canon, we did see his plaque in the Warner Bros. Movie of Book 1. Since we now know for sure he wasn't a Prefect, that would leave only one way for him to become Head Boy.

MAGICAL EYES

While at the dinner table, Moody uses his magical eye to verify for Mrs Weasley that there is definitely a boggart in the desk upstairs. The WWP Sleuthoscope is glowing electric blue. That eye is really scary! In Chapter 14 of Book 4 {"The Unforgivable Curses"}, Fake Moody looked through a desk to see that Parvati and Lavender were sneaking notes back and forth; in Chapter 23, he looked through Harry's robes to see that Harry was wearing Dobby's socks at the Yule Ball; and in Chapter 19 {"The Hungarian Horntail"}, he was even able to look through Harry's Invisibility cloak in the Three Broomsticks. Now, we see him looking through a ceiling to look into a desk on another whole floor. Was Superman that good? Fake Moody did say in Chapter 35 {"Veritaserum"} that he had been watching Harry very closely all year in Book 4, but we couldn't believe that he was doing so from such a distance and through so many barriers. That cannot be normal magic, and besides being incredibly powerful, that eye may be a Dark Object like the one sitting in Borgin and Burkes in Chapter 4 {"At Flourish and Blotts"}of Book 2.

When you think about it, however, there is one other person that has shown a similar "talent." Dumbledore also has been able to look through Invisibility Cloaks. He also has managed to somehow know about covert activities, and arrive on the scene as soon as trouble breaks out. For instance, as soon as Sirius Black's break-in was noticed and a large group was gathering, Dumbledore arrived instantly. It is possible that he was notified by his lookouts, but he arrived without hearing what had happened — only knowing that there was trouble.

Could Dumbledore have "eyes" like Moody's? We know he can become invisible without an Invisibility Cloak. Can he do what Moody can do, but not need an eye? ...Or do his half-moon glasses have some other function than just helping aging eyes to see close? There is one instance where Dumbledore is looking *through* his glasses at something far away — and it would not have been easy unless he intentionally wanted to do so. In Chapter 12 {"The Triwizard Tournament"} of Book 4, Dumbledore is staring up at the ceiling through his glasses. Anyone who has worn a pair of half-glasses would know that is not a natural pose, and he would have had to purposely thrown his head back or push his glasses up very high on his nose in order to look at the ceiling through them. HP Sleuths may want to investigate other instances where Dumbledore has purposely peered through his glasses.

If Dumbledore's glasses have special power, what about other kinds of eyewear — like monocles? What items like that would be legal, or if not, how do you get "permission"?

CLOAK AND DAGGER

While looking for his other Invisibility Cloak (since Podmore disappeared with his good one), Moody finds a picture of the original Order, including Dumbledore's brother, Aberforth. Dumbledore's brother was in the Order? Hope he didn't have to read any notes from Dumbledore in order to find the place! (For those HP Sleuths who may have forgotten, Dumbledore "kidded" that he didn't think his brother knew how to read.) So, his brother did help out last time — although we get the feeling that his brother may have been more like Dung than like Albus. You surely remember Dumbledore's comment about his brother getting into trouble for doing something illegal with a goat. We will have to take his

brother more seriously now. Why would Dumbledore have said he thinks his brother may not be able to read? Was it because his brother should have seen some obvious instructions or a warning that he missed (or ignored)? Or does his brother have a learning disability that gives him a handicap?

What happened to Podmore? Why did he disappear with the Invisibility Cloak? Is he in trouble, a traitor, or as trustworthy as Dung? What are they all doing with Moody's Cloaks? Obviously something for the Order, but it may be a good idea for HP Sleuths to look into this more carefully.

IN MEMORY

Moody shows Harry the group picture of the original members of the Order — many of whom were killed — such as Harry's own parents, Amelia Bones' brother Edgar, Gideon and Fabian Prewett, Marlene McKinnon, and Caradoc Dearborn, whose body was never found. At Harry's hearing, we learn that Madam Bones' full name is Amelia Susan Bones — which should sound familiar to HP Sleuths. During the sorting ceremony in Book 1, Harry sees a Susan Bones being sorted in to Hufflepuff — and we even got to see her being sorted in the WB movie. Observant HP Sleuths will have recognized that in Book 1, Hagrid also mentioned the Prewetts (see Rowlinguistics) and McKinnons in Chapter 4 {"The Keeper of the Keys"}.

Did you notice how the rat wormed his way into the middle of the picture *between* Lily and James? Did he slip in there recently, or was he in that position when the photo was taken? Is it symbolic of the relationship between the three of them — that is, is it possible Peter was jealous of James and knew that Voldemort wanted him dead? What worries us most is that we now know that Peter <u>was</u> a member of the Order, and can help Voldemort out by telling him secrets of the Order.

If you claim there was a murder, you've got to have a body. As we don't know exactly what happened to Caradoc, do we know for sure it isn't Rule #4?

MOLLY'S MOTHERING

While trying to banish the boggart from the writing desk, Molly is so overcome by her fears — seeing all those she loves (except Charlie and Ginny), one-by-one, lying dead — that Lupin has to rescue her and finish the job. Molly is under a lot of stress in this book. When Harry first sees her, he notices that she is pale and has lost weight. As we see from this scene, Molly is highly vulnerable. Is she the person to die in Book 5? What about all the others she loves? Harry did not see the scene from the beginning, but he did see that she considered him part of her family, and she did see Harry dead. (gulp!) Why did he not see Ginny or Charlie? Was it significant? Does Mrs Weasley think that Charlie is more protected in Romania, or that Ginny, being a child, is more safe? If so, Mrs W doesn't know "little" Ginny... (hehe!)

PAIN IN THE HEAD

After the end of the last night before school, Harry goes up to his room and suddenly his scar

burns in pain. What would have caused his scar to go off like that? Is Voldemort nearby? Is Harry subconsciously riding the back of an eagle owl? There was no "vision" like he had in Trelawney's class, and it seems illogical that in a safe haven like Grimmauld Place that Voldemort could be nearby without someone knowing it. So then, why the throbbing pain? HP Sleuths shouldn't ignore it.

Rowlinguistics

✳ Moody describes to Harry how **Gideon** and **Fabian** Prewett fought brilliantly against the Death Eaters. Hagrid had also mentioned their names back in Book 1 (Rule #1). *Gideon* means *great warrior*—the biblical Gideon won great battles despite being over-matched. The Fabian Society was a famous socialist group, formed in England in 1883 by E. Nesbit (a favorite author of Jo's) and some of her friends, including George Bernard Shaw. They were worried about societal injustice in England and hoped to use reasonable discussion to move the country toward socialism. {www.spartacus.schoolnet.co.uk}. We thought it was mostly the Black house getting to Molly, but according to Jo's website, Molly's last name was Prewett, which explains why she is so paranoid about the war.

✳ One definition of **atrium** (like the one at the Ministry of Magic) is the *upper cavity of the heart*, divided by the septa (means "7") into the left and right atrium. In ancient Rome, the atrium was the open area in the center (heart) of the home.

✳ The name of the author of *Defensive Magical Theory*, Wilbert **Slinkhard**, is probably a version of theDutch *slinkaert* which is a nickname for a clumsy person. Makes you think of Tonks, doesn't it? It also makes you think more about snakes.

✳ Based on his name, **Caradoc** Dearborn was probably a brave wizard. Sir Caradoc Briefbras was one of Sir Arthur's knights who, through a beheading challenge, discovered his true father was a wizard. He hid the wizard away, embarrassed by his mother's infidelity, and the wizard caused a serpent to attach to Caradoc's arm until the arm withered. Only a sacrifice from Caradoc's true love was able to detach the serpent from his arm. Another Caradoc was a first century Briton who led a defensive force against the invading Romans, was captured and taken to Rome, and there won even the respect of the Romans. {www.earlybritishkingdoms.com}

--- *Curiosities* ---

✳ Jo has used famous author names for some of her characters. Would horror writer Edgar Allan Poe be the inspiration for the name of Edgar Bones, the brother of Amelia Bones, who was killed by Death Eaters?

Chapter 10 Analysis

(LUNA LOVEGOOD)

What Are the Mysteries in Chapter 10?

CROWNED

Harry dreams of Ron and Hermione wearing crowns. So many people in Book 5 seem to be falling down or breaking their crowns. The nursery rhyme imagery just reinforces that. However, in this case, Ron and Hermione are wearing theirs. There is an enticing parallel in alchemy, in which the crown is the symbol of the successful completion of a stage in the creation of the (hem-hem!) Philosopher's Stone. The crown also represents the "chemical royalty," applying to either silver, for the Lunar Queen, or gold, for the Solar King. This perfection of a metal is the result of the traditional 7-stages of alchemical transformation. The final stage, coagulation, can be achieved only after the uniting of the Solar King with Lunar Queen, whose union gives birth to the crowned Red King, the Philosopher's Stone. Interestingly, one of the symbols for coagulation is the serpent and lion united. Numerous alchemical depictions show the crowned King or Queen, including *The Azoth of the Philosophers* by Basil Valentine, and a couple of the plates in *Splendor Solis*, attributed to Salomon Trismosin, reputed mentor of Paracelsus.

LOOKING AHEAD

Sirius is resolute about escorting Harry to the train, so Molly just gives up, with the warning "on your own head be it!" The HP Hintoscope is barking grimly. That lady-tiger does have a way with words, doesn't she? These words, in particular, are very ominous. More heads, and this time, it's Sirius' head. Would Sirius have any other heads he should be worried about? It's very risky going to the train, so Molly is probably right — he isn't using his very well in the first place.

"BE SEEING YOU"

As the kids are about ready to board the Hogwarts Express, Tonks sees them off, saying, "We'll see you soon, I expect." Is that just an expression? How would they see the kids "soon" if they are off to Hogwarts? Is Harry going to be tailed all year? We know Moody is a bit over the edge, but is Tonks going to be seeing them also? And does Tonks mean that they will be seeing each-other, or that she will be observer and he will be observee? Could she be concealed when this "seeing" is going on? Is this an official Auror thing, or could they be working under orders from Dumbledore?

LUNA'S PERSPECTIVE

Luna is reading *The Quibbler* upside-down, and although Harry notices there is a puzzle in it, he doesn't seem convinced that is the only reason it's not right-side-up. Luna looks at the world from a different perspective than most people, which may prompt her to read her Quibbler upside-down. Maybe she is trying to solve the puzzles, then again, she may just be seeing more below the surface. Things being "upside-down" is a running bit, and Luna and her Quibbler are a big part of that. Like Luna, HP Sleuths might want a closer

look at objects being inverted from one-another — up vs. down, left vs. right, and other yin-yang imagery.

A Nobody

When Luna asks who Neville is, he replies "I'm nobody." There are at least two famous "nobodies" in literature. (Neville's a poet and he doesn't know it?) Emily Dickinson has a poem about a nobody, in which she equates "somebodies" with frogs. The other is from Homer's bard, "The Odyssey." When Odysseus (Ulysses) is held captive by a Cyclops, he says his name is "Nobody." Later, when they attack the Cyclops in order to escape, the other Cyclops ask who is attacking, and their captor answers "nobody." So, nobodies can be important people too!

Assyria

Neville is very proud of his Mimbulus Mimbletonia plant that his Great Uncle Algie brought back from Assyria, and explains how he plans on breeding it. There is one slight problem with that explanation — in the Muggle world, Assyria hasn't existed as a country for at least a millennium (see Curiosities). How would Algie have visited Assyria? Could he have gone back in time? Is it really still there but unplottable on Muggle maps? Maybe it's like the Leaky Cauldron — it's there but we aren't sensitive enough to see it. The land of Assyria centers around what is called the "cradle of civilization," or Mesopotamia, and is older than Greek civilization. It is where modern writing, religion, art, and commerce originated, and there are many ancient artifacts — and potential secrets that would surely attract the attention of the goblins.

There is a very famous classical myth that has survived from Mesopotamia — written on 12 clay tablets — the legend of Gilgamesh. It is a tale about the search for immortality by Gilgamesh (sound familiar?). In that story, he learned that he could obtain immortality from a particular plant growing in the bottom of the sea. Unfortunately, a serpent managed to swallow it before he got to try it (snake problems go back a long way). Based on that, we are betting Neville's Assyrian plant must have interesting capabilities. Could Uncle have retrieved that plant from the sea? HP Sleuths should watch it very carefully — especially since Neville is planning to help it grow....

We can't say that we're particularly fond of Great Uncle Algie from all the stories of him pushing Neville off piers and dropping him out of windows — we don't know if we should trust him or not. Do you trust him? Do you trust a plant given to Neville by him?

Should we be glad that Neville is breeding Algie's plant? Do we want more than one of them around? Lots of things are breeding in this book, and we doubt it's a good sign.

Little Stinker

Neville pokes his Mimbulus Mimbletonia plant to demonstrate its "defense mechanism," but it squirts Stinksap everywhere — getting worst into to Neville's eyes, coating Ginny's head like a hat, and hitting Harry in the face so he has to spit out the putrid, manure-smelling sap. Besides being a sticky situation, does this conjure any familiar images in your mind? If you can visualize the three of them, there is one with sap covering his eyes, another with sap covering

her ears, and one with sap covering his mouth. Those who are familiar with the symbol of the 3 monkeys, "see no evil, hear no evil, speak no evil," may recognize this as a metaphor. Is this another monkey thing or are we just being a sap? You should have also noticed that manure reference (aka dung) Jo keeps dumping on us.

And this is only one of the things the plant can do? What other surprises does it hold? Does Neville know all the talents of this rare plant?

OPENING UP AND SLIPPING DOWN

Ron makes a joke about Goyle looking like a baboon's backside, causing Luna to laugh so hard that Crookshanks hisses and her magazine "slid down...to the floor," as her large eyes were "staring at Ron." The HP Hintoscope is chattering noisily, while the WWP Sleuthoscope is going ape! Monkey imagery in a Harry Potter book brings to mind the "monkeyish" face of Salazar Slytherin from the Chamber of Secrets. This Baboon joke really stood out. It had an odd parallel to that vivid scene in the Chamber when the monkeyish face of Slytherin's statue opened its mouth wide, and the Basilisk slid down to the floor as it followed the hissed instructions from Riddle ...searching out its victim with its killing stare. The metaphor is striking, and it makes us think a lot about Book 2, including how it is related to the rest of the septology. It is a strong parallel, but it is reinforced by similar wording in other scenes throughout Book 5. HP Sleuths should keep a lookout for them (but be ready to shield your eyes!).

Most importantly, the baboon is associated with the Egyptian god, Thoth, who is the Egyptian equivalent to Hermes. We have already seen references throughout the septology to Hermes, like Percy's owl, and symbols related to him (invisibility cloaks, lyres).

There are other things that are notable about that joke if you are looking for hints to the storyline. Thinking about the backside of a baboon...once again, we are seeing pink. It also sounds a lot like the joke Ron made in Divination in Chapter 13 {"Mad-Eye Moody"} of Book 4, when he teased about Uranus, another giant/Titan from mythology. There is something big happening with giants in this book. We know that Hagrid and Madam Maxime were sent on a mission at the end of Book 4, and we figured it had something to do with the giants (who had sided with Voldemort last time).

CATCHING OUR EAR

In The Quibbler *magazine, Harry reads an article claiming that Sirius Black is really "Stubby Boardman," a lead singer of the Hobgoblins music group who retired after being hit on the ear by a turnip at Little Norton Church Hall, and is therefore innocent because one Doris Purkiss was having a "candlelit dinner" with Stubby on the night of the Muggle murders.* Sirius may be a long-hair type, but we can't say we've seen hints about any special musical ability. On the other hand, take note of that "Little Norton Church," which sounds like a play on words. "Burnt Norton" is the name of a poem by T.S. Elliot. It is noteworthy because he removed some lines from his renowned poem, "Murder in the Cathedral," and used those as the opening lines to "Burnt Norton." It also fits with the kind of themes that Jo has been using in her Harry Potter novels, dealing with the concept of the future and past being entwined with the present. Yet, while Jo espouses the complexity of time, Eliot portrays it as destiny.

Typically, articles in even the scandal magazines tend to be based on at least a shred of

fact. Even Professor Binns admitted to Hermione in Chapter 9 {"The Writing on the Wall} of Book 2, that legends have a bit of fact. If we can assume that is the situation for this particular magazine, then maybe there are, indeed, facts embedded in it.

Had Regulus still been kicking around, he would presumably have a family resemblance to Sirius. So, we even toyed with the idea that he may have been our mysterious "Stubby" — mistaken for Sirius. It would fit that Regulus would be using an alias if he had been hiding from Voldy's followers. However, Jo's reply that he is "dead" sort of puts that to rest.

We have seen copious allusions to the story of *Alice in Wonderland* (wizard chess, dormice, rabbits, Dudley's pigtail, the crazed knight, etc.) throughout the septology, and we are seeing more in Book 5. Therefore, we take notice when we see a reference to someone who caught it on the ear, because Lewis Carroll is known for having hearing trouble in one ear. So, is it intended to be a nudge about Wonderland? Or is it maybe another hint about something going on with Wormtail and his tattered ear? We keep seeing injured fingers/hands and ears. Is there a rat around? We still haven't seen one, have we?

Jo did manage to squeeze in more goblin and catlike mentions. Sneaky.

FUDGE FOR DESSERT

Harry starts to read an article in The Quibbler *magazine about how "Goblin Crusher" Fudge has had goblins drowned, dropped off buildings, poisoned, and cooked in pies; but he just can't deal with it and skims the rest of the sensationalist magazine, including an article on the Tutshill Tornadoes.* While the article certainly is bizarre, we know someone who has had an attempted drowning and been dropped off a building. In Chapter 7 {"The Sorting Hat"} from Book 1, Neville told us that his Great Uncle Algie thought those were very logical tactics when trying to "scare" some magic out of Neville. Is the parallel to Neville intended to make us question Algie?

What about being "cooked in pies"? We can't help but think of a certain nursery rhyme about a "king" who is obsessed with his money (see Curiosities). Sound like any bureaucrat we know? You should eat your green bowler hat if you can't get this one... What damage could his "appetite" for gold do to the fate of the magical world?

Hope you noticed the pi symbolism. Note the double-T (Tutshill Tornadoes) juxtaposed to the pie word. If you pull out your *Philological Stone* and look at the Quibbler like Luna does (think different perspective), you may see a different kind of pi(e). The TT has a Greek letterish or mathematical-type of look — like the letter pi. Those of you who aren't familiar with the letter can think of the stones monoliths at Stonehenge or Avebury.

MINISTRY HISTORY

The Quibbler *article on Fudge mentions that it was five years ago that he was elected to office.* Hmmm... Putting that together with what Mr Weasley said in Chapter 5 {"The Order of the Phoenix"}, we have some information about the top Ministry position. Millicent Bagnold was the previous Minister for Magic, and retired five years ago. As we know from both Hagrid and Mr Weasley, Dumbledore was offered the job at the time, but for some (hint, hint) reason, didn't want to leave Hogwarts, so Fudge was elected in spite of Dumbledore being the popular choice (and not even applying for the job). Wonder who funded

Fudge's campaign — bet we can guess. Fudge would have taken office just about the time that Harry first heard about him from Hagrid, which is obviously why he was always owling Dumbledore back then. You would think Fudge would be grateful, but a little paranoia will do strange things to the brain....

SING A SONG OF GALLEONS

The Quibbler *article on Fudge also claims that he wants to take over Gringotts, while it had another unbelievable article about runes revealing spells that could change ears into kumquats that was apparently on page 57.* Once again, maybe the information is partially factual. The trouble is... figuring out what is fact when all of it sounds silly.

Could Fudge be somehow conspiring to take over Gringotts? It is doubtful that he would be initiating it, but could he be a puppet in a plan like that? Maybe he isn't taking it over, but could the person who wrote the article be using the medium to stir up trouble between him and the goblins? We did hear from Bill that the goblins are already upset with the Ministry, and that they are trying very hard to negotiate with them. We also know that although no one totally believes scandal magazines, loads of people still read them and frequently accept their version of the stories.

Did you see the ear reference again? You're going to keep hearing more of them. And maybe it's another (uhhh...) coincidence, but 5 and 7 make up another of those annoying 12s.

MOON GODDESS

Harry questions his sanity as he sees the strange horses (that weren't there before) pulling the carriages up to the castle, and Luna's response is that he is "as sane as I am." It isn't hard to imagine Peeves making fun of Luna like he did Lupin — considering her name truly is "loony." We all know how crazy people get at the full moon, and the name "Luna" was the Roman name of the moon goddess in Classical mythology (see Rowlinguistics). Luna gazes unblinkingly at people with silvery, moonlike eyes — very similar to the kind of stare that Mr Ollivander has in Chapter 5 {"Diagon Alley"} of Book 1, which is assuredly a penetrating stare that gives Harry the creeps.

---------------------------------- *Rowlinguistics* ----------------------------------

✳ **Luna** is the Roman name for the *moon goddess* (Selene in Greek) — it is where we get the word "lunar." The legends say that her brother was Helios, the sun, and that she is directly descended from the Titans — the giants who ruled the world before the classical gods took over. One of her Titan relatives included Prometheus, who gave fire to man. Homer's version was the goddess of the moon and hunt, Artemis, a fiercely-steadfast virgin, who didn't take kindly to anyone trying to mess with her. From the hints we pick up in Book 5, it seems as if Jo's Luna may not be as opposed to males. She has been following Ron and Harry's antics closely, but it is difficult to know if she is attracted to them... or studying them.

✳ Diane **Purkiss**, formerly Professor of English at Exeter University (Jo's alma mater), but now Fellow and Tutor at Keble College, Oxford, is the author of both *The Witch in History* and *At the Bottom of the Garden*, which is a detailed history of fairies (and other magical beings) in folklore and literature throughout history.

---------------------------------- *Curiosities* ----------------------------------

✳ Neville's plant may have come from Assyria, but like many things in Jo's world, it takes a bit of magic to make that happen. Assyria, once located upon the Tigris and Euphrates rivers, was a thriving country back in 5,000 AD. The problem is, the country was ransacked, and although people of Assyrian descent still exist, they are scattered throughout the world due to religion-based intolerance and genocide. Jo Rowling worked for Amnesty International, and they deal with the issues facing Assyrians — so she could be quite sensitive to their plight. As a scholar, she is also sensitive to the contributions of that ancient civilization — which would surely hold as many wizard-related secrets as Egypt does for Bill.

✳ English-speaking children grow up with odd nursery rhymes. Maybe it's because they're so odd, but certain phrases stick — especially those that would never be encountered in normal speech. Baking something unusual in a pie is one of those odd phrases, and it appears in the nursery rhyme "Sing a Song of Sixpence."

Sing a song of sixpence	*The king was in his counting house*
A pocketful of rye	*Counting out his money*
Four and twenty blackbirds	*The Queen was the parlor*
Baked in a pie	*Eating bread and honey*
When the pie was opened	*The maid was in the garden*
The birds began to sing	*Hanging out the clothes*
Wasn't that a splendid dish	*When down came a blackbird*
To set before the King	*And snipped off her nose!*

Chapter 11 Analysis

(THE SORTING HAT'S NEW SONG)

What Are the Mysteries in Chapter 11?

BEST OF FRIENDS

The Sorting Hat's song reinforces that the two male Hogwarts founders, Gryffindor and Slytherin, had been extremely close friends, as were the females, Ravenclaw and Hufflepuff. You wouldn't know it from looking at Harry and Draco, but that means it wasn't always war between the Houses. We have been told before that they were all friends, but Jo made sure the Hat did a Rule #1 about the former close relationship between Gryffindor and Slytherin, so it must be important. It also means that back then, it is highly likely that Salazar Slytherin and Godric Gryffindor shared many things...probably even secrets. Maybe the existence of the Chamber and what lay within was unknown to Godric Gryffindor, but what else would they have shared with each-other?

In our *New Clues* Guide we had a little poem that ended: *We admit it has us worried, when what was paired becomes now five...er...three.* That was both a serious implication with a little playfulness thrown in. We were trying to get the idea across that while they were all paired up (Gryffindor+Slytherin and Ravenclaw+Hufflepuff), Slytherin had split off to form his own external 5th "house" — leaving the other three founders with four houses to manage. The concept of pairs making "five" was also intended to convey the idea of breeding and offspring (a running bit). When we thought of the idea for the poem, we had *Monty Python* on the brain because we are thinking that is where one of Dumbledore's names came from (we know that Jo likes *Monty Python*) and thought it would be a hoot to present ours *Monty Python*-style.

DOUBLE TROUBLE!

The song of the Sorting Hat talks of pairs, and quartering, Umbridge clears her throat with a "hem, hem," and just like the twins, Dean has taken to referring to people as "mate." The HP Hintoscope is tapping on the desk in double-time... There are pairings going on all over. Some pairings have you seeing double like the TT of the Tutshill Tornadoes, some pairings are "carbon copies" like what you see when you look in a mirror, while other kinds of pairings produce little pairings... (more breeding). We're still split on the meaning of this (nudge — that's a pun), but as you continue to see more hints, you may agree that the ramifications are mind-boggling.

TONE OF VOICE

Dumbledore welcomes everyone to Hogwarts "in a ringing voice." The WWP Sleuthoscope is vibrating with tintinnabulation (a dictionary is on your Sleuth reading list...). Yet another "ringing voice." Do you hear Rule #1? That is truly an unusual way to describe a voice — many other words would fit better there. So far, the most significant "ring" in Book 5 was the one Kreacher had a fit over. Did it get salvaged, and if so, where is it now? There was another ringing metaphor back in Chapter 9 {"The Writing on the Wall"} of Book 2, that jangles the nerves a bit. When trying to recall what he had heard about the Chamber of Secrets, Ron says, *"it rings a sort of bell"* (he thought Bill had mentioned it). Are we being

told to hark back to Book 2?

PINK AND GREEN ALL OVER

Professor Dolores Umbridge, who is described as being short, with "mouse-brown" hair, and having "very pointed teeth," is wearing a "fluffy-pink" cardigan and pink Alice band, as she reminisces that it's "lovely to be back at Hogwarts." We presume that means she attended Hogwarts. If so, how long ago was she there? Did she know any of the current teachers? Based on their reactions, it doesn't appear that way, but it is not easy to determine. It's a safe bet that she was in Slytherin. However, all that pink may be camouflaging more than just her House affiliation. We couldn't help but notice "mouse-brown" hair. Does it make you think of anything rodent-like? We know that physical traits run in families, and you might want to notice just how short Umbridge is. And what pointy teeth she has! Watch out for things with teeth — there seem to be a lot of them in Book 5, and we don't want any of them to sneak up behind us and bite.

UMBRIDGE'S UTTERANCES

In her speech, Professor Umbridge speaks metaphorically about a "treasure trove of magical knowledge amassed by our ancestors," which needs to be "guarded, replenished and polished," and about changes that "will come in the fullness of time." It would, of course, make the most sense to assume she meant a metaphorical trove of wizarding skills and knowledge, however wordplay is a funny thing. Could she have been talking literally about a treasure trove compiled by their ancestors? If you think about it, we have seen a treasure trove constructed by ancestors, right under the noses of the teachers. As we have been led to believe that Slytherin's Chamber continues to be a key site, and as there is quite likely *more than one* secret in the Chamber of Secrets (plural...hint, hint), Umbridge's wording is interesting.

Those changes "in the fullness of time" is also interesting wording. Although, it would never have seemed important enough, though, had it not been for an interview that Jo did with the BBC just before the release of Book 5 in June, 2003. The question was very leading, and the answer *very* cryptic...

> **Paxman:** "So, there will be some pairing up, will there, in this book?"
>
> **Jo:** *"Well, in the fullness of time."*

If you are thinking of something to do with *time*, you're thinking what we're thinking.

GRAN KNOWS

Neville states that it was his Gran's opinion that Voldemort would return, and she is now adamant that if Dumbledore is sure Voldemort has returned, he has assuredly returned, and she has cancelled her subscription to the "Daily Prophet." Not everyone thought that Lord Voldything would return, but those close to Dumbledore certainly thought so. Some of Voldemort's followers were sure of it too. Hearing it from Neville, it sounds as if his Gran is aligned with Dumbledore, but she may just be reacting to everyone else being clueless. She a pretty scary lady, and she is a pure-blood. Where has she been getting her information, and whose side is she on? Does her vulture image relate more to Isis, or to the Death Eaters? Vultures and Death Eaters have a lot in common, and she could just as easily be

sharpening her talons at this news. Which brings up the question...where does she now get her news?

IT'S ALL IN ITS HEAD

The Sorting Hat recounts how it was present at the breakup of the Hogwarts founders. If the Hat was there, does it have the ability to give a detailed account? Considering the "lecture" it gave this year, it seems to know a lot about what is going on in present-day Hogwarts. How much knowledge does the Hat have about what happened back then? One thousand years of information is a lot to put into a little hat. Think about it — that Hat has sorted every witch and wizard in the last millennium! We hope Dumbledore has already been briefed. ☺

POWER PLANT

This year's Gryffindor's password is Mimbulus Mimbletonia, and as they go to sleep, Neville's cactus-like plant is prominently basking in the moonlight. The WWP Sleuthoscope is transmitting an S.O.S. signal to us! Even the password is Mimbulus Mimbletonia? Either this is a big Rule #1, or it's a big "Mimblewimble." If you don't remember hearing that word, HP Sleuths need to unwind your 2nd year scroll to Chapter 4 {"The Keeper of the Keys"}. The image of the moonlit plant is very striking. Does it grow by moonlight rather than by sunlight? Why has Jo called our attention to the little tyke? Keep your radar tuned to that plant — it's got our attention.

———————————————— *Rowlinguistics* ————————————————

Two new students, **Abercrombie, Euan** and **Zeller, Rose** are called up to be sorted. Pluck your *Philological Stone* out of your pocket — you will need it for this one. The new students have rather fascinating names. "Euan" is a Celtic name that has roots in *Ewan*, and an alternate spelling of *Evan*. The name means *born of the yew tree*, which begs to tie him to Voldemort. The *Evan* form of the name does look awfully familiar. Is it the *yew* relationship we are supposed to be noticing in that name? It's possible Euan Abercrombie's last name is a reference to Sir James Abercrombie. He was a spectacularly unsuccessful British general, who was defeated at Fort Ticonderoga during the French and Indian War despite his much larger and better equipped forces. Based on either meaning, we probably don't want him on our side. {www.daire.org/names/main.html} The full name of the female student, Rose, would be "Rose Zeller," which, if you say it, you can hear that it would be pronounced a lot like *rosella*. The word means a type of *parakeet* (yes, sorta like a budgie). It also means a breed of *sheep* — which, as usual, makes us think of wooly socks.

The Kenmare **Kestrels** are Seamus's Quidditch team. Kestrels, which are a type of *falcon*, are very clever birds that live in either rural or urban areas, and frequently don't even make their own nests, recycling those of birds of similar size. {www.birdsofbritain.co.uk }

Chapter 12 Analysis

What Are the Mysteries in Chapter 12?

THIS IS CHAPTER 12

Instead of diminishing after the rise of Voldemort, the hints about 12 have intensified. Therefore, it may be that "time" is really the answer. On the other hand, Chapter 12s continue to contain hints that set off alarms about the whole septology. And as we already know...dreams and diaries are not to be taken lightly...

HERMIONE'S BRAIN

Ron is impressed that Hermione can quote from Dumbledore's speech months after having heard it. It takes not only a lot of concentration, but a big brain, to read through all the books that Hermione does and then remember it all. Even so, Hermione is beyond smart. There is something a bit special about her capabilities. Does she just have a photographic memory?

CONNIVING FOR SKIVING

Fred and George have invented "Nosebleed Nougats," which cause real nosebleeds, however, they haven't yet figured out how to stop people from "shrivelling up" and bleeding to death. Eeek! Compared to Fred and George's usual pranks, that doesn't sound very innocent or safe — even if they do have an antidote. How does one go about inventing something that makes people keep bleeding? What ingredients would they use and what do they test it on? You may recall that there was a certain transaction they made with Dung for Venomous Tentacula seeds. The seeds were described as "shrivelled" — wonder if that was a hint?

We are still having noses shoved in our face. There are more nose hints in Book 5 than there were in Book 4 — which keeps us wondering about someone in disguise like Moody was. Tonks is already suspicious, and there are many people (and creatures) whose noses are... er...unique. It's not an easy puzzle.

TT

Cho Chang is wearing a Tutshill Tornadoes Quidditch team badge. Wasn't that the team the *Quibbler* accused of playing dirty? The accusations seemed absurd, but were they any more absurd than what has been printed or said about Harry in the (cough, cough) respectable *Daily Prophet* newspaper? Thinking more about that Stonehenge-like double-T — the Tutshill Tornadoes sounds a bit like Silbury Hill, Dragon Hill, or other ancient monuments. Hmmm... a little help from the *Philological Stone* and you get Tut's hill. Based on all the references to Egypt, there might have been an intentional link to King Tut when they named their team.

CLEANING UP

Harry tries to mix a Draught of Peace in Potions Class, but goes straight for the powdered moonstone, forgetting the hellebore, and Snape whisks it away with the spell "Evanesco!". That may be another reason "Evans" is so prominent in Book 5. Previously, we had seen things banished and vanishing (Snape cleans up messes all the time), but we have never before heard the spell being cast. Now we have seen both Bill and Snape use it.

Hellebore is a nasty poisonous plant — especially Black Hellebore. Does that mean Harry forgot to notice some poison again? This is not a good sign.

DREAMS OF DIVINATION

For Divination homework, the class has to keep a "dream diary" — Neville describes a dream he had in which a pair of scissors is wearing his gran's hat. Is Professor Trelawney doing it again? Are the silly things she does obscuring potential clues? Her "predictions" somehow seem to have a basis of truth in the same way that the *Quibbler* might — it just gets all twisted around.

We haven't dreamt up any explanations yet for Neville's dreams. Some of our ideas are along the lines of trying to figure out if the word scissors is a pun, and if replaced with the word "shears" or "cutters," if that would help, but so far, the Freudian explanation fits best.

What can we learn from a dream diary? You would have to be sleeping through Book 5 if you aren't starting to notice that Harry's dreams are significant. But beyond that — why a dream *diary*? What other diaries do we know? We know the Riddle diary was bad news, and Harry's dreams are quite nightmarish, so dreams in Book 5 may not be a good thing. You might want to get an extra piece of parchment and keep some notes too.

Just the word "diary" makes us think of the Chamber of Secrets, and it also makes us think of calendars. All the references to 12 and the calendar could be tied to the stars, the Chamber, or even time. Lots of possibilities...lots to ponder.

RON'S FUNNY FACES

Ron tries to remember his dream about Quidditch as he is "screwing up his face." This is the same description that is given when Tonks screws up her face to change her appearance. Ron's appearance hasn't changed, but it is probably meant to be Rule #1. So, why are we supposed to think about Tonks and morphing? Is there someone we should be noticing?

THE LONG AND SHORT OF IT

Umbridge is described as having "stubby" fingers and an "unusually short" wand. We hypothesized a potential correlation between long fingers and magical power. Some of the most powerful people and creatures in the septology (goblins, house-elves, Dumbledore, Voldemort) have extraordinarily long fingers. Maybe it's a coincidence. Then again, just to be sure, maybe you should check the fingers before you agree to a duel. Now, if the toad lady has abnormally short fingers, would this work in reverse? Does it mean she would be one of the least powerful? We thought we should point this out.

Name Dropping

Harry insists to Umbridge that Voldemort has returned, but while she doesn't even "flinch," the rest of the class is shocked. This is very odd behavior. We understand that Her Toadiness is a hardened, mean person, but even some of the bravest (think McGonagall) are unnerved at the mention of Voldemort's name. Why would she have no problem with hearing it? Is it because she doesn't have a mark? Is it because she does? Or is there some specific relationship that causes her to be at ease with it? What do HP Sleuths think?

Hogwarts' Pet Peeves

Peeves is as irritating this year as ever — teasing "Potty" Harry in baby talk about all the nasty rumors that the Daily Prophet *has been spreading.* The HP Hintoscope is babbling in toilet talk... But we must not have enough information to understand yet. The tiniest mentions can explode into the largest clues, so we have to pay very close attention. Who do we know that hangs around toilets? We know of at least one — but are there others? CONSTANT VIGILANCE!

Have HP Sleuths ever questioned why Peeves is so well-informed? Peeves usually doesn't engage in chatty or lengthy conversations, and doesn't seem to care about anything (or anyone) that can't be thrown, broken, drenched, or chased. Even Filch doesn't want anything to do with him. So where and how does Peeves keep up with all the gossip? It may also be a clue to Peeves, himself (snigger).

McGonagall's Advice

Professor McGonagall asks Harry if he had listened to Umbridge's speech, and when he answers 'Yeah," paraphrasing correctly, she compliments him for having listened to Hermione. She what? Why would she even think Hermione — let alone assume that? How would she have known? Does Professor McGonagall have special mind-reading skills, or did Hermione discuss it with her for some reason?

Rowlinguistics

* **Inigo Imago** — we already discussed the potential etymology for Inigo (Iñigo Loyola, founder of the Jesuits), but for this version, you would need your *Philological Stone*. Try it like this: *In I go...I may go.* Sounds like a door opening, doesn't it?

* **Imago** is a real word — it means an insect that's undergone a metamorphosis to become mature. Harry and everything around him seem to be changing

Curiosities

* "Moonstone" is supposed to be great for helping enhance emotional control, and we're seeing Harry is definitely in need of that — but let's also not forget Wilkie Collins' novel, *The Moonstone*, which TS Eliot hailed as "the first and greatest of English detective novels." It involves all kinds of skullduggery — and a really big important gemstone. Jo also refers to it as "a cracking read" in her interview with Lindsey Fraser at the Edinburgh Book Festival. {www.mugglenet.com/jkrebf.shtml} {www.holisticshop.co.uk}

* "Tutshill" may sound familiar to fans who know Jo's biography, as her family made their final move to Tutshill, outside Chepstow in Wales when she was nine-years-old. Jo doesn't mention her feelings for Tutshill, but she didn't much care for her new school at all. Curiously, she did note the inkwells set into the desktops. Running bits in her bio? Is that the seed for her idea about the Riddle diary?

Chapter 13 Analysis

(Detention with Delores)

What Are the Mysteries in Chapter 13?

This is Chapter 13

Welcome to *Whodunit 13*. As HP Sleuths know, there are clues hiding wherever there is a superstitious number. Jo, therefore, could not resist the temptation to have the culprit and his fiendish plot make a *cameo appearance* within Chapter 13. This is a trend that, so far, has held true through Book 4. The following are the key story-line events that take place in this chapter — we leave it up to HP sleuths to decipher whodunit. A warning this time — Jo may or may not have given us the answer at the end of Book 5. Sleuth at your own risk....

Watch Your Words

Hermione gives the Mimbulus mimbletonia password as Harry, Ron, and Hermione enter the common room, where the rain is pounding on the windows, trying to figure out why Harry is getting so many scar pains. This is surely going to give us as big a headache as Harry — having to put up with all the pounding, scar pains, and head references. Based on juxtaposition, it would seem that the "two" clues do have something to do with heads or headaches. The double-M'd Mimbulus mimbletonia is making itself noticeable, and we will see more instances where Harry feels like his head is splitting in two.

Moonstone Mystery

Harry keeps mentioning his potions homework about moonstones. What *do* we know about moonstones and their use in Potions? If HP Sleuths have been doing your Potions homework, you may recall that the Draught of Peace that Harry messed up has powdered moonstone as one of its ingredients. In that class, Snape instructed the class to go lightly with the ingredients, or it could cause very heavy or "irreversible" sleep (we are thinking "Romeo and Juliet" or "Sleeping Beauty" — but without the kiss). Why did Jo make sure we learned that, and why did she make sure she mentioned Wilkie Collin's *The Moonstone* in her interview? She spent a lot of time talking about it — was it just a good book, or was she trying to drop us a hint?

Rubbish Collection

When Hermione observes Fred and George testing their products on other students, she calls their concoctions "rubbish," Fred responds simply, with "Rubbish"; and only a bit later, Ron discovers that Hermione is hiding hats she ahs knitted for the house elves under "rubbish." There's a lot of rubbish being tossed around in Book 5. When we first heard about Moody, he was getting into trouble for bewitching rubbish bins. There is also a teacher who *is* a Binns. We have seen belching wastebaskets and Harry searching bins for newspapers. There's all sorts of garbage like that in Book 5, and our best guess so far is either another Moody/imposter hint, or something about Binns or his class.

THAT SINKING FEELING

Ron is described as "sinking" into his chair. Sliding and sinking are very slippery running bits. One connection may be the opening to the Chamber of Secrets (think sinks). This would also relate to all the pipe and water references that we keep seeing in Book 5. Maybe it's just a tease Jo did to give us a hint when Book 5 first came out about the title to Book 6. Since *Harry Potter and the Half-Blood Prince* used to be the title for Book 2, she may have been nudging us to figure it out early. Then again, you may want to grab some waterproof parchment if you are going to be tracking all the sinks, toilets, pipes, and water references in Book 5.

LOSING HER HEAD

Hermione is so worked up over the plight of the house-elves that she is knitting little woolen "hats" and leaving them around the common room so the elves can be freed if they unexpectedly pick one up. Besides being a bit unclear as to whether this technique would work, we can see that this is one of those corollaries to Rule #4. Hermione has become very emotional over her cause, and is not being her usual rational self. While it is noble to want the best for the house-elves, she can't force a whole new lifestyle on them overnight. They have no government, and no jobs, skills, or social structure except as slaves and service-workers. She needs to find a better way to help them or they may resent her and that could cause friction (they may leave her a little present).

Hermione isn't the only one who seems to have a hat fixation. All hats, including Hermione's knitted blobs, are a bit wooly (aka suspect). Hats have been important throughout the septology, and sometimes even integral to the plot. Quirrell had his turban, Peeves has his jester-like hat with bells, Dumbledore often wears silly hats, Dobby has his tea cozy, Snape will never live down one particular vulture hat, and then there is a Sorting Hat who wears himself. However, in Book 5, they are not just adornment or a mystery, but have powers and specific functionality. Some may even be pointing at clues, so HP Sleuths should keep the subject top of mind.

LOOKING FORWARD TO DIVINATION

During Divination, Ron sardonically remarks that his dream was about buying some new shoes, and later when Hermione asks what he had been doing, he just says he "fancied a walk," but in reality he was practicing Quidditch. Does satire or wry cynicism count as a joke? Does this count as another "joke" that came true? Professor Trelawney would probably interpret Ron's new shoes as meaning he will be going to Harry's funeral. ☺ But if you take it on face value, you could say that he got new shoes because he wanted do some walking, and then lo and behold...he ends up telling Hermione that he "fancied a walk."

SUBSTITUTES

Hagrid is not back yet from his summer mission, so his Care of Magical Creatures class is being taught by Professor Grubbly-Plank. If that name sounds familiar to you, it is because not only have we seen her before, but if you try her name on the *Philological Stone*, there is a resemblance (not perfect) to "Stubby Boardman." We first met Professor Grubbly-Plank when she substituted for Hagrid in Chapter 24 {"Rita Skeeter's Scoop"} of Book 4. She is appar-

78

ently highly loyal to Dumbledore and is somehow available whenever needed. Is the Quibbler mistaken-identity article intended to imply that Grubbly-Plank is suffering from a case of mistaken identity, or could someone we know be taking her place in order to watch over Harry better? Speaking of which...we haven't seen Tonks yet, and we are still waiting to run into her.

SPOTTING NOSES

Luna emerges from the greenhouse with a "smudge of earth" on her nose, and wearing orange radish earrings. Is Jo implying that the moon (think Luna) ran into the earth? (smirk) In our *New Clues* Guide, we had this as just a "Hint" because we were not sure how Luna's spot may fit in with all the others. Maybe it's just a joke — but normally, Jo's spots are deadly.

In classical literature, there have been some famous spots, such as the death spot in *Treasure Island* and *Lady Macbeth's* phantom spot. Generally, it's a good idea to beware of spots and marks, as they tend to be linked to death or evil — and that is mostly what we have seen in the Harry Potter novels. In interviews, Jo keeps talking about *I Capture the Castle,* by Dodie Smith. In it, Cassandra's author father has a philosophy of creation that says: ". . . everything is already there to be found. . . the sum-total of all the sections of his book . . .will add up to his philosophy of search-creation." By the way — Dodie is best known for a book with tons of spots: *The Hundred and One Dalmations.*

Spots are running bits, and we have seen a lot of people with some kind of spot or mark on them. In Chapter 6 {"Journey from Platform Nine and Three-quarters"} of Book 1, Ron also had a spot on his nose, which refused to come off, and in Chapter 7 {"The Sorting Hat"}, we meet the Bloody Baron, whose bloody spots are probably with him for eternity. In Book 2, there is a "spot" reference almost every time we encounter Myrtle. In Book 4, we learn that the Death Eaters are marked with a spot, the Dark Mark, that forever links them to Voldemort. Now in Book 5, there are spots and marks *everywhere*, and HP Sleuths should be watching for spots on everything — not just the body. CONSTANT VIGILANCE!

HUNTING SNORKACKS

Luna is absolutely sure that Crumple-Horned Snorkacks are real. Is Luna for real? Maybe. Lewis Carroll wrote a famous poem about the "Hunting of the Snark." In that story, no one had seen a Snark, and not everyone was sure the Snark was real, but in the end, *something* went "boo!" — but then vanished. We keep seeing vanishing spells, but we don't even understand how those work. Is Jo just leading us through Wonderland, or does Luna really know things? According to Newt Scamander, it is possible.

There are other crumple-horned creatures. Once again we go back to our nursery rhymes, where we can find a cow with a crumpled horn in "The House that Jack Built" (see Rowlinguistics). Nursery rhymes are very useful if there are little babies anywhere. We still can't help but question that if there are Crumple-Horned thingies, that it may be useful to know how those horns got crumpled.

KNOCK ON WOOD

Harry makes a joke about Oliver Wood (who is now playing for Puddlemere United) dying while

in training. Hmmm... Harry is joking. We know what happens when Ron jokes (great marks in Divination). However, we have also noticed a high hit rate with Harry too. We were previously concerned about Puddlemere United when we found out that Celestine Warbeck is associated with both them and St Mungo's. Should we be worried about Oliver, or should we be worried that Jo is messing with us?

QUEEN TUT

When Umbridge takes Harry's arm, he is repulsed by her, while noticing that she is wearing "a number of ugly old rings" — "Tut, tut," is her immediate reaction to the slicing she has done on Harry's arm. The WWP Sleuthoscope is squirming a lot. Here is a blatant example of juxtaposition. There are some rings that did not need to be mentioned in this scene, but were somehow important enough that Jo felt we needed to know about them — followed immediately by the words "Tut, tut." Not just one — but *two* tuts. *Double* T. HP Sleuths, who have been taking careful notes, can unroll your parchment slightly and contemplate how *you* feel this might relate to the Tutshill Tornadoes and other TTs that we described.

PERMANENT MARKING QUILLS

Umbridge makes Harry "write" his detention message with a special black quill, which cuts into his skin and simultaneously engraves the words onto his right hand as it draws his blood to write out the message. It is bad enough to be forced to use that evil quill on yourself over and over, but could someone use it on themselves on purpose? What if you wanted to permanently "tattoo" something into your skin forever? It would have to be something dreadfully important, and you might have to be a bit mad, but if you wanted to have it with you at all times, it could work well. Who do we know that has been described as "a bit mad" and has a useful scar? If you recall, in Chapter 1 of Book 1 {"The Boy Who Lived"}, Dumbledore talks about having a scar above his knee in the "perfect" shape of the London Underground, and then in Chapter 7 {"The Sorting Hat"} Percy was convinced that Dumbledore is quite mad. Was that a coincidence? (See Rule #3.)

During the 2004 Edinburgh Book Festival chat, Jo teased that we may find out more about the scar, saying she was "very fond" of it. Hmmm... is it the scar itself, or the circumstance surrounding how Dumbledore got it that she is insinuating? What is down there?

The idea of Dumbledore wandering the London Underground brings up images of an exquisite TV series from 1987 by the name of *Beauty and the Beast*. The hero of the story was a (errr...) lion-man who had some supernatural strengths, but was ostracized for being a freak by those he grew up with. He escaped ridicule by joining other outcasts who were living underground. The concept was that there was a whole underground society living right under our noses, around the sewers and subway systems of New York City. They used the pipes for Morse Code communication, and they moved in and out of the "real" world without being noticed, seemingly just street people. They came outside more by night, and tried to help those in need, while attempting to survive, themselves.

Maybe what is in Dumbledore's London Underground is just as complex, or maybe it's used for fighting Voldemort or is an anti-Voldemort headquarters. Maybe Dumbledore just uses it instead of Apparating to avoid having his magical activity picked up. There are so many possibilities, and HP Sleuths should have fun making up all your theories.

RON POWER!

Ron describes how he has been trying to cast a spell on the Quaffles so they would fly to him. In Book 1, Ron could hardly lift a feather with his wand, and now he's controlling Quaffles. He isn't very dedicated, but he does seem to be following in the tradition of powerful Weasley wizards. Based on what we see, it appears his new wand may be helping.

JUGGLING CLUES

While watching the twins juggle butterbeer bottles, Harry tells Hermione about the pain he felt when Umbridge touched him. The HP Hintoscope is fizzing loudly.... Why was Harry getting pains? Was Umbridge responsible? Hermione was doubtful (Rule #4, part a), and we don't believe it. We are convinced there is yet another explanation. Clever HP Sleuths might want to check for when key events happened and think of a timeline that would explain the scar pains. You probably have enough information at this point to solve the alternative explanation, but we won't be told about it until Chapter 14.

Fred and George's juggling continues the running bits. If you think about what bottles look like being juggled, they would appear to be like bicycle wheels —"spokes" turning. It does make our heads spin...

TEENAGERS

Harry is constantly angry in Book 5 and loses control, which is not normal for Harry. The HP Hintoscope is yelling a warning at us. Harry doesn't seem to "be himself." Some anger is understandable, but he lashes out at everyone — even when inappropriate. It could be just an angry teenager, it could be the headaches, or it could be there is something going on with Harry's mind.

Rowlinguistics

✳ We've already had plenty of water references, and now we have **Puddlemere** United—a *mere puddle*. This also brings to mind *Puddleby*, where Dr. Doolittle and a wide assortment of animal friends lived peaceably together.

✳ **Lachlan** means *from the lake* or *land of lochs*. Castle Lachlan is on Loch Fyne in Argyll, Scotland. The MacLachlans are supposedly descended from kings of Ireland before they immigrated to Scotland. Water...water...everywhere... {www.clanmaclachlanwesternusa.org}

Curiosities

✳ Umbridge is referred to as an "old hag" so many times, it must have a deeper meaning. Hag, like crone, is a term used to refer to the older of the 3 incarnations of the triple goddess. The Hag was also the goddess of death in pagan northern Europe, referred to as the "dark goddess." One incarnation of her included Cerridwen, equated with Hecate. This Celtic version is perhaps also related to the Hindu Kali goddess of death and destruction. Cerridwen had a cauldron of knowledge or life which she was brewing for her son until it was stolen by a boy she'd had stirring it for her. She gave chase, shape-shifting into various forms, to kill the boy. It should also be noted that the animal most associated with Hecate is the frog or toad. Hecate is believed to be taken from the even more ancient Egyptian mid-wife goddess and crone Hekek or Hequik, who was depicted with a frog/toad's head. {www.moonspeaker.ca} {www.themystica.com} {www.goddessmystic.com}

✳ "Fairy eggs," which bowtruckles eat if they can find them, are the name for a type of seed believed to float on the Gulf Stream from the West Indies to the Scottish Hebrides' shores. They were believed to have magical abilities and to protect the bearer from the "evil eye." They are also referred to as *sea-nuts*. (hehe)

Chapter 14 Analysis

—————— What Are the Mysteries in Chapter 14? ——————

HEAD BANGER

Nearly-Headless Nick warns Harry that Peeves is going to knock the bust of Paracelsus on some-one's head, so Harry turns left instead of right. The HP Hintoscope is whistling a warning. The running bits of bodiless and injured heads are everywhere, and this was a double-whammy. A "bust" is a statue of only the head part, and then it was going to be dropped on top of someone's head. Would you say that heads are big in Book 5? Hint — they may not be quite as big as you think.

Frequently, there are mentions of going one direction and then the other — enough to get your brain all twisted up. This juxtaposition to the two head references may help you with this story-line clue, or it may give you a splitting headache...

Paracelsus was considered very strange yet very brilliant. He was basically a modern medical researcher living during the Renaissance — which like many in the sciences at that time, made for some philosophical fireworks. The irony of this scene is the physician's bust being used to inflict injury.

CRISSCROSS

When Harry goes to the Owlery, he sees silver beams of sunlight that "crisscrossed the circular room," and as he walks across the straw, he "steps across...bones." The wheels in your brain should be starting to turn as you contemplate this running bit. It is not an overt mention, but this metaphor, which brings to mind a spinning bicycle wheel or flywheel, will run you over if you stand there looking at it long enough.

SCRATCHING FOR CLUES

Filch's eyes do a "raking" action on Harry, the Bowtruckles claw him in the last chapter, and Draco scratches at the back of Harry's neck in the Quidditch match. People and creatures in Book 5 have their talons out, don't they? We are thinking these metaphors are telling us to think comb-like teeth, or more creature weaponry.

WEIRD NEWS

There is a story in the Daily Prophet *about the bassist for the Weird Sisters getting married.* The Weird Sisters could easily be holding secrets. They are named after the three leg-endary seers (or Fates) that appear in mythology and literature (see Rowlinguistics). In Book 4, it looked as if it was just a clever throwaway name, but as always, in Jo's world, everything is suspect. Members of the group are named in *Quidditch Through the Ages* (on your HP Sleuth reading list), in Book 5, and even highlighted on Jo's site as a "Wizard of the Month," where we see that the newly-wed's name is Donaghan Tremlett. You may have seen that he appears on the Famous Witches and Wizards cards (if you collect those like Harry and Ron). He is Muggleborn and a fan of the Kenmare Kestrels. Note that you

don't have to be old or dead to be famous enough to get onto a FW&W card — so is Harry going to suddenly find himself on a card one day? Then he really will be "famous Harry Potter." (We want to see the look on Snape's face when that happens.)

BREAKING AND ENTERING

The Daily Prophet reports that Sturgis Podmore, who lives on Laburnum Gardens, Clapham, was arrested for attempting to break into a top security door on August 31, at 1:00 am, and was sentenced to six months in Azkaban. The WWP Sleuthoscope is splashing around. Hmmm...so *that's* what happened to Moody's Cloak. Is Sturgis really a thief? What was going on back on that date? It would have been the last day before school, and there was a celebration dinner for them back at Grimmauld Place. That was when Moody complained about his cloak...and when Harry complained about his scar pain. Could this have been related?

Classic horror story fans might recognize the name of the street where Podmore lives. Besides being (yet another) deadly poisonous shrub, *Laburnam Villa* was the place where W. W. Jacobs' story, *The Monkey's Paw,* takes place. More monkey mentions (marvey).

HP Fans who know about Clapham are aware that is a very interesting place. Clapham, in the Yorkshire Dales of England, has an extensive series of underground caves and tunnels that run for miles beneath the town. The Gaping Gill there has a waterfall (yup, water) that flows down to a vast cave and connects with other underground landmarks in the area. In the Harry Potter series, we have seen quite a bit of underground caverns and water — both under London and under Hogwarts — and that is just too much temptation. What kind of fantasy readers would we be if we didn't contemplate that they could all connect somehow? ☺

Errrr....One last comment: What's going to happen when Sturgis gets out in 6 months?

WRIGGLING CLUES

The Slytherins try to intimidate the Gryffindor Quidditch team by throwing insults at Angelina Johnson — saying her hair looks like "worms" growing out of her head. The imagery of worms growing out of the head is a direct reflection of the Gorgon called Medusa. We can't seem to get snakes out of our brain.

BLOODY WRONG

During Quidditch practice, Katie Bell gets a bloody nose from a Quaffle, so Fred gives her something to stop the bleeding, but mistakenly hands her a Blood Blisterpod (or something else they are experimenting with), and she almost bleeds to death. You know, that seems really dangerous. Fred and George's practical jokes are usually harmless and funny, and yet, they doing fairly advanced magic. In our original Guide, we had speculated about a scenario where a bad guy could be thwarted with their amazing fake wands. That would not be as funny as it would be effective. In *The Plot Thickens* fanbook, Maria Rico discussed this very subject in her article, "Fred and George: The Order's Secret Weapon?" However, something like this experimental nosebleed nougat, where someone could bleed to death would actually be a deadly weapon.

There are really ominous things going on in Book 5 with bleeding, venom, and danger-ous potions. It's not as if the magical world is all fairy-like and fun, but you can feel the world is getting darker. Do Fred and George have something to stop bleeding? That could be very useful for more than bloody noses.

POMPOUS PERCY

Percy writes a letter to Ron, which is arrogant and insulting, talking about the "Fred and George route," and containing statements like, "I feel bound...Dumbledore may not be in charge...much longer," "I count myself lucky to have escaped the stigma of association," talking about the "way the wind is blowing," being "Seriously... tarred...damaging to your future prospects" and equat-ing Order members to "petty criminals." In other words, this could just be a normal Percy let-ter. But is it? On the surface, his letter appears to be just rude, but for some reason, it also has wording that could be interpreted as predictions of future events. Harry has just shown us how he writes a letter to Sirius that embeds hidden meanings into it. It is based on using metonyms rather than code. Could Jo be giving us a hint with this letter? If you pull out your *Philological Stone,* and apply those same rules to Percy's letter, there are some very suspect references:

The "Fred and George route" could mean one of the hidden passageways from the Marauder's Map that Fred and George used so often that others were aware of it. We were told that Filch knows some of them too.

The information in "Dumbledore may not be in charge...much longer" seems to become more and more possible with each new Educational Decree. Since Percy seems to be tip-ping off Ron about Dumbledore, it led us to think that he may have been trying to help the Order. If that were true, the "I feel bound" almost sounded as if it meant he was being held or coerced somehow against his will. However, since we know from Jo that he is act-ing of his own free will, it is not likely that he would be bound in some way.

"The way the wind is blowing" — would that be from the North? It could be a hint to think Azkaban and/or Padfoot — which may be reinforced by the loose phrase "Seriously... tarred" (translation: Sirius Black).

Then there's the "petty criminals" — one of which could qualify as Peter, the Petti-crim-inal (where *is* that ratfink?). Could he be hanging around Azkaban lately?

"I count myself lucky to have escaped" directly follows a passage about Azkaban. It could be decoded word-for-word to get a message. If it was intended to be decoded, it could go like this:

I count (A total of) myself (1) lucky (7) to (2) have (equates) escaped..

That would then mean:

A total of 10 have escaped.

Could any prisoners have escaped from Azkaban? Will Dumbledore's post be chal-lenged? Are there issues with Sirius Black? Is this letter an attempt to send a secret code, is it more trickery by Jo, or is it just a letter from a stupid git?

UNSCRUPULOUS UMBRIDGE

Harry speculates as to whether Umbridge is a Death Eater, but Sirius is convinced she isn't, and explains to Harry that the whole world isn't divided into Death Eaters and non-Death Eaters. Sirius' advice is very astute, but then again... what is Sirius' track record for calling things? It seems pretty good, based on his comments about what was happening with the Ministry in Chapter 27 {"Padfoot Returns"} of Book 4. Umbridge is one of the most evil people we know, and even if she isn't a Death Eater, she still promotes Voldemort's cause.

Rowlinguistics

⁎ The **Weird Sisters** are an Anglo-Saxon depiction of the triple goddesses of destiny known to many cultures — the maiden, mother, and crone. They are also known as the fates, the Moirae in Greek, the Parcae of Roman, and the Norns in Nordic tradition. They represent past, present, and future, as well as the life cycle of humans. In Greek belief the Moirae were spinners, who spin, measure, and finally cut the thread of life for each person. A famous depiction of the Weird Sisters was created by Shakespeare in *Macbeth*, where, as witches, the three sisters foretell Macbeth's fate and set him on his course to fulfill his destiny.

⁎ **Paracelsus** is an extremely interesting person. He was kind of a maverick, advocating a whole different approach to medicine than his peers. He was also big on alchemy, and is often pictured carrying a sword called "Azoth" — he boasted that it contained the Elixir of Life. HP Sleuths will remember the Elixir of Life from Book 1— Nicholas Flamel, Paracelsus's fellow alchemist, made it from the Philosopher's Stone...well, at least in the book he did! If you do your Rowlinguistics research, you may conclude that he had the personality of a Slytherin. We've never encountered this strange guy before, have we? Don't go jumping to conclusions — think Book 1... think chocolate. {www.forteantimes.com}

⁎ **Io** was yet another favorite of Zeus's — he changed her into a white heifer to protect her from Hera, who figured out that something was going on anyway and delegated a Fury in the shape of a gadfly to torture Io. Io went all the way to Egypt trying to get away, and there turned back into her own shape and gave birth to Zeus's child Epaphus. The Egyptians worshipped her, and she's known there as Isis (according to the Greeks).

⁎ The moons of Jupiter aren't covered with mice — but they do have some fascinating stories attached to them. **Ganymede**, in Greek mythology, was a human prince who became cup-bearer for Zeus. Some versions of his story have his father being given the finest of all horses to pay for him. He is also said to have become the constellation Aquarius, the water-bearer.

Chapter 15 Analysis

———— What Are the Mysteries in Chapter 15? ————

BEHOLD! THE HIGH INQUISITOR

The Daily Prophet *has a headline announcing that Professor Umbridge is appointed to the position of Hogwarts High Inquisitor, which inspects teachers and reports back to the Ministry — followed by a smaller article tying Madam Marchbanks to "subversive goblins."* The High Inquisitor title would probably strike a chord with classical music enthusiasts. *The Mikado,* a light opera by Gilbert and Sullivan, has a character called the "Lord High Executioner." It is a satire about overzealous laws, beheadings, and disguises. It satirizes most political corruption, but there is one in particular that is probably the most appropriate. The name "High Inquisitor" is most likely a parallel to the "Grand Inquisitors" of the Holy Inquisition of Spain. The Spanish Inquisition had at the heart of it a theme of "limpieza de sangre" or *cleanliness of blood*, and the Grand Inquisitors were ruthless in their mission. We can see where Toadface got her inspiration.

We do keep seeing those goblin references. If there is anyone who thinks the goblins aren't going to be important, then we had better send you to remedial History of Magic lessons!

CLUES SET IN STONE

When Lucius Malfoy is quoted in the Daily Prophet, *his residence is given as a Wiltshire Mansion.* Mansions tend to be owned by long-standing families who have amassed a lot of wealth. We were told by the twins in Chapter 3{"The Burrow "} of Book 2, that house-elves, large mansions, and old money go together, and it was later verified that Dobby was the Malfoys' house-elf.

There is separate evidence of the Malfoys' inheritance. Lucius seems to be in an exclusive neighborhood, as it is a place of revered ancient magic. The Malfoy mansion is in an area famous for what many feel are the work of the Druids. Druids are steeped in mysticism, and by this we can infer may be part of Jo's magical world.

COMBING FOR CLUES

Harry, Ron, and Hermione are combing through the Daily Prophet *for information.* The HP Hintoscope is playing a tune on its comb. When there are hints concerning sharp little teeth, poultry, and other combs hanging around, a metaphor such as this one draws attention. We should probably be watching out for anything comb-like — and that would include people whose names make us think of combs.

DRINK AND DRUNK

Griselda Marchbanks and Tiberius Ogden resigned from the Wizengamot to protest the appointment of an Inquisitor. Talk about loyalty to Dumbledore...that's amazing. Let's see what else we can determine about those two members. Griselda Marchbanks' last name is made up of two running bits, "March" and "banks" (there's that water again).

Tiberius has a water tie as well, since his name means "of the Tiber" — a river (see Rowlinguistics), and was also the name of the second Roman Emperor, who had some problems with being influenced by people he shouldn't have trusted (uh-oh). Tiberius' last name should sound familiar. We are wondering if there is a family link to Gilderoy's favorite beverage (Ogden's Old Firewhiskey).

WE DON'T MISS IT BUT...

Professor Binns seems to have moved off of goblin wars and is now concentrating on giant wars. More wars...just change the names of the people involved. (sigh) We wonder what happened in any of these wars. The goblins obviously are able to interact with humans and conduct business — although as reinforced by Bill, human-goblin relations are still strained. (After a look at that fountain in the Ministry, it's not surprising.) However, the giants have totally secluded themselves in the mountains and apparently do not have open communication with humans. It would really help if we too could peek at Hermione's class notes.

HP Sleuths who have been scavenging all those trash references can just toss Binns in with them.

SNAPE'S SPIKY SCRAWL

Snape had written a "spiky D" grade on Harry's moonstone homework. We are betting that "spiky" letter was intended to tease us with more vampish imagery. Whether it was intended or not...it did. 😊 That is because vampire legends usually agree that the only way to kill a vampire is by a spike/stake through the heart. There is other vampire-like symbolism in that "spikyD." *Buffy the Vampire Slayer* fans may associate the name with the character, Spike. Anime fans might get an impression of *Vampire Hunter D*. It did prod us to consider that if Snape isn't a vampire, he could be a vampire *hunter*. What do HP Sleuths think?

TRELAWNEY'S ANCESTOR

Umbridge acknowledges that Sybill Trelawney's great-great-grandmother is a famous seer by the name of Cassandra. Well, that explains everything! According to legend, Cassandra was a prophetess who was given the gift of prophecy by Apollo, but because she spurned him, she was cursed to never be believed. The Cassandra of mythology made her predictions in very much the same way that Trelawney seems to have made hers — by going into a trance during which she was possessed by a being who then spoke through her. In the case of Cassandra, she was supposedly possessed by a god. Who or what is possessing Trelawney? Cassandra is known for predicting her own death — we are wondering if Trelawney may suffer the same fate.

GROOSUM

During Umbridge's inspection of her class, Professor Trelawney interprets "all" of Harry's dreams to be predicting "a gruesome and early death." The HP Hintoscope is chanting solemnly. Professor Trelawney is up to her tricks again — and it is difficult to believe her. She has "foretold a gruesome and early death," and we know that someone is expected to die in Book 5. Then again, she predicts death in every book — whether someone is to die or not. Should we be counting this as a real prediction?

If you test it with your *Philological Stone,* you will notice that "gruesome" is also *grew some.* Who or what might be growing some? Could it be another reference to Peter Pettigrew (small-grow), to a small person, or to experimental breeding? Has anyone checked Neville's plant lately — has it been growing at all? Do you trust that stinky shrub?

Up a Tree

In Care of Magical Creatures, Harry's class learns about Crups and Bowtruckles. We hope that HP Sleuths have been doing their required reading, because once again, clues are hiding in *Fantastic Beasts.* Crups are dog-like, and Bowtruckles look like (use your *Philological Stone*) "bark." Just like Book 3, we are being hounded by grim references. At least this time, we know why — since someone is destined to die. But it's a bit unnerving to keep seeing them as we trot through the pages...never knowing when it's going to happen or to whom.

Humpty Dumpty

Harry knocks over his essence of Murtlap, breaking the bowl, which Hermione repairs "as new" — but the Murtlap, itself, is not able to be returned to the container. Good information! We just learned a lesson about repairing things in the magical world. We have seen magic fix almost anything — so now we are informed of a limit to the "fixability" of objects. Whereas magic can repair the containers, the contents are lost for good. We are learning this lesson for a reason too. Is Jo planning on smashing something valuable? Is it only liquid (watery) contents that are lost? We are thinking that vapory stuff would also be lost too — that is... anything that would be absorbed or bonded to by another medium. So, the question then becomes... if there was something hard in the bowl, would that be fixable, and if the bowl is made of multiple substances, can all those substances be repaired?

Wafts and Drafts

Ron and Hermione talk Harry into tutoring them in Dark Arts defense lessons, which sort of shocks Harry into silence...as a breeze "rattles the windowpanes and the fire guttered." This is a very intense moment. Has Jo just turned on the special effects, or is there something stirring in there? In our first Guide, we were keeping an eye on those breezes because they seemed to pick up at key moments in Harry's life. This one is also happening at a critical time — as Harry is about to take on a very special responsibility.

Rowlinguistics

✳ The title of **High Inquisitor** is likely derived from a dark period in Spanish history. The Grand Inquisitors of Spain led the Inquisitions that came about from a religion-controlled government, in which the church was attempting to purge the country of non-Christians. It was a bloody crusade that was conducted by ruthless henchmen in the name of goodwill. Author Dostoevsky borrowed from it when he created his "Grand Inquisitor" who arrests Jesus.

✳ **Tiberius** literally means *of the Tiber* in Latin. In Greek mythology, Tiberinus, the son of Janus (the God with 2 faces) died while fighting on the banks of the river Albula, which was renamed the Tiber in his honor, and he became the god of the river. The river has another legend which gives it even more significance. As a punishment for infidelity, Romulus and Remus (as in Lupin), illegitimate twins of Rhea Silvia, were ordered to be drowned by her husband, the king. But, instead of doing that, his servants placed them in a cradle on a raft, and set them adrift on the Tiber river. The river god saved them, and they lived to found the city of Rome on the banks of the Tiber.

Curiosities

✳ Wiltshire is the area where the large stone circles of Avebury are located. The Druids were thought to be the architects of the Stonehenge and Avebury monuments, which were actually constructed much earlier than the Druidic time-period, with Avebury being the oldest, constructed around 5000 BC. Construction of Stonehenge occurred in three phases from 3100 – 2000 BC. Though there are many mysteries surrounding Stonehenge, including methods of construction and purpose, one of the popular current theories is that it was built for astronomical observations. The monument seems to have been deliberately aligned with solstice and equinox points, so that the summer solstice sun rose in alignment with the famous Heel stone. Thus the monument could have acted as a type of ancient observatory—an important achievement for Neolithic people who relied heavily on the Sun for crop fertility.

Oddities

✳ For some reason, the U.S. version has been spelling "Sybill's" name "Sibyll." It is presumed that the derivation of the name is from the mythological sibyls, who were prophetesses, so it would make sense to see it spelled that way. However, Jo typically inverts letters or alters the name slightly anyway, so why was this one in particular changed for the U.S.?

Chapter 16 Analysis

(In the Hog's Head)

What Are the Mysteries in Chapter 16?

LOVE AND WAR

It comes out that Hermione had been writing to Viktor Krum (to Ron's dismay). Hermione is writing to Krum, Ron is writing them off, but Jo isn't writing much about it. We'll just write Rule #2. While shippers are hoping for love letters, we are wondering if Krum and Hermione may be making big plans about the upcoming war.

THE HEAD HOG

The students are so upset about not learning any Dark Arts defense skills that they take matters into their own hands by meeting at the Hog's Head pub to discuss Harry's Dark Arts defense lessons. We know Harry isn't leading them to slaughter, but that piggy name brings to mind another revolution that also rebelled against the establishment. Just like Harry's army that is fighting unfair treatment, the animals in George Orwell's *Animal Farm* usurped ownership from the humans, and took over the farm. However, as Jo has shown in her own magical world, no matter what special powers people may have, or even if they are non-humans, they still end up with the same problems and class systems. As the war evolves, it will be imperative to monitor so that those who are fighting evil do not overreact and become like Crouch Sr — as ruthless as those he is fighting.

HEADS DOWN!

The students' defense club meeting takes place in the "Hog's Head" bar, which Professor Flitwick assures Hermione is not off-limits to students, but warns her not to use the glasses there, to have the students bring their own. Strange warning...sounds like a rough place. If you're as paranoid as Mad-Eye, you are probably thinking of poisons or other dangers (would dirt qualify?).

What was most intriguing about this information was that Hermione trusted Flitwick enough to divulge that they were going there. Just as intriguing is that Flitwick knew enough about the place to be able to advise her. ☺ Did he keep the information to himself? (Hint — probably not.)

Also, wasn't that the place where Hagrid won Norbert's dragon egg from a hooded stranger? We realize Hagrid had said in Chapter 16 {"Through the Trap Door"} of Book 1, that "it's not that unusual" for people to have their face covered at the Hog's Head. However, look what happened when Hagrid drank with one. Make sure your magical eye is working when you're in there (but don't use their glasses to dunk it).

HEADS UP!

Above the entrance to the Hog's Head is a sign with a macabre picture of a severed boar's head on it, and as they enter there is someone with a bandaged head, some hooded figures, and a witch shrouded in a veil. The HP Hintoscope is squealing loudly! As of this chapter, we are up to

our necks in head-related clues. There have been heads on plaques, hats, and in fireplaces, as well as severed, bludgeoned, and scarred heads. Now we have signs with heads, veiled heads, and bandaged heads. Where is this all heading? Well...this is what gives HP Sleuths headaches — especially since the clues seem to split between multiple solutions. They all have to do with injuries or things hidden inside. So, our advice is to start probing into them — there are many clues to extract.

GOATEE

Once inside the Hog's Head, Harry notices that it smells like a goat, and he thinks the tall, old bartender, with long hair and a beard looks familiar. The WWP Sleuthoscope is making inappropriate motions to get our attention. You were probably tipped off by the long hair and beard to think "Dumbledore," but this wasn't Dumbledore was it? Harry didn't think so, but if we run a little DNA test, we would probably find a family resemblance. You may remember Harry had seen Dumbledore's older brother, Aberforth, in the picture Moody showed him of the original members of the Order. HP Super Sleuths may even recall back in Chapter 24 {"Rita Skeeter's Scoop"} of Book 4, that Albus said his brother was "prosecuted for practicing inappropriate charms on a goat." During the 2004 Edinburgh Book Festival chat, Jo was asked about that clue, and replied that she was "proud" of it and even "sniggered" to herself when she wrote it. Did Flitwick know about Aberforth when he warned Hermione about the glasses? (Note — as of this time, we don't know if Harry knows about Aberforth.)

We don't want to (cough) boar you with the details... but while the entrance to Aberforth's pub displays the severed head of a boar, the entrance to Dumbledore's school has winged boars on top of stone pillars. We'd say we have Rule #3.

RAGGED

The barman is "cleaning" the glasses with a scuzzy rag. The HP Hintoscope is gagging in the corner. Putrid rags seem to be a little too common in Book 5. You can assume they are a story-line clue.

ROLL CALL

The Gryffindors are joined by Zacharias Smith of Hufflepuff, along with Michael Corner, Anthony Goldstein, and Marietta Edgecombe of Ravenclaw, for the DA meeting. Hmmm. Another corner. Would he be hanging out in the corner with anyone we know? Could there be any secrets in this corner? Right now, it seems to be just empty — which Ginny should discover.

HP Sleuths combing for clues may have noticed that there are a few teeth in Marietta's last name. We are always wary of things with teeth, although she does come highly-recommended by Cho.

LIL' SIS

Hermione informs Harry that Cho "couldn't keep her eyes off you," and tells a dejected Ron that Ginny and Michael Corner are going out since Ginny gave up on Harry. Jo has said that *she* feels

she has given us enough hints that we should know what's happening by now with the Harry-Ron-Hermione shipping debate. Not. (The shipping wars continue.) We know that Ginny likes Harry, that Ron wants Harry to be with her. Hermione has shown affection on various levels for Harry, Ron, and Krum, but her spats with Ron aren't always interpreted by fans to be spouse-like. Now Luna has shown interest in both Ron and Harry. While romantic relationships aren't usually a huge mystery, this "love poly-tetrahedron" (look it up — it's a joke) continues to baffle even the most avid fans. We haven't changed our opinion, we still think it's Ron and Hermione — but like everything else we say, it's supposed to be a starting point for discussion — not the actual answer. So have at it!

Rowlinguistics

+ **Hannah** comes from a Hebrew word that means *grace*—but it's also a palindrome, a word spelled the same way backward as forward. The Latin version, Anna, is also a palindrome.

+ In the Bible, **Michael** is the name of one of the seven archangels, the leader of Heaven's armies. Sounds like Michael might be a good guy to have in your Corner...

+ **Zacharias** is a form of the name Zachariah, a prophet who wrote the Book of Zachariah in the Bible. John the Baptist's father, Zachariah, lost his ability to speak due to a lack of belief. Based on how Zacharias is hassling Harry, this could be Jo's source.

Oddities

+ Hermione is studying the art of "Vanishing kittens." It is difficult to think of a disappearing cat without thinking of the Cheshire Cat from *Alice in Wonderland*. That cat had a special style of vanishing — in which it disappeared slowly from tail to front — eventually leaving only a smiling mouth (yes, we know cats can't smile). We wouldn't put it past Jo to be playing with that image. (We will know for sure if we happen to see her grin appear somewhere. ☺)

Chapter 17 Analysis

(EDUCATIONAL DECREE NUMBER TWENTY-FOUR)

What Are the Mysteries in Chapter 17?

INSPECTING BINNS

Professor Umbridge "inspects" all the teachers, but while both Hermione and Ron anticipate that she will show up in Binns' class too, for some reason, each time it does not happen. We can think of various explanations for her absence. First, we assume Queen Toad would be prejudiced against a ghost in the first place. Another issue might be that, as a ghost, Binns has nothing of value to her, and his classes and political stance are not a threat to the Ministry's propaganda plans. Conversely, she might be worried that Binns has a whole army of other "kindred spirits" who could make her life miserable if she meddled with him. Of course, there could also be something that he would know, which she does not want discovered. One clear reason, is that if she were taught by Binns (like everyone else in the last century), she most likely knows that even a Ministry Decree would probably not be able to cause him to deviate from his "curriculum."

SLIP OF THE TONGUE

Hedwig appears at the window during History of Magic with an injured wing, and when Harry asks to go to the hospital, Binns mistakenly addresses Harry as "Perkins." Ahem...more Perkins? More Rule #1. But why are we being reminded of him? Does Binns associate hospitals with Perkins? Why would Perkins' name (we can probably assume Binns taught him) stick in Binns' memory?

GABBY GARGOYLES AND GRUBBLY-PLANK

Harry brings the injured Hedwig to the staff room, where one of the gargoyles by the door makes wisecracks and the other calls him "Sonny-Jim" — as he waits for Professor Grubbly-Plank, who comes to the door smoking a pipe. Whoa...Did you happen to see those gargoyles interacting with Harry? Just what we need — a gargoyle with an attitude. We have seen a few gargoyles in the septology, yet only the one outside Dumbledore's office was lively enough to even move aside. This is the first time any of them have actually conversed with a human — and it appears that they at least keep track of who's who. If you tap your *Philological Stone* lightly, you might notice that "Sonny-Jim" could be interpreted as *Son-of-Jim*. We now know that they are capable of human speech, they are intelligent enough to throw insults, and they were awake and around during daylight hours. Where else have we seen a gargoyle? There was one in Chapter 7 {"The Boggart in the Wardrobe"} of Book 3, in Snape's dungeon, with water coming out of its mouth into a basin.

In the magical world, where men wear green bowlers and purple capes, why not a female smoking a pipe? Back in Chapter 5 {"Diagon Alley"} of Book 1, when Harry enters the Leaky Cauldron, he had seen an old witch smoking a pipe. We don't know how old Grubbly-Plank is, but since pipe-smoking doesn't seem all that popular among females, is it possible that it was Grubbly-Plank who he saw that day?

GRIMM NAME

Professor Wilhelmina Grubbly-Plank sticks her pipe in her teeth, takes Hedwig, and having "screwed" a monocle into her eye, inspects Hedwig through it. This is a strange lady. Not to mention...there are several suspicious things about her.

Her first name, Wilhelmina is a feminine version of the German name, "Wilhelm." With all the grim clues haunting us in Book 5, we couldn't help but notice a link — one of the Brothers Grimm (of fairy tale fame) is Wilhelm.

But wait...there's more.... There are a number of running bits all within this short description of Grubbly-Plank. Did you notice those teeth? And (of course) the pipe? There is yet another monocle and it is "screwed" into her eye — yet another running bit. Monocles make one eye look larger than the other, which ties in with the Mad-Eye/lopsided eye running bits.

But wait...there's even more.... Wilhelm Grimm was a linguist, and is responsible for "Grimm's Law," a philological (sound familiar?) technique that looks at the evolution of Proto-Indo-European (PIE) pronunciation. Did we say "PIE"? Yes, it could be a true coincidence, but we need to mention it or eat humble pie later.

So what is going on with Grubbly-Plank?

NECTAR OF THE UNDERWORLD

Snape enters the class with an "echoing bang" and starts the class on a Strengthening Solution, but Harry isn't paying attention, and almost adds pomegranate juice rather than salamander blood. Blood? That potion does sound a little "strong." Why was Harry subconsciously thinking pomegranate in the first place? It wasn't even one of the ingredients. HP Sleuths who are up on their mythology may be a little concerned about Harry's fate. Pomegranate figures very prominently in a famous Greek myth about the Underworld. Just how close is Harry going to get to the Underworld?

As we have already witnessed, Book 5 is a noisy book, and Snape's echoing bang, reminiscent of the "odd echoing bangs" during the riot at the World Cup, makes us even more worried about doors.

HARRY'S TAIL

According to Sirius, Harry was being tailed by the Order even when he visited Hogsmeade. The HP Hintoscope is playing some very somber notes. How did the Order know they were going to meet in Hogsmeade? Do they have a "spy" at Hogwarts? Could Flitwick have tipped them off when Hermione talked to him (is he even in the Order)? HP Sleuths should think about who (or how many?) did the surveillance and how.

SECRET PLACES

Sirius tries to help Harry pick a secret place to hold their defense practices, but Harry rejects the Shrieking Shack as impractical, and informs Sirius that the passageway on the fourth floor behind the "big mirror " is now "caved in." Why are we being reminded of the Shrieking Shack and the fourth-floor passageway? If it's caved in and not usable, why does everyone keep

bringing it up? We need to get a better look at that mirror too. There is something about mirrors that is drawing our attention.

Voldemort is hiding out somewhere, and where he is could make a difference. He could still be sitting at the Riddle house, but he may not want to be that obvious, so we do need to consider locations where he could be.

RING FINGERS

Umbridge's heavily-ringed hand suddenly appears in the fireplace reaching to nab Sirius in the act of visiting with Harry. Did you hear something? Was that another ring? It was certainly Rule #1.

BANNED FROM THE HOG'S HEAD

Sirius informs Harry that 20 years ago, the bartender banned Dung from the Hog's Head. Gee, are we surprised? Dung seems to have a track record of dumping on people. Albus Dumbledore feels that Dung helps him stay in touch with the street scene, but it clearly comes at a cost. As a petty criminal, Dung isn't very good with concepts like "responsibility," or "compassion." Nonetheless, he has a fierce dedication to Albus in particular. Wonder what Albus did to earn that kind of respect from Dung? Obviously, Aberforth doesn't share the same feelings. Why was Dung banned? (Must take a lot of talent to get banned from that rough place!) Do we know of anything that happened about 20 years ago that may relate? It was shortly before Harry was born — that's about all we know at this point.

Curiosities

✦ Considering how grim Book 5 is, we are not surprised to see "Pomegranate juice," which is associated with the "Underworld." In a famous Greek legend, Persephone, daughter of the earth, is abducted by the god of the Underworld (Hades) to be his bride down there. While hostage, she refuses food, but eventually nibbles on some pomegranate seeds. Her earth mother convinces Hermes to go get her, but discovers that she has taken food while in the Underworld. Once having eaten there, Persephone would be forbidden to return to the surface of the earth, but because it was only a few seeds, Zeus makes a deal with Hades that she can return, but only for six months of each year, spending the other six months below. The earth becomes barren as she mourns Persephone's absence, and then flourishes each year on her return — the mythological explanation for the changing seasons, and another calendar reference, of course.

✦ Salamanders and "salamander blood" may have a lot of magical properties, and they are listed in *Fantastic Beasts*. The Talmud says the salamander's a kind of toad. Other stories are much more fantastic, with the salamander having a spider or mouse-like appearance, and appearing after glassblowers stoke their fires constantly for a week's time. Salamander blood is supposed to protect against fire because it comes from a creature made from fire. There is a story about a child who is to be sacrificed being protected by salamander blood. {www.jewishencyclopedia.com}

What Are the Mysteries in Chapter 18?

BLOWING UP...

During Charms class, Harry and Ron are practicing their silencing charms on a couple of bull-frogs, one of which Harry inadvertently inflates, and the other, Ron ends up poking in the eye. Poor things! Harry does have a tendency to inflate things when he loses control (HP Sleuths should make a special note of that in your scrolls). We are getting lots of hints about things getting bigger, and the last time that happened, we ended up with a grownup rat named Peter. What is blowing up now? Not only that, balloons and bubbles are floating all throughout Book 5, so you may want to be tracking those.

QUOTH THE RAVEN...

Hermione is practicing her Charms – sitting at the desk, trying to silence a raven. Why a raven? They are smart, ominous, and maybe just silly. They are also a black bird. The Norse god, Odin, had two Ravens called Huginn ("Thought") and Muninn ("Memory"), who kept him informed of all the news of the land. One of the most famous ravens in literature is "The Raven," by Edgar Allan Poe. The themes in his poem deal with dreams, chamber doors, and mind games, plus it includes references to a bust of Athena, Pluto, and (hem-hem!) a black plume. You can look it up in your HP Sleuth reading list.

Here is a quintessential (that means ultimate) example of the principle of juxtaposition. That image of the raven on the desk isn't a random combination. First, concerning the students sitting at a (writing) desk — that would be normal for a lesson, but Jo makes sure we know that they are, indeed, at a desk. Then, Jo could have used any creature at all for the silencing practice. She used a common frog for one of them, and she could have used any other common animal (she likes chickens), but she chose to have them using a raven. That stands out. The juxtaposition of the raven and the writing desk directs us to Lewis Carroll's riddle from *Alice in Wonderland*, "Why is a raven like a writing desk?" (For the answer, see Curiosities.) It would appear that Jo is once again applying her wry humor to Wonderland.

Now, before you start accusing us of stretching things or going too far when reading into her works, we would like to point out that in the Harry Potter card game is a red card titled "Raven to Writing Desk." Now that Jo has verified her input into those cards, we know she juxtaposed them on purpose. It may be just a game she is playing with us — implying that there is no solution to these riddles — but at the very least, we can be sure the game was intentional and we have read the rules correctly.

HAMMERING ON OUR HEAD

Ron looks out and sees "hammering rain," listens to the "hammering of rain on the roof," and Professor Sprout is trying to teach over the din of "hammering raindrops." Now, this is all within *one* chapter. A writer of Jo's caliber isn't going to repeat the same metaphor that many times unless she was going for...Rule #1. This sounds like construction. We did catch a

glimpse of some building plans at Grimmauld Place before Bill got to them. Perhaps the Order is constructing something, however, this particular hammering sounds more sinister. It is possible that Voldemort is doing the constructing. The hammering is happening "on the roof," and we know Voldemort is in a "towering temper." Should we be looking for a tower going up somewhere?

It may be just a (ahem!) coincidence, but the weather has become increasingly nasty since the Dementors started poking around in Book 3. Northern Scotland isn't a tropical paradise, but the weather has become more violent as Voldemort's influence has been spreading. This year, we see that foggy England is parched dry this summer, the trip to Hogwarts is again through a dismal rain, and then winter arrives quickly with raging storms (more thoughts of Ragnarok). But is Mother Nature the only one in a bad temper? How much influence can Voldemort's emotions have?

In *The Lord of the Rings*, at the heart of Mordor was Sauron's "Dark Tower." Darkness overtook the surrounding land, and the closer they got to the Tower, the darker and more desolate the land. There does seem to be a connection between weather and wizarding "vibes" in Jo's magical world. When evil was strong at Hogwarts in Books 3 and 4, the weather was dreadful, and it would seem that an evil could be present in Book 5.

WHO'S WATCHING THE COOP?

Hermione is worried about Sirius being so "cooped up" at Grimmauld place that he is trying to "egg" them on to take chances with their plans — instead of being cautious. Yet another interesting example of juxtaposition. There are two strong metaphors in the same conversation that relate directly to each-other. The "cooped-up" and the "egg" reinforce that image, and they are both mentioned by Hermione. We can't help but think of the previous time we heard a lot about chicken coops — we ended up with a Basilisk. We already know that there is a Bundimun infestation at Grimmauld Place, so there is a lot of mold. What else could be growing in there? In an interview with Vancouver junior journalists in 2000, Jo said that Dementors don't breed, but *"grow like a fungus where there is decay."* (gulp!) The idea of Dementors springing from decay makes them as malevolent as Philip Pullman's "Spectres." As discussed earlier, Grimmauld Place and the things inside it are suspect, and it wouldn't surprise us if there's more hatching in there than the Order's war plans.

TALL TEMPER

Harry's scar hurt, and this time, Voldemort was angry — "wherever he was... was in a towering temper." Where *is* Voldemort? This makes it sound like he is in a tower. It also is yet another reference to big things and growing things. Where is Hagrid? We are thinking that he is hanging out with big things too. The two biggest candidates for growing right now are Grimmauld Place and that mimbly plant.

THE SECRET WORD

Harry recalls that Sirius had told him about a "secret weapon" Voldemort is working on, and as the kids walk up to their common room, Harry tries to figure out where Voldemort is keeping it — but his thoughts are interrupted by Ron who gives the password, "Mimbulus Mimbletonia."

Experienced HP Sleuths will think of this as Rule #2, and that is a good guideline if you want to solve the story-line clues. However, it may be covering a huge septology clue if you think in terms of juxtaposition. Just as Harry is asking himself the question as to its where-abouts, Ron's voice supplies a name. Would those be related? It is surely a plant of many mysteries.

SLIPPING AND SLITHERING

Harry is up late in the common room trying to finish his homework on "Confusing and Befuddlement Draughts," but his book falls from his loosening grip to the floor as he starts to nod off, dreaming of a windowless corridor with a door at the end. Looks like homework has the same effect on wizards as it does on Muggles. ☺ This is certainly a story-line clue, but it also reinforces themes (Rule #1) that could be septology-related. Once again, there is the non-working hand, the slipping and falling to the floor Basilisk-like, along with window-less corridors like those which lead to the Chamber of Secrets. Is the place in Harry's dream a real location? In literature, recurring dreams should usually be heeded as they tend to contain truths. If this corridor is real, why would it not have windows? We have seen that some underground magical locations will simulate windows, therefore, it is prob-ably a rarely-visited place.

BEFUDDLED

Harry dozes off around midnight while reading about scurvy-grass, lovage and sneezewort, which are used to make Confusing and Befuddlement Draughts — causing "hot-headedness and recklessness." The HP Hintoscope is howling at us. We have seen Harry getting very hot-headed lately. We already know his scar pains are causing him to be very cranky and irri-table, although he does seem a bit extreme. Is there any chance that someone is admin-istering a potion to him? It's possible, but it is more likely that this is to reinforce the state of Harry's poor muddled brain.

Did you see that it was about midnight that Harry dozed off? We are wondering if there is a reason for that particular time.

ROOMINATIONS

Harry learns that Dumbledore's Chamber Pot room was the "Come and Go Room," and that the way to call it is to walk past it three times, wishing very hard for it. Jo had told us about the Room a long time ago. How precise was Jo's hint about the Room of Requirement that she gave before the release of Book 5? If she was being precise with the wording of the hint, there may be other clues to consider. The exact wording was, it is a room:

"mentioned in book four, which has certain magical properties Harry hasn't discovered yet!..."

Now, the way we had looked at it was that Harry hadn't yet discovered the magical properties — which would have meant that he had already been in the room, but just not figured out how to use it yet. Now that we know about the room, it would seem as if Harry had never been in there before. But... what if he **had** been in there? Is that what Jo meant after all? It is a room that you find only if you know how to call it, or when you are des-perately searching so hard, you end up calling it without realizing it.

When would Harry have been so anxious to find a room that he may have inadvertently called it? Keep in mind, that some of the rooms have definitely been moving around different floors from book-to-book, so we can't be sure what floor Harry was on in all cases. What if, in Chapter 12 {"The Mirror of Erised"} of Book 1, Harry first discovers the room when he is desperately trying to hide? We don't know if Dumbledore "assisted" in the process, but Harry was surely in need that night. What makes us most suspicious is that the next time Harry went to look for the room with Ron, Harry couldn't find it where he thought it should be, and it wasn't until he had retraced his steps several times in desperation that it somehow appeared. He was, at that time, desperate to know more about his parents and "required" answers — which he found in the room with the mirror. Maybe he was just lost, but then again...maybe that was the Room of Requirement and he had, indeed, been in the room before!

Another quick reference made by Fred and George also makes us wonder if Harry could have encountered the room on another occasion. The twins said they had used it as a broom closet. When Harry and Hermione went back in time in Chapter 21 {"Hermione's Secret"} of Book 3, they were pretty desperate for a hiding spot when they ditched into the broom closet there. The only problem then, is since they scurried directly into it, it is unlikely they would have had time to pace and call it — not to mention that it was on the ground floor, while the Room apparently has a fixed location. But we thought we'd mention it since humorous remarks cannot be taken lightly when looking for clues.

BAD LUCK

Dobby tells Harry that the Room of Requirement has provided antidotes and a bed for Winky, cleaning supplies for Filch, and when Harry enters it, he finds it stocked with lots of Dark detection devices — including a cracked Foe-Glass. The WWP Sleuthoscope is flashing a warning! Where does the Room obtain the supplies that are "required"? If they are "borrowed" from other places, how does the room know about them, and what happens if the person they belong to goes to look for them or needs them? If the supplies are just "conjured" how can they be real enough to use as an antidote or as a cleaning solution? It would seem that they are probably borrowed, and if so, would that be Moody's Foe-Glass?

There is something very tricky here. In Chapter 20 {"The First Task"} of Book 4, Fake Moody shows Harry his Dark Detectors, but the Secrecy Sensor supposedly wasn't working right, while the Sneakoscope was supposedly cracked because Fake Moody needed to disable it due to it going off when it shouldn't. We find out later, of course, that the Secrecy Sensor and Sneakoscope were working fine — they were detecting the fake Mad-Eye. On the other hand, Fake Moody needed his Foe-Glass to be in perfect working order, so not only was it **not** cracked, but it was functioning perfectly.

This Foe-Glass happens to be cracked, and we don't know how well it is functioning. Would having a crack stop it from functioning properly? What other cracked mirrors have we seen? HP Sleuths may want to see if you can spot another one somewhere else in the septology.

Is this, indeed, Moody's mirror, or should we be looking for its owner? Hopefully, it will work if Harry needs it.

Curiosities

✳ If you'd like to know why a *raven* is like a *writing desk*, you're not alone. Ever since Carroll inserted the riddle into Alice's conversation with the Mad Hatter, people have tried to come up with an answer — including Carroll! You see, Carroll never intended it to have an answer, and in fact, that was the whole point of the "joke" — that it was a silly, meaningless joke. As he was inundated with requests for the answer, Carroll eventually invented his own answer to "How is a raven like a writing desk?," which was — *"it can produce a few notes, though they are very flat; and it is nevar put with the wrong end in front!"* (Do you get it?) Unfortunately, an editor who was not in on the pun corrected it to "never," leaving people to search for their ownsolution. What's yours? {www.straightdope.com/classics/a5_266.html}

✳ "Scurvy-grass" is an *herb of Jupiter*, which is the Roman name for Zeus, the god of Thunder. While sneezewort is not assigned to any planet, it's from the same family as *yarrow*, which is assigned to Venus. "Loveage" is an *herb of the Sun* and is associated with the zodiac sign of Taurus, the Bull. {www.radicalweeds.com} {www.magdalin.com}

Chapter 19 Analysis
(THE LION AND THE SERPENT)

What Are the Mysteries in Chapter 19?

LIONS AND SERPENTS AND GOATS? (OH MY!)

The title of the chapter in which Gryffindor and Slytherin clash on the Quidditch pitch is "The Lion and the Serpent." The WWP Sleuthoscope is splitting into three pieces as it prowls around menacingly. This chapter could simply have been called "Gryffindor vs. Slytherin," but it uses the words lion and serpent. It may be just about Quidditch, but when we see a lion and serpent juxtaposed — especially if there is a goat around (see Chapter 16) — we need to consider the possibilities. In Jo's magical world, putting a lion, serpent,and goat together gives you a Chimaera — one nasty beast. (Look it up in *Fantastic Beasts* if you don't remember.) Have we seen anything that looks like there could be a Chimaera around? Not yet....

TALISMAN

Thanks to Dumbledore's Army, Harry feels as if he has a "kind of talisman inside his chest" — allowing him to ignore Umbridge's "bulging eyes" and her useless Slinkhard book. The HP Hintoscope is humming a little love song. Another metaphor — and another brainteaser as to whether we are to take the metaphor literally. When thinking of what is inside the chest, most people would say a heart. Can the heart be a talisman?

You probably don't have to bother pulling out your *Philological Stone* to see this one, but just in case, have it handy. The Slinkhard book is a combination of the words "slink" and "hard." Maybe it's not important, but it is yet one more allusion to the idea of slinking down and hitting the ground.

MAGICAL MARKS

In order to announce DA meetings without raising suspicions, Hermione gives all members a Galleon that is inscribed with the date/time using a Protean Charm, so that Harry can update them all automatically — just like Voldemort's Dark Mark. This charm is very powerful, but it also indicates that in the magical world "marks" of all kinds should be scrutinized carefully. We see that similar marks can be linked to each-other, and that the marks can be controlled. There seem to be many ways of "marking" people — and Umbridge's quill may also work on the same principle since Harry is "writing" onto parchment, but the "writing" is being engraved into his right hand. It is disconcerting that Umbridge has now scarred Harry on his hand. Does Dumbledore know Harry has this scar? Does the evil toad lady have any control over this scar now? *shiver*

LUNA THE LION-HATTED

Luna comes to the Quidditch match wearing a lion hat that really roars, and as the Slytherins are beating them down, Harry is "heartened" by the sound of the roar, and finds the extra courage he needs to focus his mind on catching the snitch. Hmmm...is that just an emotional reaction,

or is it possible that Luna may have put something extra into that hat spell? In Chapter 36 {"The Parting of the Ways"} of Book 4, a single note sung by Fawkes is able to give Harry the strength to overcome his trauma at the graveyard so he can recount it all to Dumbledore.

This appears to be just a loony hat, but in addition to the effect it had on Harry, there are some running bits that should be investigated. First of all, it is a hat — which goes on top of *heads*. Then, making the hat roar so realistically has to take some talent, so Luna is showing her magical power, which can touch the heart.

SAVED FROM THE BIN

The Slytherins have made up a song to dishearten and distract Ron from his Quidditch game...and it worked:

Weasley cannot save a thing,	'Weasley was born in a bin,
He cannot block a single ring,	He always lets the Quaffle in,
That's why Slytherins all sing:	Weasley will make sure we win,
Weasley is our King.	Weasley is our King.

The WWP Sleuthoscope is sending out shooting stars! This would seem to be a big clue to Book 6. There is something truly significant about this poem. It contains some of the biggest running bits in Book 5. The hint about the "King" may have already been answered, since we now know that the name of Book 6 is *Harry Potter and the Half-Blood Prince*. As more information is revealed while we go through Book 5, it will become more obvious how the running bits all fit together.

REFLECTING ON SPOTS

Hermione is looking out of the common room's "pitch-black, snow-flecked window." It is almost as if Hermione is looking out into another world. Book 5 is spattered with flake/spot/dot/ink running bits. When thinking about how these may relate to the septology, the most visible ones are those associated with Moaning Myrtle and the ink drops from the Riddle diary. Here again is Rule #1.

Rowlinguistics

✴ In Shakespeare's works, **Montague** is the surname of Romeo from "Romeo and Juliet." It is a story about bloodlines, in which Romeo had the bad luck to fall in love with a girl from the house of his family's worst enemies.

✴ **Pucey** doesn't sound like a very nice guy, but it gets worse when you find out that puce is actually *a deep red to dark grayish purple*. Don't know about you, but that color always makes us think about Uncle Vernon.

Curiosities

✴ In explaining her **Protean Charm**, Hermione points out that there is a serial number on each coin that tells which goblin cast the coin. The goblins must not have centralized stamping processes. The practice of marking money in that way goes back to the beginning of money. Like the goblin Galleons, the ancient Roman coins were hand-minted, and had the mark of the "moneyer" who issued the coin stamped on it. The moneyer was a low-level position in the government, but this position was often a stepping stone to allow the officeholder to move up to a higher rank. We are being told about this mark for a reason, and it may be because the moneyers had a lot of control over the minting of the coins — which could get very tricky if the goblins split their loyalties. However, are we sure that *their* mint mark is just a mark? {www.romancoin.com} {Classical Numismatic Group}

✴ If you juxtapose Montague with all the nursery-rhyme ties we've been seeing — falling and busted heads (crowns) (*Jack* and Jill), crumple-horned snorkack (The House That *Jack* Built), all those corners (*Jack* Horner) and candles (*Jack* Be Nimble), and you come up with — a lot of "Jacks." It just so happens that a man named Montague Druitt was thought by some to be *Jack the Ripper*. We have seen another reference to "Ripper," of course — Aunt Marge's lovely (shudder) doggie. Why might Jack the Ripper ties be showing up? He was into bloody attacks on people he thought unworthy. (Nobody around here like that, is there?) {www.crimelibrary.com/serial_killers/notorious/ripper/druitt_14.html?s}

Chapter 20 Analysis

(Hagrid's Tale)

—————— What Are the Mysteries in Chapter 20? ——————

Eye-Opener

When Harry tells Hagrid what happened to him over the summer, Hagrid spits dragon's blood, coughs, and splutters, as his dragon steak "slid, with a soft splat, on to the floor," and then looks at Harry through his one open eye as Hermione looks on "wide-eyed." Using juxtaposition, you do get a flashback to the Basilisk scene with the opening mouth, the spluttering, and the sliding onto the floor with a "soft splat." Hermione looking "wide-eyed" just makes the analogy more strong. Are we supposed to be thinking the Basilisk or something like the Basilisk? No matter what, we are thinking Chamber of Secrets.

You know, we were told all the way back in Book 1 about Dragon's blood and how Dumbledore's work on it was sooo crucial — netting him a place on the FW&W cards. So, why is it that we have *yet* to learn anything more about that? Is this a big bloody Rule #2? It also increases suspicion as to whether Dragon's Blood is *the* number 12.

This may be Jo just playing with some imagery, but we are looking at a giant with only one working eye. If you are familiar with ancient legends you will either see a Cyclops from Greek mythology or Odin the one-eye Norse god.

A Giant Search

Even with Dumbledore's directions to the giants' mountain refuge, Hagrid and Madam Maxime's mission to find them took about a month — because once they got near, they had to avoid using magic in case Death Eaters were around. You wouldn't think that it would be difficult to find a bunch of twenty-foot giants, but *they* obviously have to stay clear of Muggles too. It is amazing how Dumbledore is aware of so many things. He does consider the giants to be important — he told Fudge so in Chapter 36 {"The Parting of the Ways"} of Book 4. Professor Binns also considers them important, and fierce adversaries too.

Having to avoid Death Eaters cannot be a trivial task. It is really unclear as to whether Hagrid was afraid of being *observed* using magic, or if someone may have been able to *detect* magic. That would seem to be an important distinction.

Hagrid's Tail

Hagrid describes how the Ministry has been monitoring everyone associated with Dumbledore, and that someone was pursuing him and Olympe Maxime on their way to the giants, but they lost him in France. A quick test with your *Philological Stone* will help to reveal the double-entendre in the title of this chapter {"Hagrid's Tale"}. Hagrid tells a tale about how he and Mme Maxime were being tailed by someone who had enough time to follow them over to France. Who was available who could be sent to **tail** them, and would also be incompetent enough to lose two half-giants? If it doesn't turn out Hagrid was doing anything else to distract him, the name Wormtail does come to mind. ☺

THE GIANT GURG

Hagrid and Maxime first meet with the Gurg (head of the giants), Karkus, but Karkus was beheaded that night, and when they return to meet the next day, Golgomath has taken control. There's a word on which you probably will need to use your *Philological Stone* (hope you have it handy). The name, Golgomath, is a sound-alike for the massive Gilgamesh of Mesopotamian legend. This is the second time we have seen a blatant reference to Gilgamesh in Book 5, which means this is a giant Rule #1 (we won't even mention the severed head).

Right about now, it would seem that Golgomath has been successfully influenced by Voldemort. However, his namesake, Gilgamesh, was a revered leader and a fair ruler. We can't make assumptions, but we can suggest that all is not yet lost with the giants.

INSIDE INFORMATION

While interrogating Hagrid about his whereabouts, Umbridge hints to Hagrid that he may have been taking in some "mountain scenery," and Hagrid tries to cover up for his injury with excuses that he "tripped" because he doesn't like (and can't ride) brooms. How did the Toad know? If the Ministry had sent the spy to tail them, and they lost the spy in France, then how would anyone from the Ministry know they went to the mountains? The people who knew about Hagrid and Maxime were most likely Rita (who supposedly wasn't talking), Voldemort, his Death Eaters ...and (hem-hem!) Professor Toad. Maybe Lucius Malfoy had informed Fudge, who in-turn informed the Toad, which would mean the whole world knew (so then what's the big secret?). But if not, this is evidence of a direct link between Umbridge and the Death Eaters.

GIANT COURTSHIP

Hagrid describes how the Death Eater, McNair, had showed up at the camp of the giants. Hagrid is obviously convinced that McNair is a Death Eater, which would prove that Voldemort is courting the giants. If he wins them over, Harry had better start paying attention to Binns' lectures on the giant wars.

Rowlinguistics

✳ **Golgomath** is most likely a play on the name *Gilgamesh*, the big, strong warrior. If you HP Sleuths want to refresh your memories you should dig out your Chapter 10 scroll and look for the information on Assyria. Golgomath's name also sounds a lot like Golgotha, one of the names for Calvary (where the Bible says Jesus was cruci-fied). Golgotha means "Skull." We don't know for sure where Golgotha is — maybe somewhere not so far from Assyria?

✳ Get out your *Philological Stone* — here's the quiz we had in *New Clues*: *Kreacher* is to *creature*.... as **Karkus** is to _____. (With a name like that, we should have known he'd be dead meat.) That's called a homophone, and it is one of the many word tricks Jo made good use of in Book 5.

Curiosities

✳ Jo likes Philip Pullman's work and has been compared to J.R.R. Tolkien — small won-der that she'd make use of indestructible armor as one of the presents for the giants. Indestructible armor has a long history in legend and fantasy.

✳ Dumbledore made sure that Hagrid brought valuable gifts to the giants in order to show their good intentions and to help win their favor. HP Sleuths well-versed in mythology are probably giggling right now. The irony of that scene once again shows Jo's wry sense of humor. Humans giving presents of fire to giants is a parody on the ancient Greek myth of Prometheus. According to Greek legends, Titans (giants) were the first rulers of the earth, and Prometheus, a giant, had secretly brought fire to humans.

Chapter 21 Analysis

What Are the Mysteries in Chapter 21?

Venomous

Hagrid's wounds continue to bleed — which makes Harry wonder if whatever caused the injuries had a venom that stopped them from healing. Is that what is wrong with Hagrid? This may be a Rule #4, but most importantly, it is assuredly Rule #1. We have seen excessive bleeding before, and are being reminded of it — as well as told that venom can cause it. However, the twins seem to be able to stop it, so there must be an antidote or a way to heal it, right?

Half a Mind

Hermione mentions how Hagrid had said that no one "in their right mind" would be interested in Knarls over Chimaeras. Guess those in their "left mind" are free to choose *smirk*. That sounds suspiciously like Rule #4a. Are we being told to "think Chimaera"? They certainly are more interesting than Knarls. HP Super Sleuths will know what a Knarl is...the rest of you will hopefully have your well-worn copy of *Fantastic Beasts* so you can refresh your memory.

Book 5 is packed with references to the mind and to states of mind. It's not difficult to notice that Harry is having a little trouble with his. Even when he isn't suffering from a splitting headache, his mind isn't all there...in fact, it seems to be wandering in places he hasn't asked it to go. Why is it doing that?

Scrambled Species Eggs

Harry and Ron are worried that Hagrid might have a Chimaera, but Hermione is sure that Hagrid doesn't have one — because she has discussed the availability of their eggs with him already. The WWP Sleuthoscope has gone to yellow alert! The last time Hagrid expressed interest in contraband eggs, he ended up with Norbert, the teething dragon. Maybe this time, Hagrid won't be getting a Chimaera, but this could be a (hint...hint) nudge from Jo that *someone, somewhere* is raising a Chimaera. There is no proof yet, but the circumstantial evidence is growing.

Seeing Thestrals

There were three people who were able to see the Thestrals in Hagrid's class: Harry, Neville (who had seen his granddad die), and a "stringy Slytherin boy." This is one of those exclusive clubs that you don't want to be invited to join. The good thing is that the Slytherin did not come across as being proud of his unique status. If you were wondering who the Slytherin was, you may have noticed Jo pulled a Rule #2 on us. However, we were spared (for once) by getting a quick answer from Jo on her website, thanks to MuggleNet.com asking the question. She told us that the boy was (as clever HP Sleuths suspected) Theodore Nott, and that he was raised by a single parent, his elderly father, who is a Death Eater. HP Super Sleuths

will have remembered that Theodore was sorted in Book 1, and that his father was at the gravesite for Voldemort's rebirthing party in Book 4.

The question that never did get answered, however, is whether or not Umbridge was able to see the Thestrals. She didn't react very much. If you think about it, she doesn't ever react very much — not even when hearing Voldemort's name. It's as if she has no emotion.

WHO DONE IT?

When Harry walks into the Come and Go Room, he is disconcerted to find that Dobby has apparently hung a hundred gold baubles with his face on them, and Harry removes them just as Luna arrives. Do HP Sleuths note anything suspicious? You may want to check a couple of your Rules of Constant Vigilance...let's say...Rule #4 or Rule #3. Was it Dobby who strung them all up there? We know Dobby would do things like that, but Dobby is a house-elf, and typically makes things with his own hands — so golden baubles aren't necessarily his style.

If it wasn't Dobby, then who would have done it? It was noteworthy that Luna was the first to arrive. She certainly has been a "big supporter" of Harry's, and she does have "interesting" ways of expressing herself. Of course, there is yet another potential culprit.... This is the Room of Requirement, it is Harry's room, and he was the first to enter. Could the room have "provided" for him? If the mystery of this room intrigues you, there is a complete discussion on it by Christina Conley in *The Plot Thickens* fanbook.

SNAKE!

In his "dream," Harry is unwittingly assimilated inside the brain of a snake, passes through some bars, sees Arthur Weasley dozing and tries to suppress the urge to bite, but when Arthur stands up and confronts the snake with his wand, "he" rears and attacks, crushing ribs as he bites. What kind of snake was that? What would the snake be like that could break the bones of a grown man? It had to be one monster snake! If you are thinking it was a Basilisk, you should notice that it faces Arthur without any effect. Therefore, it is either a baby Basilisk (assuming the babies aren't mature enough to kill yet), or something else. In Book 4, Voldemort had a huge "pet" snake, Nagini. Was it Nagini? Do we even know what species Nagini is? All we know for sure is that she is very big and has some kind of venom that Voldemort used in a potion to keep himself alive.

Nagini's name comes from *naga* and *nag*, which are derived from the ancient words that mean "snake." Other classical writers have also borrowed from that etymology. In a Rudyard Kipling story (on your HP Sleuth reading list), his two snakes were called Nag and Nagaina, and their foe was a mongoose (a type of *weasel*). That story may have additional parallels to Jo's works, but there is nothing to substantiate them at this time.

Nagini sounds like a good candidate for being the snake, but then how did she get into the building without being seen? When Harry first becomes conscious of being inside the snake, he sees himself going through some bars. Is that a gate to the area, or is it a secret entrance?

NEVILLE ON THE CASE

Harry wakes up from his vision of the snake attack on Mr Weasley surrounded by the members of his dorm, who are in a panic to help him — Neville runs off to get McGonagall. Wow! Did you notice that Neville is the one who is alert enough to run off for McGonagall? Maybe he is starting to improve this year. Is he just growing out of his klutzy stage, or are there specific reasons for his progress? Would his plant have anything to do with it, or are we barking up the wrong tree?

GLASSY-EYED

Professor McGonagall, glasses "lopsided," comes rushing into the Gryffindor common room, and as she listens to Harry's account of the snake attack, she eyes Harry through her "lopsided spectacles." The WWP Sleuthoscope is making bugeyes at us. Even though eyeglasses play an important part in the series, we can sometimes forget that so many people in the Harry Potter stories wear glasses. Professor McGonagall, Dumbledore, Trelawney, Myrtle, James, Mr. Weasley, Percy, and of course, Harry, all wear glasses. There is also Mad-Eye's magical mad eye. However, in Book 5, we are constantly reminded of eyewear. It may indicate unique attributes or powers, but it is puzzling because they are often juxtaposed to being "lopsided." The most notable reference to lopsidedness before Book 5 was Fake Moody's "lopsided mouth," which was constantly referred to in Book 4.

— Rowlinguistics —

✳ According to Luna, mistletoe can be infested with **Nargles.** A similar word is *narghile*, which is another name for a hookah, or water pipe (like the kind the Caterpillar smokes in *Alice in Wonderland*). Just thought we'd add it to our bucket of water and pipe running bits.

✳ Jo mentions in *Fantastic Beasts* that there was a person who killed a **Chimaera.** That person is Bellerophon, from Greek mythology, who killed it from the back of the flying horse, Pegasus.

Chapter 22 Analysis

———— What Are the Mysteries in Chapter 22? ————

A CAT RAT

As Professor McGonagall hustles Harry and Ron to Dumbledore's Office, she shoos away Filch's cat, Mrs Norris, and only a short time later, Umbridge is spotted by Fawkes heading up to Dumbledore's office. HP Sleuths may have noticed the "tattle-tail" (no big surprise) who informed Umbridge that the kids were up and in his office. Headmaster Dumbledore has portraits of respected former headmasters and a gallant bird to help him watch what is going on. It would seem that the Terrible Toad is relying on Filch, the Squib caretaker. Fawkes is at least as good a lookout as any Kneazle.

While he did not necessarily betray Dumbledore, Filch had no problem informing on McGonagall and the kids. He is not very trustworthy (and no one ever did trust that cat).

TAKE A SEAT

With a wave of her wand, Professor McGonagall conjures some wooden, straight-backed chairs, and they sit down while Dumbledore still keeps his eyes averted from Harry. Chairs are haunting us in Book 5. Everyone seems to like drawing a few quick chairs — at least the more powerful wizards do. Chairs aren't always bad things, but they do tend to flash back to the beastly courtroom seat. We are supposed to keep thinking about that courtroom, for sure.

Watching people conjure chairs also reveals some of the mechanisms of magic in Jo's wizarding world. Dumbledore draws up chintz chairs while McGonagall conjures stiff wooden ones. Think about how this might relate to other things Jo has taught us about specific spells and performing magic in general.

PORTRAITS

Phineas doesn't feel like carrying out Dumbledore's request to visit Grimmauld Place again, spurring the other portraits to point out their honor-bound service to the current Headmaster, while a witch in another portrait pulls out a wand asking if she should make him cooperate. Good help must be hard to find even for Headmasters (lol). So, the portraits of the former Headmasters and Headmistresses serve the current Headmaster. Does that mean they can still refuse or defect? Who started this practice — how far back does it go? When do they make the commitment — is it when they are appointed as Headmaster, when they are painted, or is it just a tradition?

Did you notice that the witch in the portrait was implying that she was capable of casting a spell on another portrait? How charming. ☺ Can all portraits do that, and do the subjects have to be painted with their wand in hand or is it enough to just have it on them?

THE ESSENCE OF IT

Dumbledore takes one of his delicate silver instruments, which chinks to life, blowing green smoke, until it forms into a green snake that opens its mouth wide, as Dumbledore asks, "But in essence divided" — *at which point, the snake divides into 2 separate snakes.* Jo did not make it clear what Dumbledore had asked the instrument, but based on what it did, we can infer what it meant — that their "essence" (their being) is divided, while they share the same mind. (Translation: Harry is in trouble!). Can you imagine sharing someone else's mind? It would give you a splitting headache — and that is exactly what has been wrong with Harry. Voldemort is linked to Harry's brain, and just like you can breathe without having to think about it, Voldemort can be sitting in there, and Harry would not know unless some emotion made itself known. Obviously, Harry had already been feeling this any time he was near Voldemort, but it has become increasingly strong. Is that because the link is growing stronger naturally, or is there a catalyst? Did you note that Harry's essence was represented by a *snake*? They are coiled around one-another's brains.

HEADS AND TAILS

When Dumbledore queries his instrument concerning "in essence divided," Harry could make neither head nor tail of this question. In mysticism, the Worm Ouroboros represents the cyclical nature of the universe. The image of the Ouroboros is a snake eating its own tail — a never-ending loop of endings and beginnings. In literature, it is the title of one of the first epic fantasies, by E.R. Eddison, which takes place on the planet Mercury (the Roman name for Hermes). The most well-known symbol for Hermes is the caduceus — a staff with two snakes coiled and intertwined around it. We have had many worm hints in Book 5, and there is even an Ouroboros hint in *Fantastic Beasts*. It is mentioned on page "ix" that the very first edition of the book was published by a Mr. Augustus Worme of Obscurus Books. If you use your *Philological Stone* on that name and title, you can reveal the Worm Ouroboros in there.

RUFFLED FEATHERS

Fawkes delivers alerts and messages to the Order by delivering one of his golden feathers. Let's hope that Fawkes doesn't have to leave too many messages, or that he grows them back really fast. ☺ What happens to this golden feather? Does the recipient keep it? Does it have any special properties? We do know that two ended up in wands....

CREATURE HABITS

When Kreacher insults the Weasleys, Sirius orders him "OUT!", which angers the elf, and as Harry begins to explain what he saw of the snake attack, he hears Kreacher's footsteps stop. For being such a helpless and demented house-elf, did you notice how Kreacher was having no problem being secretive and devious? His actions were stealthy and seemingly purposeful. It is very possible that, like other characters in this series, Kreacher may not be as "touched" as it would appear.

CROSSBONES

The hospital employees wear a symbol on their chest that consists of a crossed bone and wand. Er... yo-ho-ho? Now, if that doesn't make you jittery, nothing will. The philosophy behind mixing a wand with a bone would make sense as they are using magic to heal. However, the description of the emblem that Jo gives with the juxtaposed words "bone crossed," is a correlation to a pirate flag, comprised of a skull and "crossbones." Is this Jo's way of teasing us, or is that a warning about the institution or something going on there?

Of course, if it is an emblem, it would probably be a circular patch — which would bring to mind the cross-inside-a-circle running bit. However, the crossed icons are the only thing we have to go on for sure.

EFFERVESCENCE

The hospital is lit by floating candles inside crystal bubbles near the ceiling, which gives them the appearance of "soapsuds." There are multiple mentions of these bubbly lights (Rule #1), and while they are similar to soapsuds, another analogy might be to bubblegum.

RINGERS

The patients at St Mungo's Hospital have odd ailments — such as multiple hands, elephant trunks, a leg with a "chunk" out of it, and noisy enchantments that cause people to whistle and clang. Those disfigurements seem to ring a bell — they reinforce not only the "bell" and "ringing" running bits, but also those other terms that relate to Moody, Wormtail and other "ringers" (someone who is used as a fake or double). Who or what isn't what they seem to be? All right, so everything in the magical world isn't quite what it seems, but we still want to know if there are any dodgy imposters hanging around.

Another image is the "multiple hands," which are not only more hand injuries, but sort of sounds like a spider. Since "spindly" things are also crawling all over Book 5, they seem to go hand-in-hand.

BLOODY WELL, THANK YOU

Mr Weasley is feeling all right — except for the fact that the venom or something is preventing his wound from healing. HP Sleuths should be very skeptical about now. So far, we have learned that Fred and George can cause terminal nosebleeds and then heal them immediately. Are they more clever than the Healers at the hospital, or does it depend on what causes the bleeding? Either way, it is awfully suspicious if the twins are skilled enough to stop bleeding but the hospital can't. Veteran HP Sleuths know that WWP never has trusted this Malfoy-supported institution, and while the hospital may be safe, it does raise some questions. Arthur needed to get help from another Healer — was his first one trustworthy? Also, is it possible that someone is somehow administering something to Arthur that is keeping it bleeding — just like the Nosebleed Nougats or Blood Blisterpods?

AND THE VERDICT IS...

Mr Weasley isn't surprised that the snake attack didn't make it into the newspaper because the

Ministry wouldn't want the public to know something (Molly stops him), so he talks about Willy Widdershins' arrest for regurgitating toilets which was apparently dropped due to a bribe, and since Willy's jinx backfired, he was covered in something (but then Fred interrupts). Sometimes it's not what you say, but what you don't say that speaks loud and clear. Arthur stops short of saying more about the snake. Did it have to do with where the snake was or how it got there? Obviously, we would like to know that as well. Plus, Arthur never did finish the word to describe Willie's predicament (Rule #2) — it sounded a lot like "dung." It also sounds like Rule #1 since it was plainly intended to draw our attention to the word "dung" and/or toilet for the gazillionth time (running bit).

Time to call in Lieutenant Columbo to put all the pieces together. ☺ We now have enough information to figure out Willy. He is juxtaposed to "dung" here, so at the very least, there is probably a relationship between those two. If HP Sleuths recall, when Harry has his first dinner in Grimmauld Place, Mundungus "Dung" Fletcher is in hysterics about how he stuck it to "Will," a shyster who had bought some frogs off him. Arthur had mentioned that someone assisted in clearing Will of the charges, which is weird — who would spend the money on a bribe to get a petty street criminal off a charge and why?

WHERE THE EVIDENCE IS POINTING

Mr Weasley informs everyone that because two Muggles lost fingers, Willy Widdershins won't be able to "worm his way out" of a criminal charge concerning biting doorknobs. This is either a very handy clue or a whopper of a red herring. It is also another prime example of juxtaposition. There are not one...but two...people with lost fingers (Rule #1) adjacent to a "worm" reference. You can't help but notice that, however, what do you do with it? Do you start looking for a tail to go with it? We looked, and we think we could have at least found an ear. Check out the old guy with the hearing problem in the next chapter.

BEING SERVED

The Healers assigned to Mr Weasley's ward are Hippocrates Smethwyck and Augustus Pye, a trainee. Augustus is a respected term, but the august rulers of Rome who used that title were far from upstanding. However, since the name "Hippocrates" is revered and positive in medicine, it is not likely that this Healer would be suspect. On the other hand, Augustus Pye has a dessert-like name (à la Fudge), which may just be another nudge for us to remember the Malfoy influence, or he may be yet another "pi" hint.

DANGEROUS PLACE

Mr Weasley is on the "Creature-Induced Injuries" floor, specifically, the "'Dangerous' Dai Llewellyn Ward: Serious Bites." The HP Hintoscope is growling at us. There are creatures everywhere, and they all seem to be dangerous, or at the very least, serious. What kind of nasty creature are we being warned about? Back in Chapter 20 {"The First Task"} of Book 4, Madam Pomfrey fretted over all the horrible creatures that she has had to deal with lately, and wondered "what next"? This was surely a warning that Book 5 would have yet another deadly creature, and knowing that someone is going to die, it makes us nervous.

The Llewellyn identity could come from several sources (see Rowlinguistics), but the magical source is the most important. If you have done your required reading of *Quidditch*

Through the Ages, you will know who "Dangerous" Dai was, and why he would have ended up in the hospital and with a ward named after him. He had a little dinner engagement with a (hem-hem!) Chimaera.

YOU KNOW MAD-EYE

Mad-Eye Moody comments that Harry is able to see things from the perspective of "You-Know-Who's snake." Hmmm...this is yet another sign that Moody may be acting weirdly. Why would one of the most talented Aurors in the magical world not be willing to say the name of Voldemort? Is it out of respect for others, is it because there is something not quite right about him, or is it that maybe he knows better? He is a bit on the paranoid side.

Rowlinguistics

* In alchemy the **ouroboros** represented the alchemy wheel, the wheel of time, the cyclical nature of life — death and regeneration, destruction and creation — resurrection. It also represents the alchemical principal that "all is one," (one of the precepts of the Emerald Tablet), a concept very related to ying and yang, which demonstrates that even in the dual nature of life, there is unity.

* **Willy**'s a nickname for William, of course — it comes from the German name Wilhelm, which means *will, desire* (wil) and *helmet, protection* (helm). Guess a guy who's been hit by an exploded toilet probably *would* desire a helmet. Willy **Widdershins**' last name means *in a direction contrary to the sun's course* — otherwise known as *counterclockwise*... More time pieces, and more going backward in time.

* The hospital entrance off the Muggle street is through a storefront called **Purge & Dowse**, Ltd. A *Philological Stone* will unearth the pun *purge and douse*, yet more watery allusions. And to "dowse" is an old method for water divination.

* There may be two intended sources of the name, **Dai Llewellyn**. One may be familiar to fantasy readers. There is a series of reference guides to astrology and herbs by that name which has been around for about a century, and we know that Jo is up on her star charts and magical herbs. Another source could be the Welsh bon vivant, Sir Dai Llewellyn.

Chapter 23 Analysis

What Are the Mysteries in Chapter 23?

PESKY PLANNER

Hermione gives Harry a homework planner that is similar to a diary and says: "'If you've dot-
ted the "i"s and crossed the "t"s then you may do whatever you please!'" Dotting "I"s — more
dots. Crossing "T"s — more TTs and possibly more crosses. A calendar — yet more diary-
like items, not to mention more 12s. If Harry thinks this homework planner can be irritat-
ing, well at least he isn't being bombarded with running bits! There is also the suggestion
that he can do "whatever" he pleases. That could either be a magical or mental capabil-
ity.

DOBBY'S DOODLES

Dobby gives Harry a present of a picture he had personally hand-drawn of what looked to Fred
to be a Gibbon with two black eyes, but the name on the back identified it as a portrait of Harry.
The WWP Sleuthoscope is going ape! Yet another monkey-like Rule #1. A gibbon is a
species of primate (monkeyish). Therefore, we can add this analogy of a monkey with two
black eyes to the other Book 5 metaphors of the blinded Basilisk that slithered out of the
monkeyish face of Slytherin.

Harry as a monkey with glasses can be interpreted other ways as well. Harry's head is
being filled with a lot of Slytherin-like thoughts, and if he were to look in a mirror, he
might be afraid to see the monkeyish face of Slytherin in glasses peering back at himself.

Those black eyes also make us think of ink, which is a running bit. The last time we saw
a lot of ink was likewise in Book 2, when it was gushing out Tom Riddle's diary.

Now, there is something else to consider about Dobby's present. It is a "painting." It
does not appear to be moving or to have any special properties, but nothing says it can't
be hiding some. Knowing the power of a painting in the magical world, we cannot rule
out that hand-painted likeness of Harry from having some magical capability. Keep in
mind that it cannot have the same qualities as a portrait, since a true portrait is only of a
dead person. That has been verified on Jo Rowling's website.

SPATTERGROIT

Upon seeing Ron's freckles, a "medieval wizard" in a portrait tells him that he is suffering from
"spattergroit" and that his face will become "pockmarked and more gruesome." Ron may need
the *Philological Stone* to understand what the healer said to him about "Spattergroit."
These are more "spot" and "growing"-type words. With the *Philological Stone*,
"Spattergroit" shows up as *spatter grow it*, and Ron becoming "gruesome" is again *grew*
some. We know that Ron did a lot of growing, himself, this year, so maybe that's all it
means. Then again, Rule #1 is growing on us.

THE BETTER TO HEAR YOU WITH

Someone inquired about visiting Broderick Bode (who is having teapot delusions) — it was "A very old, stooped wizard with a hearing trumpet." The HP Hintoscope is whirring to the tune of "Taps." Bode has odd visitors — so odd, in fact, that Jo has drawn our attention to him. Who is he? If you want to try your *Philological Stone* on this, it could reveal a potential hint. Using juxtaposition, the phrase "A very" could be read "Avery," who we know from Chapter 31 {"The Death Eaters"} of Book 4 to be a Death Eater. Was this a subtle clue, or should we be focusing on that "ear trumpet"?

Unless he wandered into a rat trap, (no such luck, we're sure) Wormtail is probably still slinking around somewhere in Book 5, and HP Sleuths know that he has a "tattered" ear. Could this "visitor" be a disguised Wormtail? What would he want with Bode? What would anyone want with this teapot? CONSTANT VIGILANCE!

A-ROUND TWELVE

Gilderoy is eager to hand out his autograph, offering them a "round dozen," and also prepares a bunch of photographs, which he is sending as replies to fan mail — explaining that he is "not forgotten." Here is more practice with juxtaposition. The running bit "round" is juxtaposed to the running bit "dozen" (12). What kind of image do you see this time when you hear the phrase "round dozen"? If you see a clock, you're in sync with us. The idea is to think of a turning, clock-like gears image (like the bicycle wheels and other turning discs) but we really don't have enough information yet to go on.

Gilderoy's comment about not being forgotten is confusing. Is he experiencing a sudden flash of memory, or could he be farther along in his cure than the trio realized and slipped up here?

KREACHER'S LAIR

In trying to leave a Christmas gift for Kreacher, Harry, Ron, and Hermione check out Kreacher's cupboard under the pipes where he has a nest of rags filled with stale bread crumbs, mouldy bits of cheese, and the items he salvaged "magpie-like" from the trash that Sirius had thrown away: small shiny objects, coins, and a cracked photograph of Bellatrix Lestrange, that was mended with Spellotape. The WWP Sleuthoscope is blazing bright green — going out of its head!! There are treasures in here that we need to dig out. Notice the pipes. Notice the rags. Notice the mould. Notice the cracked glass. Notice the mag**pie** (blackbird? pack rat?) nature of the area. Notice the nest-like bed. Notice what has come out of the bin! We need to start scavenging for big clues (in small packages). Where is that ring? Is it in here? My precioussss!

OUT!

Kreacher is missing, and Harry suggests that when Sirius told him to get out of the kitchen that Kreacher may have taken that to mean "out of the house," and while Sirus didn't think it was possible for a house-elf to leave without clothes, Harry describes what happened with Dobby. The HP Hintoscope is clanging loudly! It is true that Dobby did leave. How was he able to leave? We need to know more about the house elves'"bondage" arrangement to understand.

What binds them in the first place? It could be an actual contract, a pact, or an ancient or magical law. Obviously, Dobby's only retribution for leaving the Malfoys in order to alert Harry was self-punishment. He didn't get hit by a curse or a thunderbolt from the heavens. Of course, Dobby is considered weird (even by house-elf standards). If Kreacher were to leave, where would he go after 10 years in the house?

CHOOSE YOUR WEAPON

Dumbledore isn't looking at Harry; Harry concludes that is because he is possessed and is the weapon that Voldemort will use for his campaign. We have only one thing to say to all this: Rule #4. What other weapons might Voldemort have? He obviously has something on his mind, and we are thinking that it might involve creatures.

DOGGING US WITH CLUES

One of the patients is a woman who had grown dog fur on her face, and instead of talking, she barks. The HP Hintoscope is snarling. There are so many bark and barking words in Book 5 — along with dog and grim clues. Someone is going to die, and we are seeing the Grim everywhere.

FORE BODING

Someone has sent Bode a calendar of fancy hippogriffs and a potted plant with swaying tentacles, which the Healer sets next to Bode. The HP Hintoscope is buzzing like an insect. Would these have come from the old geezer with the hearing trumpet who Harry saw earlier? That's an interesting plant — did Neville get a look at it, or was he too busy being embarrassed by everyone suddenly appearing in the ward?

GRAND LADY

Mrs Longbottom, who is wearing a long green dress with green gloves and a vulture hat, extends a claw-like hand, and greets the kids royally — complimenting Ron's family and acknowledging Hermione by name. There is only one word to describe this lady, so we have to use it: enigma. If you don't know the meaning already, you will understand why if you look it up.

Let's start with the dress and gloves. Green...all green....Slytherin green. It would make sense — Gran is a pureblood and she has very high expectations for her offspring. Nevertheless, she speaks positively of Ron's (Muggle-loving) family, and talks graciously to the Muggle-born Hermione. Compared to the meeting with Malfoy in Book 2, Gran has a lot of grace that is lacking in the other characters — she appears to be descended from nobility. Then again, she wears the vulture hat and is described as having claw-like hands — which are strong Death Eater images. The vulture is also associated with the ancient Egyptian goddess Nekhebet — part vulture and part snake. Sounds a lot like Gran. But is that the intended association? There are many interpretations, and this is just one of them. If you are interested, you can read more in depth about it in Silver Ink Pot's discussion in *The Plot Thickens* fanbook.

BUBBLE BIN

Neville's mother motions toward him and hands him a used wrapper from a piece of Drooble's Best Blowing Gum, which his Gran encourages him to throw away, but Harry is convinced that Neville has saved it in his pocket. The WWP Sleuthoscope has turned bright pink! This hospital is full of bubbles. We are being directed to notice bubbly things. Neville is obviously a "magpie" just like Kreacher. There are some crucial questions that this brings up, which need answers. First of all, who is giving the gum to his mother and should we be suspicious of it? Neville's mum did seem to think it was important that Neville be the one to receive the gum wrapper — does she recognize him at all? If Neville keeps saving her wrappers, what is he doing with all of them? Is there something special about the gum, the wrappers, or is someone (his mother or someone else) doing something to the wrappers?

On Jo's site, she has gum wrappers scattered all over and now has a trash bin. She wouldn't be trying to tell us anything, would she?

CHARMED TO SEE YOU

Gilderoy Lockhart's Healer finds him outside his ward (again), talking to Harry, Ron, and Hermione — she unlocks the door with her wand to let him back in. It is very troubling to hear that Gilderoy somehow is getting out of his ward when the Healer can't even get back in without using a spell. Since the Healer considers him to be a risk to himself, the hospital certainly would not allow him a wand, so how does Gilderoy keep getting out of a locked ward? Could someone in the hospital be "encouraging" him, or is this a case of wandless magic?

FANTASTIC IMPOSTERS

Gilderoy Lockhart is being treated in the Janus Thickey ward. If you are up on your *Fantastic Beasts* Trivia, you would know why Janus Thickey may have needed a ward. We feel really sorry for you if you haven't seen the hilarious account of what happened to Janus, but you can easily remedy that by adding a copy of *Fantastic Beasts* to your sleuthing library shelf. Is it a (cough) coincidence that this ward has a thing for imposters?

KEEPING AN EYE ON GUDGEON

Gladys Gudgeon is writing weekly fan letters to Gilderoy in the hospital. HP Super Sleuths will remember that name from Chapter 6 {" Gilderoy Lockhart"} in Book 2, when Harry had thought that being Gilderoy's secretary was the ultimate detention torture. If you summon your Book 3 scroll as well, you can look back to Chapter 10 {"The Marauder's Map"} and see that it was a Davey Gudgeon who almost got his eye poked out by the Whomping Willow. Is Davey related to Gladys? Why has Gladys taken such an interest in Gilderoy? Maybe these are just random mentions, but they sure feel like Rule #1.

POINTY THINGS

Lockhart shows off his "dazzlingly white teeth" and Harry receives a wallet from Hagrid with "anti-theft" fangs. Fangs, teeth, and pointy things are poking up all over Book 5. There are

also stacks of spindles and other pokey objects, which look pretty mean too. Those stake-like items would be standard equipment for a vampire hunter, but vampires seem to be a bit scarce lately, and our best candidate has apparently been eliminated by Jo. Therefore, we should concentrate on looking for anything suspicious that has teeth. Considering how many things in the magical world have teeth that rightfully shouldn't, how would we know if something like a comb or plant is suspicious? (Maybe Mr and Mrs Granger are missing an opportunity in wizard dentistry?)

Rowlinguistics

✴ Arthur's healer is **Hippocrates Smethwyck.** Those HP Sleuths into sports trivia may recognize the name from your *Quidditch Through The Ages*. (You do have a copy, don't you?) An Eliot Smethwyck invented the Cushioning Charm for brooms — so the Smethwyck family may have a long tradition. His first name is a bit clever. Hippocrates, a Greek physician, is pretty much thought of as the founder of medicine as it's practiced now, and credited with the Hippocratic Oath, in which physicians pledge to do no harm.

Oddities

✴ "Satsuma vs walnut" — Depending on whether you read the U.S. or the UK version, something different was stuck up the nose of the patient. UK readers saw a "satsuma" stuffed up her left nostril, while for some reason, it was a "walnut" for U.S. readers. Since U.S. readers normally would not recognize a satsuma, it is possible that was the reason for the change. The satsuma is a European tradition at Christmastime, and while walnuts are seen at Christmas, they are not as closely associated with it.

Chapter 24 Analysis

What Are the Mysteries in Chapter 24?

This chapter is double 12. It has double the intensity — and notice how intense it gets near the end of the chapter. Can Harry use the tools he learns about in this chapter as he was able to use those from the Mirror of Erised?

A CLUE?

The title of this chapter is "Occlumency." Unearth your *Philological Stone* and use it to reveal the "clue" hiding in the title of this chapter. Pronounce the title word with the accent (emphasis) on the second syllable:

Oc-clu-men-cy

(A clue men see)

REMEDIES

The Healer explains that Gilderoy is improving from his "remedial potions and charms," and then when Snape arranges Occlumency lessons for Harry, in order to hide the real purpose of their lessons, Snape instructs Harry to say that he is taking "remedial potions." Just the description of Gilderoy's "remedial" therapy puts us on our guard. We hate to bring up the "C" word again, but those sound *coincidentally* like the name of the remedy Snape dreamed up as cover for why Harry is hanging out in Snape's office.

FOUR LEGS AND A BANG

With a loud bang, Sirius' chair falls back onto its four legs. Eeek! Don't do that! This feels like a flashback to the scene in Chapter 20 {"The Dementor's Kiss"} of Book 3, when Wormtail escaped. Wormtail had grabbed Ron's wand, then zapped Ron and Crookshanks with a "bang," and, landing on all fours as a rat, got loose of the manacles to escape to Voldemort. Maybe that parallel wasn't intended, but the banging in Book 5 is becoming intense, and the last time it got this intense, someone died. In our first Guide, we related it to the "doom, boom" booming of Moria in J.R.R. Tolkien's *The Fellowship of the Ring*. We aren't sure if they relate, but we do know someone dies in Book 5. L

CAST-IRON CLUES

Snape snidely remarks that Sirius has a "cast-iron excuse" to stay in his "hidey-hole" so as to get out of working for the Order — causing Harry to come "vaulting over the table" to break up the argument. Normally, one or two of those words together would not draw attention, but the juxtaposition of "cast-iron," "hidey-hole," and "vault" makes us wonder if those are there for a reason. It sounds as if something is locked up, and considering we have "Shacklebolt" and other tie-down and chain-like running bits, it feels as if it they are links to someone incarcerated or maybe something stashed in a vault — such as Gringotts.

CASTLING

Harry and Ron are playing chess — Harry is "egging" his castle on to squash Ron's pawn — when Mrs Weasley announces that Snape wants a word with Harry, causing Harry to open his mouth, everyone else to "gape," and Crookshanks to pounce onto the chessboard, chasing the pieces off. Okay...what do we take literally and what is wordplay? The most noticeable is the "egging" his castle part. If you can visualize Jo smirking at us, she could have literally meant egging as in a real "egg" (it wouldn't be the first time one made an appearance at Hogwarts castle).

The cat on the chess board with the pieces running around brings up images of *Alice Through the Looking Glass* — part two of Wonderland. This is yet another mouth open...eyes open...plop down sequence.

The castle chess pieces are also known as rooks. A rook is a blackbird. Most importantly, it is the first part of the name "Rookwood." If the idea is to get us to notice this name and this person, all those tree references might then have something to do with the second part of his name. One interpretation could then be that Harry is egging Rookwood on to squash someone who is functioning as a pawn. Is there any scenario like that?

BUSSICK

On the Knight Bus, Tonks seats three Weasleys together with Lupin, and then upstairs, sends Harry and Ron to the back as the bus bangs on to drop off Madam Marsh, who is not taking all the violent motion very well. Nothing went wrong, but if Tonks is so worried about Harry, why would she send him alone with Ron to the back? Tonks keeps doing strange things. Is it possible that there is another lookout on the bus already? The only person we recognize is Madam Marsh, who sharp-eyed HP Sleuths would know was the carsick passenger on the bus in Chapter 3 {"The Knight Bus"} of Book 3, but we already know from Jo's website that she is basically a "nobody."

PIGWIDGEON'S PANIC

When the Knight Bus lurches and bangs, Pigwidgeon is so scared that he bursts out of his cage, and in a panic, flies up front and lands on Hermione's shoulder. Wow! This says a lot about the little peep. If you check your sleuthing notes from Book 3, you will see that when the flying car crashed into the Whomping Willow, Hedwig freaked too. She had burst out of her closed cage and made a beeline for the Owlery. That seemed to indicate some powerful magic for a bird. Now the little Pig has done the same thing. In a state of high emotion, he has magically burst open the cage door for his escape. The little Pig has some real power! It seems very similar to human children and the way they can do unintentional magic in a highly-emotional state. HP Sleuths should be thinking about Chapter 2 {"Aunt Marge's Big Mistake"} in Book 3, when Harry just wanted out of the Dursleys and the locked cupboard door burst open as he went to retrieve his trunk.

SHIP MATES

When Cho walks up to greet Harry, Hermione grabs Ron by the arm and drags him off to allow Harry and Cho to have some privacy. Okay sleuths... get ready... we are about to make one

of our rare observations about the "shipping" mystery. While it is possible that Hermione doesn't know her own mind, and we can tell that Harry is not quite in his right mind, why is it that neither of them fussed when Harry went out with Cho? Harry is obviously attracted to Cho, and it is Hermione who drags Ron off to leave the two of them alone.

If Jo had said we have to read between the lines to know who was interested in whom, then we could see another scenario locked deep inside their psyches. However, if Jo thinks she is giving hints, then Hermione being so eager to leave Harry with another girl sure seems like one. We don't know too many females who would be willing to leave that scene if they had even a subconscious interest in a male. Harry has had plenty of chances to notice Hermione — Ron has already figured out she's a girl, can Harry be that much slower?

SEEING THROUGH SNAPE

Lupin explains to Harry that some wizards have great expertise in Occlumency like Snape who is "a superb Occlumens," and the better an Occlumens you are, the easier it is to fool people about your emotions (see FAQs). The WWP Sleuthoscope keels over in a dead faint! Uhh...uh... A "superb Occlumens"? He is? He can do what? Now, let's get this straight. We already know that Snape isn't the nicest wizard in the world — he was a *Death Eater*. He has also been hanging out with Lucius "pretending" to still have loyalties to Voldemort. Now we learn that he has supposedly been fooling the bad guys (not to mention what is probably the second most powerful wizard on earth) by blocking his true feelings and nature. So how in the world does Dumbledore know *for sure* where Snape's loyalties lie? *shudder*

DREAM CONNECTION

Snape explains that "time and space matter" in magic, and although there are ancient charms and spells protecting Hogwarts from magical intrusion, they can't protect Harry because of the unique situation with his scar link. The WWP Sleuthoscope is radiating bright green! Surprise...surprise...(as always) Harry is an exception. But if time and space matter, even if the protecting charms and spells don't work on him, it would still mean that the closer Voldemort was, the more powerful the connection, wouldn't it? Harry's dreams started in Chapter 7 {"The Sorting Hat"} of Book 1, when a weak Voldemort was able to penetrate the castle via Quirrell. That time, it was intentional, but Voldemort has not been aware that Harry is now in his head. Is it only because Voldemort is now stronger that their link is so powerful from a distance, or is their distance not so great? Where *is* Voldemort, and why is that link so powerful this year?

LORD WHAT'S-HIS-NAME

Harry asks why he saw through the snake's eyes if he's in Voldemort's mind — to which Snape freaks over his use of Voldemort's name as he unconsciously rubs his Dark Mark — but then explains that Voldemort's mind was in the snake's head at the time. Snape's no chicken, so why is it he won't use Voldything's name and doesn't even want Harry to use it? We can't help but to suggest one reason: Voldemort's a very powerful Legilimens. It makes sense that under some circumstances, just saying the name "Voldemort" may draw his attention. It is a name that he created for himself, and it may have special powers. Notice how Snape rubs his arm when Harry says the name — is that just subconscious paranoia or is it Rule

#4? Could Snape's arm actually ache when someone says the name?

If saying the name does draw Voldemort's attention, that is dangerous. But if it does, why would Dumbledore be encouraging everyone to say the name? We are thinking it might be a case of jamming his radar. An analogy would be if you were in a room and occasionally heard your name mentioned, you might stop and pay attention to see what it's about. If a few people did it, you may still stop and check it out. However, if half the room was saying your name, not only would it be difficult to keep stopping to listen, but it would be impossible to follow all the conversations, so you would be less likely to notice any one person.

HARRY'S SECRET

Snape makes a Legilimens connection between his brain and Harry's, and sees flashes of Harry's abuse as a child, possibly some other memories including the Sorting Hat's recommendation to put him into Slytherin, and then starts to access Harry's intimate moment with Cho, but Harry loses control — stopping him with a Stinging Hex. Touchy...touchy. Like many people, Harry obviously considers his personal relationships to be the biggest taboo to others. But he also has one memory that, as far as we know, he has yet to share with even his closest friends. Strangely, Snape may have gotten a peek at Harry's most sordid secret — the Sorting Hat's attempt to put him into Slytherin. Did Snape see that, and if he did, how did he react to it? Snape claimed he didn't see everything, but except for Ripper, we don't know what he saw.

Harry continually shows his wizarding power through his emotions whenever he performs unintentional magic. We have seen Dumbledore "radiate" power when he is angry, but his magic is quite intentional — he is apparently focusing all that anger into fierce spells. It would seem that is what Harry needs to do with his anger — learn to corral it into a formidable wizard arsenal. That is probably a key to learning how to be a great wizard.

EMOTIONAL TARGETS

Snape makes a second Legilimens attempt on Harry, in which images of Cedric's dead body cause him to break the connection, and even Snape looked "paler than usual" — but Snape is upset that Harry is showing him emotional weaknesses like those who "wear their hearts proudly on their sleeves," thereby "handing him weapons." Clearly, Voldemort's best ammunition is people's emotions — which reveal weaknesses through which he can get to them. Snape considers emotions to be a weakness as well, and wants Harry to block them. There is no doubt that Harry is in need of serious emotional management, but just how emotionless does Harry have to be?

For all his anti-emotional ranting, Snape certainly reacted to the graveyard image. Why was Snape so pale (can he get any "paler")? Could he have been at the graveyard the night of Voldemort's rebirthing? On her website, Jo let us know that Snape can see Thestrals because as a Death Eater, he would have "seen things." What atrocities has Snape participated in?

THIRD TIME'S THE CHARM

On Snape's final attempt, Harry recognizes the corridor leading to the Department of Mysteries but Snape suddenly lifts the spell, saying that there are many things beyond the door that Harry

"wouldn't understand" — yet when Harry tries to ask him about Voldemort, his scar burns as Snape scolds him again for using the name. Why did Snape stop it right there? Notice that Snape didn't become angry for getting so deep inside this time, even though Harry was sure he was going to be. Instead, Snape started coaxing Harry for information. He didn't offer any info of his own, but allowed Harry to work out what he saw without warning Harry if there were any dangers. In fact, Snape made sure it was even more enticing by telling Harry that not only are there many things, but that Harry wouldn't "understand" them — a sure invite for a teenager! Does Snape know what is behind that door? Was he really helping Harry to block?

TOTALLY-HEADLESS

The twins have invented "Headless Hats" which fascinate Hermione due to the fact that they have "extended the field of invisibility beyond the boundaries of the charmed object" — *although she questions whether such a charm could last very long.* We already know that invisibility isn't easy magic, so Fred and George have again shown how clever they are. They have even gone beyond normal magic — enough to take Hermione's attention away from her homework (now that's impressive!).

So, why are we being taught about this? The important parts are 1) that the invisibility (or whatever) can affect something that is not directly contacting or encompassed by the charmed object, and 2) this kind of spell does not last long. We are also being reminded that missing, severed, and not-very-attached heads are a running bit and a key to Book 5.

SCAR ALERT!

Harry is feeling really sick from pain, and goes upstairs, but as he crosses the threshold into his dormitory, his scar sears worse than he has ever felt it — *as uncontrollable happiness pours into Harry's brain from Voldemort.* The WWP Sleuthoscope is emitting super-strong radio waves! What happened here? Obviously, Voldemort's happy emotions were received loud and clear by Harry. Have you noticed that Harry connects with Voldemort's brain most often in the Dorm? One reason might be because he sleeps there, so his brain is more relaxed and receptive. However, this time, he wasn't very relaxed, and he certainly wasn't asleep — he was walking in the door. Could it be that there is something about that room which allows for better "reception"?

What strands did Snape pull from his head and why did he pull them? It could be that they were private, or it could be that he didn't want Harry's Voldy-brain to have access to them.

Curiosities

✳ Fred and George created "Headless Hats" which made the wearer's head invisible. Those remind us of a legendary helmet that belonged to Hades, the Greek god of the Underworld, and was used in the wars with the Titans. According to legend, the one-eyed giants, called Cyclopes, made a helmet of invisibility that made the wearer totally invisible. They gave the helmet to Hades, and it was later used by Perseus to slay the Medusa, who had snakes for hair and turned men to stone by just looking at them.

Oddities

✳ You've seen the picture — a figure in a nightmare landscape, hands clasped to the sides of its head, screaming...it's called "The Scream," and it's by Edvard Munch (Eric Munch was the security guard at the Ministry), a Norwegian who influenced German expressionist painting. If you've seen it, you have to admit it looks a lot like Harry in this book, doesn't it... {www.ibiblio.org/wm/paint/auth/munch/}

Chapter 25 Analysis

(THE BEETLE AT BAY)

What Are the Mysteries in Chapter 25?

MAN HUNT

The newspaper article about the escaped prisoners says Gideon and Fabian Prewett were "brutally" murdered by Antonin Dolohov, while a picture shows Ministry infiltrator Rookwood looking bored. Get out your *Philological Stone* and try it on "bored" — you will see a pun that Rookwood is looking *board*. It has that constructiony feel we have been getting in Book 5.

If you recall, the Prewetts were the two members of the original Order who Mad-Eye said had fought valiantly. Now that we know Molly Weasley was a Prewett, it is important to track the whereabouts of the murderer, Antonin Dolohov. He is a Death Eater, and was convicted of their murders. He is ruthless, and he is at large. Should we be worried that he might try to finish off the family?

THE YOKE'S ON HER

The morning of the news that the Death Eaters escaped from Azkaban, the teachers at the Head Table are stunned — Professor Sprout doesn't even notice her egg dripping onto her lap. Now if that wasn't blatant imagery, nothing is. We have seen egg and breeding references before but this one is hard to ignore. Somewhere...something must be hatching. If so, it could be at Grimmauld Place, down in the Chamber, under London, or even right under our noses at Hogwarts. They're all good candidates and we have had several references that could signify any of them.

UNFLAPPABLE UMBRIDGE

While all the other teachers are stressed out over the escape of the Death Eaters, Umbridge is unconcerned. Why is it that Toad Highness can act as if nothing special (let alone terrible) has happened? There are only a few things that would explain that. One possibility is she was somehow involved (directly or indirectly), so she was expecting it and quite content with it. Just because Sirius said that the world was not totally polarized into Death Eaters and non-Death Eaters, we shouldn't ignore hard evidence. So far, everything the Toad has done has advanced the cause of Voldemort and the Death Eaters. She most likely has her own agenda, but she seems very good at carrying out that of Voldemort's. Another possibility is that she literally lacks emotion. We have seen it before with her. She didn't flinch at Voldemort's name, she didn't react one way or the other with the Thestrals, and now she isn't a bit distracted by the news. Cold fish or slimy toad? HP Sleuths decide.

HEADING UP THE INVESTIGATION

An article in the newspaper only briefly mentions that Broderick Bode is murdered. Do we have any suspects? In Chapter 23 {"Christmas on the Closed Ward"}, we watched the old man with a hearing trumpet specifically ask for Bode, and questioned if that could have been Wormtail or Avery. However, those aren't the only suspects. HP Sleuths who have

diligently been keeping notes may want to check back to their previous parchment and investigate that calendar of "fancy hippogriffs" that Bode received at the same time as the plant. Now, we're not trying to be disrespectful toward a writer (we would never do that), but according to Newt Scamander's bio, his mother is a breeder of fancy hippogriffs. It may be Rule #3, or it may be just another way of inserting hints about headless things.

Eeeek!

There is a rumor among the students that "an army" of Death Eaters are hiding out in the Shrieking Shack and intend to break into the school. Considering that the Dementors are totally absent from Hogsmeade, we can't say that is totally hogwash. Where would a Death Eater hide? If you had a Hitler-like army, would the Shrieking Shack sound like a good place? Maybe not for a whole army.... but what about just one or two? With all the yelling, screaming, and shrieking in Book 5, the Shack does seem a bit suspicious — and now add to that this rumor about it hiding someone (or something?).

Detention Marks

Harry sees that Lee Jordan's hand was cut open from having been to Umbridge's detention. Harry isn't the only member of the "Resistance" to be scarred by the evil Toad. Umbridge is obviously giving out detention marks to other students. Even if it isn't a magical bond, there is surely an emotional tie among those who have received this detention mark.

Snape's Loyalty

Ron suggests that maybe Snape isn't helping Harry, but is instead trying to make it easier for Voldemort to get into Harry's mind, however Hermione "angrily" disagrees — pointing out how many times Harry was wrong about Snape. Hmmm... if this were a normal conversation, then we would just pull out Rule #4 and leave it at that. However, for some reason, Hermione got angry (Rule# 4a). Plus, Jo is getting trickier — it is very odd that she spends a whole scene raising the question that is in everyone's mind and then has Hermione just blow it off. What do HP Sleuths think?

Seeing Through the Trees

Cho is thinking that Oliver Wood had been recruited by the Pride of Portree team, but Harry corrects her that it was Puddlemere United. This is just full of little symbolisms, isn't it? Guess it would be easy to think of a "Wood" going to play on a "Tree" team. (hehe) Another "tree" reference. We know of a couple of important trees — there is the Whomping Willow and then there is the Black Family Tree.

Another extremely interesting symbol is planted in this dialogue. If you consult your well-thumbed copy of *Quidditch Through the Ages*, the emblem of Puddlemere United is "two crossed bulrushes." Considering that Celestina Warbeck already ties Puddlemere United to St Mungo's, the similarity of their emblem to St Mungo's crossed wand and bone should have you boning up on Rule #3.

DOUBLE STANDARD

Cho notices that while there were plenty of Dementors searching for Sirius when he escaped, none were around Hogsmeade looking for the ten escaped Death Eaters. That was very observant, and very scary. Who is in control of the Dementors? If it is Fudge, is Malfoy then controlling him? If it is not Fudge, is Voldemort somehow exerting his influence? (We're keeping a large supply of chocolate handy.)

LUNA'S HEAD IS SWIMMING

Luna dreamily stirs her gillywater with a cocktail onion stick. Why is our attention drawn to Luna and her cocktail? There are several images contained in that one stirring motion. It would surely seem to tie-in to the continual time-related clockwise/counterclockwise themes that run through Book 5. If you use your *Philological Stone* on "cocktail," you will see that it would possibly contain references to both the Basilisk in Chamber of Secrets, and one ratty tail. The dream references are obviously reminders of Harry's dream problem.

We couldn't help but notice Luna's radish earrings earlier when she was walking out of herbology, and people are being hit by turnips. Lots of unusual plant references. Hmmm...do we know any unusual plants?

The "gillywater" sounds a lot like the "gillyweed" that Harry used in task 2 of Book 4 to breathe underwater. If you aren't already drowning in scrolls, HP Sleuths may be able to find your Book 3 notes and see that McGonagall is another person who likes to drink gillywater. What is in gillywater — is it made from gillyweed? Harry didn't seem to think that gillyweed was all that tasty. Not only is this another water reference, but it's yet another thing that makes us think about what is going on under the lake.

RAISING OUR ANTENNAE

Rita Skeeter is really irritated by Hermione's blackmailing — she threatens "...one of these days...," calls Hermione a "silly girl," and Harry is convinced Rita wants to "seize the paper umbrella sticking out of Hermione's drink and thrust it up her nose." We get the point. ☺ But Rita hasn't learned yet! You never call Hermione a "silly girl." This time, however, Rita got a pretty good deal — she didn't have to spend time in a bottle.

Now, did HP Sleuths recognize that imagery of the umbrella? Do you recall a certain troll with something stuck up its nose? In Book 1, Harry stuck a wand up a troll's nose. Then at Grimmauld Place, Tonks (of the changeable nose) is always tripping over the troll leg that has an umbrella stuck into it. Why are we being reminded of that troll? It could be that we are supposed to be thinking "bathrooms."

Rowlinguistics

✳ There were two names given to Rookwood. In Book 4 and in the U.S. version of the story, his name was Augustus Rookwood. However, in the UK version of this chapter, his name is listed as "Algernon" (see FAQs). **Augustus** was the title of the first Roman Emperor (note that all Roman emperors went the way of Julius Caesar). **Algernon**, a nickname from Norman French (aux gernons) translates "having a moustache." This sounds like a disguise. There is an Algernon *Blackwood*, a famous horror writer, and an Ambrose **Rookwood** whose parents were imprisoned in England for their Catholic faith. Later in life he became one of the people who conspired with Guy Fawkes (where Fawkes the phoenix got his name) in the Gunpowder Plot (an attempt to blow up Parliament) hoping that it would turn the country back toward Catholicism. {www.britannia.com/history/a-rookwood.html}

✳ **Antonin Dolohov** does not have much in the way of redeeming qualities. A Czech composer, Antonin Dvorak, who died in the early 1900s, is known (among other things) for his work *The Spectre's Bride*; it is the story of a woman who waits many years for the return of her love, only to have him come for her as a ghost who is determined to take her to the grave with him. {www.ipswichchoral.com}

Curiosities

✳ "Ornithomancy" is (or was) an actual form of divination which dates from Greek and Roman times that involved a lot of bird-watching. Whenever a bird or flock of birds flew overhead, it was deemed to hold special meaning. Wonder if Trelawney hangs out in the Owlery in her spare time. . .

✳ Bulrushes grow in wet areas, so they seem like a natural choice for a team with a name like Puddle Mere. Moses, who led his people out of slavery, was found by the Pharoah's daughter in the water in a basket made of bulrushes ...water, water, every-where, whatever could it mean?

Chapter 26 Analysis

What Are the Mysteries in Chapter 26?

READING, RUNES, AND ARITHMANCY

Hermione is reading Magical Hieroglyphs and Logograms. Considering the huge number of references in Book 5 to Druids and Egyptian mythology, it may be a really good thing that Hermione is practicing up on all that. In fact, she is apparently very skilled if she is playing with logograms. Those are not only Hieroglyphics (see Curiosities), but are used as secret codes — the type of thing Harry did in his letter to Sirius. For example, he used the term "biggest friend," which was meant to represent Rubeus Hagrid, the half-giant professor. Now we are seeing that Hermione is studying that technique. We hope you have studied Rule #1.

SNATCHING THE SNITCH

Showing her Quidditch talents, Ginny plays Seeker against Hufflepuff's Summerby, and catches the Snitch — but assures Harry that when he is allowed back on the team, she is interested in the Chaser position. Was Ginny lucky, or is she that talented? Maybe she's really good at magic. Was it really a coincidence that Summerby sneezed when the Snitch appeared, or was it Rule #3 (maybe we should ask Ginny)?

Have HP Sleuths noticed that the most powerful wizards also seem to be the best Quidditch players? We are learning a lot in Book 5 about wandless magic and the power of the mind when doing spells, and it is beginning to feel as if there may be a relationship with their sport. There is still that issue of where the Snitch hangs out when it's not around and why it never wanders off too far.

Why is Ginny so confident that Harry will be back on the Gryffindor team? Harry has been banned for life, so how could she know for sure? Does she know something we don't? Somehow, we think her performance here should guarantee her a position — and we also need a new captain, don't forget.

If the name "Summerby" sounds familiar, HP Sleuths who regularly visit www.jkrowling.com will have seen that Felix Summerbee, inventor of the Cheering Charm, was the Wizard of the Month for May 2004. Oddly, there was a duplicate of him (doubles) as the Wizard of the Month for May, 2005. It is possible that the surname spelling changed and that the Seeker is a descendent, but even if not, it would seem that we are being told to notice that name. Using the *Philological Stone*, we get a "summer bee." Knowing that "Dumbledore" means *bee*, it may bring to mind an image that many HP Sleuths still chuckle over — Harry's musings in Book 4, Chapter 2 {"The Scar"} of Dumbledore on the beach for summer vacation.

The most interesting part of the Summerbee name is his first name, Felix. According to Jo's site, there is a chapter (14) in Book 6 titled "Felix Felicis." In Latin, the words "Felix" and "Felicis" are the same word — just different forms of it. Unlike "felicitas," which is happiness, "felix" means good fortune. Therefore, it is unclear how we are to interpret these words — except that they seem awfully cheery for a book about a war (?).

OPPOSITE OPINIONS

Some of the letters that Harry receives about his interview in the Quibbler (like the one from Paisley) are pro, some are con — about equally split in opinion as to whether or not they believe Harry — Fred even finds one letter where the person, himself, is "in two minds." There's a big cracking sound coming from the HP Hintoscope. In Book 5, Harry's poor mind is already split (and the Occlumency lessons aren't helping that), the opinions of his readers are split, Dumbledore sees splitting snakes in his instruments, and letters are coming from Paisley. Er...yah, paisley. How does a paisley fit into all this? If you have ever seen a paisley pattern, it is very similar to half a yin-yang symbol, and based on juxtaposition to all those opposite opinions, it does seem to be intended as reinforcement.

SCRUBBED SCROLLS

The students find many creative ways to disguise the newspaper article about Harry that Umbridge banned, including wiping clear the text so it looks as if they are carrying a blank parchment. Book 5 has a lot of vanishing *("Evanesco!")* in it. The magic that students used to hide the pages of the Quibbler article sound a lot like the spell that the Marauders used on their map. From the description, it probably isn't that hard to hide writing on a parchment. Therefore, HP Sleuths will want to carefully inspect blank pages that suddenly turn up. CONSTANT VIGILANCE!

KNEEDING ANYTHING?

Seamus apologizes to Harry while peering at Harry's "left knee." Why would Seamus be staring at Harry's knee? Usually when describing someone who is embarrassed, they are looking at the floor. Okay, so maybe Seamus wasn't looking that far down...but why the *left* knee? That's just a bit too specific. HP Sleuths who have been vigilant will remember that Dumbledore's own scar is above his left knee — and will remember Rule #3.

CRAPPY STUFF

Fred and George have put up a poster-sized version of Harry's Quibbler interview, and enchanted it with a talking spell, but as the spell begins to fade, it just says the words "Dung" and "Umbridge" over and over, in a high-pitched voice. You had better sit down for this one — it will take a bit of tinkering. Go find your *Philological Stone* and use it on the description of the weakening talking spell of the poster. It says that the words "Dung" and "Umbridge" are juxtaposed, and that the words were speeded-up and at a higher pitch. If you try it like a tongue-twister — saying the two words very quickly — in a high-pitched voice, you get "da garbage" — yet another *rubbish* word!

DORM DREAMS

Harry's scar is twinging, he feels sick, and as soon as he gets into bed he starts "dreaming," about a place with a "branch" of candles, "clenched" hands that loosen their "grip," a velvet chair, and Rookwood (a pockmarked, kneeling man), who is "stooped" when he stands and "croaks" as he speaks. So many running bits...so little time. ☺ We had suggested that it was Avery who had killed Bode, but based on this description, it could have been

Rookwood. It is difficult to know if all those running bits are to focus us on this scene, or if these are just more hints. For instance, the croaking may relate to Rookwood or his croaking may be there (just like all the others) to keep reminding us of toads. We now know that both Bode and Rookwood used to work in the Department of Mysteries. There is one more employee, but we don't know his whereabouts. We saw him back in Chapter 7 {"Bagman and Crouch"} from Book 4. Mr Weasley pointed him out as the other "Unspeakable" (Croaker) of "Bode and Croaker." Hmmm... Since we now have seen two Unspeakables, should we be on the alert for Croaker?

Where is this place? It is presumably Voldemort's lair. Is he still in the Riddle house? That is unlikely since it is too exposed and his enemies now know he is re-birthed. There is still the question as to how Dumbledore has been tracking Voldemort all along...how he knew Voldemort was in Albania. Does he know where Voldy is now? This has a feeling of being underground or entombed.

Here we go again... the closer Harry gets to his dorm, the more his scar twinges and the worse he feels. Is there something about the dorm? According to Rule #3, we should be calling in the inspection team.

MUDDLED MINIONS

Rookwood tells Voldemort that Avery's information was inaccurate, and he is sure that Bode, having worked in the Department of Mysteries, would have known that he would not have been able to touch it. The WWP Sleuthoscope is creeping silently around... Let's see...it was Avery who told Voldemort that Bode would be able to remove it. How was Avery's information so wrong? Why would Avery take a chance on telling Voldemort something that he didn't know for sure? (He has to remember the consequences of Voldemort's wrath.)

Let's review what we know about Avery. In Chapter 33 {"The Death Eaters"}, he asks forgiveness and Voldemort replies by torturing him. In Chapter 30 {"The Pensieve"} from Book 4, we are told that Avery had said he was under the Imperius Curse and was thus not imprisoned — which is different from the others who are famous for their killings. Could Avery be a plant? Could he be purposely giving Voldything misinformation?

TWO FACED

Harry looks into a "cracked, age-spotted mirror," where he sees Voldemort's snake face reflected back — he screams, thrashes around in his bedding, falls to the floor where he ends up "flat on his back." The WWP Sleuthoscope is in hyper-mode, bouncing off walls and strobing like a pulsar! We can see how the running bits (mirrors, spots, and cracks) all fit together into a monster hint about the septology. HP Super Sleuths will have recognized that mirror description. Back in Chapter 9 {"The Writing on the Wall"} of Book 2, we see that in Moaning Myrtle's bathroom there is a mirror described as "a large, cracked, and spotted mirror." It also mentions a damp floor, stubs of candles, plus scratched and flaking wooden doors. This is bad...this is really bad. Why would Voldemort have a mirror that is apparently identical to Moaning Myrtle's? We know from Book 2 that he has strong ties to that bathroom. Where is Moaning Myrtle? If this is any indication of the things going on, we should care.

Harry seems to be doing the snake and Satan routine again — the open mouth, sliding to the floor, and now "flat on his back" parallelism to Milton. He isn't dreaming, and he isn't possessed here, but his brain is connected to a snake man.

SHOCKING NEWS

Hermione thinks Bode would have been under the Imperius Curse, but was told to grab the weapon, and on doing so, was shocked out of his curse. That means a big shock can shake off the Imperius Curse — keep that in mind. It also means that whatever Bode touched must be pretty powerful since not only did it blow off the curse, but it put him into the hospital. It is interesting to note that he was cursed through the Invisibility Cloak — therefore, keep in mind that the Cloak is *not* a shield against spells.

GRANTING WISHES

Harry "wishes" that he could talk to Sirius. The HP Hintoscope is playing an Arabian tune. Harry needs to think harder about how to contact Sirius. ...But you knew that already, didn't you? Sometimes wishes are granted, but we don't stop to see that the answer has been handed to us — if only we would open our eyes and look.

WHAT SNAPE KNOWS

During his Occlumency lesson, Harry sees the scene where Dudley tried to put him in a toilet and the image of Rookwood kneeling — which causes Snape to break their link and demand how Harry managed to see "that man" and "that room" — to which Harry just stared at a dead frog in the office. Hmmm...why would Snape say "that room"? Does this mean Voldemort is in the same "hidey hole" he was in last time he was so powerful, or is this a new place? If it is a new place, it would mean that Snape has been there and seen it. Which would then mean that Snape knows where Voldemort is hiding out. Septology alert!

Once again we see the words "toilet," "staring," and "frog" juxtaposed with Voldemort's hideout. Does Myrtle's bathroom have any relationship to him still? *shiver*

SNAPE'S JOB

When Snape reprimands Harry because it's not his business to find out "what the Dark Lord is saying to his Death Eaters," Harry rebuffs with a little sass by saying that is Snape's "job" — which Snape proudly assures him that it is. It is? We don't get much detail, but it is now confirmed that gathering information on Voldemort is what Snape believes to be his mission. How does he accomplish it? By playing the role of cowardly Death Eater? If Snape is playing the role of coward, then he probably would not have been at the graveyard scene — as Voldemort was informing those present about who was *missing* (which included the cowardly one). Snape is fairly close to the Malfoys — which is probably why he treats Harry so badly in class — so Draco can go back and report to his father how many terrible things Snape does to Harry and how he loves Snape so much. But is it all an act?

Even with all this information (actually, because of all this information), Snape is still a complete mystery. The more we learn, the more complex and questionable his

character becomes.

We have been told about Snape's skills as an Occlumens, but he must be truly exceptional to be able to hide his true allegiance from Voldemort...or is he hiding it? We can't yet feel safe about his true allegiance until we know more. Dumbledore isn't perfect — he has been fooled by at least Fake Moody (not sure about Quirrell). If Snape can fool Voldemort, can he fool Dumbledore? To whom is Snape loyal?

For a fan-tastic discussion on Snape and his loyalties, HP Sleuths might want to check out the articles by Alexander Benesch (Stic) of Germany in *The Plot Thickens* fanbook.

TROUBLED MINDS

During his Occlumency lesson, Harry fights back and ends up in Snape's memory where he sees a boy crying in a corner as a hook-nosed man yells at a woman in a corner, a greasy-haired teen in the dark — wand aimed at the ceiling as he zaps flies, and a girl laughing at a boy who is having trouble getting on a bucking broom. Who is the hook-nosed man — is it Snape's father? Was Snape also an abused kid? If so, look at the choices that he made...

As a teen, Snape is greasy-haired and killing flies for no reason. The greasy hair image reinforces what we have seen with other wizards. It may be just the way that Jo describes her Dark Wizards, or it may be that there is a physical correlation between Dark Magic and greasy hair. Borgin, the shopkeeper at the Dark Arts shop, Borgin and Burkes, from Chapter 4 {"At Flourish and Blotts"}, was described as "greasy."

Another "ceiling" reference looms overhead...otherwise known as Rule #1.

Why was the broom bucking? Is it like a horse — knowing the rider was fearful, or did the girl jinx it? Rumor does have it that Snape was jealous of James at Quidditch. ☺

DOOR TO HARRY'S MIND

When Harry breaks through the door, for some reason, Snape is even more upset than he was when Harry saw into his memories. It is this total contradiction that is fueling fan debates. On one hand, Snape almost seems to be doing whatever he can to make Harry's mind *more* open, but then he turns around and scolds Harry for allowing his mind to be too open. Could this be a ploy so that Snape can pretend to be helping Voldemort by purposely opening Harry's mind up just a wee bit so Voldemort will think Snape is on his side...but then when Harry doesn't work hard enough at blocking, Snape gets upset because Harry allows him in *too* far? If so, that is really, really dangerous! Snape is playing with Harry's mind, and the security of the Order — not to mention that Harry is still just a 15-year-old kid, whose mind is mixed up enough without having to share it with a bunch of roommates.

THE POWER OF WORDS

Harry asks Snape why Death Eaters are the only ones he hears call Voldemort "The Dark Lord," but before Snape can answer, they are interrupted by a scream. Now that is interesting. Jo is making a point, but which point is she making? We actually have seen people we didn't consider to be Death Eaters uttering that name. So, is Harry doing a Rule #4, or is this a septology clue about all the people who have used the name? Who has called him "Dark

Lord" besides *confirmed* Death Eaters? There are several:

Crouch Sr	Dobby	Phineas Nigellus	Ernie Macmillan
Crouch Jr	Kreacher	Trelawney's Possessor	

If we are being slyly told that those who use the name are most likely Death Eaters, we have some powerful evidence here....

Dobby: It is easy to understand why Dobby would use the name since he spent his whole life in a family of Death Eaters.

Kreacher: We understand why Dobby would use the name, but why would Kreacher use the name? Does this mean the Blacks are Death Eaters after all or does he have a personal relationship with the Malfoys (or both)?

Crouch Jr and Sr: Thinking about the Crouches, this may help answer the question from the graveyard scene about the Death Eater who was most loyal to Voldemort (see FAQs). If Crouch Jr was a Death Eater, that means Karkaroff is the one who Voldemort intends to kill, and it then tells us that he thinks Snape is playing the cowardly role. It also raises many questions about who really taught Crouch Jr his Dark Arts skills, and where Crouch Sr's loyalty was.

Trelawney's Possessor: In mythology, it is a deity who usually takes possession of the prophetesses, while in modern fortune telling, it is typically a dead relative. Who (or what) possessed her and why would that spirit have used the term?

Phineas Nigellus: Phineas' use is a bit disconcerting. We already have seen the allegiances of many members of the Black family. If there is a chance that he is at all affiliated with the Death Eaters, then he could still be dangerous — even if he supposedly has a "duty" to serve the current Headmaster — considering we don't know enough about that commitment.

Ernie Macmillan: Ernie is the most bothersome since he is playing the upstanding citizen role and has demonstrated that he can influence a lot of his peers — and even lead them down the wrong path. He is potentially the most dangerous of all if this is, indeed, a clue for us to ponder.

Exit at the Entrance

Sybil Trelawney is in the entrance hall with two trunks, one upside down; her glasses are "lopsided" so one eye looks bigger than the other, and she is making a scene as Umbridge is attempting to expel her from Hogwarts — but Dumbledore appears and intervenes. Why did the Lord High Toad choose Trelawney as her first victim? That is a good septology question that will be touched on later in Book 5.

Are you eying those "lopsided" glasses? It seems as if most people with eye correction are looking like the mythical Cyclops. It could also be that we are to notice the spectacles, themselves. Some of those spectacles could be magical, but if so, we are being held in the dark. The trunks are also asymmetrical — one is up while the other is down — yet another yin-yang image that may relate to Harry's mind or may hint at things up above or underground. Where else have we seen someone associated with trunks and uneven eyes

making a spectacle of themselves before? Mad-Eye Moody's entrance in Chapter 12 {"The Triwizard Tournament"} of Book 4. Why are we being reminded of that scene — do we have an imposter or someone watching?

Rowlinguistics

✳ **Paisley**'s a weaving *town* in Scotland — it's also the *name of a fabric pattern* that resembles half of a yin-yang symbol. In the 1800s Paisley became famous for the shawls they wove using this pattern, which had evolved from designs used in popular shawls originally imported from Kashmir. Kashmir had a long weaving history — its invasion by several groups, including the Mughals, made a real difference in its patterns. Mughals...hmmm...why does that sound so familiar...(Muggles?)
{www.victoriana.com/library/paisley/shawl.html}

Curiosities

✳ Hermione is reading *Spellman's Syllabary*. A "syllabary" is a kind of shorthand, with syllables reduced to single characters. That may sound complex, but not only do you have your *Philological Stone* to help you out, many of you HP Sleuths practice it when u r chatting /w ur buds on the inet. This is most likely another hint that Jo is telling us to play with syllabary when trying to pick up on her clues.

✳ "Logograms" are the pictures used for ancient Egyptian *hieroglyphics*, They are also used for creating coded messages because one word can be used to mean a whole thought or phrase. It is similar to saying "D-day" — which would stand for not only a specific date, but for the whole operation that is to take place on that date.

Chapter 27 Analysis

What Are the Mysteries in Chapter 27?

SUBTLY POISONOUS

Lavender and Parvati bring Trelawney some daffodils. That was very nice, wasn't it? Maybe. If you are at all familiar with your herbology, you will automatically know it was also another reminder of poison. Daffodils may look nice, but are known for being very poisonous (and they just happen to be of the genus Narcissus).

START PROGRAM

Firenze is teaching out of Classroom 11 — which is a rarely-used classroom on the main floor near the entrance, and which Harry perceives as a "cupboard or storeroom." Isn't that sort of the way the Room of Requirement was described? Gred and Forge had used the Room as a cupboard, and we are still wondering if Harry and Hermione may have used one when hiding in the hall just after they time-turned in Book 3 (this classroom is in about the right place for it).

The transformation of this classroom is similar to what was done for the "Yule Ball" in Book 4. Is this a permanent transformation? The way the Room of Requirement functions is very similar to a "holodeck" (a room in Star Trek which you can program to look and act like anywhere in the universe, or even places out of fiction). The difference may be that this classroom holds the same environment and you don't have to "wish" it into existence, but there is nothing to prove or dispute that. How are those two rooms alike or different? We don't have enough information on either of them to know precisely.

MOON MARK

The centaurs have left a scar in the shape of a hoof on Firenze's chest where they kicked him. Scars must be the new fashion statement — Harry is famous because of his scar and now they all want one. Unless it is an unusual scar, the general shape of Firenze's scar will not be as detailed as the hoof that made it, so it is most likely in a general crescent shape. Moon imagery is very prominent in Book 5. There are moon characters (Luna), there is moonlight, there are moon shapes (crescents), moonstones, and there are Dumbledore's half-moon glasses. Jo has tons of crescent moon shapes all over her site (note especially the coffee stains). She must be telling us that there is yet more to be revealed about moons in Book 6.

HEAVENLY EFFECT

Firenze's classroom darkens to show the sky overhead, where a "twinkling red star winked at Harry." (Note the planetarium-like effect when the light dims.) Would the "sky" in Firenze's classroom be simulated or real?

How many times have we heard the words "twinkling" and "Dumbledore's eyes" juxtaposed? Err...is "winked" another one of those figures of speech? Maybe this time it isn't

Dumbledore, but when stars shining Gryffindor-red are "winking" at Harry, those are the kinds of metaphors that become the magic of this series. Is someone keeping an eye on Harry?

That "red star" (aka the planet Mars) should also bring back memories of Harry's first encounter with the centaurs. Four years previously, the centaurs could already feel the change in the tide of events, and were predicting bad things. Ronan and Bane kept talking about how red Mars looked that night. Firenze now verifies that what the centaurs have seen was that the wizarding world is still in the middle of a big war, and here in the classroom, we now see the red planet "winking" mischievously at Harry. That's cruel.

JARRING BELLS

Forgetting they were indoors, everyone jumps when the bell sounded for the end of class. This jarring bell can be grouped into the noises of Book 6 as another ringing type of clue. It is also a story-line clue — but even if you got the clue, it is not too useful at this point in time.

FOEGOTTON GLASS

Dobby risks a lot to warn Harry of Umbridge's raid. Wow! Talk about loyalty...after two years out of work, that little guy put his only job on the line to warn Harry of the danger. Hopefully Harry appreciates that loyalty.

The most disconcerting question, though, is why did Dobby have to warn Harry? This *is* a defense class, and they *did* have a Foe Glass hanging in there. Was Harry just too distracted to notice, or was it not working properly? Whose Foe Glass was it, and does the crack have anything to do with its functionality? That crack is also a bit familiar. Does it have any relationship to the mirror in Myrtle's bathroom or the mirror that Voldything looked into when Harry was sharing his brain?

STOOLPIGEON DROPPINGS

Willy Widdershins, the one who was rigging the Muggle toilets, was spying for Umbridge at the Hog's Head pub. If this is the "Will" who Dung had been referring to, then that frog story of Dung's suddenly becomes a whole lot funnier. ☺ And if, indeed, it was Willy, then the other frog and dung references (not to mention some of the "headless" hints) throughout Book 5 could have been nudging us to make the leap of logic that would point us to Willy at the Hog's Head. Would all the hag hints also apply to Dung and his hag disguise?

THE REAL STORY

Fudge accuses Dumbledore of inventing fantastic stories about Harry such as "a reversal of time, a dead man coming back to life," and then he throws in a reference to an "identical twin in the Hog's Head," which Percy laughs at like a joke, in spite of it being intended as biting sarcasm. Ahem...Do we take Fudge literally or not? Everything else he said was true in some fashion — so would this be true too? If you consider that Harry is of two minds, you could say that he *and* his "twin" were present that day. But it still makes you wonder. Based on the Geomancy attribution of Albus as Gemini, in *The Plot Thickens*, S.P. Sipal postulated in her

essay if Albus and Aberforth may be twins. While there is no direct canon to back that, it would be another demonstration of choices over genetics.

Doesn't Percy's laughing and obvious fawning bother you? Have we seen anyone else like that? Those are not the actions of a brave Gryffindor, but are the pandering of an insecure lemming (creatures that would die rather than question where they are being led).

COMING TO HER SENSES

Kingsley "whispers" a quick spell, which causes Marietta to forget why she betrayed the DA and gives a blank look to her eyes. We learn some important lessons about spells here. First, we see that Kingsley can just "whisper" a spell. Is this something that anyone can do, or is it the skill of an Auror? Either way, we are beginning to think that the magical world is a very dangerous place — not knowing what is reality and not necessarily being able to trust your own senses.

We had already seen that blank look before, and now it is reinforced here on Marietta. Spells that affect the brain will cause the eyes to have a blank or distant look to them. That is why it is so important to see people's eyes, and why we are highly suspicious when we don't — and especially when we are told that someone is purposely avoiding the eyes. Of course, in Dumbledore's case, we are assuming he has his reasons — especially since every time Harry gets a good look at the Headmaster, he wants to take a bite out of him.

A SWEET TREAT

One of the former Headmaster portraits is of Fortescue. The name Fortescue has been hanging around since Chapter 4 {"The Leaky Cauldron"} of Book 3. You may run across Florean Fortescue if you ever visit Diagon Alley. HP Sleuths can unroll your Book 3 scrolls until you find him helping Harry out with the history of witch burnings while he served Harry ice cream at his shop. We don't know if there is any direct relationship, but we are betting there could be.

MIRROR, MIRROR

When Marietta looks at herself in Umbridge's mirror, the traitor sees that Hermione's spell caused purple boils to break out all over her face, spelling out the word "SNEAK," and she is so embarrassed that she won't speak — prompting Umbridge to call her a "silly girl." Too bad Myrtle isn't around — she would love to see that someone has it worse than she does (hehe). Why do we find out about Umbridge's mirror? We might want to reflect on the significance of mirrors as we already know they do more than just show one's image. The mirror in the Leaky Cauldron and the one at the Burrow talk back, and given all the *Alice in Wonderland* parallels in Jo's novels, there is probably a lot more to them. In our first Guide, we had postulated that they were a means of communication. So far we haven't seen any proof of it, but we need to keep our eyes open!

Yet another person who uses the term "silly girl." Maybe it is just a nasty put down, but since most of them have dealings with Dark wizards, maybe Jo is implying that they have all come into contact with someone who uses the phrase a lot?

JOLLY GUY

Umbridge informs Fudge that Madam Edgecombe, Marietta's mother, is in the Floo Network office of the Department of Magical Transportation, and is spying on the Hogwarts fires for them — to which Fudge replies, "Jolly good, jolly good!" It would seem that at least some of the sharp teeth we were supposed to be watching out for are in the form of "combs." Like mother, like daughter? Unfortunately, without more information, it is impossible to know whether the Edgecombes are just totally misguided or if they might be Voldemort supporters. They are dangerous either way; however, some enlightening may help if they are only misguided.

This may have gone over our heads if it were not for the article in the *Quibbler* about Fudge wanting to steal the Goblin gold. Fudge's repetition of the "jolly" words are highly suggestive of the "Jolly Roger" — the name for the pirate flag. Knowing that Fudge is heavily involved with St Mungo's, the Jolly Roger and the emblem of crossed wand and bone are just too much of a coincidence. (Check Rule #3)

BURNING QUESTION

Umbridge keeps asking Marietta to tell what she knows, and is so furious that Marietta doesn't testify against Harry that she starts to shake her rudely, but Dumbledore raises his wand, and Kingsley "started forwards" when suddenly a surge of power causes Umbridge to release her. Now this is interesting. HP Sleuths should recognize that this is the same kind of magic that caused Uncle Vernon to release Harry in Chapter 1. Who actually caused the shock that stopped Umbridge? Dumbledore's wand was raised, but as far as we can tell, no spell was cast. Kingsley is very quick, and he could have sent another fast spell as he was moving forward, but no spell was uttered. Of course, it could have been wandless magic, but unless he really is a genie, could he have done that as wandless magic? Nevertheless, he is still the most likely candidate. There are still other possibilities... We have no idea how powerful Marietta is, so just like Harry did with Vernon, if deep down she was conscious of being shaken, she could have sent out her own surge if she didn't like it. There is also the possibility that someone else entirely was responsible. Dawlish? How about Harry, himself? Harry was upset enough, and we already know he has that trick up his sleeve....

Considering what the black quill has done, it is evident that the Terrible Toad has no concern about the feelings of students. Dumbledore was upset that the Toad was shaking the student that hard. However, was concern for the Sneak the primary motive for Dumbledore's reaction? We have an example of how a shock to Bode broke a strong Imperius Curse — so maybe a strong shaking could have helped jog Marietta's memory?

If Dumbledore is concerned about shaking a student, how would he react to the detention quill? We're not convinced that Dumbledore knew about the quill.

WE WANT ANSWERS... WE WOULD LIKE ANSWERS... PLEASE GIVE US SOME ANSWERS...

Umbridge wants to catch the students "red-handed," so needing evidence of the illegal student meeting, she has Pansy Parkinson go into the room and Pansy conveniently finds the list of DA members. She did say "red-handed." (hem-hem!) There are so many "damaged hand" references associated with the Stubby Toad that you can't help it when your brain starts connecting the two. How could those relate?

The workings of the Room of Requirement are complex and powerful, yet subtle. It is

such an intriguing room with so many interesting properties, that we find we have more questions than answers. In order to understand better how this Room works, these are some important questions that need to be asked....

Who created the Room? If creatures such as Dobby can call it, can creatures such as Crookshanks or a ghost call it? Does the Room only offer one kind of theme at a time? For instance, will it provide a section with chamber pots if Dumbledore needs it at the same time it is providing for the DA? Can the room supply something that contradicts the purpose intended by the person who initially calls it? Is the person who first conjures the Room the only one who can control the contents or can anyone who then enters call something up? Based on what happened with Pansy, the implication is that she had a requirement of evidence, and the Room provided to her in spite of the fact that it was initially called by someone else. We don't yet know enough about this room, but these are important questions that need to be asked in order to make sure that the Room doesn't become a trap instead of a help.

DUMBLEDORE'S POWER

Dumbledore refuses to be taken to Azkaban, explaining that he could easily break out, so it would be "a waste of time." Now we understand why Voldemort might fear Dumbledore. Not only can Dumbledore see through him, but his power is awesome. This demonstrates a whole other subject that is only subtly introduced into Jo's story. Differences between people make the world interesting and good, but they also allow for inequalities that can be perilous. We can laugh at Dumbledore's sarcasm, but the fact that Azkaban couldn't even hold him is a very scary concept. It is the same condition that caused Voldemort's initial arrogance and subsequent megalomania — superior powers. When people become very powerful they have a responsibility to those not so powerful. Voldemort took advantage of his superiority to hurt others, while Dumbledore doesn't use his unless he needs to put things right.

DUMBLEDORE'S PLANS

Dumbledore tells them that he is not going to go away — but that Fudge "will soon wish he'd never dislodged me." Now why does that sound an awful lot like Peeves? (lol!) Where would Dumbledore stay if he is in the area? Would he stay in Hogsmeade or would he hang out inside the school grounds? We still don't know what kind of creature his Animagus is. (The former Transfiguration teacher *has* to be one, doesn't he?) We speculated a bee like his name, but we have also been told on Jo's website that his Patronus is a phoenix. Therefore, we have no way of knowing what to look for. CONSTANT VIGILANCE!

SPOTTING DOTS

Percy is so eager to transcribe the events that he spatters ink all over his face. More dots and spots? Hmmm... this would seem to imply that Percy is also a Sneak (which would make sense if he is acting of his own free will).

PICTURING PHINEAS

According to Sirius, Phineas Nigellus is Hogwarts' least popular Headmaster. We assume that means the least favorite "so far." Obviously, Phineas isn't very popular as a portrait either. We understand that these portraits are "duty-bound," but if house-elves can defy their masters without serious consequence, is there anything preventing these portraits from defying the current Headmaster?

MARCH OF THE CLUES

Professor McGonagall "marches" them out of the Headmaster's office. This chapter began with thoughts about a "dull March," and ends with McGonagall on the march. Considering that there is a war beginning, the military imagery is drilling into our brains. Dumbledore's Army may yet be called upon to show what they learned.

Rowlinguistics

* There was a **Fortescue** in the time of King Henry the Eighth who probably made it into a portrait or two, though we don't know if this is the same as the one in Dumbledore's office. Adrian Fortescue was distantly related to Anne Boleyn, Henry's second of six wives, and was known for being a quiet, careful man. His hobby was apparently collecting wise sayings, and he acted as a justice of the peace at some point. He was condemned untried and executed, for reasons never made clear at the time — later examination showed it was probably because he was a Catholic. He was beatified (the first step to sainthood) about 350 years later.

──────────── Curiosities ────────────

✳ In order to conjure a Patronus, you have to be able to concentrate really hard on a happy thought and be a fairly powerful wizard. And even if you get that far, to be able to do it in the face of mortal danger is asking a lot. On the other hand, in Book 1, Ron was all frustrated because he couldn't even lift a feather, but when faced with danger, he was able to knock a troll out with his own club! Just for the record, here are the Patronuses that Harry's class has been able to produce (or not):

> Cho Chang — a flying swan
> Hermione — an otter
> Lavender — only silver vapors
> Neville — only wisps of smoke (trying to think of something happy enough)
> Seamus — very briefly something hairy

✳ A "cock and bull" story may be a reference to the myths of Nergal (means *dunghill cock*), a popular ancient idol in Phoenicia, India, and Persia, which additionally related to Osiris, who was known as the Egyptian bull. So a "cock and bull" story would imply a mythical story.

✳ When Dumbledore escapes from his office, the possible scenario for who did what and who made what sounds is:

> McGonagall — the hand who brings Harry and Marietta to the ground
> Shacklebolt — the "dark figure"
> Umbridge — the "shriek" and "thud" (because a "shriek" would most likely be female)
> Dawlish — the "No!" (because he would have been upset about Umbridge going down)
> Dawlish — then attempted a spell and was floored
> Fudge — the "frantic scuffling" (realizing all was lost, tried to get away — and he would also have been the last one Dumbledore would have worried about since although he is most likely more powerful than Umbridge, he would probably have been relying on his minions rather than getting his own hands dirty)

Note — the order of the last two wizards could be reversed if Dawlish made a final stand instead.

──────── ✦ ────────

Chapter 28 Analysis

(SNAPE'S WORST MEMORY)

What Are the Mysteries in Chapter 28?

A PUMPKIN AND FUDGE PIE

After Dumbledore's spectacular exit, there are some strange rumors about what occurred (including Fudge being in St Mungo's with a "pumpkin for a head"), but Harry is surprised that the rest of the information is quite accurate. There were several times in the series when it was difficult to imagine how anyone would have known anything at all. For instance, in Book 1, everyone knew about their journey through the trapdoor, and in Book 2, everyone seemed to know what happened in the Chamber. How would anyone know what happened if someone didn't tell? In this case, there was only Harry and Marietta. Considering Marietta doesn't remember anything, and Harry isn't talking, how would the rumors have gotten out? This seems to imply a huge security leak. Is it one of the portraits, is there a "bug," or is there an implication that Ron or Hermione is the source? What do HP Sleuths think?

The most famous pumpkin head we know is "Jack Pumpkinhead" from the land of Oz. Add this "Jack" to your list of "Jacks" from nursery rhymes. If you think about the shape of the toy "jacks" that kids use to play with, you will see that they are crossed in 3-D. It would appear that this could be the intent of all those jacks.

DUMBLEDORE ON THE LAMB

Headmaster Umbridge asks Harry to her office in order to pry information out of him (using Veritaserum) about where Dumbledore and Sirius are hiding, but Harry notices a picture on her wall of a kitten with big blue eyes like Mad-Eye's, which reminds him to be alert. The HP Hintoscope is keeping mum on this one. Even though Harry says he doesn't know where Dumbledore is, and even though he really doesn't, based on Dumbledore's own last words to Harry before he escaped in the previous chapter, HP Sleuths have a good idea that he has not gone far. Where would Dumbledore stay if he is in the area? He could stay in Hogsmeade (he does know someone there who might have a spare room), or he might be hanging out inside the school grounds. He must know some really interesting, little-known places.

Should we be suspicious of the blue eyes on that kitten? First we have planets "winking" at us, and now we have a kitten staring at us with Moody-like eyes. It is a bit unnerving.

FREAKY FIREWORK

The twins have set off fireworks which create total chaos, and out of his dorm tower, Harry sees silver-winged piglets, and fireworks that spell out "POO." Yes, more dung. However, there may be more to those fireworks than just a rude word. If you think about the way you view fireworks, they are up in the sky and can be seen from any direction. Both the UK and U.S. versions of Book 5 do not punctuate it at all — it is a straight POO without anything else. That would mean if someone were to view it from the ground or a different tower, they may see it spell out OOP. If you get out your *Philological Stone*, and set it upside down and backwards — you will see Jo's little wordplay. (Hint — **Order Of the Phoenix**) ☺

DOORS AND ADORING

Harry drifts off to sleep and enters farther into his corridor dream than ever before — he sees a circular room lined with doors, then enters a room with mechanical clicking, and finally gets to a room with towering shelves holding "spun-glass spheres" — but before he can investigate, he is waked by Seamus saying that the fireworks look "like they mated." The WWP Sleuthoscope is dancing around the HP Hintoscope. Something or someone is driving Harry toward those spheres. Since we already know that Voldything is sharing his brain, it would make the most sense to assume he is the one controlling this. However, we are not given enough information to know for sure the dynamics of these "dreams." And why are they becoming so strong? Is it because Harry hasn't been practicing his Occlumency, or could the lessons or other influences be causing these images to grow stronger? Snape would know.

The mating of the fireworks would seem to be additional reinforcement that something somewhere has mated. Grimmauld Place already has things breeding in it — but it would be nice to know if we are talking mould or monster. Otherwise, should we be concerned about the Chamber or anywhere else? How about in the lake or under the castle? *gulp*

MEMORY LANE

While viewing Snape's memory of OWL exams in the Pensieve, Harry hears Professor Flitwick address a student by the name of Stebbins. HP Sleuths may not remember his face, but we have met a Stebbins before. In Chapter 23 of Book 4 {"The Yule Ball"}, Professor Snape blasted the rosebushes away to reveal Fawcett and Stebbins together. What relationship would the Stebbins that was a classmate of Snape and Harry's dad be to Harry's current-classmate? The only thing we know is that the younger Stebbins is in Hufflepuff House.

As this scene in the Pensieve is some 20 years previous, we can see that Professor Flitwick would have taught (and be familiar with) most of the Hogwarts students. This could be really useful if, in a war, they turn out to be your opponents. ☺

EYES OF THE BEHOLDER

While in Snape's memory, Harry watches his father write out the initials L.E. on his exam paper. Let's clear up the easy mystery first. We are assuming those initials would belong to Lily Evans, Harry's mum. Now for the brain-beating mystery — how is it that Harry was able to go back into Snape's memory and yet see what James had privately written on his paper. How did that get into Snape's memory when he could not have possibly seen it? This is very complex magic, and we don't have all the facts. It would appear that the Pensieve picks up all events — even those which are not accessible to the original observer. So, does that mean by using the Pensieve, Snape can go back and watch his own memory from another perspective — see things he could not have seen originally?

I PENSIEVE, THEREFORE I WAS

In the Pensieve, Lily asks James what his problem is with Severus, and James responds it is merely that "he exists...." At the time we wrote *New Clues*, we were thinking this was yet another suggestion about Snape being a vampire — and that it was related to prejudice. However, now that Jo drove a stake clean though that theory, we need to look for other rea-

sons. What would James mean by that? Why such animosity? Is this an indication that James was as extreme about Dark Wizards as Crouch Sr was?

OVERHEARING RULE #4

In the Pensieve, Harry observes Snape walking out of the exam (still reviewing his paper) following the Marauders, and when the Marauders sit, Snape sits, and as Lupin reads, while James, Sirius, and Peter discuss their monthly adventures and their boredom — Lupin looks up from his book to suggest if they are bored, they could help him study for Transfiguration. It would be nice to know we could trust Snape, but here is another example of how he may be the instigator and the stalker. In Chapter 10 {"Luna Lovegood"}, we see Luna pretending to be reading, while she is obviously listening to what is going on around her. Now we see Lupin supposedly reading, but he is monitoring his friends' conversation. Is Snape really that engrossed in his paper, or is he as attentive as everyone else?

OWLS are given at the end of the 5th year, and we know from Lupin that in their 5th year the Marauders learned to become Animagi, and Sirius tricked Severus into going into the tunnel under the Whomping Willow. From what Professor Lupin told the kids in Chapter 18 of Book 3 {"Mooney, Wormtail, Padfoot and Prongs"}, Severus did not know about Remus until he was tricked by Sirius. Did the "trick" occur before or after the OWLs, and did Severus overhear any of that conversation (they were using their Animagi names)?

JO'S "JOKE"

While viewing Snape's memory, Harry sees Peter Pettigrew totally captivated as James monotonously catches and releases a Snitch — so after several minutes of this, Harry can't believe that James just didn't tell Peter to "get a grip on himself." That gives Sleuths a good look at the personality of the wormy little ratfink. This is not a leader — this is a person who needs to follow others, and is very good at playing the game of sucking up to the Big Marauders On Campus. (barf!) This is also a little joke by Jo — Harry thinking it would be nice if Wormtail got "a grip on himself" — especially with his new silver super hand. ☺

BUBBLE, BUBBLE, COIL, AND TROUBLE

James humiliates Snape in front of all the other students — turning him upside down (letting his dirty grey skivvies show), and then cursing him so pink soap bubbles ooze from Snape's mouth. It was difficult at the time to understand why Snape had gotten so upset when Harry walked in on him with his robes up as Filch is tending to his leg wounds in Book 1. However, now we understand it may have been just too much of a parallel. The pink soap bubbles had to have been the worst, though. They sooo look like pink bubble gum, don't they? We are thinking Neville's mum...we are thinking Jo's website...we are thinking *gum wrappers*. We also are wondering if the pink is hiding something in Snape's words. What do HP Sleuths think?

VANISHING SLYTHERINS

Montague, who Gred and Forge had stuffed into a Vanishing cabinet, reappears on the fourth floor inside a toilet. We already know who was responsible for the regurgitating toilets, and

we know all about Dung's dealings, so why another toilet reference? We are still worried about Moaning Myrtle and her bathroom.

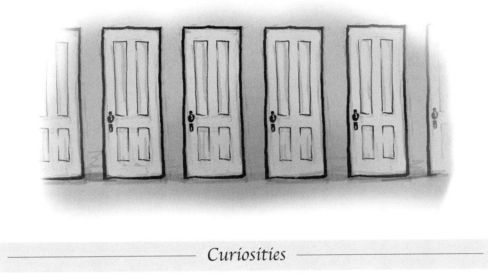

Curiosities

— There are several definitions and uses of the word "mate" — you can check the FAQs to get some ideas as to how they could be hints.

— All those "flying pigs" are curiouser and curiouser. The music groups Pink Floyd and Caravan refer to flying pigs, but the more famous line comes from (what else) *Alice in Wonderland* when the Duchess is being particularly toady. Alice states "I've a right to think," and the Duchess answers, "Just about as much right...as pigs have to fly..."

Chapter 29 Analysis

(CAREER ADVICE)

What Are the Mysteries in Chapter 29?

FUNNY RON

Ron jokes that the likelihood of Gryffindor winning the Quidditch Cup is about the same as his father becoming Minister for Magic. Looks like a Rule #4, Corollary "b" to us. However, when asked if Arthur would be the new Minister for Magic, Jo responded on her website with, "Alas, no." This does not sound good for either Arthur or the Wizard community. We can always hope that Mr Weasley will be the following Minister (if he lives).

NOT-SO-FUNNY

Harry gets all weird upon receiving an Easter Egg — he has to talk to Sirius. Harry's getting sentimental... He's also in need of a parent who will care for him, and Sirius is that parent. Harry's emotions are starting to drive his needs — which isn't surprising considering he is already emotionally-deprived thanks to the Dursleys. That is becoming a weakness for Harry.

The egg, itself, is a big tie to Grimmauld Place. It ties to the breeding and to Kreacher's nest, plus it draws Harry to Sirius.

FAITH — WEASLEY STYLE

In spite of it seeming impossible, Ginny is convinced there must be a way for Harry to talk to Sirius — based on her experience with the twins that "anything's possible if you've got enough nerve." It's not bad enough that there are magical things going on that would normally seem impossible, but now we are told that these wizards think "anything's possible." Of course, there are Muggles who believe the same thing, but the word "anything" takes on a whole new meaning when there's true magic behind it. Should we be asking her to define "anything"? Watch out for Ginny!

MR AND MRS

Harry sees the resemblance of Ron and Hermione to Mr and Mrs Weasley. We see some really nasty land mines ahead. So, we're not getting in the middle of it. ☺

RED POWER

Madam Pince is raving over chocolate in the library — prompting a little "damn" out of Ginny. We are aware that Ginny is growing up and becoming more powerful. However, this also begins to give us the idea that she is a no-nonsense type of person.

THE LONG AND SHORT OF IT

Professor McGonagall, who "towered" over Umbridge, talks to Harry in "ringing tones." There

are more bells tolling again. Is this another death knoll like we saw developing through Books 3 and 4? *shiver*

It also brings up images of bell towers. Does Hogwarts have a bell tower?

ON GUARD

As Harry gets ready to break into Umbridge's office, he hides behind a suit of armour and pulls out his Invisibility Cloak — as the helmet of the suit of armour "creaked around to watch him." Is it just us, or were you worried when you saw that head turn? Totalitarian Toad makes it clear that she has spies everywhere. Can we trust the suit of armour not to notify her somehow? This just seems odd that it didn't bother Harry. He obviously knows what he's doing...right?

KREACHER KOMFORTS

Harry gets through to Remus Lupin, who says Sirius is upstairs looking for Kreacher who is (as always) "hiding in the attic." The HP Hintoscope is howling like a ghoul. Is Kreacher really up in the attic? How does Sirius know? Just how big is the attic that he can't easily find Kreacher? You would think by now Sirius would know all of Kreacher's hiding places up there. What is up in the attic that would amuse even a deranged house-elf for that long? Is it full of family heirlooms? Are there any other places a house-elf might hang out? We shouldn't trust Kreacher no matter what, and it would be good to find out what the notorious Black family and/or Kreacher could be hiding up there.

EXIT AT THE ENTRANCE — PART 2

During the twins' exit from Hogwarts, they are surrounded by a "great ring" of students — many of them covered in what appears to be Stinksap. It just has that feel of "the one ring." There is something important about rings, bells, and circles. Circles are everywhere in Book 5, and this has the feel of the ancient ritual circle — similar to Stonehenge. It fits with the spoked wheels, the Avebury hint, and all the calendars and astronomical references. But where did all the Stinksap-like stuff come from? Did the twins actually use Stinksap? (They probably have a good supply of it by now.) Neville didn't mention it, but you never know. The more unusual the item, the more intrigued they are with it — and that rare a plant would have been a big temptation for them. Hmmm... Could they be breeding more Mimbulus mimbletonias?

EXIT... STAGE UP!

Fred and George summon their brooms, which break away from the chains on the wall, and they fly off — as Umbridge yells for someone to stop them. Why doesn't she just stop them herself? Does she just not want to break her little fingernail, or it is beneath her to go chasing the nasty students? Could she be afraid of the twins? (If she's smart, she should be. ☺) Why also does she have the brooms chained Muggle-style to the wall? Is that just for display, or is it the best she can do to secure them?

151

Rowlinguistics

✦ **Gregory the Smarmy** was also mentioned in Book 1 — the twins had found a secret passage behind him their first week of school. Smarmy means *hypocritically, complacently, or effusively earnest; unctuous*. Good name for somebody who's hiding something! Gregory the Smarmy seems to be located on the 5th floor, east wing — at least that's where the remains of Fred and George's swamp is...

Chapter 30 Analysis
(GRAWP)

What Are the Mysteries in Chapter 30?

STICKY SWAMP

The swamp left by Fred and George seems to be impossible for Umbridge and Filch to remove, but Harry is sure that some of the teachers would have been able to remove it easily. Why would such an important Inquisitor have that much trouble removing a silly swamp? Is that because of her "unusually short" wand? Is it possible that the Stubby Toad is almost a Squib? Would that be why she relates so well to Filch? (They do deserve each-other.) This gives yet more credence to the theory that longer wands and fingers mean more power.

MASTER OF CHAOS

Peeves is reveling under the new management — he is taking every opportunity he can find to create havoc — and is even being helped along by McGonagall! Wow. It looks as if there is a bit of suppressed rebellion in Minerva after all — go girl! ☺ It would also seem that Dumbledore knew what he was doing by keeping Peeves at Hogwarts. The little fiend has been a big help in ensuring a constant state of confusion and strife for Her Toadiness.

So far, we know a lot about Peeves — and not much at all. A poltergeist is supposed to be a troubled spirit, and Peeves is certainly trouble. He is solid and can move things, and at the same time, he can become invisible and pass through walls. Poltergeists tradition-ally are tied to an individual, and are considered a subconscious manifestation of a human's emotions.

WWP now has a theory about who/what Peeves is and why he's allowed to stay at Hogwarts. If we look to the sci-fi genre, we find some evidence. What if, like in *Forbidden Planet*, Peeves is a manifestation of the Id — drawing his essence from the highly-potent magical field surrounding Hogwarts? Could Peeves be Dumbledore's Id? Dumbledore did say, when he escaped from his office, that Fudge would regret removing him from Hogwarts — and Peeves certainly is making Umbridge regret taking over. On her website, Jo talks about the character she would most like to be — Peeves "causing mayhem and not bothering." So since Dumbledore is Jo's alter-ego, it seems plausible that Peeves could be Dumbledore's puckish spirit.

Makes us wonder if Peeves would disappear if Dumbledore were to die, or if the id in Peeves is strong enough that he would continue to exist? Typically, the poltergeist goes with the person who instigates it, but even if he is Dumbledore's we don't know how this works in Jo's world.

TEA FOR THREE

In Charms class, the trio is practicing making teacups walk, but the legs on Harry's cup are too short and "wriggled pointlessly" in the air, and the "thin, spindly" legs on Ron's cup are too weak so it topples over and cracks in half, while Hermione's cup has "sturdy little willow-patterned" legs and jogs around the table in circles — until it runs off and falls on the floor when she becomes

distracted. These are like walking "running" bits. ☺

So what does it all mean? There are several possible analogies.

One way to look at them is (going by the reference to the "willow pattern"), to look at them as the Marauders. Using that analogy, Harry's cup, which is "wriggling pointlessly," would represent Peter (who is missing a finger, so he is "pointless"). Ron's cup, which is quite fragile, would represent Lupin, and the "crack into two" could refer to the fact that he is both human and werewolf simultaneously. Hermione's would represent Sirius, galloping along on his four padfeet.

Another analogy would be to see them as creatures. Harry's is clearly snakelike, Ron's is spidery, and Hermione's is a lot like her otter.

Similar to that, they can also represent fears — Harry's of turning into a Slytherin, Ron's of spiders, and Hermione's of failure (as hers runs off the desk). Note Ron's teacup trembling knees (although that could be reminding us of a certain knee scar).

Using them as divination tools for Harry, alone — we see some scary predictions. The snakes and the Wormtail reference indicate that Wormtail is up to no good (we have to get out the mousetrap), the cracking in two of Harry's brain, and the scampering of Sirius around Wormtail, and then...oops! Better hope not.

You could also interpret them as each person's personality. Right now, Harry is fairly dysfunctional at times due to all the problems he is having, Ron is at war with his inferiority complex, and Hermione is fairly confident (as always). Overall, just as it seems magic is tied to the personality of the wizard, this could be showing how their personalities interact with their magic. Are the boys' fears and lack of confidence manifesting itself in their magic? Hermione has no specific fears (other than flunking) at this time — so she produces a happy running teacup.

THE BRAINY ONE

Harry thinks that his guilt about his dreams may be due to the part of his brain that "often spoke in Hermione's voice." He does? It does? Is there room for anyone else in Harry's poor head? These metaphors are killers. If it were not for the fact that in this magical world dreams are not just imagination, and people do actually share brains, we would let it sit, but it would be a disservice to let this go unmentioned. It is probably just another reminder about Harry's splinched brain, but given how powerful Hermione is, she may have some Legilimens skills of her own going on here.

SEEING BLACK

When Harry and Hermione go to visit Hagrid before the Quidditch match, they find him with a bloody nose and two black eyes. More eyes, and both black, have an uncanny resemblance to Dobby's painting of Harry in Chapter 23 {"Christmas on the Closed Ward"}, which Fred thought looked like a gibbon. As discussed back in that chapter, with Harry's brain being so full of the heir of Slytherin, and the gibbon being monkey-like, it brings to mind that monkey-like statue of Slytherin where the Basilisk was living. If you think of that monkey or that snake with two black eyes, it sounds a lot like what happened to the snake after Fawkes got through with him, doesn't it? And now, we have two black eyes again. Rule #1.

Don't Hurt the Messenger

Hagrid has been trying to teach Hermione's name to Grawp — but shortened it to a Giant-comprehendible "Hermy." The name "Hermy" is just like "Hermes." Besides being the name of Percy's owl, Hermes is the messenger of the Greek gods. We have seen numerous references throughout Book 5 to Hermes (Mercury in Latin) — including his helmet of invisibility, his tie to the Worm Ouroboros, and his caduceus. The hint could be about anything, but is most likely warning us via Rule #1 of the entwined snakes of the caduceus — which recall Dumbledore's deduction of "in essence divided."

His Cup Overfloweth

Harry and Hermione see Ron proudly holding his Quidditch Cup. If you reflect on this scene, you may recognize that we have seen this image before. HP Sleuths will recall that in the Mirror of Erised from Chapter 12 of Book 1, Ron did see himself with a badge and the Cup. While what is in the mirror is only what one *desires* and is not a prediction, it shows that Ron's desires are very strong, and have happily been fulfilled. It also may be a little more of an indication of his possessing some divination skills.

Another Tree Uprooted

Harry is thinking about Grawp pulling trees up by their roots. We are thinking about the Black family tree and Neville's squirty plant. They're not very happy images.

Rowlinguistics

※ The name of the centaur, **Magorian**, presented quite a challenge, and while we might be stretching, we found out some interesting, if sad, things, that might tell us where Jo got the name.

We know she likes to use place names for characters. In the second half of 2003, Jo went on safari to Africa with her family — obviously a place of special interest to her since, according to her Canadian publisher, Raincoast, she worked at Amnesty International on "human rights abuses in Francophone Africa." There is a camp in Magoro, Katakwi, (near Uganda) filled with people whose lives have been devastated by constant civil war. Could she have been familiar with Magoro and named the new character to honor the people who lived there?

---※---

Chapter 31 Analysis

(OWLs)

What Are the Mysteries in Chapter 31?

RON'S RIGHT

After the Quidditch match, Ron goes on about the maneuvers he used — describing all the back and forth, left and right. Ron is helping us to see things from another perspective — the trouble is, we are confused as to what that perspective is. We are sure this is another hint about Harry not knowing which part of his brain is reality. But there is more to it than just Harry's brain. It is demonstrating the difficulty of knowing reality when everything is reversed. It should remind you of a mirror-image, which is a major theme in Book 5.

MIXED MEANIES

When Harry and Hermione tell Ron about Grawp, he reminds them of the problems with all of Hagrid's previous "monster mates." This play on words has us worried. We are already nervous that something is breeding. Would Hagrid be involved in experimental breeding? He does have his hands full with Grawp, so it isn't likely he has much time for "pets." What monsters are mating?

BRAIN BOOSTER

The upcoming OWLS inspire illegal sales of purported brain-enhancing substances such as Baruffio's Brain Elixir. We have seen this name before — do you recall? If not, we have a little elixir you could try. ☺ HP Sleuths can check their Book 1 scrolls about Professor Flitwick's class in Chapter 10 {"Halloween"}, where he discussed the importance of pronunciation in spells — and if you notice, an elixir from Wizard Baruffio may have undesirable effects....

KID BITS

While preparing for OWLS, Hermione keeps picking up and putting down her silverware, while her fork falls from her limp fingers onto her plate. Since we have seen so much nursery rhyme imagery, the tableware could be a tie to "Hey Diddle Diddle" or associated with the final scene in *Alice Through the Looking Glass*. However, the most important association is that limp/non-working hand. It is nagging at us that Wormtail has to be close at hand (or at least busy doing something we should know about).

CONVENIENT CLOSET

Professor Marchbanks asks where Dumbledore was, looking around as though he might "emerge from a broom cupboard." Note the juxtaposition of Dumbledore with Marchbanks. Why the mention of a broom closet? Could it be that our wanted Headmaster is hiding in a broom closet? That is not so far fetched when you consider that the Room of Requirement is a broom closet — at least it was for Fred and George. ...And Dumbledore is in need of a place to stay (not to mention a chamber pot).

157

STARTING TIME

Professor McGonagall turns over an "enormous" hour glass to start the OWL exams. Yes, she got our attention. It wasn't a big, oversized, large, or even a huge hour glass — it was an "enormous" one. We are being told to notice it. So, what do we see? We see several analogies: hour "glasses," glass spheres that are tempting Harry, and a super-sized time-turner. They are all important, but they may not relate to one-another.

ONE SIDE MAKES YOU TALLER...

During his Charms exam, Ron inadvertently turns his dinner plate into a mushroom and Harry grows a rat to several times its normal size. Harry's still at it — still inflating things when he gets stressed out. If you have visited Wonderland, you will immediately recognize the imagery. It was a mushy that helped Alice to grow or shrink in size — depending on whether she nibbled on the left or right side of it. There is a Horklump mushroom mentioned in *Fantastic Beasts*, but unless Fred and George have figured out what to do with it, the only use it has is as a fungus. The fungus references are bothersome since, if nothing else, fungus is certainly growing at Grimmauld Place. We do keep seeing things that remind us of a certain rat who likes to change size, and his juxtaposition to the fungus...er...mushroom is suspect.

RUINED RUNES

After the OWL exams, Hermione discusses how she mixed up ehwaz (defense) with eihwaz (partnership). She is saying that the "eye" makes all the difference. That is evidence of Norse mythology links, since Odin is the one-eyed god.

Eihwaz, the 13th letter of the Rune alphabet means *yew tree*, and is associated with the Norse god Odin. Some experts consider that Yggdrasil, the tree of life, was a yew tree. They are tied to immortality as well.

Ehwaz, the 19th letter, is from the Old German word for horse, and is also connected to Odin. It loosely translates to "travel" as the horse was the most convenient way the Norse had to travel. Besides partnership, it can also mean marriage (shippers take note).

NEFARIOUS NIFFLERS

Someone managed to sneak another Niffler into the office of Umbridge — and it attempted to remove a "chunk out of her leg." *Fantastic Beasts* lists the Niffler as "gentle and even affectionate" — the only things that get them excited are precious metals and shiny objects. So, why would this cute little loving creature try to take a chunk out of someone's leg? Is it possible that they aren't full-blood Nifflers? The only logical thing we can imagine is that our High Inquisitor has something shiny attached to her leg that attracted the Nifflers attention. But what?

We are seeing several legs with chunks out of them. In Chapter 9, Moody took a chunk out of a chicken leg, and then in Chapter 22, there is a witch in St Mungo's with a peculiar chunk out of her leg that is now smelly. Moody, himself has a bum leg, so that adds to the mystery.

SEEING STRANGERS

During Divination OWLs, Harry interprets the tea leaves to mean that Marchbanks will be "meeting a round, dark, soggy stranger" and then, during palmistry, tells her she "died the previous Tuesday." Harry thought the exam went badly. ...Did it? Doesn't the name "Marchbanks" sound a lot like a river or lake? How do we know she doesn't hang out with the Giant Squid? As to having already died, how do we know for sure she isn't being impersonated? We are still on the lookout for Dumbledore and/or Tonks to be in disguise — considering that we were told outright that Dumbledore would be lurking on the premises.

STAR HUNT

Here is an Astronomy OWL quiz for HP Sleuths:

1. What warrior is in the constellation of Orion?

 > Answer: Orion was a giant and a hunter/warrior, who was placed into the sky as a constellation when he died.

2. What is Orion's companion constellation?

 > Answer: The big and little hunting dogs, Canis Major and Canis Minor, follow him through the sky.

3. What is the brightest star in Orion's companion?

 > Answer: Alpha Canis Major, known as Sirius.

SIDEKICKS

When trying to remove Hagrid from Hogwarts, Umbridge brings Dawlish to help her. Who did Fudge bring to confront Dumbledore about Harry's Defense meeting? Dawlish seems to be very eager to help Umbridge and Fudge. Dumbledore did say that Dawlish excelled in his NEWTs. He seems like another Percy, doesn't he?

OWL OBSERVATIONS

While Professors Tofty and Marchbanks are administering the Astronomy OWLs, everyone stops to watch as Umbridge and her squad stun McGonagall and attempt to take Hagrid — prompting Professor Tofty to remind them to finish their exam. HP Sleuths should observe the events during the Astronomy exam very carefully. We see that both professors started the exam, but we seem to stop seeing or hearing from Professor Marchbanks just about the time that the disturbance started. We have seen possible hints that she may really be Dumbledore, Tonks, or someone else in disguise. Did she go to the scene, herself? (himself?)

BUZY BEE

During the History of Magic exam, Harry is distracted by a wasp buzzing loudly. Hmmm....a buzzzzz. Was Harry sure that was a wasp? Do we know anything else that buzzes? A Dumblebee perhaps?

GOBBLEDYGOOK

During History of Magic OWLs, Harry doesn't answer the question about "wand legislation" and the effect on the goblin riots, and he guesses at a question about a breach in the Statute of Secrecy in 1749. More goblin references, and not good ones. How do wands relate to goblins, and why does there need to be wand legislation? Professor Binns — help! These laws will only work if everyone abides by them. We can only hope....

SEEKING KNOWLEDGE

As Harry's brain isn't working very well during exams, he wishes very hard that he could retrieve information from Pavarti's head via Legilimency — oddly, the information comes to him. We've all had that happen to us, so it does happen by chance. On the other hand, he may have really accessed it. Is it even possible to do that in Jo's world — to go after a specific piece of information in someone else's brain? We don't know enough about how Legilimency operates, but according to what Snape said, it doesn't sound that easy.

Rowlinguistics

✴ **Knarls** sound like interesting critters—take their final "l" off and you get another knot reference, and a tree reference too, as a knar is a *knot in wood*.

―――――――――――――――――――― *Oddities* ――――――――――――――――――――

✳ The year 1749 may be significant for vampires. We cannot confirm it, but there are two possible sources for vampire legends from that year. Dom Augustin Calmet is said to have written a book, published in 1746, but revised and reissued under a slightly different title in 1749, called *Traité sur les Apparitions des esprits et sur les vampires ou les revenans de Hongrie, de Moravie etc.* This book had quite a following and was considered responsible for inflaming a vampire craze throughout Europe. It was also translated into English and was the first major book in English on vampires. It is still cited today as a pivotal work on the subject. There is also a general belief that in 1749 that the naturalist Georges Buffon actually labeled the Desmodontidae bat as a vampire bat and implied that they sucked the blood of humans. Muggle scientists say that is wrong, but the magical world may just be covering up another breach in security. ☺
{www.muse.jhu.edu/cgi-bin/access.cgi?uri=/journals/eighteenth-century_life/v021/21.2huet.html&session=16629323}

Chapter 32 Analysis

(OUT OF THE FIRE)

What Are the Mysteries in Chapter 32?

HEARING VOICES

After the dream in which Harry sees Sirius captured, a "voice in his head" says "Ron and Hermione." Would that have been a real voice, and if so, why? (Where's Snape?) Hermione did say, back in Chapter 10 of Book 2, that hearing voices in your head is not a good thing.

TRANSMISSION PROBLEMS

As Harry is being held captive by Umbridge, she calls Snape into her office to fetch some more Veritaserum, and Harry tries desperately to convey the information about Sirius to him telepathically — but Snape seems oblivious to his thoughts. It could be said that Snape is close-minded (groan). Is it really possible for Harry to transmit like that to Snape? Did Snape receive any images? Harry did not think he got through, but maybe he did. Many wizards must possess some Legilimens ability, so this may be a situation where Snape intentionally blocked his mind so that Umbridge could not read his thoughts (and a possible lie about the Veritaserum).

HERE, BOY

When Snape informs Umbridge he has no more truth serum, her response is that she is highly disappointed because "Lucius always speaks most highly" of him. This reinforces a close relationship between Umbridge and Lucius. So...how closely is she associated with the Death Eaters?

There is obviously a very strong tie between Lucius and Snape as well. In Chapter 24, Sirius had accused Snape of being Lucius' "lapdog," and now Umbridge says he comes highly-recommended by Lucius. Does Lucius treat his lapdogs like he treats his house-elves? *GW looks for a big rock to hide under before speaking* ...And are we being told to trust the lapdog?

MENTAL TRAPS

When Harry decides that they must rescue Sirius, Hermione tries to caution him not to fall into a trap, as he tends to have a "saving-people thing." The HP Hintoscope is playing a superhero theme. Hermione is usually right, except when emotional (Rule #4), and she seems pretty cool-headed right now. So, we probably better heed her advice. Traps are everywhere, so be careful where you tread — there is good reason to be wary whenever the Chamber is discussed.

BAD ELF

Harry sticks his head into the Grimmauld Place fireplace where he only sees a deserted room,

and thinking he hears a mouse, sees it is Kreacher with bandaged hands. The HP Hintoscope is screeching! Sirius isn't around, and Kreacher isn't going to divulge anything to Harry. Kreacher has been very sneaky and you can tell that he isn't as mindless as people are being led to believe — he has an agenda of some kind. Kreacher's definitely been up to something — just look at his hands.

PLAYING WITH THEIR PREY

After Harry is caught using the fireplace, he sees that Draco is now holding his wand — and tossing it into the air and catching it. Playing with your prisoner's wand seems to be a characteristic of a twisted, egotistical, bad guy. So, who do we know that fits that mold? HP Sleuths might want to check your Book 2 scrolls for the scene in Chapter 17 {"The Heir of Slytherin"} when the memory of Tom Riddle first encounters Harry.

DOES HE HAVE HIS OWN GLASSES?

Hermione tells Umbridge that they have been looking for the expelled Headmaster in the Leaky Cauldron, the Three Broomsticks, and the Hog's Head — to which Umbridge responds by calling her an "Idiot Girl" and scoffing at the idea that Dumbledore would be sitting in a pub. Uh ohhhh...What did Toady call Hermy? She shouldn'ta done that....

So where is Dumbledore? Would he be hanging out in a pub? This is a guy who wraps the most precious gem stone (Philosopher's Stone) in plain brown paper — so why not sit in a pub while the whole Ministry is looking for him? Of course, we know that the Hog's Head is, indeed, quite a likely place anyway...

TAKING UMBRAGE

To make Harry talk, Umbridge threatens to use the Cruciatus Curse, but when Hermione points out it's illegal, Umbridge responds with "What Cornelius doesn't know won't hurt him," and admits to having sent the Dementors after Harry because the Ministry would not act to stop him. Well, at least one story-line mystery is solved — we know who sent the Dementors. The questions still remain as to how the Toad was able to send the Dementors without Fudge or anyone else knowing, and how they knew exactly where to find Harry. Was Dung's cauldron deal part of Umbridge's plan? How extensive is her network? If the Dementors are truly within Ministry control, then why would they attack a Muggle?

This woman is fanatical — but who is she following? In Chapter 14, Sirius tells Harry that "...she's no Death Eater" — but these actions make us question Sirius. She also doesn't seem to care what Fudge thinks when she wants to use the curse. She is certainly a pure-blood bigot, but using Unforgivable Curses goes beyond mere intolerance — those are the actions of a Death Eater. And everything she does helps Voldemort achieve his goals. If she isn't a Death Eater, Umbridge is doing an awfully good job of impersonating one.

BLIBBERING

The Chapter begins with Harry "gibbering," and by the end, Snape is offering him a "Babbling Beverage." There is a bundle of baby talk in Book 5. Some of it, like the Nearly-Headless

food talk, is intended to show us techniques that we can use throughout. However, mated with the nursery rhymes and other references to young foals, there are numerous hints about children and offspring. There is a good chance it may correlate with the breeding theme. If so, we are very interested in knowing where the nest is or what sapling we should be watching.

Rowlinguistics

* Harold **Dingle**'s surname is another tree-type word. It means *a wooded valley or dell*. {Oxford American Dictionary}

Chapter 33 Analysis

(FIGHT AND FLIGHT)

What Are the Mysteries in Chapter 33?

BAD GRAWPY

As Grawp reaches out to grab Harry, he knocks over a snow-white centaur. So far, this is the first snow-white centaur we have seen, but we did not catch his name (not that he had time to give it). Does a snow-white centaur have any special significance? Is this a slightly different breed than the others — in the same way a snowy owl is from a different part of the world than a barn owl? Or could he be an albino centaur, or even part unicorn? Maybe his snowiness is because he is an old, venerable centaur — like a Dumbledore among their herd. Could this be someone who is disguised as a centaur? Maybe he is just another centaur, but it feels as if he was brought to our attention for a reason.

OH...THAT GINNY

When Ginny is determined to join the rescue party, she makes a face that looks so much like Fred and George that it is "striking." This is the most overt sign we have that Gred and Forge's personality traits have truly rubbed off on Ginny. We have been told that she was sneaking into the brooms when no one was around, and she has made it very evident that she has no trouble tossing Dungbombs or causing a bit of hallway havoc. We can see which side of the family she takes after. ☺ Although, actually, she does have a bit of all members in her. She's got the catlike qualities of her mum, the brains and power of her idol, Bill, the tolerance of her father, the flying talents of her brother Charlie, loyalty like Ron, and the nerve and enterprising spirit of the twins. (Percy doesn't count.) We are going to really enjoy seeing more of Ginny (hope, hope).

LET'S TALK THESTRALS

Luna says they should fly by Thestrals to London to try to rescue Sirius — especially since Thestrals are skilled at finding their rider's desired destination. Magical creatures certainly have one up on Muggle beasts. Wow — Thestrals could be really useful! We are sort of curious how they do it. Like owls, they must somehow understand human speech. We want to know more about them, but there is scant information on these rare creatures in *Fantastic Bests* under the "Winged Horse" listing. We still would like to know more about animal communication.

Thestrals may also finally explain why Hagrid (who has problems flying brooms), said in Chapter 5 {"Diagon Alley"} of Book 1, that he had flown to get to Harry at the cabin. And how Dumbledore flew to London and back so quickly in Chapter 16 {"Through the Trap Door"}.

Rowlinguistics

The title of this chapter, "**Fight or Flight**," is also used in medicine as a "fight-or-flight response"—a name given to the various systems in the body's response to stress. Chemicals are released that prepare the muscles and nervous system for swift response, and give access to an intuitive, less-planned-out (but hopefully still successful!) way of coping.

Chapter 34 Analysis

──────── What Are the Mysteries in Chapter 34? ────────

THESTRAL DRESSAGE

Everyone struggles to mount their Thestrals except Luna, who chooses to ride side-saddle, and when they land, everyone practically falls off their mounts, except Luna — who "dismounted smoothly." So, how many strange and exotic beasts has Luna been riding? Any with a crumpled horn? Even Harry, who has one of the fastest racing brooms, and has ridden Buckbeak, found the ride to be difficult. As Luna is named after the goddess of the hunt, it is not surprising that she has a special way with beasts. We would not even be surprised if she can calm the wild ones.

COOL BLUE

The rooms are lit by candles burning with cool blue flames. Blue Alert! This is not the first time Sleuths have run across blue flames. Hermione was able to put one in a jar, and in Chapter 8 {"The Deathday Party"} of Book 2, Nearly Headless Nick had black candles with blue flames. What seems to be unique about blue wizard flames is, unlike blue Muggle flames, they are cool so that the jar could be held, and Nick's party room was practically freezing. The orbs burn warm, so the room needs to be cooled with blue-flame candles. It would appear that this is the wizarding version of refrigeration. Cool!

CAUTION — BRAINS AT WORK

The kids enter a room that contains only desks and a large glass tank in which brains are drifting around. From the descriptions, we cannot be sure they were human, but they still made Hermione nervous. In any event, brains are not usually self-powered, and these drifting ones seem to be a bit over-ambitious. Is this a tank with brains, or is it a brain tank? ☺ There are groups of people who come together to try to solve very difficult or near-impossible tasks — called "think tanks." These think tanks are usually made up of people with extensive experience who have a lot of knowledge from which to draw in trying to figure out solutions. This almost has the feel of stockpiling the brains of the most learned wizards together — only without their bodies — to be consulted as needed. Based on Hermione's reaction, however, these brains appear to be somewhat hostile and dangerous. Could someone be studying them?

X MARKS THE SPOT

In order to make sure they know which of the many doors in the rotating circular room they entered, Hermione marks the entrance they used with a "fiery X," and later marks another door with a "fiery cross." Wow! Hermione's clever brain is a life saver at times. After all those X and cross symbols inside of circles, it would seem that this room is the focal point for that imagery. It is a circle with 12 doors around it — on face value, a giant clock, which reinforces all the 12s and time-related references. The appearance of the room creates an effect just like Stonehenge with its monoliths standing upright in a circle — and it spins

with its spoke-like exits just like a bicycle wheel.

Calendar and time imagery is very strong even in this room. We do not get a good sense as to whether the rooms in the Department are larger than the space allocated, or if they fit perfectly. It is possible that each door leads to a different time/dimension, but there is no proof that they do. In classical works, there is Vitruvian man, which relates to the spinning wheel and is assuredly worth studying, but does this room point to physiological, cosmological, or septological hints? WWP is leaning toward the wheel of Taranis. That wheel encompasses many of the themes that are running through Book 5 (see Curiosities).

It would be logical to assume that the running bit of the "cross in a circle," or "wheel" would have been related to the spinning room and that we already have the answer on that. However, on Jo's website, she has continued the theme of crosses in the center of circles. You can see it in her trash room — there is a spinning top in there with a circle and spokes, and in the rubbish bin, where if you move away from the screen a bit but look carefully, you will notice that the rim of the wastebasket also has four subtle notches in it — creating the crisscross effect inside the circle (Rule #3). Therefore, we need to look for other possible meanings.

The most confusing thing is how people find out how to use the spinning room. Is this room well-known or is it normally a secret? Most importantly, who built it and why is it there?

SIREN SONG

The kids enter a stone amphitheater containing an arch at the center with a slightly-fluttering, hanging black veil, from which Harry, Luna, Neville, and Ginny think they hear voices (Ron and Hermione do not) — and Hermione needs to drag Harry away as he listens, entranced. The HP Hintoscope is sobbing. There is danger here. HP Sleuths who are keen on Homer's *Odyssey* and their Greek mythology, would recognize an effect similar to that of the deadly Sirens (see Curiosities). But why this from a tattered old veil? And, why these four — why not all of the kids? They are not the same kids who could see Thestrals, since Ginny also heard the voices (unless her near-death experience at the pen of Tom Riddle counts). One strong common element among those four is the Stinksap which got Harry, Neville, and Ginny, plus "spattered" Luna's magazine — and may have also touched or affected Luna. Could this be the meaning of the dots, spots, and flecks hints we keep getting?

What is the significance of the veil? There is a legendary "veil" separating the worlds of the living and the dead. This veil is supposed to be very thin and fragile, and given the right circumstances, on occasion people in legend have been able to cross that boundary. Is this the veil between those worlds or is there another world or existence behind there? We have no information except that it is very ancient and very black. That means ominous to us.

STONES

The room with the veil has a "great stone pit" surrounded by stone benches. Stone and stones are everywhere in Book 5. We see stones being thrown, lots of stone floors, steps and walls, stone pillars with stone gargoyles on top, stone slides and stone basins, moonstones, Rune stones, Gobstones and even hailstones once.

In Book 2, there was a creature who turned people to stone. We have been wondering if there might be another Basilisk being raised in Book 5. There are certainly enough references to hint at that.

As a metonym, "stone" has an allegorical meaning which was used to mean "Peter" in the Bible. We do have a missing person by the name of Peter, and whatever he is doing would probably be important (assuming Voldy trusts him to do anything).

Stones can also evoke images of ancient wonders like Stonehenge, and this veil seems to be of at least that age. Therefore, there could be a link between them.

SEEING THINGS FROM ALL SIDES

When Harry and the rest of the kids are viewing the veil, it is swaying, "as though somebody had just passed through it." The WWP Sleuthoscope is quivering at the knees. Is this one of those famous metaphors of Jo's that's not really a metaphor? The kids are the only ones in that chamber, and there probably has not been anyone else around for some time. The veil is *moving* in a room where there is no movement of air. So what is causing that veil to move — could someone have recently passed through it, and if so, through it to *where*? Is there another "side" to the veil? Could there be something pressing against it from another "side"? It could imply a time-shift in which someone just touched it, but is no longer in the present. If time travel can occur in the magical world, then other dimensions would probably be allowed to exist as well. This veil is very mysterious, and Hermione doesn't like it at all... no, no, no.

BLIBBERING SOMETHING-OR-OTHER

When Harry can't open one of the doors, Ron is sure that is "bound" to be the right one, but this door "melts" the blade on Sirius' unlocking knife, and as Luna is about to suggest what is in there, Hermione jokes about it being something "blibbering." We know it's a clue, but a clue about what? It probably all depends on your definition of "blibbering." ☺ We have numerous references to locks, chains, and things that are "bound." And the juxtaposition of this locked room to Ron's use of the word "bound" seem to be indicating that this is the subject of those hints. Something either very important or very dangerous is locked in here.

IT RINGS A BELL

Harry finds himself in the right room, with shimmering light, ticking clocks, and a "towering" bell jar containing an egg that hatches and grows into a hummingbird...but then recedes back into an egg...only to hatch again — in a never-ending cycle before their eyes. The ringing bell! This room would seem to contain the answer to the bell hints — a bell jar of time. This is a real-life enactment of the proverbial question, "Which came first — the chicken or the egg?" It is basically impossible to answer that question, which has the same mystical connotation as the Ouroboros Worm that is eating its own tail. Just like the Department of Mysteries houses secrets of the universe, we are sure it contains the secrets of the septology, and this never-ending cycle of life and time is somehow at the heart of it. HP Sleuths should have fun exploring...

WATTS UP

As the kids wander between the shelving lined with orbs, they noticed that some glow, while the rest were "as dull and dark within as blown light bulbs," but then the one with "Harry Potter" on the label is "glowing with a dull inner light." This would seem to be a direct analogy to a light bulb. If so, the concept is that some of the prophecy orbs still function, while others are "blown" or "burned out." But what happens to make them burn out? We get a good hint when Ron finds Harry's orb, and it is glowing only dimly, and we know that his is partially fulfilled. Are the ones that are dark the ones in which the prophecies have come true already and are finished, while the ones which are still glowing would be the prophecies yet to pass? Do *all* prophecies come true or are there any that do *not* come true? It could also be that those that did not come to pass as predicted are the ones that are "smoky."

APPLE OF TEMPTATION

As the six kids creep down through the rows of "towering shelves" in the Prophesy room, Harry's heart is "hammering against his Adam's apple." The biblical and religious symbolism is acute in this scene. We are reminded of "Adam's apple." Note the room has a ceiling as "high as a church." In Harry's dreams, he had described it as a "cathedral-sized room." Looking at this imagery along with the hints about T.S. Eliot's "Burnt Norton," the correlation to Eliot's epic work, *Murder in the Cathedral,* is striking. The central themes of that work are temptations and doing *the right thing for the wrong reason.* This is a lot of responsibility to put on the shoulders of a fifteen-year-old, but Harry has taken it upon himself and is now faced with very grave decisions.

Curiosities

✳ Taranis was one of three pan-Celtic gods of the great triad. He was the lord of thunder and carried the wheel of time (also called the solar wheel or the lightning wheel), governing the change of seasons and the celestial rotation of the constellations. The wheel is often pictured with spokes, looking like a wagon (or bicycle) wheel. Note — he is often pictured and associated with the lightning bolt.

✳ Sirens from Greek Mythology are half woman and half bird (Veela anyone?) and have beautiful voices, calling or singing to passing home-sick sailors. The sailors were tempted to turn their boats and head for the sound — only to be crashed against the rocks surrounding the land, and the men devoured by the Sirens. (Ref Veela in Chapter 8 {"The Quidditch World Cup"} of Book 4)

Chapter 35 Analysis
(BEYOND THE VEIL)

What Are the Mysteries in Chapter 35?

BABYTRIX

Bellatrix is talking baby talk to Harry saying what he "fort" was "twoo." Harry is split in two, so this isn't just baby talk. How deeply should we look into this? There may be more hints located in her words, but Jo is making it very complex and our heads are splitting from trying to decipher anything. Those HP Sleuths whose brains are less mushy than ours are right now can pull out your *Philological Stone* and see if you find anything before your head aches. ☺

VOLDYTHING

When Harry says the name "Voldemort," Bellatrix asks how he "dares" to use the name. How is it that even Bellatrix does not use the name Voldemort? Given her reaction, she is treating it as a god-like name — one of reverence. Is that why no one uses it — is it a name to be worshipped by his followers? (Don't make us puke.) It would still fit that by saying his name, you call him to you — but it is still not obvious why people are so intense over Voldy's name.

A MINOR DETAIL

Bellatrix calls Harry a half-blood, Harry retorts by informing her that Voldemort is one also. Just one itsy-bitsy slip... The half-blood lineage also is quite an obsession with Bellatrix, and we are given the impression that Voldemort may have omitted that "little" detail from his background — that he is a half-blood as well. If so, we can't wait to hear that blow out! We are sooo there.

CASSANDRA ROWLING

Bellatrix casts a spell that Lucius deflects, hitting some orbs instead of Harry, and as they break, an old bearded man says "...at the solstice will come a new...," and a young woman says "...none will come after...." Jo is probably just messing with our brains now — but those prophecy orbs sure sound like they could be talking about Jo's own books. Funny. Very funny. If that is so, was that her own prophecy being spoken as a young woman? (lol!) For the record, keep in mind that there is also a winter solstice that occurs in late December that marks the shortest day of the year.

EVASIVE MANEUVERS

In order to escape from the Death Eaters, the kids blast the shelving so it topples onto everyone — Ginny, Ron, and Luna pass Harry, Neville and Hermione following behind, but then "something heavy" hits Harry in the face, but "he merely ducked." Getting hit in the face doesn't sound trivial, but Harry easily avoided it. That is most likely his Quidditch training coming through from all those years of dodging Bludgers. ☺ Fred and George would have been

proud if they had seen that. All that confusion — too bad Peeves missed it.

OLD JOKE, NEW INFORMATION

Fortunately for the kids, they spot the door that they used still ajar. It's a very old joke, but it is quite appropriate. The joke goes: "When is a door not a door? When it is a-jar!" We have seen the bell jars and know that they are being used here to experiment with time. If a door is "a jar," would that be a hint to mean it is a time portal? Even if it isn't a hint, we can see that there is something very fishy going on with these 12 doors.

MIA

When the kids get to the next room, Ginny, Ron, and Luna are not there, even though they had gone ahead — Hermione thinks they went "the wrong way." How did they manage to go the wrong way when they only needed to get to the next room? This sounds extremely suspicious (unless it was Ron's superb sense of direction) *smirk*. If they did make it to the next room, it would have placed them right there in the time room. Now... if you were running for your life, and knew what a time-turner was, what would you do when you got to the time room? If you don't at least consider the possibilities, then you haven't been paying attention — especially with Ginny on the team. ☺

THINKING DOUBLE

Although Hermione mutes one of the Death Eaters, he still manages a silent curse on Hermione, who falls to the ground — Harry can only think "Don't let her be dead, don't let her be dead..." HP Sleuths should be getting a definite flashback to Book 2, when Harry can only think "...don't be dead — please don't be dead," when he sees Ginny in the Chamber of Secrets at Riddle's feet. More reminders of the Chamber.

PRIORITIES

Antonin Dolohov kicks at Neville, breaking his wand (in two), and Neville laments that his Gran will be upset as it had belonged to his Auror father. Does Neville have his priorities straight or what? He is battling for his very life, has a broken nose, and can't buck a leg curse, but what is his biggest concern? What his Gran will say to him about breaking his father's wand! Maybe he should worry about staying alive first. Poor Neville. Is that broken wand such a bad thing? If you recall, Mr Ollivander made it clear that a wizard isn't as effective with someone else's wand. So, therefore, Neville's hand-me-down wand may actually have contributed to his problems. Maybe that will motivate Gran to get him a new wand. We can't wait to see Neville with a wand that picks him.

PLANETARY DEMOLITION SQUAD

Ginny, Ron, and Luna find themselves in a dark room floating around with the planets — one of the Death Eaters grabs Ginny by the ankle and breaks it, so Luna "blew up Pluto in his face." Now, what were they doing near Pluto? Back at Grimmauld Place we saw Ginny fight a music box that entrances people, then we see her with a badly-injured ankle where Pluto

is blown up. It's not a perfect analogy, but it does make you think of Orpheus. He was the most skilled musician in the world, and his wife was bitten by a snake on the ankle and died. He went to the Underworld to try to fetch her back — playing his music so enchantingly that everyone was entranced and let him pass — even the three-headed dog that guarded the gates of the Underworld. He asked Pluto if he could take his wife back, and Pluto agreed — only if Orpheus never looked around to see her before they reached the surface of the earth. Unfortunately, Orpheus couldn't stand it and looked around, so Pluto took her back. Only occasionally did mortals make it to the Underworld and return, but like in this case, it usually isn't a positive experience when they do.

POINTING YOUR WAY

The floor is blasted at the very spot Neville's hand had been "seconds before." That is scary...but not as scary as the septology implications. Is there any chance this is a foreboding? We did see an almost identical occurrence in Chapter 5, when Sirius just got his hand out "seconds before" a bread knife hit the table. Probably just a coincidence. (Did someone say something about Rule #3?)

BESTED

Harry watches Tonks and Auror Moody go down at the hands of the Death Eaters. We had better hope these were not the best defenders the Order has, or we're in big trouble. ☺ Tonks is still quite young, so it could be her lack of experience in a real fight, and Moody could just be getting too old. However, both of these members have already given us reasons for being suspicious of them. Moody has made some apparent mistakes, and we do keep seeing parallels to the impersonation from Book 4. Tonks has done some highly questionable moves and her pinkness sends a warning message. Should we be suspicious of either or both characters? We were shown how Dumbledore zapped Kingsley on purpose in order to not raise suspicion of his allegiance. Could Tonks or Moody have used that same tactic? Something to think about as we watch Moody's eye roll along the floor in the same way it rolled out of the head of Crouch Jr in Book 4 when the Polyjuice wore off...

SEAMS ODD

While dueling with the Death Eaters, Harry grabs Neville's robes, and they tear along the left seam — causing the prophecy orb to fall out of Neville's pocket and smash. This may be nothing, or it may not really matter, but just in case.... Since it was the left side of Neville's robes that split — causing the prophecy orb to fall out, that would mean the orb was in a *left* pocket of his robes. It is unclear whether Neville had bothered to keep holding his wand or not. Harry had pocketed his own wand, and Neville was busy catching the orb and trying to walk with squirmy legs, so it is reasonable to assume that Neville would have put his own wand into his pocket. If so, he was free to place the orb in whichever pocket was convenient, and it just so happens the orb ended up in a left pocket. Does that mean Neville is left-handed?

PROFESSOR DUBBLEDORE

Neville's broken nose is interfering with his speech, and upon seeing Dumbledore arrive on the scene, he announces that it is "Dubbledore!" Interesting word. It sounds a little like "Drooble's" bubblegum, and as we have seen, there are plenty of bubbly hints in Book 5.

The Weird Sisters of Shakespeare are the most famous "double bubbles" in classical literature. Their prophecy of Macbeth's fate includes the "chorus" "Double, double, toil and trouble; Fire burn and cauldron bubble." A possible meaning could relate to a prophecy.

Maybe we are supposed to be thinking of bubblegum. Between all the gum wrappers littering Jo's desk and the bubblegum references at St Mungo's, this would be a reinforcement of Neville's gum wrappers.

The most direct association would be the homophone-like equivalent of "double door." It is another "double" reference, of course. It is, in fact, a double-door reference (Rule #1). Most interestingly, it brings up a vision of the entrance to the Chamber of Secrets, where the doors part as Harry enters. The running bits expose even more parallels. We have seen several references to "stone," "towering," "ceilings," and "entwined" snakes. Look at this passage where Harry first enters the double doors to the Chamber of Secrets: *"Towering stone pillars entwined with more carved serpents rose to support a ceiling lost in darkness...."*

SWAN SONG

Sirius falls in a slow-motion reverse swan dive through the arch, which seems to take an "age" to happen; the veil "fluttered for a moment as though in a high wind, then fell back into place." Did his dive really take an "age"? You would think it's just Harry's perception, except that there is scientific support that such a thing could happen when passing through a paper-thin barrier in our universe. Scientists have postulated that this type of physical slow-motion would happen if someone were to fall into a black hole. Black holes distort time at the edge ("event horizon"), and may even lead to another universe. As the unlucky person approaches the event horizon, their time becomes "slower" and they appear, to an observer, to move slower and slower the closer they get. Is our black veil a black hole? Not sure, but we still know more about black holes that we do about this fluttering veil.

Is this time distortion what was meant by "age"? Where else have we heard that word used? In Chapter 7 {"Bagman and Crouch"} of Book 4, when talking to Harry about how long he was gone getting the water, George tells him he was gone for "ages." That is when we postulated that the twins might have been involved in a little time travel. Would this veil have anything to do with time? Could be, but it more likely has to do with other universes.

That fluttering is really bothersome. Notice how it rippled only when Sirius went through it, and then stopped. We can't get rid of that creepy feeling as if something, or someone, had gone through there about the time that the kids first looked in the veil room. *shiver*

BAD BLOOD

Sirius is killed by one of his own blood, Bellatrix, who brags of her deed. Sirius' death at the hands of Bellatrix shows the extent of the animosity created by the pureblood bigotry.

Bellatrix is ecstatic over killing Sirius just because she doesn't like his ideologies — just because he exists. We know these two weren't kissing cousins, but do you think Phineas will approve? How does she reconcile her desire to preserve their "pureblood" family with destroying the last of their line? As much as he doesn't like Sirius, Phineas cannot be happy. He will have seen his only living heir destroyed by one of his own family. There is no logic to fanaticism.

Rowlinguistics

✳ Wonder what **Mulciber** does when he's not chasing children around the MoM... in *Paradise Lost*, Mulciber was the architect of Pandemonium (awful noisy there!), the city in Hell. Mulciber is also another name for the god Vulcan.
{www.education.yahoo.com/college/student_life/cliffsnotes/commentary/paradise_lost.html}

✳ The 17th century Italian folk dance called the *Tarantella* had a very fast (allegro) tempo—just dancing it was supposed to cure the effect of a poisonous spider bite (specifically those of the tarantula). It was not totally without basis because the dancer would sweat out enough venom to lessen the effect. To keep up with the fast pace of the song, the dancer probably looked like he just had a **Tarantallegra** spell put on him...

--- Curiosities ---

DEs Present, Paired, and MIA

A few lists to help in your DOM battle sleuthing. First, the list of Death Eaters present:
1) Lucius Malfoy
2) Bellatrix Lestrange
3) Nott
4) Jugson
5) Rodolphus Lestrange
6) Crabbe Sr
7) Rabastan Lestrange
8) Antonin Dolohov (Book 4, {The Pensieve} — tortured countless Muggles and non-supporters)
9) Macnair
10) Avery
11) Augustus Rookwood (Book 4, {The Pensieve} — spy from within Dept. of Mysteries)
12) Mulciber (Book 4, The {Pensieve} — specialized in Imperius curse)

Here's how they're paired. (Note: Rookwood is the one sent out solo as Nott is incapacitated.):
1) Bellatrix, Rodolphus "take the left"
2) Crabbe, Rabastan "go right"
3) Jugson, Dolohov "the door straight ahead"
4) Macnair, Avery "through here"
5) Rookwood "over there"
6) Mulciber, Lucius "come with me" — "me" being Malfoy

Now for those Death Eaters we know who are not present:
1) Wormtail (Peter Pettigrew)
2) Goyle Sr
3) Travers (Book 4, {The Pensieve})

Chapter 36 Analysis

— What Are the Mysteries in Chapter 36? —

THE ROOM RESPONDED

In his desperation to get to Bellatrix, Harry throws out a question, seemingly to nowhere, asking for the exit...and the room answers, opening a door behind him to the lifts. We've seen it before — Harry hurts himself by not asking questions, or similarly, by not recognizing the resources he already possesses. We must also consider the implication of the room answering a question from anyone. Does it work like the Room of Requirement, only answering to those in desperate need? It may be that it is a form of wandless magic, and this could be showing the extent of Harry's power. Does it only answer a certain type of question — such as where's the exit? Would it only answer a recognized Ministry worker or visitor (after all, Harry is wearing a visitor's badge)? Lots to consider...

WELCOME TO THE MINISTRY

Harry "roars" to Bella (in spite of his searing scar pain) that Voldemort is nowhere around, when Voldemort just appears in front of him; likewise, the only hint that Dumbledore has arrived was that the statues spring to life. We never heard them coming. Neither did Harry. No little pop or crack. These two powerful wizards, Voldemort and Dumbledore, make the stealth helicopter sound like a volcanic eruption. Sometimes the sound of Apparating seems to be related to how skilled the wizards are, but in other cases, it is almost as if it relates to their personality (think Fred and George). Being quiet sure has its advantages. What are the implications behind soundless Apparation? You never know when someone may be watching...or standing right behind you. ☺

Did you hear Harry's "roar"? His lion side is showing finally. Up until now, we have seen ongoing references to the snake-like side of his brain, which has been dominating Book 5. We are happy to see here that he still has the heart of a great lion.

Harry was fooled — even with his scar pain to help. This isn't very good. It used to be that Harry knew when Voldemort was around, just by monitoring his scar pain. However, lately, his pain has intensified — even when Voldemort has been far away. ..Or has he? Due to his link with Voldemort's mind, Harry could feel the pain even when Voldemort was at the Riddle house (as he did in the dream sequences in Book 4). But now Harry is getting images and pain from Voldemort constantly, so he cannot easily determine Voldemort's proximity. How close has Voldemort been through most of Book 5? (Because right now he's a little too close.).

The worst part of this is how quickly and easily both Voldemort and Dumbledore arrived in the Ministry. We are betting they didn't bother with a badge either. (hehe) Did they Apparate directly in? One would think the Ministry of Magic, of all places, would be well protected from casual intruders. The Ministry workers Apparate in and out all the time — so it may be they can only do it during certain hours. And what about adult visitors who can Apparate? It would make sense that they would be restricted to certain locations only since they would need to pass through security. We can see that since Malfoy seems to have the run of the place, he may easily get himself into the Ministry by just walk-

ing in, so it isn't very surprising that he and his "friends" could have figured out a way to get in there. Nevertheless, the Ministry might as well not have any security measures for all the popping in and out that is going on in there. We would hope that by next year they will have improved.

BELLA

Voldemort calls Bellatrix, "Bella." Voldemort seems to always address his Death Eaters by last name — *except* for his right-hand people: Wormtail, Lucius, and now Bella. One very creepy observation is that Voldemort uses "Wormtail," the name of Peter's Animagus form. With Bella, Voldy uses not only her first name, but an abbreviated, almost intimate, form of her first name. Now, we know Jo is trying to discourage any thoughts of shipping for Voldemort, but the way he uses her name does have a very personal feel to it.

HARRY'S SAVIOUR

The headless wizard statue, which apparently Dumbledore had mobilized, jumps in front of Harry, throwing out its arms in protection. Think about it a minute — a headless man with his arms flung out. Would look a bit like either a "T" or a cross, wouldn't it? (Nice image of sacrifice there.) We will be looking for evidence of Taranis and his sun wheel in Book 6.

Also, if you will notice, Harry first sees Dumbledore "standing in front of the golden gates." Oh, no! Yes, Dumbledore is the mentor, and that's practically a death-knell already—and here he is standing in front of the iconic image of the entrance to heaven. Then again, it could mean he is emerging from heaven to help as needed.

THE MARK OF DEATH

Voldemort shoots a killing curse at Dumbledore, but it hits a desk, which "burst into flame." That's one nasty curse! So what exactly happens to a spell that doesn't meet its target — where does the energy go? We see passing spells making Harry's hair stand on end in this instance, or feeling like a "draft or bird wings" as it did when Kingsley released Marietta from her memory in Chapter 37 {"The Centaur and the Sneak"}. One result of misdirected magic is that if it doesn't hit the intended target, it still ends up doing damage somewhere (like the desk). Apparently, the more dangerous the spell, the more damage it does. Do you think several missed killing curses could destroy a house... perhaps a house in Godric's Hollow?

And yet...oddly, although the killing curse will vaporize a desk, you will recall that the curse doesn't leave even a mark on the victim. There is something very strange about the properties of that spell, and we don't have enough information to understand it.

GONNGGG

Voldemort deflects Dumbledore's spell by producing a "shining silver shield," which makes a "deep, gonglike note" as the spell hits it. That shield would seem to be very similar to a Patronus, only without the animal. In fact, Lupin specifically describes the Patronus as a shield.

The gong sound is really intriguing. Author Algernon Blackwood, who wrote fantasy stories like "The Willow," described other universes that are adjacent to our own, where the separation between our universes becomes very thin in places, so they overlap and things can pass between. He associates a gonglike sound with that overlap — a sound that reverberates in the other dimension. In the case of Voldemort's shield, he is taking the hit of the energy and dispersing it...but to where? The gong could be the sound of the energy echoing in the other universe.

THINGS WORSE THAN DEATH

Dumbledore asserts that there are "ways of destroying a man" other than killing, while Voldemort responds that "There's nothing worse than death"— however, Dumbledore reaffirms that this belief is Voldy's "greatest weakness." Dumbledore seems to feel that Voldemort should know what he means — do *we* know? What could be worse than death? In our first Guide, we hypothesized that it might not be too much fun for Voldy if all of his victims were allowed to take him and have at it. Another thing we can't imagine being too pleasant is having your soul sucked out by a Dementor, or to be constantly under the influence of them (although we doubt Voldything would be affected anyway). One thing that has already been mentioned is what a terrible thing it would be if you were suffering near-death, and drink some unicorn blood — allowing you immortality — but never removing the excruciating pain. We then have to wonder how Voldemort became mortal again after having drunk the blood, or how Quirrell managed to die after having drunk the blood. Finally, we have one other idea, which isn't the most horrible in the world for most people, but would be the ultimate purgatory for a megalomaniac — to become a permanent ghost that can't do anything but yell "boo!" at people (poor widdle baby).

THE *OTHER* DEATH

Voldemort shoots a killing curse at Dumbledore, which Fawkes intercepts and dies in a burst of flame (the newborn phoenix falling to the floor), while Dumbledore sends a smothering swell of water to entomb Voldemort — but Voldemort breaks free from it and vanishes. Fawkes gives his life to save Dumbledore's — the ultimate sacrifice. Even if Fawkes is reborn, you have to know that he suffered excruciating pain — enough to kill. The phoenix, the emblem of loyalty shown by the members of the Order, is well demonstrated here. Two more deaths in Book 5 at the hands of Voldemort and his followers.

Dumbledore's control of the water is impressive. Even though it wasn't permanent, it slowed Voldemort down. HP Sleuths who have done their schoolbook reading will probably recall a similar struggle with a Lethifold.

COLD, SLIMY FUSION

Voldemort disappears, and a creature takes possession of Harry, fusing their bodies together in pain so that Harry doesn't know "where his body ended and the creature's began." Why does Voldy disappear during the possession? Where did his physical body go? It may be that is an artifact of the process of possession — that the physical body becomes "transparent" from the energy needed to perform the possession. It could be that he completely enters the entity being possessed — so that Voldemort is totally encased within his victim. There

is the possibility that Voldemort went to hide out while his brain did its dirty work.

Think about that image of pain fusing Harry's body to the snake. They are at this point one. We've discussed the Worm Ouroboros... here we are seeing the reality — but it does not last. Something stops the unification. But what? HP Sleuths probably guessed, but Harry will have to work it out later.

RELEASING EMOTIONS

Because of the pain of Voldemort's possession, Harry wishes to die so he can end the pain and join Sirius — at which point, his love and emotion drive the Voldy-creature from him. It would seem that Voldemort doesn't take too well to positive emotions. Is it the specific emotion of love, or emotions in general that drove off Voldemort? Either way, how long will it last before he's back trying again?

THE GREEN LINE

When the Floo Fireplaces at the Ministry of Magic start up, they have green flames. It looks as if green means "go" when using the Floo network. In Book 2, we saw the flames turn green with Floo Powder, and here the transportation fires in the Ministry of Magic fireplaces are all green. It is not possible to know if that is the only spell which turns the flames green, but if you see green flames, they are likely to be for transportation. We have seen some green spells, of course, but they don't seem to relate to Floo flames...that is...unless Avada Kedavra transports a person beyond the veil.

THE SCARLET AUROR

A wizard with a long pony tail and scarlet robes, who Fudge calls "Williamson," exclaims that he saw Voldemort escape with a witch. In Chapter 7 {The Ministry of Magic"}, Harry saw a wizard with similar hair and robes in the Aurors' office, with his feet up on the desk. So, we feel it's safe to assume Williamson is that Auror.

ANOTHER DEADLY CHAMBER

Dumbledore informs Fudge that several Death Eaters are being held in the Death Chamber by an "Anti-Disapparation Jinx." What did Dumbledore call that chamber? (The last time we were in a Chamber bad things were happening too.) Is he referring to the veil room? If so, it certainly seems bad for Sirius. At least we now have a name for the spell that prevents Disapparation at Hogwarts. Would there be a separate spell for Apparation? Also, the name "Death Chamber" does seem to support the theory that this room could have, at one time, been used to carry out the death sentence.

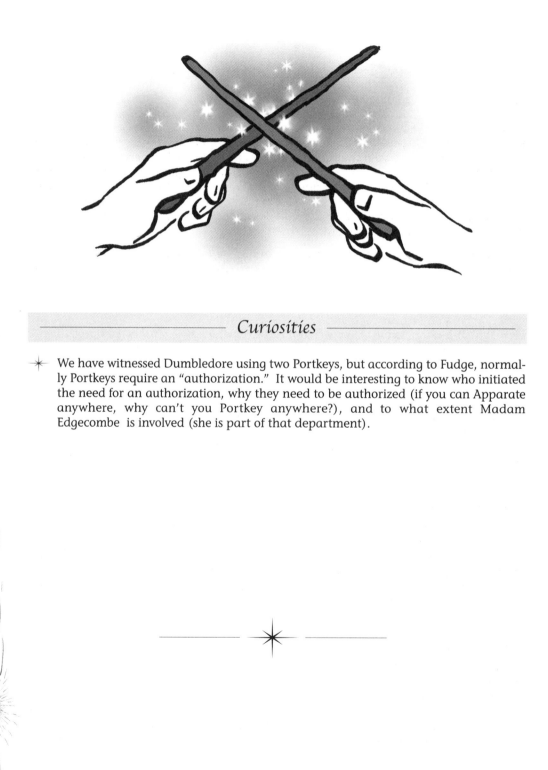

Curiosities

✳ We have witnessed Dumbledore using two Portkeys, but according to Fudge, normally Portkeys require an "authorization." It would be interesting to know who initiated the need for an authorization, why they need to be authorized (if you can Apparate anywhere, why can't you Portkey anywhere?), and to what extent Madam Edgecombe is involved (she is part of that department).

Chapter 37 Analysis

What Are the Mysteries in Chapter 37?

WIZARD CHAIR

Harry is Portkeyed to Dumbledore's office where, upon his arrival, a couple of the portraits talk to him — including Phineas Nigellus, and one "corpulent, red-nosed wizard," who is sitting on a "thronelike chair." We've seen the running image of a chair; we've seen the references to kings and queens. Now we have a throne. Do wizards distinguish between Muggle and wizarding royalty? Based on the description of the *"corpulent, red-nosed wizard,"* this would be the portrait of Fortescue who we saw back in Chapter 27. Does this mean that Florean Fortescue is an heir to royalty? With the *Half-Blood Prince* coming soon, it could be important information. Good thing he seems to like Harry.

Of course, the other meaning of "throne" can relate to (not again!) toilets and bathrooms. So does that mean all the toilet references are pointing to a throne, or is this throne hinting about toilets?

SNAKE SNACK

Harry is overcome with guilt, which feels like a "writhing" "parasite" inside his chest, making him wish he was someone else. Harry no longer wants to be Harry. And who could blame him? Least of all Jo. She said in her World Book Day chat in March 2004, that if she were Harry for a day she'd run and hide because "I know what's coming."

What about that painful, parasitic image still inside Harry? Voldemort's left Harry's body, but it would seem the snake that almost put him into Slytherin House is still inside of him, trying to gnaw away at his Gryffindor heart and the part that is really Harry. If he isn't careful, it could devour him.

PONDERING THE PORTRAITS

When Dumbledore reenters his office via his fireplace, many of the headmaster portraits welcome him. That was "many" welcomed. Not all? We already know that Phineas is awake. Was his voice one of welcome? He does think Dumbledore "has style," but he's also grumbled about carrying out Dumbledore's wishes. We've pondered throughout this Guide what pact (magical or otherwise) binds the portraits to the current Headmaster, and considering the conversations they are privy to, we'd like to be reassured no one could break ranks.

PASSION AND PAIN

Harry throws a temper tantrum, demolishing Dumbledore's office, demanding answers, and insisting that he doesn't care anymore — yet Dumbledore assures Harry that the anger he feels is because he cares and, indeed, cares so much it feels "as though you will bleed to death with the pain of it." Sure sounds like Dumbledore knows what he's talking about. While we relate well to Dumbledore, we still know so little about him. Was he an angsty, talented fifteen-year-old wizard, or was he always as we saw him in the Riddle Diary — logical, skeptical,

and mature? And what loss did he suffer that helps him understand so well how Harry feels now? Is this the way Dumbledore felt or reacted when his family members (or other loved one) were taken from him? (We feel a Dumbledore love story coming up soon.)

PHINEAS' LAST MARCH

Phineas Nigellus reacts to the news of his great-great-grandson's death, the last of the Blacks, with what appears to be shock and disbelief, marching out of his portrait to go to his other one in Grimmauld Place, and, as Harry believes, walking through the other portraits, calling for Sirius. It is one thing to criticize your own family...it is quite another to lose your last remaining heir — especially at the hands of another family member. Although Phineas has spoken contemptuously about Sirius, he seems to be genuinely grieved with his death. Is it merely shock? Or does Phineas cover real emotion with a brusque manner?

Notice that he "marches" out of his portrait. That march reminds us of the war to come. With such a loss, at least to his family's honor, will Phineas march alongside Dumbledore more solidly now? If Phineas is calling for his lost grandson throughout Grimmauld Place, we have to wonder what he would say to Kreacher should he run into him.

While it is not very likely, what are the chances that Phineas was part of the plan — that he helped Kreacher? Harry imagines him visiting the other portraits in Grimmauld Place. What stops Phineas from visiting the other portraits on any boring summer evening? Would he not communicate with Sirius's mother and Kreacher and anyone else normally, and could he have passed other messages? We are wondering if, because of the Fidelius Charm, he had to be told about Grimmauld Place like everyone else, or if because his canvass is already in there, he didn't need to be told (we can't see them telling Sirius's mother about the Order, but she interacts with them). This might be a security leak.

SUNLIGHT SHINING

As Dumbledore pauses in his explanations regarding his attempts to prepare and protect Harry, including arranging Occlumency lessons with Professor Snape, sunlight from the window slides across Dumbledore's desk, illuminating "a silver ink pot and a handsome scarlet quill." Hmm. What does the combination of ink and a quill make you think of — especially with the silver and scarlet thrown in? Riddle's Diary, Fawkes, and the Chamber of Secrets? Where is Tom right now? And could we be soon paying another visit to his hidden chamber?

PHOENIX NOTES

Dumbledore explains to Harry that, while Snape had to pretend ignorance of Harry's warning in front of Umbridge, Snape did indeed immediately contact Sirius using methods much more reliable than Umbridge's fireplace, and "requested" him to stay to be the messenger. So, we've been given a hint regarding how the Order communicates. On her website, Jo explains that the way the members of the Order communicate with each-other is by wand only, and that we had even seen it used by one of its members prior to learning about the Order in Book 5. Back in our original Guide, we had speculated that the symbol Dumbledore sent up to summon Hagrid in Chapter 17 {"The Madness of Mr Crouch"} of Book 4, may have been a communication method for the Order. It would seem that could be right, but we will have to wait until Book 6 to know for sure if that's what she meant. Note, too, that Snape took the opportunity to practically egg

Sirius on to the Department battle by telling him he was needed to remain behind to pass messages. No way was Sirius going to remain at Grimmauld Place after that swipe.

KREACHER'S CONDUCT

Dumbledore explains why Sirius was not there when Harry came calling...Kreacher had somehow injured Buckbeak, and "Sirius was upstairs trying to tend to him." What a vicious creature. Kreacher can betray his master and injure an innocent beast. We hope there are not many more house-elves like him.

THE TRUTH

Dumbledore tells Harry that Snape gave Umbridge fake Veritaserum when she was trying to locate Sirius Black. How do we know for sure the Veritaserum was fake? Harry didn't drink it, remember? So, once again, the slick potions master is left with a good alibi.

TRUSTING SNAPE

Dumbledore reiterates that he trusts Professor Snape, but as always, does not give a specific reason why. We have seen Dumbledore fooled before by very clever wizards in camouflage (Fake Mad-Eye). Snape is a superb Occlumens, according to Lupin, and Dumbledore knows that — so why is Dumbledore so convinced Snape is loyal? What would it mean for the magical world, for the Order — for Harry...should Dumbledore be wrong in his trust this time? One possibility occurs from the juxtapositions in this chapter of feathers and truth...could Snape have called Fawkes to himself during a time of need, and thus shown true loyalty to Dumbledore, much as Harry did in the Chamber of Secrets?

HERE'S LOOKING AT HARRY

Dumbledore weakens, closing his eyes, burying his face in his "long-fingered hands," before lowering his hands "and surveyed Harry through his half-moon glasses." We've seen it before. During times of intense thought, Dumbledore looks *through* those half-moon glasses. Could they hold special magical powers? Could they magnify inner sight, or perhaps enhance Legilimency?

THE WEAPON X 2

Dumbledore tells Harry that the weapon Voldemort has been seeking since his return to power has been the knowledge contained within that prophecy..."the knowledge of how to destroy" Harry. Dumbledore's said it, so it must be true. The prophecy was indeed THE weapon.

Or was it? It doesn't seem that a brilliant Dark wizard would rely on one weapon only. So why would Dumbledore not expect another as well? Maybe he does, but just voices his thoughts on the big one. What other weapons might Voldemort have? We are concerned about what might be breeding somewhere — such as Basilisks, Chimaeras, and mould-related Dementors. Also, there are a lot of mentions of experimental spells and magic. It might give us a clue to know what weapons his predecessor Grindelwald employed.

SMASHED PROPHECY

Harry informs Dumbledore that the prophecy globe smashed when he was trying to pull Neville up the benches in the Veil room. Is this why we learned the important lesson about the essence of Murtlap in Chapter 15? The globe may be repairable, but not the prophecy which it contained. But if a memory in a Pensieve can be better and more complete than in the actual head it's taken from, could Bellatrix recall it for Voldemort? Beyond that...what's preventing Voldemort from accessing Harry's new knowledge of the prophecy in their direct mind-connection? (...once the effect of Harry's emotions wears off, that is.)

WHO WILL KILL AND WHO WILL BE KILLED?

The Prophecy predicts "And either must die at the hand of the other for neither can live while the other survives..." On first glance, this portion of the prophecy seems to indicate that Harry must kill Voldemort or be killed by Voldemort, and this is the way Dumbledore also understands it. Prophecies are tricky things, so are we sure that's the only way to interpret it?

THREE TIMES DEFIED

Dumbledore interprets the prophecy for Harry as meaning that the child of the prophecy would be born to parents who had defied Voldemort three times...which at the time applied to both Harry and Neville. So, both the Potters and the Longbottoms had defied Voldemort thrice. Somehow, we feel a big story developing here — don't you? We know the Longbottoms were Aurors. What could have brought James and Lily three times into direct conflict with Voldemort? Does that mean Lily or James, or both, were Aurors too? What about Gran and Algie — what do they know and what have they told Neville (if anything)?

We have the heir of Gryffindor possibility as well. If Harry is indeed the Heir, that means James was, before him. What if it wasn't the heir of the Potters the Heir of Slytherin was trying to kill?

STROKE OF FORTUNE

Dumbledore states that, "My — our — one stroke of good fortune" was that someone detected the eavesdropper, a "he," and had him thrown out of the Hog's Head. We've seen lots of eavesdropping throughout Book 5 — who would be a good candidate for having done this important piece of eavesdropping over sixteen years ago? You know, Dung was thrown out of the Hogshead about 20 years ago.... (Rule #3?)

Why the emphasis on "our" good fortune? Is Dumbledore referring to Trelawney? How would it have affected her if the eavesdropper had not been caught? Does anybody remember Bertha Jorkins from Book 4? Her mind was forever altered, and her life finally taken, for the information her mind held. It seems highly probable that Trelawney has been given sanctuary at Hogwarts.

HOSTILE INHERITANCE

Sirius, the last direct heir to the Black family estate, is now dead. Sirius was the last of the

Blacks — a noble wizarding family with a huge house in London. Obviously there is some wealth involved. Sirius was also Harry's godfather. Sirius's death could affect the lives of many people. There are important questions to be answered: Will Harry inherit Sirius' wealth and responsibilities? Will Harry inherit the house, Kreacher, or anything, or would it go to a blood relative? There is no way to know if there are wills in the magical world and if so, what kind of laws govern them, but we can't see Harry inheriting everything without a fight.

And what implications does Sirius death have for the Order? Will the Order have to find new headquarters? Will Kreacher's code of silence be broken with the death of the last family member (what little good that code of silence did anyway)?

Curiosities

✳ **Instruments Fit For a King** George Adams Sr and Jr made all kinds of unusual and delicate instruments for King George III (the King of England during the American Revolution) — including globes, microscopes, and telescopes. George Adams, Jr even constructed a functional model of the solar system (an orrery). George Sr — well, he gave the king a clock — in a **bell jar**.
{www.sciencemuseum.org.uk} {www.rauantiques.com}

Chapter 38 Analysis

What Are the Mysteries in Chapter 38?

HE'S BAAACK!

The Daily Prophet reports that "He Who Must Not Be Named has returned to this country...." This article is really weird as it implies three things: first, the assumption that he *just* returned; second, that unlike previously stated, Voldemort was known to have been outside of the country; and most confusing is that they seem to have acknowledged Voldemort was never dead — or the headline would have been more like "Voldemort Seen Alive and in the UK." Is Fudge finally admitting that he was wrong, or is Fudge finally admitting that he was concealing the truth? Obviously, *someone* in the Ministry had a lot more information — which will certainly be Fudge's downfall.

LORD — THINGY'S SERVANTS

The Daily Prophet report states that the Dementors are no longer guarding Azkaban, and are now following "Lord — Thingy." The HP Hintoscope is sounding like a klaxon! It certainly looks like both Voldemort and Dumbledore were correct when they stated the Dementors were going to defect. That is scary. First of all, what happened to all of the prisoners when the Dementors left — were they able to walk away after the effects of the Dementors wore off? Were the Death Eaters who were captured at the MoM already in Azkaban when the Dementors "walked off" the job, and if so, what kind of security are they now using to hold a bunch of powerful Death Eaters? If Voldemort can get past any security measure, then it really can't be that hard for him to help the prisoners escape — unless Dumbledore is using a few of his own tricks....

SNORKACK SAFARI

Luna tells Harry that she and her father will be going on an expedition to Sweden to catch a Crumple-Horned Snorkack. According to Jo's 2004 World Book Day Chat, Harry has his "shortest stay" at the Dursleys next year. Is this maybe why Harry leaves so early from the Dursleys? Does he get an invite from Luna to join her? Once you catch a Crumple-Horned Snorkack, what do you do with it?

SWAMP OF AGES

Professor Flitwick sops up Gred and Forge's indoor swamp "in about three seconds" *— but leaves a tiny patch under the window as a monument to the twins.* We thought so — the short-wanded High Inquisitor was basically a High Squib. Flitwick was certainly impressed with the twins' magic — did they even get *any* OWLs in Charms?

SQUIDWARD

The weekend after OWLs, Harry walks around the school ground, and notices students swimming in the Hogwarts Lake, "accompanied by the giant squid." Confirmation — our giant

squid is friendly! We had one good indication back in Chapter 16 {"Through the Trap Door"} of Book 1, when F&G and Lee were "tickling the tentacles of a giant squid" — but tickling could have been the twins' way of irritating someone they didn't like. So, now the question is: was it the giant squid, or the Merpeople, who rescued Dennis Creevey when he fell out of the boat in Book 4 on the way to the sorting?

BREAKOUT PLANS

Draco confronts and threatens Harry, informing him that Lucius will be "out of Azkaban in no time..." Draco is once again proving how well-informed he is about what is going on in the Death Eater camp. Fortunately, he seems to have quite a loose tongue, so when Draco speaks, HP Sleuths listen.

GRAWPY FEEL ALL BETTER NOW

Hagrid reports that Grawpy is doing better, is now "better behaved" *and Hagrid is consider-ing finding him a* "lady friend." By Giant standards, "better" is all relative. But why is the little giant better? We can speculate that when Professor Dumbledore had to go into the Forbidden Forest and straighten out the little disagreement between Umbridge and the Centaurs, that the name Grawp may have been mentioned. Could our Headmaster have lent a helping wand? What will happen to Hagrid's "little" brother? It would, of course, be quite handy to have a giant defense.

MIRROR, MIRROR...

Using the mirror that Sirius gave him, Harry tries it out by saying "Sirius....Sirius Black," *but upon hearing no response, concludes it did not work because Sirius did not have his mirror with him when he fell through the arch — and in frustration, Harry throws it back into the trunk where it shatters.* Mirrors are a significant part of Book 5, and this may be one of the clues. Was that the only way Harry could have used the mirror? Did he try everything possible?

Now the mirror is smashed. It's broken. Will Harry be sorry? Maybe... maybe not so much. Mirrors are funny things. If you cut a mirror it two pieces, it not only works, but you have two mirrors — just smaller. So, we can hope that the magic in Harry's mirror did not break when he shattered it, but that each fragment might still work.

GHOSTLY PROPERTIES

Harry decides to see if the Hogwarts ghosts could help him find Sirius, but at first, he could not find any of the resident ghosts, but then finds Nick, who had no answers for him. In spite of the number of individual ghosts we've met (and some of them are definitely individuals), we still do not know much about ghosts, in general. For instance, just what do ghosts do all the time, and where do they "live"? Is there a "ghost common room" or a place where they just float or drift when they don't want to think or flit around? Was it truly odd that Harry didn't see any ghosts, or was it that he was just in a bigger hurry than usual. Ghosts could be very handy as protection, but they also could be nasty spies. Right about now, it would be really good to get some info about the Bloody Baron.

MANUFACTURING MAGIC

Luna tells Harry that her mother died when one of her mother's experimental spells "went rather badly wrong..." It appears that the Committee on Experimental Charms must keep quite busy. Obviously, Lord Voldything is not the only person doing experimental magic. But we also see why it isn't legal, considering that it can be quite hazardous (and even lethal). Book 5 is one long lesson in the pitfalls and perils of magic, including that visit to St Mungo's where we saw the aftermath of spells gone haywire. Of course, it must be tempting for any witch or wizard to be creative and come up with their own spell, or new creature, or new potion, or new firework... (we don't know anyone like that, of course).

PLOTTED PLANTS

Neville's Mimbulus plant grew "a great deal" *and Harry heard* "odd crooning" *sounds from it.* Ummmm. Just how big does one of these become? "Crooning"? That is an odd word to use — as it means to hum, or sing. Is it crooning in Assyrian? (We have this image of a gremlin humming quietly.) We doubt that Neville ever saw the Muggle movie *Little Shop of Horrors* — but we did. *gulp!* Just what "plant food" do you give to a rare plant like that? Neville certainly seems to have a green thumb with it. What happens when the plant becomes potbound?

COUNTDOWN TO WAR

The Daily Prophet is now running articles about the rise of Voldemort, to which Hermione comments, "It hasn't really started yet, ... But it won't be long now." Rule #4 says that we need to be on constant never-ending vigilance. Do we know what may happen? Turn to the Restricted Area, if you dare....

UNIVERSES APART

Harry feels like a different person after the death of Sirius. He feels as if he is "stretched across two universes" *with Sirius in one and missing from the other.* Harry is already living in two different existences. He is, of course, "in essence divided." He will need to share this experience with others who can see Thestrals. Another expert of being stretched across two universes is Lyra, in Philip Pullman's *His Dark Materials* trilogy — one of Jo's recommended books. Lyra had a mental companion to share it with, but right now Harry is all alone in his brain — except for the snake. He is very confused and a walking emotional time bomb. Harry now has to deal with the guilt of having lost his godfather because he let himself fall into Voldemort's trap. We can see why Jo says it will be a terrible challenge for Harry. Now that he is aware of the cause, will he be able to better control his anger and frustration?

THE AWAKENING

Book 5 begins with a "drowsy silence" *lying over Privet Drive, and ends with* "Uncle Vernon, Aunt Petunia, and Dudley hurrying along" *in Harry's* **wake.** As we mentioned in our analysis of the first chapter, this points us right to *Finnegan's Wake*. In that novel, the ending is the beginning and the novel is completely cyclical. One of Jo's big themes is the concept of time repeating, and we see it here. The ancients often viewed the universe and time in circular

imagery, as in the wheel of Taranis, the Worm Ouroborus, or the cycle of the constellations. What goes around comes around, and it is only the choices that are made that change the tides.

Back at the end of Book 4, Dumbledore could see this coming. He warned of the need for unity and that the choices would be difficult. He was, of course, right. But the war is just beginning, and all we have had was a taste of the first battle, and already it was tragic. If the events of Book 5 are any indication of what Harry will be up against, it will be a long journey to Book 7.

Key Rememberit Clues from Book 5

(HARRY POTTER AND THE ORDER OF THE PHOENIX)

Book 5 Mysteries Not Yet Solved

Godric's Hollow Cliffhangers

- What happened the night Harry's parents died, and why was the house destroyed?

- Why was the order of the shadows that emerged from Voldemort's wand changed in later editions of the book?

- How did everyone (inside and outside the Order) know about and communicate the events that took place the night Voldemort attacked the Potters?

- How did Voldemort get his wand back, where was it, and who had it all this time?

Privet Drive Cliffhangers

- What/who protects Harry at Privet Drive (besides the protection based on Lily's blood), and how — and who has permission to get past the protection?

- What is the relationship between Arabella Figg and Perkins?

- How many times did Dumbledore and Aunt Petunia communicate in the past, and exactly what did they discuss?

- How did the Dementors get so close to Harry if he is protected?

- Why did the Dementors attack a Muggle (Dudley)?

- How did Mrs Figg so accurately describe the Dementor attack, when, as a Squib, she couldn't actually see them?

- What did Dudley see, or experience, when attacked by the Dementors?

- Who or what opened the door to Harry's room as the advance guard entered the house?

House of Black Cliffhangers

- What is the precise lineage of Sirius's mother and what is her first name?

- What secrets does Tonks conceal?

- Which Hogwarts house was Tonks in? *?*

- Is Sirius "properly dead"?

Dumbledore Cliffhangers

- Is Dumbledore in control of events? *But No*

192

ledore's other sources that are keeping track of

umbledore set up to thwart Voldemort?

ink was "getting stronger"?

during the summer?

between Dumbledore and Aberforth?

r?

(and what was he up to) when he was forced out of
oridge?

angers

ow between Harry and Wormtail, and how does that

ry's blood transfer to Voldemort, besides his protec-
?

else ("one more death" in Chapter 1)?

Eater and the one that has left Voldemort forever?

Death Eater) be hiding in his office that would link

lty when they put him in Azkaban?

r get to be such a powerful wizard?

ch Harry how to fight the *Imperius Curse*, and why?

y Crouch Junior's body, and what condition is it in?

a half-blood wizard or Muggle (and if so, how)?

owner" of the Riddle House?

at has he been up to?

- Why was Goyle Sr not at the DoM battle? (Or Travers, for that matter?)
- What is the status of the baby-headed Death Eater? Was he cured?
- As the prophecy is now lodged in Harry's mind, does Voldemort have direct access to it?
- Were the Death Eaters unaware of Voldemort's half-blood status?
- What power is imbued in saying Voldemort's name?

 C Where is Voldemort's headquarters?

 C What kind of snake is Nagini?

Hogwarts Cliffhangers

 C Why haven't we seen a regular Astronomy class, or more of the tallest tower?

 ● As Madam Pomfrey asked — what terrible thing are they going to have at school next year?

 ● Why does Snape hate Harry so much?

 ● What did Snape do to earn Dumbledore's trust?

 ● Was Snape's dangerous task to find out what Voldemort was up to?

 C Is Neville's memory problem due to a Memory Charm, and if so, who or what did he see?

 C Who was Florence, who was kissing her, and who put the hex on her?

 ● Exactly how does the Pensieve work, and can we trust the accuracy of Snape's worst memory?

 C Who will be the new Prefects next year? Ginny? Luna?

 C What experiment killed Luna's mother?

 ● Who will be the new captain of the Gryffindor Quidditch team, who will be on it, and will the bans be lifted?

 C Who was Hagrid and Madam Maxime's tail on their trip to find the giants?

Weasley Cliffhangers

 C How did Fred and George know, in advance, the final outcome of the World Cup?

 ● Is Percy in any danger and would he recognize it if he is?

 C Was Percy personally responsible for any of the Ministry's actions against members of the Order?

 ● Does Percy know about the Order?

 ● What will happen with Percy in regard to his position in the Ministry and his relationship with his family now that the truth regarding Voldemort has been fulfilled?

 C What will be the long-lasting effect of Ron's encounter with the brain in the DoM?

Organizations and Ministry of Magic Cliffhangers

 C How much control does Lucius Malfoy (and his money) have over the Ministry?

- Who are Voldemort's spies in the Ministry?
- Was Bagman actually guilty?
- Where did Bagman go?
- Whose side is Rita Skeeter on?
- Is St Mungo's under the influence of Lucius Malfoy?
- What exactly is behind the locked door in the Department of Mysteries?
- Was the Death Chamber really used as a "death chamber"?
- Whose brains are those in the tank and why are they there?
- Why are the prophecies being archived and how do the orbs work?
- What happened to Umbridge — where did she go?
- Who will be the new Minister for Magic?
- What is happening at Azkaban — who's minding the fort?
- Sturgis Podmore should have gotten out of Azkaban already — where is he and what is his status?
- Who sent the Devil's Snare to Bode at St Mungo's?

Ghost and Creature Cliffhangers

- What is the magic behind Owl Post and owls?
- What are Hedwig's heritage and magical abilities?
- Why are house-elves subservient to wizards — how did that happen?
- What happened during the goblin rebellions, and who won?
- What is the background of the Bloody Baron and what is he up to?
- Are Myrtle's special water skills unique for a ghost, and what other capabilities might she have?
- Where is Myrtle?
- What will become of Buckbeak and Kreacher with Sirius gone?
- Who will the goblins and giants side with in the war?
- Will the centaurs become involved in the war?
- Will Aragog get involved?
- What are the Dementors up to?
- How do you destroy a Dementor?
- Is there really such thing as the Crumple-Horned Snorkack?

Spells, Potions, and Magical Objects Cliffhangers

- ☾ What are *Switching Spells* and how do they work?

- ☾ If the *Killing Curse* doesn't leave any marks, why does Harry have a scar?

- ☾ How did the shadows from Voldemort's wand know that the Portkey is set to travel back to Hogwarts and how did it get set to do that?

- ☾ What's going on with Harry and poisons (or any other immunities)?

- ☾ Do you have to be moving to show up on the Marauder's Map?

- ☾ Do ghosts show up on the Marauder's Map?

- ☾ Now that we know about metamorphmagi via Tonks, does that explain how Harry grew his hair back overnight?

- ☾ What happened to the silver music box and the gold ring with the Black family crest which Sirius was throwing out?

- ☾ What properties does Neville's Mimbulus Mimbletonia have?

- ☾ What exactly is the Veil, where did it come from, why is it there, and what do they know/not know about it?

Miscellaneous Cliffhangers

- ☾ What are all those "banging" noises?

- ☾ What is the significance of long (or short) fingers?

- ☾ Was the false image in Harry's mind the "imposter" in Book 5? And if not, who is?

- ☾ Who is the villain in Chapter 13?

BOOK 6 AND BEYOND
(WHAT IS FORETOLD)

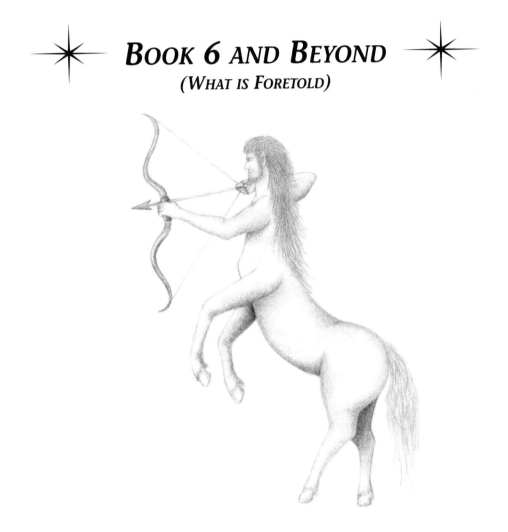

Mars is Bright

BEWARE!

We tried a little speculation in our previous Guide.

We are doing a similar thing here.

The RESTRICTED AREA holds facts about what will happen — according to what J.K.R. has actually divulged in media interviews.

However, our own speculations are forward-looking predictions by WWP Super Sleuths – based on the clues in the books, combined with J.K.R.'s interviews.

These are *speculation only* — but could come true...

READ ON AT YOUR OWN RISK!

RESTRICTED AREA

Restricted Area

The War

The war is upon us.

The centaurs were right. They did see the war coming, and the deaths of innocents will be followed by battles that touch every member of the magical world. What is Voldemort up to? How is he going to become, as Trelawney prophecized, "greater and more terrible than ever before"? Here are some of the things we are seeing that Voldemort may be planning:

Voldemort's Army

Purity of Breeding √

Jo made a trip to the Holocaust Museum after she'd already come up with the half-blood, pure-blood, and Muggle-born designations, and was "chilled" to see the similarities in logic between the Death Eaters and the Nazis on the subject of genealogy. We think we might see those distinctions used by the Death Eaters the same way the Nazis used them—to justify and organize mass killings. Just like the Nazis, Voldemort entices armies of followers through false premises.

Experimental Breeding

There are way too many creature experiments in Book 5 to think that they are rare instances. In spite of everything the Ministry has done to restrict them, we have seen that it is easy enough to be breeding illegal critters. The one we are watching the most carefully is Kreacher. Given that he shuffles around the room, hunchback-style, we can just picture the Frankenstein's Monster piecing together a new monster. The problem is knowing who is the brains behind this. If Kreacher is an analogy to "Igor," then he is most likely taking orders from someone else. Would that be Mrs Black, or an unknown person? Where is this breeding taking place? It would seem that since Kreacher spends most of his time in the attic, that could lead to the location. It is also possible that Kreacher could be visiting other people (think Wormtail) – we have seen that he has food in his bedroom, so he probably has to leave the house sometimes. Would he be helping the Malfoys or Voldemort in some experiments to design new formidable creatures (a little clone attack preparation)? If Kreacher isn't involved, the breeding could be taking place anywhere.

Breeding an Army

Voldemort's plan crashed (literally), and now he's lost his cover. The wizarding world knows he's back. If he can't stay hidden, then he might as well build an army.

Voldemort led an army of creatures before, but he may just be looking for the super creatures. We saw in Book 5 that he is very intent on getting the support of the giants. Since the giants are not going to be much help with strategy or diplomacy, the only reason he would be gathering the giants would be to bust heads. Could Voldemort be supplementing them by breeding an army? There have been many Basilisk-like and Chimaera-like references in Book 5, and considering how effective those would be in a war, it raises suspicion as to whether he has been working on Plan B all along...

Worse than Breeding

One thing that may be growing in or near Grimmauld Place are Dementors. According to an interview that Jo did for *The Canadian Press* in October, 2000, Dementors *"grow like a fungus where there is decay."* The Black Family mansion is in decay both literally and figuratively. It could easily be a nest for them. Something around there killed the Puffskeins.

People

Aunt Petunia √

We are convinced that Aunt Petunia is the one who will use magic "late in life." It is highly possible that it is only her abhorrence of magic that has successfully suppressed it all these years. The question is, what happened to make her hate it so much? We are wondering if she may have encountered a bad wizard. No matter what, there is no doubt she knows more than she tells Vernon.

Umbridge

Umbridge has been almost as big a help to Voldemort as Peter. Maybe she isn't a Death Eater, but she sure seems like one to us. She may be helping Voldemort out because she has a personal interest in his cause. She may also have a family stake in it as well. Did you notice her "mousy-brown" hair, her little pointy teeth, her short size, and her lack of wizarding power? Does it remind you of anyone? It reminds us of Peter—somebody who's not terribly smart or terribly magical (in Book 3, Professor McGonagall likened him to Neville). Peter is short, with mousy brown hair and sharp little teeth—and that same deep urge to be on the right side of whoever's perceived as having power. We know that his mother got his "remains" when he was supposedly blown up – so she was around at the time. We may be seeing a family resemblance and Umbridge may be Peter's mum. We are concerned that she may yet end up as Minister of Magic by putting all the blame on Fudge, but hopefully (for everyone's sake), her character has run its course.

Tonks

We are very suspicious of Tonks. Her pinkness, her clumsiness, her ability to alter her appearance so easily, and her Slytherin roots are all evidence that she should be

watched carefully. We don't buy her clumsiness – it seems too coincidental, and we already saw how effectively Quirrell had us fooled. However, it was the mirror that did it. Looking into the mirror in Harry's room while helping him pack – it looked too much like a signal that was being given. The trouble is, who would have been getting the signal – the good guys or the bad guys?

Bode

In trying to sleuth Bode's killer, we have evidence that there was an old man with a hearing trumpet, and that could have been anyone. But there was an odd piece of evidence – the calendar of fancy hippogriffs. In Fantastic Beasts, we find out that Newt Scamander's mother was a breeder of fancy hippogriffs. We hate to do this, but we have to bring in Mr Scamander for questioning...

— Creatures and Other Living Things —

Crumple-Horned Snorkack

Hermione says Crumple-Horned Snorkacks are fictional, Luna says they are real and she and her father are going on safari to find one, while Newt Scamander has no doubt new species will be discovered (requiring a new edition of *Fantastic Beasts*). We're betting Hermione will have a surprise...

As a major hint that we will be going on safari—in late 2003, Jo sneaked away and went on a safari in Africa with 5-month-old David in tow. This could have been a little research trip for background on creatures with horns.

There is more than a little similarity in sound between Snorkack and "Snark." The Snark, from Lewis Carroll's "Hunting of the Snark" was a rare beast, and a team of ten adventurers set sail to find one. Unfortunately, the Snark comes in two kinds, and if it is a Boojum, then "you will softly and suddenly vanish away, and never be met with again." The poem is a complex satire, and ends in an unsolved mystery. Carroll admits that he thought of the last line, and then created the entire poem around the punch line.

House-elves

We found the sudden use of the term "hobgoblin" in Book 5 fascinating. Sure, it's supposed to be the name of Stubby Boardman's band—but look it up, and you get a definition of something very like a house-elf. It is possible that the little guys are a subspecies of goblins, which would mean Dumbledore has a whole raft of powerful goblins downstairs who think he's the best thing since tea towels. For the record, Jo says house-elves have "the ability to appear and disappear within the castle". Not Apparate and Disapparate.

Peeves

Jo calls Peeves "an indestructible spirit of chaos", and says he's no ghost. He is categorized as a poltergeist. Poltergeists are usually considered to be the result of an overactive psyche. A person's emotions will be so strong that they manifest themselves in physical actions. For instance, a person who is disliked by someone who can cause poltergeist activity may find that rocks will rain on their house. Also, since they usually are not in control of these manifestations, furniture will move or objects will bang in the perpetrator's own house, and like uncontrolled underage magic, children are more likely to generate a Poltergeist than an adult. We are thinking that this poltergeist may be tied to Dumbledore, which is why he is not able to have Peeves removed.

Occamy

If Sirius' ancestors had to have the finest of everything, they assuredly would want the quality of their silver to be the finest as well. Where would they have found the most exquisite silver? In *Fantastic Beasts*, there is a description of the Occamy, which lays eggs of "purest silver." We are thinking that the Black family could have either imported their eggs, or even may have bred them.

Goblins ✓

There is a mini-hint about what might be behind all that trouble with the goblins. If the goblins crafted the Black family silver, and were treated as many have been through history, it could be that they were only the miners and craftsmen for humans and then revolted in order to share in the profits of their work.

Magic, Magnetics and Mimbulus Mimbletonia

Hermione informs us, in Chapter 28 {"The Madness of Mr Crouch"} of Book 4, that powerful magic interferes with normal Muggle electronics, so things like Muggle radios and computers won't work. There are mentions throughout the series that the Ministry is able to detect Underage Magic, and magic that involves Muggles. Similarly, during the duel between Dumbledore and Voldemort, we clearly saw powerful spells being deflected by shields and objects. To a Muggle Engineer, this looks like magical spells are similar to strong pulses of electromagnetic waves – like pulses of intense laser light and bursts of powerful radio waves that can be detected (received), reflected from mirrors and deflected by metal.

If the magic of Jo's wizard world follows this, then a "magic spell" is a burst of magical energy – which hits and affects the target. The more powerful and magical the wizard, the more powerful the spell.

Mr. Ollivander states wizards do their best magic with a wand that selects them – matched to the specific magical power of the wizard. However, we see wizards using wands other than their own. Similarly, the antennae on a radio or TV, or a broadcast tower have to be matched to the electronic transmitter to be most effective, but will still work even if not perfectly matched. The wizard wand is the equivalent of an antenna. Wandless magic fits this, since only more powerful wizards can do it, or less powerful

wizards when they are particularly stressed out and focusing all their magical energies.

The telepathic connections between wizards replicate Muggle TV – the wizard mind seems to be more capable of transmitting and receiving than the Muggle mind. The infamous lighting-bolt evil curse scar makes the connection between Harry and Voldemort even better.

Keeping all that in mind...the interlocking (connection) between Harry and Voldythingy seems to be getting stronger and stronger every year. This year, in particular, it is intense. Why this year? One reason is because Voldemort got his body back and is now becoming very strong. However, we could not help but notice the coincidence (cough) that the "best connection" between Harry and Voldemort was when Harry was *in the Gryffindor dorm room.* Of course, we can say that is because Harry's mind is more relaxed or sleeping, but several of the most disturbing connections were when Harry was quite awake, and not at all relaxed. Is the dorm a special antenna? Perhaps, but in Chapter 11, Neville placed his rare Mimbulus plant on his moonlight nightstand in the dorm. Can one of the properties of the Mimbulus Mimbletonia be that it acts like a magical amplifier – increasing the strength of the telepathic connections between Harry and Voldemort? Perhaps this plant uses moonlight to grow – it is always a pale color – and perhaps the connection is strongest during moonlight. Can someone know about this power and be using it to help Voldemort?

Jo has a radio being tuned on her website that conveys the meaning of "reception" – a signal being transmitted and received. Is this a hint? Maybe the plant is another secret weapon.

If the Mimbulus Mimbletonia is not acting as an amplifier, then what is? Could there be something above or below the dorm?

The Prophecy

Trelawney's Prophecy said that "either must die at the hand of the other." There is the phrase "the other." Could "the other" not mean either Harry or Voldemort, but be an other (third) party? If so, the hand of the other could imply that the killing of Voldemort would not necessary have to be done by Harry. But, who is "the other?" With the mention of "the hand," Pettigrew, of course, comes to mind. Could that be how he repays his debt to Harry for saving his life back in the Shrieking Shack? Will Voldemort die at the hand of Wormtail (the other)? Could he die at the hand of Neville – the "other" child of the prophecy?

While the phrase "neither can live while the other survives" may seem like it means they can't exist simultaneously, that clearly isn't true (they're both here and they do both exist), so what could it mean? We are thinking it could be interpreted that neither Harry nor Voldemort will be able to truly function as a whole person (live) – as they will always be in each-other's brains from now until either dies. We certainly hope that Harry is studying his Occlumency over the summer.

RESTRICTED AREA

————————— *The Meanings of Some Running Bits* —————————

The Number Twelve

Dumbledore is famous for his discovery of the twelve uses of dragon's blood, but as of the end of Book 5, HP Sleuths still have no idea what these uses are. That could be a direct correlation to Rule #2. In fact, it is even possible the numerous references relating to 12 could be pointing us in the direction of dragon's blood. Afterall, we met a dragon, a hatching one at that, in the very first book. Could Norbert return? Could he return in some method to help save his "mummy"? Could one of the 12 uses of dragon's blood relate to a key septology mystery — such as the self-sacrifice of Lily, the power of love? WWP thinks we'll discover a crucial use of dragon's blood before it's all over.

Rubbish, Rings ✔

All those references to rubbish and bins may be pointing to the Black family heirlooms that Kreacher has been hoarding. The two that caught our eye most were the musical box that almost put everyone to sleep and the ring with the Black family crest on it. It is highly likely that Kreacher managed to salvage either or both of those. The ring running bits reinforce that as well. The Weasley is Our King song juxtaposes rings and kings. Could the Half-Blood Prince have been in the Black family? No matter what, just like the box, the ring probably holds great power. Does Kreacher know what these artifacts are and how to use them?

It also could be pointing to Neville and his gum wrappers. One possibility is that his mother is trying to get a message to him, and those wrappers may be extremely important. Hermione is studying various symbolic languages – maybe she could help him with it. It may also be that the gum is being given to Neville's parents by someone who wants to prevent them from recovering. Whatever it is, it is extremely important because Jo has them littering her whole site. She claims it's because of her own desire to chew gum – but we've heard that before...

Just to tease us, Jo has a huge waste basket on her site. In fact, there is trash strewn around everywhere – you've heard it said...one man's trash is another man's...

Twos

According to the Prophecy, it could have been either Harry or Neville, but it was Voldemort's own choice to attempt to destroy Harry that "marked" Harry as the child of the Prophecy. Two babies to choose from, two minds intertwined, references to "mate" throughout Book 5, and a hint from Jo that Book 2 originally contained the key to Book 6. This may have been Book 5, but it also kept bringing us back to Book 2. It would seem that there is probably something being mated. We have all kinds of possibilities – dangerous breeds, new breeds, an endless army of Dementors, or even something very horrible that Voldemort would dream up.

The two babies and all the references to items in twain (twos) got us thinking. It could be just a (hem-hem) coincidence, but we noticed some interesting parallels with Mark

Twain's Pudd'nhead Wilson. The Twain novel was originally composed as a story about Siamese twins – a physical condition that could easily describe what is going on with Harry's and Voldemort's brains. Pudd'nhead Wilson is about two boys, Tom and Chambers (cough), who were born on the same day, but were switched at birth. One was the son of a wealthy Caucasian, while the other looked Caucasian, but having a drop of African blood in him, according to that era, designated him as a slave. Thus, it is a story of prejudice, bigotry, and social standing, in which appearances are not what they seem. It is also about a perceived dunderhead, who turns out to be the hero. Most importantly, it explores the theme of choices that people make.

Overall the twos apparently tie in to a repetitive cycle that is a strong theme throughout Jo's septology. Stonehenge, the Wheel of Taranis, the Worm Ouroborus, calendars, diaries, clocks and time – all relate to the cycle of the universe. Jo's characters are tied to that cycle and to events that repeat themselves – with the choices being made being the distinguishing factor.

The Chamber of Secrets

Throughout our analysis of Book 5 we have been drowned in hints pointing HP Sleuths back to the Chamber of Secrets. Blackened eyes, slithering things sliding to the ground, and monkey-like references have run amok. We've been bombarded with ink, snake, feather, and underground running bits.

As analyzed in The Plot Thickens in S.P. Sipal's Chamber of Thoth essay, Jo's Chamber of Secrets bears a curiously strong resemblance to the myths and legends surrounding the ancient Egyptian god Thoth (later to be aligned with the Hermes of Greece) — the scribe, the lord of wisdom and legendary author of many ancient secret books of knowledge and technology. Perhaps his most famous credit is as the author of The Emerald Tablet, which was revered by later medieval alchemists and used as the cornerstone of alchemy.

Just like the Philosopher's Stone, that tablet could really exist in Jo's world. We believe Harry will most likely return to the Chamber of Secrets and discover some form of knowledge preserved there by Salazar Slytherin. After all, it is the Chamber of Secrets — as in, more than one. ☺

Wheel of Taranis

Time references have kept us looking at our watches throughout Book 5. We've particularly paid attention to the juxtaposition of time with the circle inscribed with a cross imagery. This image would be familiar to the ancient pan-Celts as the wheel of Taranis, one of their gods of the great triad. He was the lord of thunder and carried the wheel of time (also called the solar wheel or the lightning wheel), governing the change of seasons and the celestial rotation of the constellations. The wheel is often pictured with spokes, looking like a wagon (or bicycle) wheel. Note - he is often pictured and associated with the lightning bolt.

Indeed, the Department of Mysteries seems to be constructed as a giant clock, or in the manner of the wheel of Taranis. Is that room a *time* room? Each of those doors could

lead to a different time or dimension. The whole building could be touching on other universes – which may tie in with the veil.

Additionally, on Jo's website in the trash room, you can see a spinning top that looks just like the sun wheel image. If you look at the top edge of the waste basket, you will see that even the waste basket rim is another 4-spoked wheel image. Another hint, perhaps?

How would the wheel of Taranis relate to upcoming mysteries? We could very well see another trip back in time...perhaps farther back than a mere 3 hours. As Hermione says, the ramifications of wizards who engage in time travel is alarming. But, if as we suspect a bit of time traveling has been happening on the side, then maybe Fred and George (and perhaps Ginny) will help Harry along. We are thinking that the hints about Orpheus may indicate that Ginny, Luna, and Ron may have encountered the Underworld using one of the time-turners.

Stonehenge

Stonehenge has mystified people for generations...for millennia. The Malfoy mansion is located near Wiltshire, which is near Avebury and Stonehenge. Stones have pelted us in various forms from all directions in Book 5. And the time image, particularly as it relates to the image of the Taranis wheel, also reminds us of the circular construction of the stones of Stonehenge.

As HP Sleuths have anxiously awaited the relevation of the mysteries buried in the Harry Potter series, so have archaeologists and enthusiasts waited, researched, and postulated regarding the stubbornly lingering mysteries shrouding the purpose of Stonehenge. One of the most popular theories is that Stonehenge was designed for ancient astronomers and astrologists as an observatory.

The astronomy tower remains a strong mystery in the Harry Potter series, as we see so little of it. But could Stonehenge, or a megalithic structure like Stonehenge, pop up in Books 6 or 7 (after all, Alfonso Cuaron was allowed to use this type of structure in Movie 3 when the graveyard was denied him)? WWP thinks so, and is waiting anxiously to see.

Mirrors

It would seem that it is important that the mirror communicators like the one Sirius gave Harry are identical mirrors. The process of making them identical is the issue. Can you get an identical one by breaking it, and if so, would those two pieces be automatically able to communicate? There were many suspicious mirrors in Book 5. The one in Harry's bedroom, the one in front of the caved-in secret passage, the one in Umbridge's office, and the Foe Glass in the Room of Requirement. The Foe Glass was cracked. Fake Moody had some cracked instruments, but the mirror was not one of them as far as we knew. However, the Foe Glass in the Room of Requirement didn't seem to function very well, and had a distinctive crack. We are thinking it may not have been just a Foe Glass, but a communication mirror.

There is one mirror in particular in Book 5 that gave us the willies. The cracked and age-spotted mirror that Harrymort looked into when he saw himself as Voldemort, was most likely in Voldemort's lair. It was also identical in description to the one in Moaning Myrtle's bathroom. All those references to trolls and bathrooms may be playing on this mirror. Would Voldemort somehow be communicating with anyone in the bathroom? He has already used that bathroom before for the Chamber, and he could be using it again. He could be looking straight into Hogwarts! The cracked Foe Glass could also be part of that mirror network.

Snakes

It begins with a song that sounds very much like a now-familiar prophecy. Go and read the classic Kipling story Rikki-Tikki-Tavi like we did and you find a little mongoose who was thought to be have been killed when his house was destroyed, but turned out to be alive—who is forced to fight the king of the snakes and his mate for the safety of his House, who is helped by 3 friends, one knowledgeable, one clever, and one who overcomes his fears—and who makes the choice to kill the offspring of the snake, rather than risk the lives of those who trust him.

We think the parallels are too many to be ignored, and we think there is a very good chance Harry will soon be put in the same position Voldemort was before Book 1 even began—having to make the choice of whether to kill, not just his enemy, but the child of his enemy.

The Black Family Tree Tapestry

We are highly suspicious that the Black Family Tree may, like the Whomping Willow, be camouflaging the entrance to a hidden corridor. That corridor may go anywhere, but since the roots on this tree are at the top, we are thinking it may be in the attic somewhere. No matter what, the idea of having a figurative tree hiding something that is similar to the actual tree would be very difficult for Jo to resist.

Sirius' Mother's Portrait

Harry thinking that the portrait was a door when he first saw it, tells us to question it. We already know that portraits hide doorways. There could be another whole level underground in this mansion that no one knows about. If the mansion is as old as it seems, it could have a very extensive structure that could have been added to several times over the centuries. Who knows what is attached to it...

Half-Blood Prince Ramblings

We don't seem to have enough evidence to be able to identify who the Half-Blood Prince might be. However, there are some hints that we think might lead us to some interesting speculations.

Fortescue

The corpulent, red-nosed wizard in the portrait in Dumbledore's office appears to be royalty, as he is seated on a chair that looks like a throne. If so, his heir could be a half-blood prince. We have met a Florean Fortescue in Diagon Alley – he runs the ice cream shop. However, he wasn't just an unschooled shopkeeper – he was extremely knowledge-able about wizarding history, and helped Harry with his homework. Therefore, he is a potential candidate.

King Tutankhamen

There are some prominent references to "Tut" in Book 5. The Tutshill Tornadoes Quiddtich team is mentioned several times, and it is possible that the Half-Blood Prince is an ancient Egyptian prince around the time of King Tut. It is also possible that the family heirloom ring of the Black family (original ancestors Nigellus) came from Africa and ancient Egypt.

Wild Speculation ☺

We've been given a myriad of "twin" and "two" hints throughout Book 5. We've been given the information that pure-blooded wizards had trouble breeding, and would have died out if not for marrying Muggles. Sirius says his parents thought being pure-blood was almost like being royalty... Maybe "Stubby Boardman" was Sirius's twin brother, and Sirius was actually the product of an alliance between Mr. Black and a Muggle woman, taken to insure the Black line continued.

Chapter 1 FAQs

(Dudley Demented)

ON WHAT DATE DOES BOOK 5 BEGIN?

On what day does *any* Harry Potter book begin? Ask a fan and they will most likely immediately inform you that the books begin on Harry's birthday. But that's the kind of answer that makes our anally-retentive Rememberit Quill ooze ink! Yes, Book 1 technically began just after Halloween. On the other hand, the reason we don't consider that book to "begin" then is that the first chapter is treated as background information. The events throughout the rest of the series are generally viewed from *Harry's perspective*, but in Chapter 1 of Book 1, Harry's perspective was a bit (shall we say) *small*.

Now, Book 5 has also deviated from the pattern slightly (which makes the WWP Sleuthoscope slightly restless). To set the record straight, according to the official court records at Harry's hearing {Chapter 8, "The Hearing"}, the events that kick-started Book 5 occurred on August second (two days after Harry's birthday).

WHAT ARE THE MYSTERIES BEHIND WANDLESS MAGIC?

Wandless magic in Jo's world seems to work very similarly to the way extrasensory perception (ESP) is described in our own world. With ESP, the most frequent accounts of people having reportedly moved objects (telekinesis) are when they are very afraid or angry. Similarly, the most frequent ESP reports of psychic communication (telepathy) are when a close companion (human or otherwise) is badly injured or has passed on. In other words, extremely strong emotions supposedly trigger extrasensory events that would normally not be possible. We see that in wizards; emotions can tap latent power. That is what happens to child wizards when they get upset and the magic just sorta slips out. That is what happened to Harry with the "Vanishing Glass" and all his other unintentional uses of magic. Aunt Marge and her dog, Ripper, can be considered a real inspiration for inducing magic.

At the end of Book 4, when Dumbledore got very angry about Imposter Moody, the description was that he "radiated" power. We also know from Harry's attempt to zap Bellatrix with the Cruciatus Curse at the end of Book 5, that a wizard's mental state has a *lot* to do with performing magic. If Dumbledore, or any wizard, can "radiate" power at times, can a wizard purposely focus external power?

In Chapter 2 {"A Peck of Owls"} from Book 5, we saw Harry's wand unintentionally send out sparks when he was infuriated with Uncle Vernon. We have even seen Harry perform *wanded* magic when his wand wasn't even in his hand! Then there was Moody's painfully graphic description in Chapter 3 {"The Advance Guard"} of accidents that can happen by stashing your wand in your back pocket (that guy is a bit morbid). So, Harry isn't the only one who can do that. In our original Guide, we contemplated what Ollivander was implying when he said that you wouldn't get as good results from someone else's wand. If "the wand chooses the wizard," would that not imply a special relationship between a wizard and his wand?

What proportion of the wizarding community can intentionally do wandless magic? That ability does not seem to be common, and yet certain magic appears to require it. For instance, Animagi transformations must be wandless magic as Sirius changed frequently at Azkaban, and yet they should have taken his wand away (plus, we don't recall seeing Snuffles use a wand to change back). We also have some indication it's not very common

from what happened with Severus in Chapter 28 {"Snape's Worst Memory"}. Even if just a few wizards are capable of doing wandless magic, what are the ramifications of the mere existence of that ability? If you are interested in knowing more details about what could happen under those circumstances, it was the main theme in a classic science-fiction movie called *Forbidden Planet*.

Based on what we have seen of powerful wizards, we are probably to assume that strong emotions are quite useful — meaning the wizard can focus their emotions directly into their magic. Harry seems to have a lot of emotion lately, doesn't he?

WHAT CAUSES HARRY'S SCAR TO HURT?

Using the evidence we have so far, apparently the only person who can cause Harry's scar to hurt is Voldemort. Before Book 5, we can verify that Voldemort was present (or in a rage) whenever Harry's scar alerted. When Harry's scar hurt around Quirrell, Voldemort was there. When it hurt during the "dreams" he had in Book 4, he had been paying Voldemort a little house call. Even when it hurt around Crouch, we know that Voldemort was throwing a fit back at the cemetery because Harry had just slipped through his fingers (yet again) and was returning to bear witness of Voldy's rebirthing to Dumbledore. Now, in Book 5, every incident of Harry's scar pains, where we could *verify* the cause, was due to... Lord Voldything. (When we discuss Chapter 13, we give a hint as to what triggered that indistinct pain.)

Harry has encountered Death Eaters and former Death Eaters throughout the septology. We have no evidence that Lucius Malfoy, Wormtail, Karkaroff, Snape, or even a crowd of 10 Death Eaters in the Department of Mysteries, can so much as make his scar twinge. Yet, Voldemort only needs to feel a bit giddy lately, and Harry gets a big headache. And the more intense Voldemort's emotion, the worse it hurts.

The implications of this are that we either need to pay very careful attention to what Voldything has been up to at all times, or we had better worry whether anyone else can set off Harry's scar alarm. Right now, based on what we know, we're not in a worrying frame of mind. So, until we see further evidence, we will assume that a painful scar means Voldemort is the culprit.

— *Chapter 2 FAQs* —

(A PECK OF OWLS)

HOW DOES OWL POST WORK?

For being so intelligent, how is it that the owls smash into windows? The answer may also hold a key to owl delivery magic. Consider what might have caused the owl to head for a closed window.

We still may not understand owl delivery, however, in Book 5 we have a whole flock of new evidence about how it works. Notice the recipient's address can be verbal, written, or even in code (such as in Chapter 14 {"Percy and Padfoot"}), or that additional instructions can be given *verbally*. (Ron's fingers sure seemed to have noticed in Chapter 4 {"Number Twelve Grimmauld Place"}). The most intriguing insight comes again from Chapter 14, where Harry feels it necessary to *whisper* his instructions to Hedwig while in the Owlery. So, whooooo would have overheard Harry?

WHAT DID AUNT PETUNIA'S HOWLER MEAN BY "REMEMBER MY LAST"?

We know from Chapter 37 {"The Lost Prophecy"} in Book 5, that it was Dumbledore, himself, who sent the Howler. Why didn't Harry recognize his voice? Would Dumbledore have needed to disguise his voice?

Even though the part about Dumbledore's "last" message was a bit cryptic to us readers, Aunt Petunia seemed to know very well what it meant. What communication would that have been? It could have been the letter he left with the baby Harry on their doorstep, which explained their commitment on taking in Harry. But it may not have been. Just to be sure, HP Sleuths may want to investigate exactly when it was that Aunt Petunia and Dumbledore would have "last" communicated. (Hint — there does appear to be some contact with the Dursleys — for instance in Chapter 5 {"The Whomping Willow"} from Book 2.)

HOW DOES HARRY'S PROTECTION AT PRIVET DRIVE WORK?

According to Voldemort in Chapter 33 {"The Death Eater"} of Book 4, due to the ancient magic that Dumbledore has cast, he can't touch Harry at the house on Privet Drive. Dumbledore's description of this magic in Chapter 37 {"The Lost Prophecy"} tells us that the protection is based on a mother's love. Since love is something that is repulsive to Lord Voldything, he will not learn that magic, and therefore has trouble combating it. Harry is safe at Privet Drive.

Yet, there are still several questions about how that safety works. How did Dobby get in? Does it extend beyond the bounds of the property? We had thought it did until we saw the Dementor attack just a few blocks away. Dumbledore said that Harry only needs to visit Privet Drive to have the protection all year long. What *kind* of protection? Could it be that Harry is vulnerable to anyone *except* Voldemort?

Dumbledore's words in Chapter 37 {"The Lost Prophecy"}, were that the original letter that accompanied baby Harry was left on *"her"* doorstep. This may have been a convenient way of phrasing it, but if you look at its juxtaposition (jux-ta-position, Rule #1a) to his explanation of the importance of Petunia's blood, then it is very likely intentional. Dumbledore's wording about Lily's blood protection is the key clue. Dumbledore is now very specific in Book 5 that the blood protection must come through Lily's line — and that Petunia is the last of that line. Because the spell was cast by Lily, apparently James' relations would not suffice. Does this mean that there could still be some relations on Harry's father's side around after all? How does that fit in with Sirius' comment in Book 3 about "the last Potter"? We don't know, so our best advice is CONSTANT VIGILANCE!

COULD CROOKSHANKS BE AN ANIMAGUS?

Even before Book 5 hit the shelves, people were speculating whether Crookshanks could possibly be an Animagus. That was based primarily on his being so intelligent, coupled with his uncanny ability to communicate with Padfoot. Although we don't know for sure, WWP is fairly convinced that Crookshanks is a part Kneazle (reference *Fantastic Beasts*).

If Crookshanks were an Animagus, it would seem that Padfoot should have recognized him as one. In Book 3, Sirius called Crookshanks one of the smartest "of his kind." It is unlikely Sirius would have called him that if his "kind" were human. A less definitive but highly logical reason that Crookshanks is not an Animagus was made quite clear by Jo. Ron commented in Book 3 that Animagi parading as pets is highly deceptive and not at all acceptable

215

behavior for a good guy. Unless Animagi can change gender when they transform, we also cannot imagine that Crookshanks *(he)* would be hanging out in the girl's dorm after what we saw happen to Ron in Book 5 (tee-hee).

The "coincidental" description of Mundungus Fletcher was most likely done by Jo with the specific purpose of teasing us. However, it now has people wondering As this is a magical world, it is possible that there could be some tie between Crookshanks and Mundungus Fletcher. Nonetheless, we are absolutely positive that Crookshanks is *not* Mundungus. Our proof is from Chapter 5 {"Order of the Phoenix"}, where everyone, including Dung, himself, is sitting around the table as Crookshanks settles himself onto Sirius' lap.

Chapter 3 FAQs
(THE ADVANCE GUARD)

WHAT'S THE DIFFERENCE BETWEEN A METAMORPHMAGUS AND AN ANIMAGUS?

Both Metamorphmagi and Animagi are people who have the ability to transfigure. The primary difference seems to be that one is a human-to-human transformation and the other is a human-to-animal transformation — although that is not confirmed. For instance, Tonks can change her appearance rather dramatically, but as far as we know, she retains a human form. Another big difference is that the Metamorphmagi are born with the natural ability to alter their features without any training, while Animagus wannabes have to diligently study highly-advanced transfiguration techniques, which they may never be able to master.

WHAT IS THE DIFFERENCE BETWEEN DISILLUSIONMENT AND INVISIBILITY? ✓

Alert HP Sleuths had already known about Disillusionment Charms from *Fantastic Beasts*. However, we did not know exactly how they worked until Book 5. Unlike the Invisibility Cloak, the Disillusionment Charm doesn't make you invisible — it just makes you blend in with the background. You take on the appearance of whatever is around you. So, it isn't perfect. If you get too close to someone, it will be obvious, and if you move around a lot, people would notice the distortion in the background. It probably looks as if the background is shifting in the same way the Romulan "cloaking devices" from Star Trek cause a ripple in space. (Hint — if you're not a Trekkie, it may help to know a few chameleons.)

WAS TONKS THE LAST AUROR SELECTED FROM HOGWARTS?

In Chapter 29 {"Careers Advice"}, Professor McGonagall told Harry that they hadn't selected an Auror candidate from Hogwarts in the last three years. She also described how Aurors have to take an extra three years of training. That means, if the person who was selected three years ago is now an Auror, that person would have just completed the extra training, and qualified this year. However, Tonks has already been an Auror for a year, plus she sounded a bit apologetic about it — as if it took her even longer than some people. So, it doesn't seem as if she was the last (we wonder who was).

Chapter 4 FAQs

(NUMBER TWELVE, GRIMMAULD PLACE)

WHY IS IT CALLED "GRIMMAULD PLACE"?

You may have recognized the "Grim" in Grimmauld Place. However, did you take it the rest of the way? This is not just tricky, it's a jump out and yell "Boo!" Rowlinguistic. It is at least a *quadruple* pun. Here are the meanings that we have (thus far) deduced. Note - they do hold clues:

Grim	=	Death omen
Grimm auld Place	=	"A grim old place"
Grimm	=	Grimm fairy tales
Grimm	=	Grimm's Law of philology (from Jacob Grimm)

WHAT IS A "SKIRTING BOARD" AND WHY IS THAT IMPORTANT?

When Harry first entered Grimmauld Place, he was a bit confused, and some readers may have been too. Harry hears something "behind the skirting board," and U.S. readers who have the UK version would probably not have understood what that was. The U.S. version clarifies it to mean *baseboard*. However, *skirting/skirt* is a one of the basic running bits that is scampering throughout Book 5, so it is important that HP Sleuths know about this first (and critical) use of the running bit (see Hints below).

WHY ARE THE TWINS ALLOWED TO APPARATE AND WHY DON'T THEY HAVE TO FINISH SCHOOL?

Gred and Forge may act like baboons, but they are really talented wizards. The kind of magic required for their masterpieces of mirth is quite advanced, although according to Hermione, their talents may not be what you would call "traditional." In Chapter 7 {"Bagman and Crouch"} of Book 4, Bagman was highly impressed with their fake wands, which were even able to fool Mrs. Weasley (who should have known to expect them). Then, in Book 5, not only was Professor Flitwick delighted with their Portable Swamp, but they even received a compliment from Hermione about their fireworks and Headless Hats.

Although Fred and George may have only squeaked by with a few OWLS, we suspect that is because they learned what *they* considered most useful — which, of course, was anything tied to making money (and mayhem). The real-world equivalent to that would be the difference between someone who teaches himself to be an expert computer wiz vs. someone who studies for a Ph.D. in Literature. That is why the twins were able to pass that difficult Apparating exam "with Distinction," even though Charlie had to take his twice. (We suspect that the twins may have already had an "understanding" of how to Apparate long before they went for training and testing.)

A wizard is qualified to test for their Apparating License at the age of 17 — just like a Muggle could go for their automobile Operator's License. They only have to be of age; they do not have to be finished with school. We know from Chapter 16 {"The Goblet of Fire"} of Book 4 that Gred and Forge missed the 17-year-old age cut-off by just weeks (poor babies) — proof they had turned 17 in the middle of their sixth year at Hogwarts. That is why they had already taken their Apparating exam even though they were still in school.

According to the system in the magical world, which seems to be similar to Muggle schools

in the UK, once you have taken your exams and shown a certain degree of competence, you are considered finished with your education. There is no requirement to continue with school or to take the more advanced NEWT tests. In the case of Gred and Forge, the degree of competency was apparently nominal — given that we know several talented wizards who achieved 12 OWLs, whereas the twins' *combined* OWLs were only half that. Nonetheless, upon receiving their OWLs, the twins are officially qualified as practicing wizards. It's the difference between being at the top of your class vs. the bottom of your class — you still finish school. So, there is nothing keeping them in school except dedication to their House (and a little Pandemonium to ensure they are included in the next edition of *Hogwarts: a History*).

WAS SIRIUS IN SLYTHERIN HOUSE?

After knowing Sirius, it is hard to imagine him a Slytherin. Yet, a bloodline Black was expected to uphold the family tradition in the same way a bloodline Malfoy would do. Based on Phineas' Slytherin affiliation and a few snake trinkets around their house, we are quite sure Sirius' "noble" ancestors were Slytherins. In Book 1, Malfoy told Harry in Madam Malkin's shop that he already *"knew"* he would be in Slytherin — just like the rest of his family. Indeed, the Sorting Hat had *"barely touched his head"* before putting him in Slytherin.

Would Sirius have also been an automatic Slytherin? We don't have any concrete evidence, but we do have a few good hints to dispute it. One is that Sirius has put others' needs before his own (not a very Slytherin-like thing to do). Then there is the overall theme of the Harry Potter septology: "choices." Sirius may not have been perfect, but he never acted out of personal ambition at the cost of others. We know he despised his family's beliefs. Most importantly, in Chapter 9 {"The Woes of Mrs. Weasley"}, we have a hint that may be almost good enough. If you carefully read the conversation about who became prefect and who didn't (among James, Lupin, and Sirius), you will notice that it sounds as if the selection was made from among the three map makers. See our FAQs in Chapter 9 {"The Woes of Mrs. Weasley"} for more on the Hogwarts Prefect system.

— *Chapter 5 FAQs* —

(THE ORDER OF THE PHOENIX)

IS NEVILLE JUST CLUMSY? IS TONKS JUST CLUMSY?

Nothing is as it first appears in the magical world. Animals can be humans, spiders can be boggarts, and bathrooms can be deadly! We can't trust people to be who they seem, and people can't even trust their own memories. Therefore, when we see someone behaving a bit peculiarly, our assumption is that it is normal for them to be that way in this fantasy world. However, the characters in the Harry Potter books expect humans to have some minimal abilities and what would be considered abnormal mental problems in the Muggle world are abnormal in the magical world as well.

Because we have come to expect it of Neville, we think of his clumsiness as "just Neville" — yet he is considered abnormally clumsy. We now speculate that his condition may have the same cause as Bertha Jorkin's problems — an over-zealous memory charm (or two or three...). Tonks' clumsiness is considered a severe case. Yet, when we see Tonks' problems, we think of it as "just Tonks." We have no confirmation at this time that Neville's condition was caused by magic, however, all evidence points that way. So, if we are suspicious of Neville's nerdiness, should we also be suspicious of Tonks' tripping tendencies?

Does Silver Have an Effect on Werewolves like Lupin?

Werewolf hunters always carry a silver bullet in their hunting supplies. That is because one of the legends about werewolves is they can only be killed by a silver bullet in the heart. However, that is not the case in all werewolf legends, and we haven't yet had any hint if it is true in Jo's magical world.

Could silver hurt Lupin just by his touching it? Although we don't have absolute proof, we are fairly confident the answer is "No." Lupin sat down to dinner at the table with everyone else, and unless he didn't use any of the plates, cutlery, or cups, he had to have been eating with the "finest" sterling silver of the renaissance.

So, maybe Lupin won't shrivel up from touching a silver plate, but could a sterling silver knife do the trick? Possibly — then again, knives are usually not a good thing. And what about other silvery objects? We have seen theories about Wormtail's silver hand. Just as all that glitters is not gold — silver doesn't necessarily mean sterling. Silver is a very soft metal. A silver hand that is strong enough to crush things, such as the one Wormtail now has, would probably not be sterling silver. It is more likely that it is a magical silver, and if so, it could be even more deadly!

The answer right now is we have no indication that Lupin would need to be killed using a method that differed from other animals or humans. It is certainly possible that he is more resistant to deadly injuries — just as giants have tougher skin. Without further evidence, we will have to consider him to be basically human with a human soul — it's just that he gets a bit more irritable every 28 days...

Why Is the Voldything Resistance Called "Order of the Phoenix"?

We have not actually been told Dumbledore's specific reason for calling his group "The Order of the Phoenix." We can make a lot of assumptions — such as Dumbledore likes phoenixes or Fawkes plays an important role (maybe striking fear into the enemy). Whenever we are not told information, that is usually a sure sign it's a clue. But we really don't know yet. There isn't anything very meaningful about OOP... that is... unless you're Dung or Luna!

How Does the Fidelius Charm Work?

Don't feel badly if the Fidelius Charm is still a bit confusing to you. As Professor Flitwick explained in Book 3, it is complex magic, and not easy to understand.

The simple part is that there is a secret that needs to be kept, and a person to keep the secret — a "Secret Keeper." Once the charm is in place, whatever the person wants to keep secret is not/no longer known to anyone else — even if they would have thought of it previously. So, as was explained by Flitwick in Book 3, even if the Potters were right there in their house, since they were the secret being kept, they could not be seen. Similarly, even though the Order of the Phoenix does have their Headquarters at Grimmauld Place, because it is under the Fidelius Charm, they and the house cannot be seen — even by other wizards who might be looking for them.

Of course, the person who is the Secret Keeper does know the secret, and can tell anyone he wants. Once he divulges the secret, it is known to whoever he tells. However, only the Secret Keeper can divulge it to others. For example, if Dung slipped up and mentioned it to someone else, they could look all they wanted, but they still wouldn't be able to find the

Order. Only Dumbledore is capable of letting others in on his Secret. That is why Moody was not able to just tell Harry about Grimmauld Place — he had to show Harry the note that was handwritten by the Secret Keeper, himself (Dumbledore).

So what mischief can a demented house-elf cause? As Dumbledore explained, since Kreacher wasn't the Secret Keeper, he couldn't reveal the Headquarters location to anyone. There also are additional conditions, due to the enchantments binding Kreacher to his duties as a house-elf. Not only could Kreacher not divulge Dumbledore's secret, he also couldn't defy a direct order from Sirius. However, Sirius only instructed Kreacher to not tell anyone about vital information. For instance, Kreacher was probably instructed to not tell anyone who their visitors were or anything they discussed, but it didn't stop Kreacher from mentioning a few personal observations....

That was the loophole Voldemort capitalized on. The simple question of who was emotionally important to Sirius had not specifically been forbidden. It was not covered by the Fidelius Charm or by Kreacher's duty to Sirius, his master. Since there was nothing to stop him, Kreacher told Narcissa about Sirius and Harry. It's the little things that getcha...

WHY IS MUNDUNGUS IN THE ORDER?

He's foul, he's smelly, he's a crook, and he's in the Order of the Phoenix. So, why does Dumbledore have a Dung in the Order? The reason we are given is actually a very logical one. Dumbledore needs to use all the resources he has available (even some more unusual ones) in order to stay informed about whatever Voldemort is up to. We already know that the people who align themselves with Voldemort tend to be a bit unsavory. In fact, there could be evidence that Dung is having no trouble getting in tight with the enemy (see hints below). No better way to keep track of the unsavory types than to hear the gossip first-hand. So, how valuable is Dung's contribution to the Order? How valuable is your silverware?

Chapter 6 FAQs

(THE MOST NOBLE AND ANCIENT HOUSE OF BLACK)

WHAT DOES "TOUJOURS PUR" MEAN?

The literal translation of "Toujours Pur" is *Always Pure*. The translation that is closer to the implied connotation is *Forever Pure*. The implication is almost one of an oath, and reinforces the concept of superiority through purity of blood.

WHAT ARE THE POSSIBLE ROOTS TO THE HOUSE OF BLACK?

There are too many holes for us to do a verifiable genealogy of the immediate Black family members we know — let alone those who are more distantly related. For this chart, we have made the assumption that Sirius was being specific when he called someone a cousin (unqualified) vs. a "removed" cousin. We also started with the premise that Nigellus was, indeed, Phineas' last name. We don't know Sirius' mother's name (first or last)! She said the house was her ancestors', and they implied intermarriage, so it is possible that she may have been a Black, herself. We just don't know.

When trying to determine Arthur Weasley's relationship to Sirius, what helps us there is that a *second-cousin once removed* is very specific. We can at least illustrate the relationship. However, even when assuming that Arthur branches from the Nigellus line, there are still

two valid scenarios. This is one best-guess representation of the Black family genealogy based on known information.

Chapter 7 FAQs
(THE MINISTRY OF MAGIC)

IN WHAT WAYS ARE THE MINISTRY OF MAGIC OFFICES LIKE A MUGGLE OFFICE?

Mr. Weasley would be fascinated to find out that his Ministry of Magic office is an underground version of a typical Muggle office complex. By reading carefully, you will discover that the Atrium is on eighth floor where there is a bank of lifts (elevators) just like in a highrise. The "golden symbols" that keep changing on the ceiling are the magical equivalent of a stock ticker board or a corporate notice board. The inter-departmental memos are more similar to how memos used to be delivered in the ancient days (before computers). But if anyone wants proof that magic can't solve the problems of the world, we now see that even the Ministry workers are cursed with cubicles for workspace. (sigh)

WHAT IS THE WIZENGAMOT?

In Anglo-Saxon medieval times, the powerful and learned people of the land would assemble to made decisions and offer advice. This assembly (many of whom were elders) was referred to as a witenagemot. Jo has done a little pun thing and created a wizard version. How Harry attracted enough notoriety to warrant such an audience can only be explained by Draco Malfoy: *"Famous Harry Potter."*

WHY WAS HARRY TRIED IN COURTROOM 10?

The first question that needs to be answered is why Harry was even *in* a courtroom? Harry was summoned to a "disciplinary hearing" as stated in the letter he received from the "Improper Use of Magic Office." According to the information that Mr. Weasley had been given, the hearing was to take place in the office of Amelia Bones, the Head of the Department of Magical Law Enforcement. That seems to have been standard practice for a violation such as this — based on the reaction from the adults. Instead, Harry's hearing actually took place in a criminal courtroom. Just as Muggle children would not be tried by the same courts as an adult, it was not expected that Harry's infringement would have been overheard by the entire Wizengamot. As Harry estimated about 50 Wizengamot members present, it required the use of a large room. Assembling all those judges in that particular courtroom was assuredly intended as intimidation.

WHY DID THEY CHANGE THE TIME OF HARRY'S HEARING?

We can answer that with just one word: Dumbledore.

Without Dumbledore, Harry would surely have been convicted. This is very Kafkaesque and arbitrary — in which laws of government are "altered" on the whims of individuals. It is depressing that Fudge would have allowed such a thing — let alone have encouraged it.

Chapter 8 FAQs

(THE HEARING)

WHY DID DUMBLEDORE AVOID EYE CONTACT WITH HARRY?

It doesn't take NEWT-level detective work to notice that Dumbledore was avoiding looking at Harry throughout most of Book 5. The reason Dumbledore was being so shifty was because Voldemort was being such a pain in the head to Harry.

In Chapter 24 {"Occlumency"}, Harry learned that eye-contact is a key. Where have we heard that before? Didn't Imposter Moody mention it in his lessons too? Seems that is an essential part of those spells which target the brain. Normally, Voldything would have to make direct eye contact in order for his mind-controlling spells to work. But, since he has a direct mind-meld to Harry via the scar, he doesn't need to make eye contact with him — he just turns on his Voldy charm to make the link. However, eye contact is necessary for people other than Harry, and even observing the eyes of those affected is revealing.

Considering that Voldemort is actually sharing Harry's brain, if Harry, in turn, makes eye contact with someone else, then Voldemort can just look right through Harry — directly into the mind of whoever Harry is eyeing. If you were Dumbledore, you might not want to look Harry in the eye either!

There was one more nasty side effect of this. We need to ask how far Voldything can go in controlling Harry's thoughts. We have already witnessed Voldemort inducing Harry to "see" things that are not real (such as Sirius in the Department of Mysteries).

This is what Dumbledore's concerned about. This is why Harry needs Occlumency lessons — to learn how to block Voldemort from sharing his brain.

CAN FIGGY REALLY SEE DEMENTORS?

Figgy didn't fool all the Wizengamot, and she didn't fool Harry. We know she didn't see the Dementors, but we don't know why. We assume it was because she arrived late from trying to beat the crap out of Dung. However, she gave an accurate account of the order of events as they occurred — including the details about the number of times that Harry attempted his Patronus spell. We never witnessed Harry telling anyone what happened that night, so how would she know if she wasn't there to see it? It is likely that Harry could have discussed it with the adults and they would have informed Dumbledore. But that is only speculation.

We are told that Squibs can see Dementors. We are told that Figgy is a Squib. Yet, she obviously did not see them that night. So, did someone brief her about what happened so she could describe it at the Hearing, or did she witness the attack but not truly see the Dementors after all? The jury is still out on that one.

Chapter 9 FAQs

(THE WOES OF MRS. WEASLEY)

WHO ARE THE MEMBERS OF THE ORDER OF THE PHOENIX?

Just like with Voldemort's Death Eaters, we don't know all of Dumbledore's members of the Order of the Phoenix. Here is the list of known current and past members.

Sirius Black	Past/Current	Marlene McKinnon	Past
Edgar Bones	Past	Dorcas Meadowes	Past
Caradoc Dearborn	Past	Alastor Moody	Past/Current
Dedalus Diggle	Past/Current	Peter Pettigrew	Past
Elphias Doge	Past/Current	Sturgis Podmore	Past/Current
Albus Dumbledore	Past/Current	Lily Potter	Past
Aberforth (Dumbledore)	Past/Current(?)	James Potter	Past
Benjy Fenwick	Past	Fabian Prewett	Past
Arabella Figg *(Old Crowd)*	Past/Current	Gideon Prewett	Past
Mundungus Fletcher *(Old Crowd)*	Past/Current	Kingsley Shacklebolt	Current
		Severus Snape	Current
Rubeus Hagrid	Past/Current	Nymphadora Tonks	Current
Hestia Jones	Current	Emmeline Vance	Past/Current
Alice Longbottom	Past	Arthur Weasley	Current
Frank Longbottom	Past	Bill Weasley	Current
Remus Lupin	Past/Current	Charlie Weasley	Current
Minerva McGonagall	Current	Molly Weasley	Current

(All members listed as "Past" were killed — except one rat, Frank and Alice Longbottom, and Caradoc Dearborn, who vanished and his body was never found.)

WHAT IS "MOLLYCODDLING"?

"Mollycoddling" is a real word and is simply someone who pampers people excessively. Not our Molly, the saber-toothed tiger lady, is it?

HOW DOES THE PREFECT SYSTEM WORK?

There is a male and female Prefect chosen for each House — from fifth year on up. That means, just for the fifth-year class, there are two Prefects, each, for Gryffindor, Ravenclaw, Hufflepuff, and Slytherin. There are also two Prefects per House for sixth and seventh-year classes. Head Boy and Head Girl are chosen only in the final (seventh) year. Nowhere are we told, yet, if someone can be replaced as Prefect in a later year if they messed up. Additionally, It would seem logical that it would be quite difficult (if not impossible) to become Head Boy or Girl if you did not make it to Prefect. However, we seem to have had a situation like that at Hogwarts (see Hints below).

Using the evidence that Tonks gave us about why she hadn't been chosen as Prefect, we can conclude that the Head of House has a major say in the selection. We also know that Headmaster Dumbledore informed Harry in {"The Lost Prophecy"} that it was *his* decision not to appoint Harry as Prefect. It is reasonable to conclude that the Heads of House nominate the candidate(s), and that the Headmaster makes the final approval.

Chapter 10 FAQs

(LUNA LOVEGOOD)

WAS THERE NEW EVIDENCE ABOUT OUR LUPIN-JAMES SPECULATION?

If you don't know about our Lupin-James theory, we speculated in our first Guide that Remus and James may have switched places using a Switching Spellbefore Voldemort's attack. Here are some of the points where people have had confusion.

A Switching Spell could be used as the ultimate disguise to switch two humans. The reason the switching spell would work is that only the body parts are switched — the internal person stays the same. Since werewolfism is caused by a bite (a person is not born that way), it makes sense that it would transfer with the body parts.

If you dispute our theory based on the wand shadows in Book 4, we were going by Dumbledore's description of them in Chapter 36 {"The Parting of the Ways"}. Jo specified that the shadows were only *"a kind of reverse echo" (Dumbledore repeated the word "echo," Rule #3)*. The wand echoes are *not* the soul of the person — just a bounced "image." It would be similar to the portraits, which always look like the person did at the time they were painted.

As to the *reason* for the switch — we were implying that if the "Potters" were somehow important to the existence of wizards in the same way Harry is, then it would be imperative that James stay alive and safe (and under wraps) *at any cost*. We were **NOT** implying that James was a coward or that he was saving his own skin! We also think that if our theory is true, he could somehow have been getting glimpses of Harry all these years the same way that Sirius did in Book 3.

Now in Book 5, we have four incidents that keep us alert — all having to do with Lupin touching Harry. In this chapter, look how Lupin shook hands with everyone else but only gave Harry *"a clap on the shoulder."* In Chapter 24 {"Occlumency"}, there is an identical situation in which Lupin, again, shook everyone's hands and all we are told is that he *talked* to Harry. However, in Chapter 35 {"Beyond the Veil"}, as Harry dashed toward the Veil, Lupin grabbed him firmly around the chest. If we are right about the switch, normally that could have been dangerous — given Harry's Legilimens link (think about what happened in Chapter 27 {"The Centaur and the Sneak"} when Dumbledore touched him!). In this case, though, Harry's mind was so focused on one thing (*get-to-Sirius!*) that there was no way any other emotion could have eeked out.

We still do believe there is *something* going on with Lupin. Remember — his parting words to Harry were *"Keep in touch."*

DID DRACO MALFOY REALLY KNOW ABOUT PADFOOT?

Throughout the whole septology, Draco has been kept quite well informed by dear Daddy. In Book 2, although his father wouldn't tell him everything, he knew a lot of details about the Chamber of Secrets. In Book 3, he knew that Sirius Black was Harry's godfather even before Harry found out. In Book 4, he knew exactly what was going on with the Death Eaters at the World Cup, and was told all about the Triwizard Tournament before arriving at the train.

Sirius explains in "Order of the Phoenix" that Wormtail would have informed Voldemort that Sirius was an Animagus, so the Death Eaters would have also known. There is proof of that in Chapter 36 {"The Only One He Ever Feared"}, when Bellatrix tells Voldything that she was dueling with *"the Animagus Black."* Snape tells Sirius in Chapter 24 {"Occlumency"} that

Lucius had recognized him at the train. Therefore, Draco was, indeed, aware that it was Sirius who was bounding along with Harry. We just can't be sure whether Draco shared this information willingly or unwillingly with anyone else (yes, that's a hint).

Chapter 11 FAQs

(THE SORTING HAT'S NEW SONG)

WHAT DID RON SAY TO NICK?

Ron was a bit insensitive to Nearly-Headless Nick, so with the help of a glare from Hermione, he attempted to make it better. However, with a mouth full of food, what came out was somewhat garbled. This is like a Rorschach* psychological test for language fans (you know — the ones where they show you an ink blot and you have to try to see some kind of creature in there?). Don't get stuck on the letters — just say it out loud and concentrate on the big picture. Learning how to read foodtalk is yet another Book 5 lesson for HP Sleuths. (Note that the words have a bit of a Dudley look to them too.)

Here is what Ron said to Nick and the translation:

Foodtalk: Node iddum eentup sechew
English: No (de), I dun' mean t' upset you

* *(pronounced roar-shack)*

IS THERE SOMETHING SIGNIFICANT ABOUT THIS YEAR'S PASSWORD?

As usual, the passwords contain clues. This year's Gryffindor common room password was: Mimbulus Mimbletonia. As Harry would say, "that's definitely a mouthful!" (hehe) You are probably aware that it was the only password this year. Why was there only one? If you asked the Fat Lady, she'd probably have told you it was so difficult that she figured none of the Slytherins could say it — let alone remember it! If you ask us, we would say either it's a really, really important clue, or Jo thought we needed a lot of time to think. We can assure you that it's probably both. Now, you may need to come face-to-face with a baboon's backside or be hit in the head with some Stinksap (like we were) to get it — but it is a skeleton key to Book 5!

To start you off, here are some derivations of the name. Study these carefully — or the Stinksap might catch you by surprise...

Mimbulus Mimbletonia
Possible Derivations of the Words

Mimbulus
 Nimbus = halo
 Cumulo Nimbus = storm cloud
 Nimble = move (movable)
 Gimble = Jabberwocky (find an annotated *Alice*)
 *Mimulus = Figwort family = monkey flower
 Wimble = bore, extract, helical, auger
Mimbulus Mimbletonia
 MM = double, twain
 Mimble-Wimble = spell is ineffective
 (per HP Trading Card Game/Nintendo)

Wimble-Wamble = roll about as walking

Mimbletonia
 tono = thunder
 Pun = Miltonian
 Wordplay = mumble, mimsy/bumble, "M"s
 (keep your annotated *Alice* handy)

*It just so happens that one species of the Mimulus flower has taken a liking to the University of Exeter campus, overgrowning cracks and buildings at an astounding rate. There is also a similar coincidence about one of the leading experts on that species.

Chapter 12 FAQs

(PROFESSOR UMBRIDGE)

HOW CAN PROFESSOR UMBRIDGE DO THINGS THAT DUMBLEDORE DOESN'T WANT HER TO DO?

That's what everyone is asking, but the reality is that Umbridge truly *does* have the authority. Even though Dumbledore is in charge of the school, he doesn't own it. His situation is no different than any other school headmaster. Dumbledore can make decisions about his staff and students that concern everyday affairs. However, his overall educational plan would have to be approved by the school Board of Governors (you know — the Board that Malfoy used to be on before they booted him out in Book 2). That Board normally appoints or removes the Headmaster, intervenes in crises, and from our experience with Book 5, oversees the OWL and NEWT exams.

From the conversations we have witnessed up through Book 4, there is apparently an ongoing power struggle for control over the school between the Ministry and the Board. They have disagreed on critical issues and have overridden each other in order to implement their own agendas. We have not yet learned how the system is structured, so we don't know what department(s) from the Ministry are involved. In Book 4, Fudge said to Dumbledore "I've given free reign, always." Was he talking as Minister of Magic, or possibly as a member of the Board?

The tricky part, which got very complicated in Book 5, is that somehow (probably the same method that was utilized in Book 2) the Board gave the Ministry enough power to start passing their own rulings. Once the Ministry had that kind of power, they were able to continue issuing whatever decrees they deemed "prudent." That also allowed the Ministry to appoint Umbridge to the position of "High Inquisitor" in Chapter 15 (and we all know how popular that was).

As High Inquisitor, with the legal sanction of the Ministry of Magic behind her, Umbridge was able to do almost anything she thought was necessary — as long as it didn't infringe on Dumbledore's legal authority (of course, as soon as she found that it did, she immediately issued a new decree). Will this major bone of contention between Fudge and Dumbledore, concerning the intervention of the Ministry of Magic into the hallowed halls of learning, be rectified in Book 6?

Chapter 13 FAQs

(DETENTION WITH DOLORES)

WHAT DO WE NOW KNOW ABOUT THE THIRD TASK FROM BOOK 4?

We now have one of the lingering mysteries from Book 4 cleared up. Hermione explains that no one saw anything that happened in the maze during the third task of the Triwizard Tournament. The audience would have been watching a dark area of bushes while the champions battled for their lives — similar to the way they sat at the edge of the lake during the second task for an hour. Those who have trouble trying to envision what would be so exciting about that probably have the right idea. We can only assume that it was more of a big social gathering than anything else.

CAN HERMIONE REALLY FREE THE HOUSE-ELVES?

It is not like Hermione to get her facts wrong, but then again, she is emotionally tied to her cause. She is also a bit handicapped by a lack of information about it in her favorite history book. Let's see what we know about house-elves and their masters:

A house-elf...

- ✳ Is bound to serve one house and one family forever. {Book 2}
- ✳ Is considered enslaved; the house-elf's enslavement is tied to the family and all direct descendents. {Book 2 and 5}
- ✳ Can only be freed by being "presented" clothes by the master (According to Dobby, the clothing need only be "passed" directly to the house-elf). {Book 2}
- ✳ Cannot leave the house (without punishment) unless set free. {Book 5}
- ✳ Is bound by the "enchantments of his kind." {Book 5}
- ✳ Has extremely powerful magic, but can't use it without permission. {Book 2}
- ✳ Keeps the master's secrets, never speaks ill of him, and upholds the family's honor. {Book 4}
- ✳ Is never "seen nor heard." {Book 2}

In order to determine if Hermione can free the house-elves with the method she is using, the following questions should be answered:

Is Hermione considered a master?
Since a house-elf is bound to serve a house, they take orders from the whole family who lives there. For instance, Draco would be able to give orders to the family house-elf. As a resident of Hogwarts, it is possible that the students can give orders to the house-elves. As Master, Dumbledore could have given the house-elves an overriding command not to take orders from the students.

How do the students get food from the elves?
When the twins want food, all they have to do is bop on down to the kitchens and put in their request. We've seen Ron place his order for treats, and Dumbledore even reminisced how James used the Invisibility Cloak to nick food from the kitchens. The house-elves are delighted to serve in all cases, so would this be considered taking orders from students or overly-zealous hospitality?

How was Harry able to give Dobby an order?

We see three possible answers to this. One is that Dumbledore *does* allow, or can't stop, all students from issuing orders to the school house-elves; thus, as a resident student, Harry is considered a master. Another is that since Dumbledore knew of the "special circumstances" of Dobby's freedom, he intentionally allowed a loophole for Harry. The third is that, since Dobby is a free elf, he may not be bound by any rules except when given a specific order.

Even though the house-elves wouldn't clean Gryffindor Tower, the only reason Dobby gave was that they were "insulted". Nothing was said regarding fear of being set free; and they are keeping their silence about it. So, if the Hogwarts house-elves pick up one of Hermione's hats by accident, or even on purpose, we still don't know if that would automatically free them. At least we can be sure that Dobby will keep his status as best-dressed house elf.

WHY DOES UMBRIDGE USE THE QUILL WHEN SHE'S GOT FILCH?

It is easy to understand how the black quill would make people think twice about defying Umbridge or one of her rules. What is not as overt is the psychological impact of having the quill engraving into the skin over and over. Umbridge is trying to force her will on people, and those who are less strong in their convictions or less determined to fight, will get the point quickly. However, that quill is a very nasty means of torture. It is more effective than Filch's shackles, especially when attempting to break down those who know they are right and are willing to stand up for their convictions. It is a form of psychological warfare, which fits in very well with the kind of war that Voldemort is fighting right now.

There is an analogy to Umbridge's quill in Franz Kafka's "The Penal Colony" (on your HP Sleuth reading list). If your stomach is up to it, you can read how the "professionals" implement this kind of torture (although even at high school age, it still leaves a mark, so it is **not** recommended for everyone!). Suffice it to say that the deeper it cuts, the deeper the message penetrates. Harry was able to stand up to Umbridge, but if his detention had continued, it is unclear how long he would have endured before being "convinced" not to defy the Queen Toad.

WHY WOULD LUNA BELIEVE IMPOSSIBLE THINGS?

Who only believes in things for which there is no proof? Hermione says that description fits Luna to a "T". As Jo referenced during her appearance in Albert Hall, if you've been in Wonderland, you would also know that the White Queen believed "six impossible things" every morning, because she "practiced." It can be interpreted as Luna having unbridled faith — which allows her to accept concepts that seem impossible. Can that help her to accomplish things that none of the other wizards can? Of course, none of us believe in any of this wizard stuff anyway, do we?

Chapter 14 FAQs

(PERCY AND PADFOOT)

WHAT DID HARRY'S LETTER TO SIRIUS MEAN?

You'll need your *Philological Stone* to help you here.

Harry wrote in a pseudo-code for his letter to Sirius. It used ambiguities to describe things Harry could not say outright. By doing that, only someone who would have been intimate-

ly familiar with the information would have been able to comprehend it. If you had received Harry's letter, this is how you would "read" it:

Harry starts off by telling Sirius, in plain English, that things aren't going very well, so Sirius is prepared to look for clues about what's wrong.

When Harry tells Sirius that Umbridge is "nearly as nice" as his mum, he is saying Umbridge is about *equal in niceness* to Sirius' mother. All Sirius has to do is think about how much he likes his mum, and he knows instantly how much Harry must like Umbridge (blah!). However, someone else who doesn't know Sirius' mum will just assume that Harry is saying that both of them are "nice" (hem-hem).

Then, Harry avoids saying the word he means by saying "that thing I wrote to you about last summer." Although Sirius wrote to Harry at least a couple of times, it seems Harry only wrote to Sirius once. Therefore, it's easy for Sirius to remember that one letter, and to realize Harry is, again, talking about his scar (which no one else would know).

Finally, Harry mentions "our biggest friend," which most people would interpret as a "best" friend. However, the biggest friend they have is *really* big, and with a little thought, Sirius would know from that giant clue it meant "Hagrid."

As with everything we see in Jo's novels, it's there as a lesson for us. You may want to try out what you learned in other places throughout Book 5 too (wink).

WHY DID FILCH THINK HARRY HAD DUNGBOMBS?

Professor Toad got other people to do her dirty work for her. She also doesn't want to make it obvious that she is trying to intercept legitimate mail from the students (at least not until she has passed an Educational Decree). Her devious method of getting her stubby fingers on Harry's mail with a legal and legitimate excuse entailed telling Filch she suspected Harry of ordering Dungbombs. Filch would not question her source. He would have been quite happy to just confiscate Harry's letter and bring it straight to Umbridge. In that way, Umbridge would have been able to read Harry's mail — even though Dungbombs had never even been on Harry's mind. This is called an "abuse of power" — by which someone in authority twists the rules for their own purposes. Umbridge did a lot of that (which is why we cheered for the Centaurs). Hermione was right to be suspicious.

HOW DID UMBRIDGE KNOW SIRIUS WAS IN THE FIREPLACE?

In the next chapter {"The Hogwarts High Inquisitor"}, Umbridge says that Marietta's mum works for the Floo Network Office in the Department of Magical Transportation. Umbridge had somehow "recruited" Madam Edgecombe — either willingly or unwillingly — to monitor the school's Floo Network for her. The Floo Network extends beyond the boundaries of the school, so how does this fit in with the security system? We assume that Dumbledore would somehow have some secure way to shut out other flues while still authorizing access to Grimmauld Place. What we don't know is what would have happened if Umbridge caught hold of Sirius' head.

Chapter 15 FAQs
(THE HOGWARTS HIGH INQUISITOR)

WHY IS CONJURING MORE DIFFICULT THAN VANISHING?
If you want to pass your Transfiguration NEWTs, this may help. There are six degrees of difficulty given for vanishing and conjuring:

Least difficult to **Most difficult**

Vanishing			Conjuring		
inanimate	invertebrate	vertebrate	inanimate	invertebrate	vertebrate

*Just to clarify things: An "**inanimate**" object is something non-living so it isn't very animated (doesn't tend to move around much). A "**vertebrate**" is a creature with a (internal) skeleton — having a backbone with vertebrae, such as a raven or human, which is typically more intelligent. An "**invertebrate**" is usually low intelligence with no bones — something slimy and squishy like a worm or (you guessed it) a slug.*

The magic in Jo's world seems to take into account the complexity of the object or creature to which it is being directed. The more complex the object or creature, the more difficult it is to perform magic on it. The degree to which it has the "essence of life" and "free will" makes a difference. That means that while Vanishing a hat is a no-brainer, a lion would take a *lot* more skill (especially when it's charging!).

CAN WIZARDS REPAIR ANYTHING?
Magic can do very cool things. We have already seen it fix broken bones, allow people to fly, and even make things disappear (we're still working on Draco). However, magic also has limits. It cannot bring back the dead, and it can only fix things — not create or recreate them. In our first Guide, we explained how conjuring "out of thin air" is a temporary condition — as described by Jo in her interview with SouthwestNews.com (July, 2000). The conjured object only lasts for a short time (although we still don't know how long is "short" or what determines the timeframe).

Repairing objects, however, is possible and is done routinely. But we now know there are even limits to that kind of magic. When Harry knocked over his bowl of Murtlap, that was yet another lesson for us. It taught us that even though we can fix a container with "Reparo!", we can't put the essence back into it. The container can be repaired, but the spilled contents are lost (unless what was in there was owl treats — bet Pig would find those!).

We see the same circumstances in *Professor Snape's* office in Chapter 26 {"Seen and Unforseen"}, where the liquid encasing an oogie leaked out of the broken jar. Although *Professor Snape* repaired the jar, the liquid that had already escaped ended up on Harry's robe (uck!).

Ultimately, these lessons were to reinforce the sad fact that once the prophecy orbs were smashed, the contents could never be "repaired" or retrieved.

Chapter 16 FAQs
(IN THE HOG'S HEAD)

WHO WAS THE BANDAGED MAN IN THE HOG'S HEAD?
See next question for the answer...

WHO WAS RESPONSIBLE FOR THE REGURGITATING TOILETS?

See next question for the answer...

WHO WAS THE CULPRIT BEHIND THE BITING DOORKNOBS?

Haven't you now figured out the answer? The Muggle-baiting mysteries were cleared up by Mr. Weasley in Chapter 22 {"St Mungo's Hospital for Magical Maladies and Injuries} when he discussed an article about the arrest of Willy Widdershins. It seems that Willy was responsible for both the regurgitating toilets and the biting doorknobs. Professor Umbridge then confirmed that Willy was also the bandaged man in the Hog's Head. He had been her informant, ratting on the students' off-grounds meeting. Yes, Willy Widdershins was a very busy man. In fact, we believe he was involved in yet one more deal, but we have no proof except Rule #3 (see our Hints for Chapter 5 {"Order of the Phoenix"}). Did you wonder why Willy was all bandaged? Remember — he got injured when his toilet spell backfired on him (pew!). Guess he didn't quit while he was ahead.

WHAT STUDENTS WERE IN DUMBLEDORE'S ARMY?

MEMBERS OF THE D.A.

Hannah Abbot *(H)*	Justin Finch-Fletchley *(H)*	Padma Patil *(R)*
Katie Bell *(G)*	Seamus Finnigan* *(G)*	Parvati Patil *(G)*
Susan Bones *(H)*	Anthony Goldstein *(R)*	Harry Potter *(G)*
Terry Boot *(R)*	Hermione Granger *(G)*	Zacharias Smith *(H)*
Lavender Brown *(G)*	Angelina Johnson *(G)*	Alicia Spinnet *(G)*
Cho Chang *(R)*	Lee Jordan *(G)*	Dean Thomas *(G)*
Michael Corner *(R)*	Neville Longbottom *(G)*	Fred Weasley *(G)*
Colin Creevey *(G)*	Luna Lovegood *(R)*	George Weasley *(G)*
Dennis Creevey *(G)*	Ernie Macmillan *(H)*	Ginny Weasley *(G)*
Marietta Edgecombe *(R)*		Ron Weasley *(G)*

** Note: Seamus Finnegan attended only the last meeting*

Chapter 17 FAQs

(EDUCATIONAL DECREE NUMBER TWENTY-FOUR)

DOES SNAPE REALLY WANT TO TEACH DEFENSE AGAINST THE DARK ARTS?

Rumor has it that Snape really wants the job of Defense Against the Dark Arts, but Dumbledore won't give it to him. We can be reasonably sure from Umbridge's inspection of Snape's class that the rumors are, indeed, correct. Snape confirmed he has applied for the position every year and has yet to be appointed. So, why does Dumbledore refuse to appoint him? Dumbledore may have reasons similar to Jedi Master Yoda's criteria for students. Then again, it could be like keeping a drink away form a recovering alcoholic (Avada Kedavras Anonymous)?

WHY IS UMBRIDGE INSPECTING THE TEACHERS?

Umbridge is an evil person, but she didn't conduct those inspections just to be mean. There were several strategies she had in mind — all of which coincidentally (hem-hem) were a benefit to Voldemort and his plans. Her primary reasons for "inspecting" the teachers seem to

have been:

- Discerning teacher allegiances — who is for/against Dumbledore

- Controlling the curriculum at Hogwarts so that students are unable to defend themselves

- Using her Inquisitorial Squad as intimidation and for spying on those who were aware of Voldemort's return

- Determining what teacher would be easiest and least controversial to sack

- Removing teachers who would present the biggest barriers to her plans (or to anyone else who could be thinking of infiltrating the school)

- Discrediting Dumbledore through his choice of faculty

- Convincing the Ministry that Dumbledore is incompetent overall in his methods of running the school

- Possibly covering for her desire to remove Trelawney from the protection of Hogwarts (remember — Umbridge told Filch to look for Dungbombs when she was really spying on Harry)

It just doesn't seem as if all of these would benefit the Ministry or Fudge (in fact, you might argue that removing Trelawney would improve the reputation of the school). Was Umbridge doing this because she knew what Voldemort needed, or does she just see things from the same perspective?

Chapter 18 FAQs

(DUMBLEDORE'S ARMY)

WHY DID WWP MISS THE HINT ABOUT THE CHAMBER POT ROOM?

As most HP Sleuths now know, our *Ultimate Unofficial Guide* theories were correct concerning almost all of the mysteries revealed *so far*.... except for one obvious "oop!" where we rejected the Chamber Pot Room as a candidate for the "Room of Requirement." Yes — we were fooled. You see, Jo tricked us (and we fell for it!). Geesh.

And this is why we blew it... We verrrry carefully read the exact quote from the interview where she revealed that there would be a magical Room (*BBC Online*, March 12, 2001). This is how Jo described the room:

"...a...room, mentioned in book four, which has certain magical properties Harry hasn't discovered yet!"

The criteria we used for speculating which room it would be was solely from that quote. These comprised the basis for our conclusion:

1. It was described as a room
2. It was mentioned in Book 4
3. The room, itself, has magical properties
4. Harry hadn't yet discovered the magical properties
5. Since Harry hadn't **yet** figured out the magical properties, that implied he had been in the room **already**, but just hadn't discovered those properties

As we now know, it was, indeed, the Chamber Pot room that was the Room of Requirement in Book 5. Although we had considered the Chamber Pot room, we immediately rejected it — based on the last item in that list. You see, we knew Harry had never been in Dumbledore's Chamber Pot room. (Groan)

So, we either should have considered that the *room* — as well as its magical properties — hadn't been discovered by Harry, or (see Hints section below).

How Did Harry Get Back the Marauder's Map?
When last we knew...

In Chapter 25 {"The Egg and the Eye"} of Book 4, Imposter Moody had narrowly saved Harry from Filch, Snape, and nosy Mrs. Norris — as Harry huddled under the Invisibility Cloak with his leg stuck in the trick stair. During that ordeal, Imposter Moody had spotted Harry's map sitting on a step and retrieved it just in time to prevent Snape from nabbing it. Once Harry was free, Imposter Moody (who marveled at the map), asked to borrow it — which Harry thought was fair repayment (not knowing, of course, how it would be used). At the end of Book 4, Imposter Moody still had the map somewhere in his possession at the time that he was kissed by the Dementor, so we had questioned where that map was going to end up in Book 5. As it turns out, Harry did get it back. We're not sure if he retrieved it himself, or it was given back to him. That is the interesting question.

Chapter 19 FAQs
(The Lion and the Serpent)

Why Doesn't Harry Question Things More?
When Harry has wondered about his parents, his family, or other things in his background, why hasn't he asked someone about it? When Umbridge was torturing him, why didn't he discuss it with one of the other teachers? When Harry thought that the reason Dumbledore wasn't looking at him was because he was angry at him, why didn't Harry ask what was going on?

We have only one response — don't ask questions! (The Dursleys *do* get their point across.)

Chapter 20 FAQs
(Hagrid's Tale)

Did We Learn Anything New About How the Marauder's Map Works?
The answer is "no" (drat!). We did see another ghost go by (Nick) with the map right there in Harry's hand, but Harry didn't mention if he even saw a nearly-dot on there. Therefore, we still don't know if ghosts show up on the map or not.

In Book 5, Harry had to keep the map well-hidden from Umbridge and her spies, so he rarely pulled it out to look at it. In fact, in all books, when Harry did look at the map, he was in a hurry and only checked it for threatening activity. He was not likely to notice someone like Pettigrew back in his dorm among all those other dots, when he was worried about the

ones much nearer to him. That is probably the way it was used by Fred and George, and they had already memorized it. Since the map is both illegal and valuable, it is not very likely that any of the kids had it out and studied it for very long. If the map works as we have speculated in our first Guide and it only shows those who are moving, then not everyone would show up anyway — especially if they were seated or curled up in bed. That means there may have been other undesirable entities lurking around Hogwarts in Book 5, but Harry would not have known from the map.

Chapter 21 FAQs

(THE EYE OF THE SNAKE)

You may or may not have noticed, but there are a trunkful of running bits and clues that all relate back to Mad-Eye Moody and/or his nemesis, Imposter Moody. Did you see all the one-eyes or one-eye-bigger references? How about damaged legs, noses, and lopsided things? In this chapter, we see *"gnarled,"* *"Mazin,"* and *"lopsided ...I'm not mad!"* (jux-ta-position). Something's afoot.

Here is where you should start looking. Take your list of running bits and go back to Book 4. Look at the passage describing Mad-Eye Moody's entrance when we first met him in Chapter 12 {"The Triwizard Tournament"} of Book 4. You will encounter approximately 30 Book 5 running bits in the description of his big entrance — in addition to several "coincidentally" prominent phrases used in Book 5. Check your Dark Detectors carefully as you read:

U.S.: pages 184 — 185
UK: pages 163 — 164

We know that Moody is back again for Book 5, but we don't see much of him. Therefore, all these Moody clues should have caught the eye of HP Sleuths and gotten you started searching for the instigator. Why are these hints here? Probably because they are the keys to the secrets in Book 5? We've already shown you all this, but we will give you one more hint to help you solve it.... Think Trick-or-Treat. Think *analogy*. Think...

CONSTANT VIGILANCE!

Chapter 22 FAQs

(ST MUNGO'S HOSPITAL FOR MAGICAL MALADIES AND INJURIES)

WHAT IS BUTTERBEER — CAN IT MAKE YOU DRUNK?
The students are permitted to drink butterbeer and we haven't seen any of them get drunk on it. Yet, Winky got totally stewed. Is it alcoholic or not? In Chapter 28 of Book 4 {"The Madness of Mr. Crouch"}, Harry implies that there is certainly some alcohol or alcohol-type substance in butterbeer, *"...it's not strong, that stuff."* But Dobby answers, *"'Tis strong for a house-elf."* So, we know that there is, indeed, a form of alcoholic ingredient in butterbeer, but it's not very effective on a human (although we haven't tried it on Professor Flitwick yet).

IS THERE A CURE FOR LYCANTHROPY (WEREWOLFISM)?
Madam Pomfrey can cure broken bones in less than an hour and even re-grow them

overnight. It is evident that wizard healers have capabilities far beyond Muggle doctors. Additionally, just like in Muggle medicine, wizard medical researchers also make new discoveries. For instance, even though it's not a cure, we learned in Book 3 about "Wolfsbane Potion," which can make a werewolf docile. And that had not even been discovered when Lupin was a kid. Nonetheless, according to Mr. Weasley in Chapter 22 {"St Mungo's Hospital for Magical Maladies and Injuries"}, there is no cure.

In Book 2, however, Gilderoy Lockhart boasted that he had completely cured a werewolf with the *"immensely complex Homorphus Charm."* Even though he was a big fake and didn't personally do any of his feats, they were supposed to have been based on events that *really happened.* He bragged how he cunningly extracted the details of how a wizard accomplished his amazing spell, and then zap the poor guy's memory. As he was already a liar, maybe the story of curing a werewolf was just a tall tufted tale. However, we have to wonder if, through greed and petty self-indulgence, Gilderoy may have destroyed the mind of a person who had discovered a cure for all the people who suffer as Lupin does.

So, do wizards currently know of a cure? The answer is "no." Is there really a cure? Only "Mr. Smiley" knew for sure... and lately he's not much help (less than usual, even...).

WHAT IS DUMBLEDORE'S WIDGET, AND WHAT DID IT TELL HIM?

Are you aware that we may have seen Dumbledore's delicate silver instrument previously? In Chapter 5 {"Diagon Alley"} of Book 1, Harry sees some *"strange silver instruments"* in the shops at Diagon Alley. The description isn't detailed enough, so we can't be sure, but Rule #3 tells us that we should mention it or we're not doing our job.

As Dumbledore said, in Chapter 37 {"The Lost Prophecy"}, he had suspected the powers of that scar all along. Nonetheless, it wasn't until Harry witnessed/participated in the attack on Mr. Weasley, that Dumbledore was able to verify it.

Dumbledore's little instrument seemed to be able to tap into the underlying cause of Harry's mental and physical state. It sort of reminded us of reading smoke signals or Firenze's description of reading fumes from burning sage and mallowsweet. Just like smoke signals, it began with little puffs that kept getting longer and longer until they connected into long spiraling plumes of smoke. Then, suddenly the one plume divided (cell-like) into two identical plumes.

This is what provided Dumbledore's observation that Harry's predicament had something to do with being *"...in essence divided."* Just like those two plumes of smoke, which had one common "origin," but were two separate existences. Harry and Voldemort share a mental core.

Is this how Dumbledore has been able to comprehend some of the really complex events?

Chapter 23 FAQs

(CHRISTMAS ON THE CLOSED WARD)

WHAT DOES THE WORD "MATE" MEAN AND WHY DOES EVERYONE KEEP USING IT?

The twins are using the word "mate" constantly in Book 5, Ron and Harry seem to have picked up on it. Even the Mapmakers in "Snape's Worst Memory" toss the word around. What does it mean? There are several definitions, and if you've been paying attention

throughout our Guide, you would know that Jo means ALL of them.

Twin, Twain, Two *(The mate to my sock)*
Friend, Fellow *(Me and me mates)*
Assistant *(I'm the boss...here's my mate)*
Significant Other *(Wife, husband, etc,)*
Procreate *(Make babies)*
Greeting *(Hey, Matey)*
Schoolmate *(Hogwarts kid)*
Checkmate *(Game of chess)*

So, why does everyone keep using the "mate" word? It's easy, mate, it's a clue that's double-trouble!

Chapter 24 FAQs

(OCCLUMENCY)

WHAT EXACTLY IS LEGILIMENCY ...AND HOW CAN OCCLUMENCY STOP IT?

We've been seeing what appears to be mind reading throughout the septology. In Book 1, Voldything clearly indicated that he can always tell when someone is lying; he somehow knew the Philosopher's (Sorcerer's) Stone had found its way into Harry's pocket from the Mirror of Erised in Chapter 17 {"The Man with Two Faces"}. Harry was already convinced by Book 2 that Snape could somehow read his mind about the flying car in Chapter 5 {"The Whomping Willow"}. Lupin was the scariest with the mind reading thing — he kept finishing sentences for Harry in Book 3 as he did in Chapter 10 {"The Marauder's Map"}. And in Book 4, Chapter 28 {"The Madness of Mr. Crouch"}, Dumbledore seemed to somehow know exactly what Harry was about to do (send an owl to Sirius).

Most of those could be explained as "great minds think alike," coincidences (hem-hem). Or, as we had rationalized, there appeared to be enough inside information that those weren't too difficult to deduce. However, we were sure that Voldything had some form of extra special powers. Now we know there is a magical explanation for all of them.

So, what exactly was the magic behind all this "mind reading"? We don't want any of you HP Sleuths to get detention from *Professor* Snape for not understanding the fine subtleties between mind-reading and what happened in those examples. Therefore, we will help by explaining the delicate distinctions between mind-reading and the skill of Legilimency.

"**Legilimency**" is the ability to access images, memories, and emotions from someone else's mind. Since brains are dynamic (thoughts are constantly being processed), and ideas and thoughts are stored in various forms (sights, sounds, smells, emotions, conversations, etc.), it is not possible to just enter a brain, search the index, and locate the information you are seeking. Also, there are typically higher emotions or more immediate/dominant thoughts that would get in the way of delving into specific thoughts you might like to access.

For instance, if you want to know something about Draco's next caper, but he just had the best birthday ever and can only think about his roomful of presents, then you may never get a glimpse of what you are seeking. However, if Harry is concentrating really hard on that Stone he just pulled from the Mirror of Erised, it probably wouldn't take any effort for Lord Thingy to observe that image in his brain. And the reason it works for lying is most likely because either the person is usually concentrating on the truth as they formulate the lie, or there is something else that happens when a person lies, which Voldything can detect (sort of like a magical lie detector).

It appears that there are some ways, however, to "trigger" a flow of memories. During Harry's Legilimency lessons, *Professor* Snape forced Harry's mind to replay highly emotional memories. Conversely, when Harry took control of their "mind link," it was Severus' highly emotional memories that were recalled. Even then, we are told, the intruder *doesn't* necessarily get to see *all* of those images either.

Voldemort has shown what a highly skilled Legilimens can accomplish. He was able to transmit the fake image of Sirius being held captive into Harry's brain so convincingly, Harry was unable to distinguish it from the real ones (see our hint below to get Lupin's opinion on who has the skills to combat the Master of Legilimency). That should plant some concerns in the minds of HP Sleuths.

"**Occlumency**" is the defense against Legilimens. If you want to block someone from tinkering with your brain, you need to learn Occlumency. The whole idea is to suppress your emotions and clear your mind. According to *Professor* Snape, controlling emotions is the key. That makes sense — as thoughts containing the highest emotions are the most accessible. The problem is, Harry was right — he wasn't receiving much help in learning how to block. However, *Professor* Snape was *also* right — Harry wasn't trying exceptionally hard either.

So, how does one become skilled in these subtle arts? Not by taking Remedial Potions.

How does Voldemort Use Legilimency to Get What He Wants?

In Chapter 16 {"The Heir of Slytherin"} of Book 2, Tom Riddle/Voldemort tells Harry, *"I've always been able to charm the people I needed."* We now know from Book 5 that Lord Voldything's "charming charisma" was due to his ability to enforce his will on people through Legilimency.

Voldemort also uses his Legilimency to access information about people in order to control them. By knowing what people's deepest fears and secrets are, Voldemort can manipulate them. During Occlumency lessons, *Professor* Snape keeps telling Harry not *to "wear his heart on his sleeve"* — in other words, not to expose his emotional weaknesses. He explains that by doing so, Harry is *"handing him weapons."* Voldemort then knows how to get to him.

That may be how he controls his Death Eaters. It is definitely how he is getting to Harry. If Harry can't fight it and leaves himself open to Voldemort, we could end up calling him "Lord Potter."

What Did Harry See In Snape's Head (and Vice-Versa)?

What Harry saw:
A young boy crying in a corner, watching a "hook-nosed man" yelling at a woman
A teen with oily hair, shooting at flies with his wand, as he sits by himself in a dark bedroom.
A "scrawny" boy, attempting to get onto a "bucking broomstick," watched by a laughing girl.
What Snape saw:
Dudley and his friends harassing Harry during elementary school.
Harry being forced by Dudley to stand in a toilet.
Rookwood kneeling to Voldemort.
Harry enviously eyeing Dudley riding his new bike.
Harry being forced up a tree by Ripper, watched by the laughing Dursleys.
Harry during the sorting, as the Hat recommends placing him in Slytherin.
Furry Hermione, after the Polyjuice didn't work correctly.
Harry being approached by Cho under mistletoe.
Harry seeing a rearing black dragon.
Harry watching his parents in the Mirror of Erised.
Harry looking into Cedric's lifeless eyes.

Watching the letterbox at #4 being nailed shut by Uncle Vernon.
Dementors sweeping towards Harry (from across the lake).
Harry being hurried by Mr Weasley down the windowless corridor.
Harry approaching a featureless black door.
Mr. Weasley diverting Harry away from the door to go left and downstairs.
Gaping mouth of a Dementor.
Snape standing in front of Harry.
Traveling quickly through the corridor leading to the Dept of Mysteries, then
 going into the circular room illuminated by blue flames.
Harry surrounded by doors.

Chapter 25 FAQs
(THE BEETLE AT BAY)

WHY DID AUGUSTUS ROOKWOOD HAVE A DIFFERENT NAME IN THE UK VERSION?

On page 480 of the UK version of Book 5 (U.S. equivalent is 543), Augustus Rookwood was called "Algernon Rookwood." That is the only place in the whole book where that occurs. As U.S. readers know, it isn't that way in the Scholastic version, and it seems odd that with electronic search functions it would have gone totally unnoticed. We can't say that we know for sure, but we can say that looks suspiciously like a clue.

If it *is* a clue, the most likely reason it's there would be to point us to a certain famous author whose name has a familiar ring. A classic fantasy/horror author by the name of Algernon Blackwood wrote spellbinding tales about the interaction of the spirit world with our own. His stories include some titles that should twiddle the ears of HP Sleuths: "Dudley and Gilderoy", "The Willows", and "The Centaur."

WHO ARE THE KNOWN DEATH EATERS? (AND THEIR STATUS AS OF THE END OF BOOK 5)

KNOWN DEATH EATERS	CRIME or EXCUSE	CURRENT STATUS
Avery	*Acquitted — Imperius Curse excuse (mysterious)*	Captured
Black, Regulus	*Wanted out, but was killed by a Death Eater*	Dead
Crabbe	*Acquitted — told Voldemort he would try harder*	Captured
Dolohov, Antonin	*Convicted — Gideon & Fabian Prewett murders*	Captured
Goyle	*Acquitted — told Voldemort he would try harder*	**At Large**
Jugson	*No info — was he a cry baby?*	Captured
Karkaroff, Igor	*Released — squealed on the others to get out*	**At Large**
Lestrange, Bellatrix	*Convicted — tortured the Longbottoms*	**At Large**
Lestrange, Rabastan	*Convicted — tortured the Longbottoms*	Captured
Lestrange, Rodolphus	*Convicted — tortured the Longbottoms*	Captured
Malfoy, Lucius	*Acquitted — bought his way out, Fudge implied*	Captured
Macnair, Walden	*Acquitted — Executioner for Ministry of Magic*	Captured
Mulciber	*Convicted — specialized in the Imperius Curse*	Captured
Nott	*Acquitted — told Voldemort he would try harder*	Captured
Pettigrew, Peter	*Never Fingered — assumed a victim*	**At Large**
Rookwood, Augustus	*Convicted — Ministry spy*	Captured
Rosier, Evan	*Died in battle — got part of Moody's nose*	Dead
Snape, Severus	*Not accused — Dumbledore testified for him*	??
Travers	*Convicted — helped murder the McKinnons*	**At Large**
Wilkes	*Caught in the act — Killed by Auror*	Dead

Chapter 26 FAQs

(SEEN AND UNFORESEEN)

WHAT IS SNAPE'S SECRET MISSION FOR THE ORDER?

At the end of Book 4, we were left with a Snape cliffhanger. Dumbledore said that *Professor* Snape was going to resume a secret mission of doing what he did last time to help fight Voldemort. Since we knew that last time *Professor* Snape had spied on Voldemort, it was a reasonable assumption that would be his mission this time as well. So we waited expectantly to find out all about Snape's secret mission. We're still waiting....

Although Book 5 has confirmed that Professor Snape is, indeed, working for the Order against Voldemort, it still doesn't answer all our questions. The first one that comes to mind (and Harry's too) is, what exactly is he doing?

We now know from *Professor* Snape's conversation with Harry in Chapter 26 {"Seen and Unforseen"}, that he is supposed to be finding out what Voldything is telling his Death Eaters (*"That is my job"*). But we sorta already figured that out. The question is, how is he accomplishing it? There seem to be only two ways for him to do it. One is through Legilimency, and the other would be to physically appear when called (as a Death Eater).

It is possible that Snape *is* using some Legilimency on the Death Eaters to obtain his information. We have evidence that he is staying close to Lucius Malfoy (his subject?). There are certain comments that link him recently to Lucius Malfoy. One was Umbridge's remark in Chapter 32 {"Out of the Fire"} about Lucius Malfoy having "recommended" Snape highly. Another was Sirius' accusation in Chapter 24 {"Occlumency"} of Snape being Lucius' "lapdog," Remember — Snape also knew it was Malfoy who had recognized Padfoot at King's Cross.

There is also a chance that Snape could have been under a hood at the Death Eater circle in Chapter 33 {"The Death Eaters"} of Book 4. It would explain why Snape was so pale when he saw Harry's vision of Cedric's death (bet Cedric always got *his* potions right). Then again, if Snape had truly given up the Death Eater scene, why would he have shown up there?

Maybe he had no choice because of that mark on his arm.

Keep in mind, Sirius said his brother was murdered when he wanted out of the Death Eater business. As Sirius told Harry, *"...you don't just hand in your resignation to Voldemort."* So, how could Snape have done so? ...Or did he? We think not. We don't see how it is that Snape could have left and now be walking around free. If you recall from Chapter 25 {"The Pensieve"} of Book 4, Dumbledore testified to the Council that Snape had not quit, but had become a double-agent. He may have had no other option if he wanted to stay alive (that's assuming he's not already undead. Hehe).

Then, how does Snape masquerade as a Death Eater without anyone knowing? Snape, himself, has verified that Voldemort does know when someone is lying. *Professor* Snape is also a master Occlumens; he could be blocking his feelings so effectively that even Voldemort wouldn't be able to know his true loyalty.

So, is Snape still a Death Eater? Depends on whether you ask Dumbledore or Voldemort. The important question is whether he has really reformed, or if he is playing both sides? (hmmm...)

WHO ARE THE THREE DEATH EATERS VOLDEMORT HINTED ABOUT IN BOOK 4?

HP Sleuths have been debating this passage for three years. In Chapter 33 {"The Death Eaters"} of Book 4, Voldemort had slowly proceeded around his circle of Death Eaters, discussing his satisfaction with their performance. He personally addressed some of them by name, some he only referred to by their actions, and yet others he passed by without engaging in conversation at all. The most interesting discussion was when he stopped in front of an empty space where some of his Death Eaters should have been, and described the three who were still alive — one of whom was not there because he was (at that moment) at Hogwarts. (gasp!)

As we had just found out that both Headmaster Karkaroff and Snape were former Death Eaters, the status of these three missing members caught our attention. Voldemort did not mention any of their names, therefore we were left with another riddle to solve. This is all he said about them:

> "'...One, too cowardly to return ... he will pay. One, who I believe has left me forever ... he will be killed, of course ... and one, who remains my most faithful servant, and who has already reentered my service.' 'He is at Hogwarts...'"

The simple (and possibly the intended) interpretation is:

Cowardly = Snape
Left (be killed) = Karkaroff
Faithful Servant = Crouch Jr

The reason this would make the most sense is that Crouch Jr referred to himself as the "most faithful," and had been placed at Hogwarts by Voldemort. It was also common knowledge that the snitch (Karkaroff) had a bull's eye on him. That leaves Snape (or so it seems) — who could have been using any excuse to stay out of Lord Voldything's way.

Nonetheless, there are other logical scenarios, which should be considered. Although we don't know enough to be conclusive, we can profile each person in order to narrow the number of possible combinations. These are our assumptions for **Coward**, **Left service**, and **Faithful servant** — based on character information:

CROUCH JR

Coward — No, unlikely to be cowardly or mistaken for cowardly. Impersonating Auror Moody right under Dumbledore's nose was as far from cowardly as you can get (it even beats dancing in public at the Yule Ball).

Left — No, he was *in* Voldemort's service — even received a Kiss of thanks for it. Therefore, he couldn't be misinterpreted as the one who left.

Faithful — Yes and No, not necessarily faithful servant — may never have been a Death Eater. Daddy shipped him off to Azkaban without a trial, so we don't know if his conviction was only circumstantial evidence. Once in Azkaban, an impressionable kid, abandoned by his own father to be tormented by the Dementors, may have been easy mark for recruitment. He could have already been a Death Eater when they sent him away, but unless he was, he can't qualify as the faithful servant "*...who has already reentered my service.*"

KARKAROFF

Coward — Yes, definitely the cowardly type. We saw him in action at the Yule Ball in Book 4: when in doubt...flee!

Left — Yes, you could say he left Voldemort's service. Disappearing without a trace does seem to qualify. Voldemort could not have been happy about it. Yup, dead Death Eater.

Faithful — No, not faithful. Nope, nope, nope.

SNAPE

Coward — No and Yes, could be coward — if that's the role he is playing to get out of being a Death Eater. Could also be crazed — double-agent between the two most powerful wizards in a century? Good act for a "coward."

Left — No, they probably still don't know he left (of course, we don't either). We were worried last year that he was a goner, but if that were the case, Malfoy knows where to find him, and Snape is still alive. (Then again, Malfoy did need a replacement servant boy.)

Faithful — Yes and No, another big...maybe, on the faithful routine. He seems to be hanging out with Malfoy, and he doesn't appear to be in any danger. Guess that means the bad guys still think he's one of them? We have no proof (not even a teensy reason, for that matter) that Snape has given up all his evil ways. The only one who is convinced the master of Occlumency has defected from Voldything is Dumbledore. (hem-hem)

This is how it stacks up....

DESCRIPTION	CROUCH JR	KARKAROFF	SNAPE
Coward		X	?
Left / to be Killed		X	
Faithful Servant	?		?

As long as Crouch Jr was the faithful servant, there are no issues. He was most likely eliminated because either the Dementors were already receiving orders directly from Voldemort, or Malfoy was helping to cover up all knowledge of Voldemort's return — and we know how Fudge likes to make Lucius happy (jingle, jingle). Unfortunately, now that Crouch Jr can't talk, we also don't know if he had previously been a servant of Lord Voldemort or not.

If Crouch Jr wasn't already a Death Eater, then that could be really scary — as he doesn't even belong on this list! We would have to start looking for *another* "faithful servant' who had 'reentered' Volde's service at Hogwarts." It could be Snape, or it could be yet another unknown baddie (gulp!). Even if it's not Snape, Voldemort could still have thought it was, but why would he have talked about Snape as if he were already contributing to his cause? If Snape wasn't the "faithful servant," was he even the "coward"?

We had already suggested in our first Guide that it may not have been as easy as it looked. Book 5 throws a monkey wrench into the works. If there is any chance that Snape is still hanging out with the Death Eaters as part of his mission, then we need some answers before the mystery of the three missing Death Eaters is solved.

Chapter 27 FAQs

(THE CENTAUR AND THE SNEAK)

QUESTION: WHAT IS FIRENZE'S CLASSROOM?
Answer: A Holodeck
Question: What is a Holodeck?
Answer: Just like Firenze's Classroom

COULD DUMBLEDORE REALLY BREAK OUT OF AZKABAN THAT EASILY?
That's what he said, and we're not going to dispute it — so why are you looking here?

WHAT WAS IT THAT HARRY FELT BRUSH BY HIM?
Book 4 confirmed that you don't have to be in direct contact with the jet of a spell in order to feel its effects. In Chapter 9 {"The Dark Mark"}, when the group of Ministry wizards were all casting spells at once, Harry could feel a draft from the jets whizzing overhead. We also know from other incidents — like the spell Draco cast four chapters later (before he was turned into the *"amazing bouncing ferret"*) — that a grazing spell can cut or burn.

In this chapter, when Harry felt something brush by him, it was a wisp of a memory spell that Kingsley muttered and slyly released. It was, in fact, this memory spell that Dumbledore referred to later, which prevented Marietta from remembering the information so she was unable to betray them.

Did you see Marietta's glazed eyes? That reinforces our lessons that by watching people's eyes, it is possible to know if they are being affected by memory charms, Imperius Curses, or other spells which influence the mind. According to what we've been told, while the memory is lost forever, the dazed effect of the memory charm passes. However, Imperius Curses, which are constantly in effect, will continue to cause the odd look in the eyes as long as the person continues to be under the spell. Note — it is also likely that the eyes will clear a little if the victim is able to fight the spell.

It appears that someone performed *another* spell in Dumbledore's office too. When Umbridge was shaking Marietta, she suddenly let go as if she had been zapped. This was the same kind of reaction Vernon had in the first chapter when he was throttling Harry at the window.

It was probably either Kingsley or Dumbledore who had stopped her, but it was Dumbledore who claimed the responsibility. Useful spell.

HOW DOES A PATRONUS GET ITS SHAPE?
Although the Patronus spell works the same way for everyone, the shape of the Patronus varies with each individual. The Patronus seems to be an extension of a person's personality. You can think of it as: "If you were an animal, what would you be"? The only difference is that you don't actually choose — it just sort of pops out.

There is a link here, again, to the portraits and to what Dumbledore saw in his silver instrument. For those who are into such things, you could call it an external manifestation of their psyche.

That means we can definitely infer things about people — based on their Patronus. Cho Chang's was a Swan — which implies that although she is beautiful now, she may have been

an "ugly duckling" as a child. Philip Pullman developed a Patronus-like concept for his trilogy (see Suggested Reading).

Chapter 28 FAQs

(SNAPE'S WORST MEMORY)

WHY DID SNAPE PUT HIS MEMORIES INTO THE PENSIEVE?

When we read about the Pensieve in Book 4, it was unclear whether the "thought" that was placed into the Pensieve was a copy or was actually removed from one's mind. We can now conclude that the memory is physically removed. Another issue, which has yet to be resolved, is how the "memory" is viewed in third-person (you can watch the person whose memory it is). That makes some difference when trying to understand what is "real" vs. what is only stored in memory.

Why does *Professor* Snape remove some of his memories before working with Harry? We know (from having seen it) that at least one of them was a very painful and degrading memory that he did not wish Harry to access. But were the others similar in nature?

We are thinking that there may have been several reasons that Severus removed those memories. In addition to the embarrassment of having Harry see the memories, it is possible that he didn't want Voldemort to have access to them either. They could be the kinds of memories and emotions that should not be accessible to a manipulator like Voldything.

The other memories Snape removed may not have all been personal. Instead, they could have related to the secret work that Severus is doing. It may have been random chance that Harry ended up seeing "Snape's Worst Memory" rather than "The Order's Secret Battle Plan." That could be the same reason why Dumbledore may not be willing to share the Order's plans with Harry! Since everything Harry sees is presumably accessible to Voldemort, the consequences could have been even worse than they were. But then, isn't Snape already of the opinion that rules don't apply to Harry?

WHY WAS JAMES PLAYING WITH THE SNITCH — DID HE PLAY SEEKER?

The jocks on a professional U.S. football team will play with a football — even if they are linemen who never touch the ball in a game (except when it pops into their arms!). Similarly, a goalie will run around with a soccer ball — even though all he cares about is batting it away during the game. It is a status symbol of their profession. Therefore, we cannot make assumptions about the position that James played solely on the basis of his playing with the Snitch.

Having said that, we do have enough evidence to question whether James ever played Seeker.

The only way we knew what position James played was from a chat with J.K. Rowling on Scholastic.com from October in 2000. She told us then that James played Chaser. However, in the first Harry Potter movie, there was a Quidditch plaque that had listed James as Seeker. And now we see him playing with the Snitch.

Well, there is no reason to believe that he only played one position. In Book 5, Ginny is playing Seeker for the Gryffindor team and helped to win the Cup for them. However, she made it very clear to Harry that she would like to play Chaser *when* (not if) Harry returns to

the team. It is very possible that James played **both** positions.

CAN PEEVES BE EXPELLED BY THE MINISTRY OF MAGIC?

How do you expel a ghost? We do have a precedent for the reverse of that. In Chapter 25 {"Egg and the Eye"} of Book 4, Moaning Myrtle described how she was "forced" by the Ministry to *stay* in her bathroom. We are not sure what would happen if she then tried to leave, but we know that they have some kind of "authority" to make her stay. So, if they can force a ghost to stay, why can't they force a poltergeist to leave? Even if they do have the right to make him leave, there is one sticky problem.... Where do you expel Peeves to where he won't create worse chaos?

Chapter 29 FAQs

(CAREERS ADVICE)

WHO IS THE BLOODY BARON?

We don't know much about the Bloody Baron except that he's not the sociable type. Not only is he quite ghastly for the living, but even the ghosts are intimidated by His Bloodiness. He does attend the "ghost council" meetings, and we know he will even push his weightlessness around there. What we do know is that he is covered in blood, he is very mysterious, and he is the only one who can control Peeves the Poltergeist. That gives us a hint about the kind of living character he was.

There is one character that does seem to fit the description of the Bloody Baron quite well. In the *Contes du Temps*, by Charles Perrault, a character by the name of "Bluebeard" killed several wives all because they couldn't resist taking a peek into a locked room, which held the carnage of all of their predecessors. The way he found out they cracked was that once they used a magical key, they couldn't clean off (what else) the blood.

There is another strong candidate as a model for this gruesome ghost. The Baron Redesdale was an Englishman. Unfortunately, he was also a supporter of Hitler and anti-Semitic organizations. The Baron's whole family were in Hitler's inner circle... except one daughter. That daughter stood up for what was right just as Jo's characters are asked to do. That brave daughter impressed Jo so much that there is now a certain link between her and Jo.

The Bloody Baron may not relate to either of these, but until we get more information, we feel they are bloody good possibilities.

Chapter 30 FAQs

(GRAWP)

WHY DID THE CENTAURS ATTACK FIRENZE?

As we described in our first Guide, the centaurs really do know what lies ahead. They differ from Trelawney and "fortune tellers" in that their divination powers are not only very real, but foretell events that effect all living creatures rather than individuals. Centaurs may not have been able to predict whether Binky the bunny was going to die, but they would

know about the return of the most evil wizard in a century. They see major events — not necessarily on a day-to-day level, but over time — on a world-level. They have now clearly seen the signs of war as Mars brightens. (Did you know that, as we write this Guide, Mars is *truly* closer to us — and brighter — than it has been in 60,000 years?)

However....

The Centaurs are in some way sworn to not reveal the secrets of this power. Bane made reference to that in Chapter 15 {"The Forbidden Forest"} of Book 1, and now in Book 5, it was the cause of Firenze's banishment from the herd and he was almost executed for it! The reason could be strictly due to prejudice, due to an ancient pact that they are upholding through honor, or maybe by divulging the secrets, it would break an enchantment and they would lose the gift. By exposing the future, there is also a possibility destiny could somehow be corrupted by those trying to alter it.

We're in a bit of a fog as to why the centaurs are not supposed to share their knowledge, but what is clear is it is a brutally-guarded secret. The worst part for Firenze is that he is sharing the knowledge with a human (considered by centaurs to be animals in their own right), and therefore, unworthy of the information. The relationship between centaurs and humans is already tenuous, so any incident, such as this one, is enough of an excuse for them to justify bloodshed. Unfortunately, they are willing to kill Firenze for siding with a human (Dumbledore) — in spite of their knowledge that Voldemort is gaining power. Some more background reading on this can be found in your copy of *Fantastic Beasts*.

What Is the Meaning of Grawp's Name?

Hagrid relates how Grawp was (gulp) small for a giant. He had been teased and unloved by everyone — including his own mum. He has a very hard time with words, although as Hermy found out, he does try as best he can.

The Harry Potter books address intolerance on all levels, and show how much bickering goes on — even *within* groups who are suffering at the hands of others. The giants are exiled, without a true home. However, rather than unite and fight together, or unite and work out a contingency plan together, the giants just keep fighting among themselves — killing each other off.

Grawp is a child of this animosity. His name is highly appropriate in a story about intolerance, and is very sad. When Hagrid asked Gawp his name, it was difficult to understand what the little tyke said — but we were able to. Fans of Classic Trek may have already guessed it, or you can use your *Philological Stone* if you need help. If you think about the way he was always teased about how small he is, the only words the others ever used to him were:

"Grow up!"

Chapter 31 FAQs

(OWLs)

How Do OWL Grades Work?

OWL grades are fairly similar to Muggle school grades. From what we have been able to determine, this is how the system works. There are five possible grades (If you don't count

Troll):

Passing ————————————————————————————
 O = Outstanding
 E = Exceeds expectations
 A = Acceptable
Non-passing ————————————————————————
 P = Poor
 D = Dreadful

 (T = Troll ?)

For every passing grade you get, you receive one OWL. So, if you take ten exams and pass them all, you receive 10 OWLs. If you take 10 exams, and pass all but one, you would have 9 OWLs. If you take 10 exams and only pass three of them, then that would mean you would be Fred or George (3 OWLs each).

The written exam for a class is worth one OWL; and the "practical" exam is worth one OWL; so, each subject is worth two OWLs. You can pass with an "Acceptable" or you can pass with honors ("Outstanding"). When the students went for careers advice, we saw that some of the careers required not just a minimum number of OWLs, but honors-status grades.

When they take their OWLs, they don't find out their scores immediately. Professor McGonagall advised them that they would not receive their grades until July (Book 6) — when they would be delivered by OWL Post.

How Did Harry Manage to Mix Up His Planets?
When Harry was taking his Astronomy OWL, he messed up the names of two of the planets before he noticed and corrected them. He had inadvertently marked Venus as Mars. If you are looking at the planets, that is difficult to do — one is brilliant white, while the other is bloody red. In fact, if you interpret it from the "classical" (or Luna's) perspective, it would mean he mislabeled "Love" as "War." Would that have been a Freudian slip?

Chapter 32 FAQs
(Out of the Fire)

Is It Realistic that Students Would Help Umbridge?
The High Inquisitor deputized some of the students into her "Inquisitorial Squad" to oversee and report on the others. You can be sure she would have personally hand-picked the students who are sympathetic (or in Malfoy's case — enthusiastic) to her cause, are ambitious, or are looking for special favors. Those students are, therefore, even willing to overstep "legal" bounds to gain favor with her. This was a popular method of indoctrination for the Hitler Youth movement.

Percy's letter from Chapter 14 {"Percy and Padfoot"}, also employs a similar tactic, where he implies that Ron should rat on Harry. This undermines relationships and is difficult for anyone to counteract. Therefore, it is highly effective as a subversive strategy, and was used very successfully by Hitler to coerce children to turn in their own parents!

Hitler's "hit men" were Hitler's Elite Guard — like a "Secret Service" — otherwise known as the "SS." You never knew when they would pop up, and when they did, it was usually bad news (kinda like a Death Eater). Cognizant that there is a war about to start and Voldemort is recruiting troops, we can't help but think "SS" as we see all those double letters throughout Book 5. (Keep in mind — we're *not* implying that's the *only* explanation for the double letters.)

All of this parallels Hitler's psychological warfare techniques. Voldemort takes this one step farther through his brilliant scheme of using the media to discredit anyone who could be a threat. Thankfully, Dumbledore is also brilliant, and he's on our side!

Chapter 33 FAQs

(FIGHT AND FLIGHT)

WHY COULDN'T HARRY SEE THE THESTRALS BEFORE?

According to Hagrid's lesson, you can only see Thestrals if you have witnessed someone die. Harry did see Cedric die in Book 4. So, if you have been wondering why Harry didn't see the Thestrals last year on the way back to the train, you are not confused; you are asking the right question.

In fact, Jo was asked that very question when she appeared at Albert Hall only a few days after Book 5 was released. Happily she let us in on the "secret." You see, Hagrid forgot to mention something in his lesson — Thestrals don't instantly become visible. Why didn't Hagrid remember to tell us? There's a story behind it. Jo had already written about the Thestrals in *Fantastic Beasts* because she wanted to have them visible to Harry. However, she decided that she didn't want to just stick them into the end of Book 4 without any explanation. There is now an extra detail about who can see Thestrals. At the Albert Hall appearance, she specified that *"you had to have seen the death and allowed it to sink in a little bit before slowly these creatures become solid in front of you..."*

Chapter 34 FAQs

(THE DEPARTMENT OF MYSTERIES)

WHAT IS THE DEPARTMENT OF MYSTERIES AND WHY IS THE VEIL THERE?

By the end of Book 4, the only thing we knew about the Department of Mysteries was that the people who worked there were called "Unspeakables." In Chapter 6 {"The Portkey"}, Ron explained they are called that because no one knows what they do. It is definitely top-secret type of work that is perceived as scary or "out there." Everyone else is afraid to talk about *them*. Notice that in Chapter 7 {"The Ministry of Magic"} of Book 5, even the lift/elevator "voice" wouldn't say any more. (Sort of like talking out loud about You-Know-Who).

All throughout the Department, there is evidence of either scientific-type study or museum-like archiving. There are bell jars, tanks of weird specimens (even strange by Snape's definition), huge collections of timepieces of every nature, classroom-style rooms with multiple desks, archival shelving with carefully-preserved artifacts in a climate-controlled environment, and an amphitheatre-style room, which could have been used as a lecture hall or observation gallery. This Veil is apparently quite ancient — implying that it could have been

one the "original" Veils, and is now housed and studied in the Department of Mysteries.

Even if it was not originally intended, the amphitheatre could, also, have been put to use for more sinister purposes. It has a bit of a Colosseum-like feel to it — especially since there isn't much to watch once a person goes through the Veil. Because some of the rooms on that level included courtrooms that hadn't been used in years, it is implied that it might have been tied in to trials and executions. Maybe it was used for capital punishment. We know the three Unforgivable Curses, at most, carry only a lifetime sentence in Azkaban. However, it is possible that wasn't *always* the case. At this time, we don't have enough evidence to say.

In addition to the observed evidence, in Chapter 37 {"The Lost Prophecy"}, Dumbledore told Harry that the room behind the locked door was one of *"the many subjects for study that reside there."* Nearly-Headless Nick also told Harry in Chapter 38 {"The Second War Begins"}, *"I believe learned wizards study the matter in the Department of Mysteries — ."*

There is no doubt that the Department of Mysteries studies really far-out subjects and is probably equivalent to Quantum Physics research by Muggles. Since we have already seen that they can control time, their study of it is probably quite advanced. If someone were to find a really odd object (such as a Philosopher's/Sorcerer's Stone), it would probably be brought here for the experts to study. They are possibly even looking into the question of why magic exists (or maybe why some people are magical).

What Is the Veil and Why Would Harry and Luna Hear Voices In There?

The "Veil" in the Department of Mysteries most likely represents (or is) the Veil of the Dead — a kind of "wall" between the living and the dead. The concept of a veil separating the two existences comes from the myth of the Egyptian goddess, Isis. A statue was placed in front of her tomb, in Memphis, Egypt, with the inscription: *"I am all that has been, that is, that shall be, and none among mortals has yet dared to raise my veil."* That was a very strong image in itself, but what has reinforced it are accounts about an incident with another Veil in the Bible, at the time of Jesus' death; *"And, behold, the veil of the temple was rent in twain from the top to the bottom."* Matthew 27:51. The Bible's Veil was similar to Harry's Veil in that it separated human existence from the domain of God while providing a portal for communication. From those ancient Veils has evolved the image of a "gateway" into the land of the dead.

It is possible that wizards may be familiar with the land of the dead and what separates it from the living. This particular "curtain" could be like a two-dimensional "hole" between the two universes (living and non-living). Philip Pullman investigated such a scenario in his *Dark Materials* trilogy. Before Dante's Inferno, tales of the "afterlife" focused on a wispy, shadowy "Underworld," where the spirits of the dead wafted through — somewhat emotionless, yet a bit morose. That was the "Hades" of Greek legends. If the souls of the dead are in there, then those would have been the "voices" Harry and Luna heard.

Classical mythology is full of people like Hercules and Ulysses who had visited the land of the "underworld" and returned. So, we know it has been and can be done. However, they walked in and walked out. Sirius was *"sent"* off to a place that we don't know anything about, so it may not even be possible to communicate from there, let alone return from there. Even one of his best friends, Lupin, was completely convinced he was gone for good. We don't know if he went to Hades or to some world Jo has for dead wizards.

If the "Unspeakables" have studied the veil, how much have they been able to find out?

WHAT IS GOING ON IN THE BELL JAR?

The room where all the shimmering and ticking is going on is a room of time devices. The ticking is from the clocks, and the shimmering is coming from a huge bell jar. We are already convinced that the Department of Mysteries is where they study all the great mysteries of the universe. The presence of a bell jar with strange properties reinforces that.

Bell jars are most typically used by scientists to create artificial environments. This bell jar contains a closed loop of time — meaning events inside repeat themselves over and over — in a speeded-up state. As Harry watches the bell jar, he sees an egg that breaks open and releases a humming bird. As the bird drifts upward, it ages almost instantaneously...reaches an apex...and then drifts back down to the bottom of the bell jar. As the bird descends, it de-ages almost instantaneously, so that by the time it gets to the bottom, it has returned to infancy and is enclosed once again in the egg.

In our previous Guide, when we were talking about time, we had discussed in our analysis of Book 3 the paradox of "which came first...the chicken or the egg?" It seems that the wizards in the Department of Mysteries have been studying that. Is it possible that they have found the answer and Jo is holding out on us?

WHAT DID THE INITIALS UNDER HARRY'S ORB MEAN?

When Harry saw his prophecy orb, there was a notation just below it. It had the cryptic message:

"S.P.T. to A.P.W.B.D."

If you had trouble figuring those out, you just had to think about who foretold the prophecy and who heard it. Those are just initials for the names of the people who witnessed the event. Why are there so many letters? We know from Harry's hearing that Dumbledore had a lot of names (as if Dumbledore wasn't long enough or hard enough!). The letters stand for "Sybil P. Trelawney to Albus Percival Wulfric Brian Dumbledore."

Chapter 35 FAQs

(BEYOND THE VEIL)

WHAT COLOR WAS THE SPELL THAT HIT SIRIUS?

If you read very carefully, you will confirm that we have no idea what color the spell was that knocked Sirius through the Veil.

"Harry saw Sirius duck Bellatrix's jet of red light: he was laughing at her...The second jet of light hit him squarely on the chest."

There are *two* ways to interpret this. Either it was *another* jet of the same color which would have been red; or it was just another jet of light (unknown color). It was not specific, so it could just as easily have been a jet of purple or even green. From the way Harry reacted, however, we are led to infer that it probably wasn't green after all. If Harry was expecting a still-lively Sirius to emerge from the other side, it doesn't seem likely that it was green, or Harry would have been far more sure of Sirius' death.

If that spell wasn't a killing curse, does that make him any less dead? Probably not. Could it make him less "properly" dead? Possibly.

According to a WBUR radio interview with Jo in 1999, people can't come back to life if they are **"*properly* dead."** Notice how she specifically left the door open with that modifier. So, knowing Jo's knack for twists, until we have confirmation either way, we're with Harry — we're not convinced.

Chapter 36 FAQs

(THE ONLY ONE HE EVER FEARED)

WHAT COULD BE WORSE THAN DEATH?

Ron comments that there can't be anything worse than death. In Chapter 36 ("The Only One He Ever Feared"), Dumbledore tells Voldemort that *"there are other ways of destroying a man."* This feels like a Rule #1 to us. We are being told to start thinking about ways of destroying Voldemort other than just killing him (that didn't work the first time anyway). In our first Guide, we wondered what those echoes from his own wand would do to him, if they could. (smirk)

According to Dumbledore, there are definitely fates worse than death. In fact, literature is full of the possibilities. Many authors have envisioned horrible destinies that involve continuous torture. However, our favorite is not something Bellatrix would do, but more like something Gred and Forge might dream up. If HP Sleuths want to see a humorous literary perspective on the enticing possibilities that await Voldything, you should peruse a French classic called *No Exit* (*Huis Clos* in French). It's on your HP Sleuth reading list.

WHAT HAPPENED TO VOLDEMORT AT THE END OF THE DUEL?

Voldemort was at the fountain as this first battle between the two great wizards was ending. Dumbledore managed to cocoon him in the water — completely encased Voldemort (think chocolate dip) which became a shield as it was smothering him on all sides. It prevented Voldemort from being able to get at Dumbledore or anyone else with his wand, but it didn't prevent him from doing magic. If you look at the description of the Lethifold attack in Fantastic Beasts, you will get an idea of what Voldemort went through as Dumbledore's water attacked him.

Voldemort was able to do magic on himself in order to Disapparate or dematerialize (we weren't told exactly how), and left the scene temporarily...only to reappear *inside* Harry. Dumbledore was most afraid at this point when he couldn't see Voldemort. Possibly because he couldn't look at Voldemort and anticipate his next move, or because he had a feeling that Voldemort might try doing exactly what he did — take over Harry's body.

WHY DID VOLDEMORT POSSESS HARRY AND WHAT MADE HIM GO AWAY?

Voldemort doesn't gain pleasure out of torturing people (unlike the toad lady). The reason Voldemort inflicts pain on others is because he wants to control them, and that is his method of doing so. Although Voldemort can clearly do whatever he wants to other wizards, he prefers to manipulate them in order to achieve his ends. (When your "ends" are immortality and ultimate rule of the magical world, it's definitely a waste of brain cells to bother zapping peons unnecessarily.)

Anyone that gets in the way of Voldemort's achieving his ends (e.g. Lily) is controlled or

killed. Since he can't control Dumbledore, he would like to kill him. Voldemort makes use of any opportunity to get what he wants, and what he wants is Harry — his primary obstacle.

Voldemort is exceedingly brilliant. In this battle, when he realized that he couldn't bypass Dumbledore to get to Harry, he *became* Harry. By possessing Harry and attacking, then Dumbledore is forced to defend himself. Voldemort gave Dumbledore a horrible dilemma — whether to shoot spells at the VoldeHarry (Harry's body) or let Voldemort attack him. Either Harry or Dumbledore would have suffered. Wonder what he would have done? (He probably had something clever in mind but he never had to go there.)

Harry was in excruciating pain from the possession. On the other hand, Harry's intense emotions about Sirius were excruciatingly painful to Voldemort. Voldemort could not inhabit Harry's body when he was that filled with love and emotion... so Volde flew the coop.

WHY DIDN'T HARRY'S CRUCIO CURSE WORK?

If you will search through your trunk of sleuthing scrolls and pull out the ones from Book 4, you can probably find the answer. Imposter Moody had told Harry's class that it took more than just uttering the spell. The lesson we are given is that Magic is not just words but the power behind the words. That would explain why some wizards are stronger than others. Imposter Moody had said that even a whole classroom full of students uttering the spell at him wouldn't *"get so much as a nosebleed."* So are we surprised that Harry couldn't pull off an evil curse?

HOW DID THE STATUES IN THE FOUNTAIN "COME ALIVE"?

This was not simple to spot, because it was done so stealthily that even Voldemort didn't notice! The statue that jumped in front of Harry caught Voldything completely off-guard. Dumbledore had sneaked up on him and cast the spell in time to save Harry. Then Dumbledore casually Transfigured the rest — just like McGonagall had done with the Wizard Chess set in Book 1. How interesting that Voldemort couldn't stop Dumbledore's fountain army. Yet, what we found most intriguing was how the statues were able to walk off to another part of the building in order to get Fudge.

Chapter 37 FAQs

(THE LOST PROPHECY)

HOW DO WE KNOW THAT WAS THE EXACT WORDING OF THE PROPHECY?

If you are asking this question, you are thinking correctly. The Pensieve is a container — it holds thoughts from people's minds. It would seem that those thoughts could only be as accurate as the person's memory of them. So, how can we be sure that Dumbledore remembered the precise wording? We have no proof, but we do have Dumbledore's statement from Chapter 37 {"The Lost Prophecy"}: *"...the prophecy was made to somebody, and that person has the means of recalling it perfectly."*

How does Dumbledore recall it "perfectly"? Is that the same talent Hermione used when she recalled the exact wording of Umbridge's speech? Or Is it possible that the power of the Pensieve includes the ability to guarantee a perfect recreation of the event as it truly hap-

pened? We don't know — we just have to take the Headmaster's word for it (that doesn't mean we packed away our fishing rods).

WHAT IS THE "POWER" THAT HARRY POSSESSES WHICH VOLDEMORT DOES NOT?

The clues to this "power" seem to be the spell of *love* Lily cast on Harry as she died, the emotion Harry had for Sirius, and Dumbledore's words, *"It was your heart that saved you."* If we take the clues literally, we assume he means the power of *love*. It is this power of love that Dumbledore discussed with Harry at the hospital in the last chapter of Book 1.

However, we have some contradictory information that seems to imply it is either more than love, or even something beyond love. In Book 5, Dumbledore describes this power as, *"...a force that is at once more wonderful and more terrible than death, than human intelligence, than the forces of nature."*

If HP Sleuths recall from the hospital scene in Book 1, Dumbledore talked about **truth** in the same way that he talked about the power of love here, *"The truth...is a beautiful and terrible thing, and should therefore be treated with great caution."*

Does Dumbledore really mean that love is *"...more wonderful and more terrible than death"*? Does he mean truth? Truth and love have been known to be equated. It is also possible that he means something else completely or even a combination of emotions. We have assembled a list of possible interpretations for the "power" that Dumbledore described:

Chivalry	Faith / Faithfulness	Loyalty
Compassion	Goodness	Love
Courage	Guilt / Remorse	Nobility
Emotions	Life	Truth / Honesty
Honor		

DOES SOMEONE REALLY HAVE TO DIE IN ORDER TO FULFILL THE PROPHECY?

Dumbledore says the "only chance of conquering" Voldemort is in this prophecy. It seems that he believes it too — since he didn't even try to kill Voldemort in their duel. Can this indicate that Dumbledore feels it unwise to meddle with prophecies, or does he have something more sinister in mind?

The prophecy talks about "vanquishing" the "Dark Lord." We need to think about those words carefully. Does it have to be a death, or can someone just *"Evanesco!"*? We'd like to see a way around this murder paradox, but prophecies can be tricky things (Oedipus can attest to that).

The prophecy also states, *"...either must die at the hand of the other..."* — that's pretty definite in our opinion. However, you don't have to take our word for it. Dumbledore reinforces that in order to fulfill the prophecy, someone has to be killed. Harry asked him, *"'...does that mean that . . . that one of us has got to kill the other one . . . in the end?'*

'Yes,' said Dumbledore."

(Note the tear as well.)

Chapter 38 FAQs

(THE SECOND WAR BEGINS)

IF HARRY MUST KILL VOLDEMORT...

WOULD YOU CONSIDER HIM TO BE A MURDERER?

Jo teaches us that the choices we make define who we are. What if the choices are to kill or be killed? What are Harry's choices now? He is the only one who can stop the worst Dark Wizard in a century, but in order to do that, he must be a murderer. He can save many lives and much pain just by killing one terrorist. If he kills, is he a murderer or savior? As a baby who didn't know any better, his protection temporarily defeated Voldemort and made him into a hero. If he now kills with the knowledge that he is doing so, will he still be a hero?

If you think he should only kill if attacked, then should he be at a disadvantage and become a sitting duck? Or should he go after Voldemort? Is Harry really responsible to the whole world for this terrorist? If everyone knows Harry is the only one who can kill Voldything, then what should be the focus of their resistance?

WHAT DID NICK MEAN ABOUT "DECIDING" WHETHER TO GO ON?

You may feel sad, but Muggles now know that death is final for them. Only wizards can come back as ghosts. That is definite. Nick seems to be caught in a limbo between "here" and "there," and he isn't privy to what "there" actually is. By choosing to stick around, he has ended up being caught in-between. Nick doesn't appear to be happy with his situation. Although the living want to see people come back as ghosts, the ghosts seem to be trapped for eternity on earth yet without a true existence. It almost seems as if we could be considered selfish for wanting to keep them here. They are no longer part of this existence, and they need to go on to the next plane. Their decision to stay is a bondage — not a benefit. If you want to see how the subject is dealt with cleverly and humorously — scare yourself up a copy of *The Time of Their Lives*, starring Abbott and Costello.

WHY DID VOLDEMORT CHOOSE HARRY?

Lord Voldything thinks he is the most powerful wizard in the world. He was informed that someone could be good enough to challenge him. When he evaluated Neville against Harry, he chose the one who seemed to be the biggest threat. The similarities between the two of them were striking, and that triggered the "red flag" in Voldemort's mind. He was prepared to see a carbon-copy of himself when Harry grew up. But as we know, that wasn't the case at all. Nonetheless, the similarities (translation: coincidences) are definitely there. It just so happens that there is another (ahem) coincidence. There is at least one more person who uncannily resembled Voldemort. His name was Hitler.

Classical Mythology Sleuthing Reference

Greek	Roman	Norse	Egyptian	Celtic	
Zeus	Jupiter	Odin	Amun or Amon & Amaunet	Nuada (Silver Hand)	
Hera	Juno	Taranis Frigg			
Apollo	Apollo	Baldur	Ra/Aten/Bastet		
Artemis	Diana	Brynhildr			
Selene	Luna				
Hephaestus	Vulcan				
Aphrodite	Venus	Freya	Hathor		
Poseidon	Neptune	Njord			
Demeter	Ceres				
Hermes	Mercury		Thoth		
Ares	Mars	Tyr	Montu		
Athena	Minerva				
Hestia	Vesta				
Hades	Pluto	Hela	Apepi	Cernunnos	
	Aurora				
Eros	Cupid				
	Uranus				
Persephone	Proserpine				
Charon					
Daphne					
	Janus				
Helios	Sol				
		Thor			
Hecate	Hecate		Heqet or Hekek	Cerridwen	
			Ammit		
			Anubis		
			Apis		
			Horus		
			Isis		
			Ma'at		
			Nut		
			Osiris		
			Seth		
			Sothis		
			Mut		
			Bast		

DOMAIN, ATTRIBUTES	SYMBOLS
G/R — prophecy, weather, kingship, justice	Zeus — thunderbolt; Odin — winged helm, floppy hat, blue-gray cloak, one-eye; Amun — serpent
god of the wheel and thunder — relates to Zeus	sun wheel, thunderbolt
G/R — marriage, childbirth	peacock
sun; Apollo — prophecy, poetry, music, harp, agriculture	Ra & Aten — solar disk; Bastet — cat, Ra—hawk
G/R — chastity, hunting, protecting young, childbirth	bow and arrow, crescent moon
Moon goddess — pre-dates Artemis	crescent moon
vulcanic fire; craftsmanship, blacksmith, lameness	Hephaestus — anvil, throne, chair
love, sex	Hathor — cow
G/R — earthquakes, sea	Poseidon/Neptune — trident
earth — harvest, fertility	grain, pigs, basket of flowers or fruit
Hermes/Mercury — messenger, traveller, leads souls to Hades, trickster; Thoth- knowledge, secrets, writing	caduceus, Thoth — ibis, baboon; Hermes — winged sandals, rooster
war	Thoth — writing tablet; Montu — hawk
wisdom, war, weaving, chastity	owl, olive branch, spear
chastity, domesticity	hearth
underworld, dead	Apepi — serpent; Cernunnos — antlers, stag; Hades — invisibility hat
dawn	chariot
love, sex	bow and arrow
earliest god of the sky	with Gaia, his wife,
in Greek and Roman beliefs	gave birth to the Titans
Queen of the Underworld	pomegranate
boatman on the river Styx — where you get ferried to the Underworld	
nymph who was turned into a tree to save her from Apollo	laurel tree
Roman god of doors and gates; beginnings and endings	two faces looking in opposite directions
sun god — pre-dates Apollo	fiery chariot, haloed youth, rooster, eagles
thunder	hammer
Crone/Hag; Hekek — child birth; Hecate — goddess of moon and spirits	Cerridwen—cauldron, Hecate & Hekek — frog; Hecate — dogs
eater of souls	head of crocodile, body of leopard, bottom of hippo
presides over embalming/oversees judgement	jackal
intermediary between human and divine worlds	bull
sovereign of Egypt; king incarnate	Horus — falcon, hawk
Isis — women, children, magic	Isis — hawk, veil, throne, red
law, truth, cosmic order	feather of truth
sky, wind, celestial sphere	naked woman, covered with stars, arched over the world
representative of deceased pharoah, eternal life, judges departed souls	staff and whip; green skinned man
winds, storms, chaos, evil, darkness	jackal-type animal; man with red hair or eyes
herald and harbinger of Nile annual flooding	star Sirius; woman carrying water jars
universal mother; grandmother of the gods	vulture
sun, women, cats, secrets	cat

MORTALS	KNOWN FOR
Perseus	cut off Medussa's head; rescued Andromeda
Andromeda	tied to a rock for Draco's lunch; rescued by Perseus
Penelope	wife of Odysseus, king of Ithaca, who kept her suiters at bay while hubby off fighting at Troy
Daedalus	created labyrinth; created wings and escaped with son Icarus, who flew too close to the sun and fell into the sea
Cassandra	gave prophecies which were never believed because she rejected Apollo's love
Narcissus	beautiful youth who was condemned to fall in love with his reflection in a pool
Orpheus	mythical Greek poet and musician who went to Hades to bring back his wife who'd died from a snake bite, but turned to look at her on his way out and lost her forever
Pandora	opened the box and let loose all woes, but quick enough to reclaim hope
Prometheus	obtained fire for humans by stealing it from Zeus
Medusa	a Gorgon with a head full of snakes; killed by Perseus
Achilles	Achilles heel
Argus	monster with 100 eyes; killed by Mercury
Odysseus/Ulysses	in the Iliad and the Odyssey - brain behind the Trojan Horse, husband to Penelope, encountered Circe, Cyclops, Sirens, Scylla & Charybdis
Arachne	wove so beautifully she challenged Athena to a contest and Athena turned her into a spider
Bellerophon	fell to his death after slaying the Chimaera
Tiberinus Silvius	9th king of Alba Long; drowned in the Albula river, which was then renamed the Tiber
Gilgamesh	Mesopotamian warrior hero
Romulus & Remus	twins raised by a wolf who founded Rome

Bibliography

Chats and Interviews with J.K. Rowling

America Online, October 19, 2000
BarnesandNoble.com, March 19, 1999
BarnesandNoble.com, September 8, 1999
BarnesandNoble.com, October 20, 2000
BBC, Fall 2000
BBC Online, March 12, 2001
CBBC Newsround, September 19, 2002
CBC Newsworld, July 18, 2000
CoS DVD (Interview with Steve Kloves too), April 11, 2003
Edinburgh Book Festival Interview, August 15, 2004
Entertainment Weekly, September 7, 2000
eToys.com, Fall 2000 (not dated)
Houston Chronicle, March 20, 2001
Larry King Live Interview, October 20, 2000
Raincoast Books, March, 2001
Scholastic.com, February 3, 2000
Scholastic.com, October 16, 2000
SouthWestNews.com, July 8, 2000
The Sydney Morning Herald, October 28, 2001
Time Magazine, October 30, 2000 – Vol. 156 – No. 18
World Book Day Online Chat Transcript, March 4, 2004

Official Harry Potter Publications

- ꙮ *Harry Potter and the Philosopher's Stone,* Bloomsbury Press, 1997.
- ꙮ *Harry Potter and the Sorcerer's Stone,* by J.K. Rowling, Scholastic, Inc., 1997.
- ꙮ *Harry Potter a l'Ecole des Sorciers,* by J.K. Rowling, translated from English by Jean-Francois Menard, Gallimard Jeunesse, 1998.
- ꙮ *Harry Potter and the Chamber of Secrets,* by J.K. Rowling, Scholastic, Inc., 1999.
- ꙮ *Harry Potter et la Chambre des Secrets,* by J.K. Rowling, translated from English by Jean-Francois Menard, Gallimard Jeunesse, 1999.
- ꙮ *Harry Potter and the Prisoner of Azkaban,* by J.K. Rowling, Scholastic, Inc., 1999.
- ꙮ *Harry Potter et le Prisoner d'Azkaban,* by J.K. Rowling, translated from English by Jean-Francois Menard, Gallimard Jeunesse, 1999.
- ꙮ *Harry Potter and the Goblet of Fire,* by J.K. Rowling, Bloomsbury Press, 2000.
- ꙮ *Harry Potter and the Goblet of Fire,* by J.K. Rowling, Scholastic, Inc., 2000.
- ꙮ *Harry Potter et la Coupe de Feu,* by J.K. Rowling, translated from English by Jean-Francois Menard, Gallimard Jeunesse, 2000.
- ꙮ *Harry Potter and the Order of the Phoenix,* by JK Rowling, Bloomsbury Press, 2003.
- ꙮ *Harry Potter and the Order of the Phoenix,* by J.K. Rowling, Scholastic, Inc., 2003.
- ꙮ *Fantastic Beasts and Where to Find Them,* by Newt Scamander, Obscurus Books (U.S. Publisher, Scholastic Press, 2001) for Comic Relief U.K.

- ☾ *Quidditch Through the Ages*, by Kennilworthy Whisp, Whizz Hard Books (U.S. Publisher, Scholastic Press, 2001) for Comic Relief U.K.
- ☾ *Conversations with J.K. Rowling*, by Lindsey Fraser, Scholastic, Inc., 2000.

LITERATURE & ART

- ☾ Aeschylus – *Prometheus Bound*
- ☾ Jane Austen – All Works
- ☾ L. Frank Baum – *The Land of Oz*
- ☾ L. Frank Baum – *The Annotated Wizard of Oz*
- ☾ Charles Boyce – *Shakespeare A to Z*
- ☾ Lewis Carroll – *Alice in Wonderland*, (we use annotated edition by Donald J. Gray – Norton) (Mad Hatter Tea Party), *Through the Looking Glass*, "Hunting of the Snark," Discussion of "Raven-to-Writing Desk" (www.straightdope.com/classics/a5_266.html)
- ☾ Leonardo da Vinci – sketch "Vitruvian Man"
- ☾ Emily Dickinson – "I'm Nobody"
- ☾ E.R. Eddison – *The Worm Ouroboros*
- ☾ T.S. Eliot – *Murder in the Cathedral*, "Burnt Norton"
- ☾ Elizabeth Goudge – *The Little White Horse*
- ☾ Homer – *The Iliad* and *The Odyssey*
- ☾ Washington Irving – "Legend of Sleepy Hollow," "Rip Van Winkle"
- ☾ W.W. Jacobs – "The Monkey's Paw"
- ☾ James Joyce – (In moderation!), *Finnegan's Wake*, *Portrait of the Artist as a Young Man*
- ☾ Franz Kafka – *Penal Colony, Metamorphosis, The Trial*
- ☾ Carolyn Keene – *Nancy Drew* mysteries
- ☾ Rudyard Kipling – *Rikki-Tikki-Tavi*
- ☾ C. S. Lewis – *Chronicles of Narnia*
- ☾ Michelangelo – painting "Crucifixion of Peter" (hint – upside-down)
- ☾ John Milton – *Paradise Lost*
- ☾ A.A. Milne – *House at Pooh Corner*
- ☾ George Orwell – *1984, Animal Farm*
- ☾ Charles Perrault – *Contes du Temps*
- ☾ Edgar Allan Poe – "The Raven"
- ☾ Philip Pullman – *His Dark Materials* (theologically controversial)
- ☾ Saki – "The Open Window"
- ☾ Jean Paul Sartre – *Huis Clos (No Exit)*
- ☾ William Shakespeare – "King Henry V," (Act III, Scene 6), "Romeo and Juliet," "Macbeth"
- ☾ William Shakespeare – *The Unabridged William Shakespeare*
- ☾ Robert Louis Stevenson – *Treasure Island*
- ☾ Frank R. Stockton – "The Lady or the Tiger"
- ☾ Alfred Lord Tennyson – "Sir Galahad"
- ☾ J.R.R. Tolkien – All Works
- ☾ Mark Twain (Samuel Clemens) – *Puddin' head Wilson*
- ☾ H.G. Wells – "The Red Room," "Under the Knife"

REFERENCES

- ☾ Mythology references by Irad Milkin, Michael Grant & John Hazel, and Edith Hamilton
- ☾ *Who's Who in Classical Mythology*, by Michael Grant & John Hazel, Oxford University Press, 1996.
- ☾ *Dictionary of Classical Mythology*, by Pierre Grimal, Penguin Books, 1990.
- ☾ Dictionary — Hermione's favorite tools — the biggest (and heaviest) English-language dictionary (preferably International) that you can find, and a local reference library.
- ☾ *Webster's Third New International Dictionary of the English Language Unabridged*, Merriam-Webster, 1986.
- ☾ *Dictionary of Phrase and Fable* (Brewer's or Oxford versions)
- ☾ *The Holy Grail (Its Origins, Secrets, & Meaning Revealed)*, by Malcolm Godwin, Viking Studio Books/Penguin, 1994.
- ☾ The Leaky Cauldron Fan Website: http://www.the-leaky-cauldron.org The most comprehensive source of new and archived Harry Potter information.
- ☾ *Bartleby's Reference* (Printed or Online)

CLASSICAL MYTHOLOGY/MYSTICISM RESOURCES

- ☾ Greek, Roman, Norse, Egyptian Mythology
- ☾ Druid Legends & Monuments
- ☾ Ouroboros Eastern Mysticism resource

OTHER INTERNET RESOURCES

www.bartleby.com
www.bbc.co.uk
www.encyclopedia.com
www.en.wikipedia.org
www.frankmarrero.com
www.jkrowling.com
www.leprosymission.org.uk
www.library.thinkquest.org
www.loggia.com
www.newadvent.org
www.newmanjunior.wa.edu.au
www.roman-emperors.org
www.sparknotes.com
www.theoi.com
www.wordquests.info

KIDS KORNER NURSERY RHYMES

- ☾ *The House that Jack Built*
- ☾ *Humpty Dumpty*
- ☾ *Jack and Jill*
- ☾ *Little Jack Horner*

- ☾ *Peter Piper*
- ☾ *Sing a Song of Sixpence*
- ☾ *Three Blind Mice*

FILM AND TV

- ☾ *Harry Potter and the Sorcerer's Stone,* Warner Brothers Pictures, 2001.
- ☾ *Harry Potter and the Chamber of Secrets,* Warner Brothers Pictures, 2002.
- ☾ *Harry Potter and the Prisoner of Azkaban,* Warner Brothers Pictures, 2004.

- ☾ *Deathtrap* (Michael Caine, Christopher Reeve – can be controversial!), Warner Bros.
- ☾ *Forbidden Planet,* Metro-Goldwyn-Mayer
- ☾ *The Highlander,* Fox/EMI Films
- ☾ *Monty Python's Life of Brian,* Warner Bros./Orion Pictures
- ☾ *Rosencrantz and Guildenstern are Dead,* Cinecom International
- ☾ *Time of Their Lives* -Abbott and Costello, Universal Studios
- ☾ *Young Frankenstein* - Mel Brooks, Fox
- ☾ *Wizards,* animated film by Ralph Bakshi, Twentieth Century-Fox, 1976.
- ☾ *Dr. Who* TV series (Tom Baker as the Doctor – Adric companion), British Broadcasting Company (UK), PBS (USA).
- ☾ *The Prisoner TV series,* ITC Incorporated Television Company, Ltd., 1967.
- ☾ *Star Trek* TV series, Paramount Pictures.

MUSIC LYRICS

- ☾ Moody Blues – "The Dream" from *Threshold of a Dream*
- ☾ Gilbert & Sullivan – *The Mikado*
- ☾ Caravan – *In the Land of Grey and Pink* - Album

TCG

- ☾ The Harry Potter TCG (Trading Card Game) by Wizards of the Coast (www.wizards.com).